REVOLUTIONS

Michael Löwy
editor

REVOLUTIONS

translated by
Todd Chretien

Original edition: Révolutions (Paris, Hazan, 2000)
Original updated edition: Revoluções (São Paulo, Boitempo, 2009)
(c) Michael Löwy, 2000, 2009
Published with the permission of Boitempo, Brazil
© 2020 Michael Löwy

Published in 2020 by
Haymarket Books
P.O. Box 180165
Chicago, IL 60618
773-583-7884
www.haymarketbooks.org
info@haymarketbooks.org

ISBN: 978-1-64259-160-6

Distributed to the trade in the US through Consortium Book Sales and Distribution
(www.cbsd.com) and internationally through Ingram Publisher Services International
(www.ingramcontent.com).

This book was published with the generous support of Lannan Foundation and Wallace
Action Fund.

Special discounts are available for bulk purchases by organizations and institutions.
Please call 773-583-7884 or email info@haymarketbooks.org for more information.

Cover photograph, *Woman with Flag*, 1928, by Tina Modotti.
Cover design by Eric Kerl.

Printed in Canada by union labor.

Library of Congress Cataloging-in-Publication data is available.

10 9 8 7 6 5 4 3 2 1

Contents

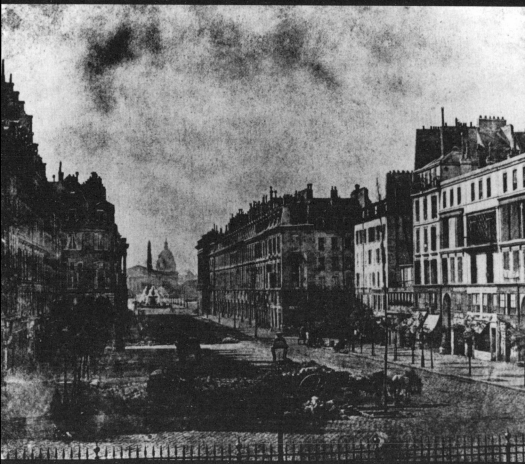

Remnants of barricades on rue Royale, 1848.

The Revolution Photographed

Michael Löwy

Two barricades block a narrow street. The combatants are invisible, awaiting an imminent attack. The barrier that is closer up in this photograph, built out of paving stones and carriage wheels, appears dissected by a spear that might be a flagpole (could it be red?). The street is empty. We can almost hear an expectant silence.

This barricade cannot help but bring to mind rue Saint-Maur in June 1848 described by Victor Hugo in *Les Misérables*:

> The wall was built of cobblestones. It was plumb-straight, precise, perpendicular, leveled square, reinforced with twine, lined with lead wire The street was deserted as far as the eye could see. All windows and doors were closed.... No one to be seen, nothing to be heard. Not a cry, not a sound, not a breath. A tomb.[1]

1 Victor Hugo, *Les Misérables* (Paris, Flammarion, 1979, v. 3), 200–201. [Note: modified translation from the 2013 *Les Misérables* Penguin translation by Christine Donougher.] Hugo contributed mightily to the construction of the revolutionary myth of the barricade. Certainly, he refers to the barricades of 1832 that took pride of place in his *Les Misérables*, but he also made reference to insurgents building them in June of 1848, such as at the entrance to the Saint-Antoine neighborhood, where he described the barricades first as a monster, then as a sacred monument: "It was enormous and it was alive, and like the back of some electric beast, it threw off lightning bolts. The spirit of the revolution covered its peak with a cloud where the voice of the people sounded like the voice of God; a strange majesty resonated from this titanic mound of rubble."

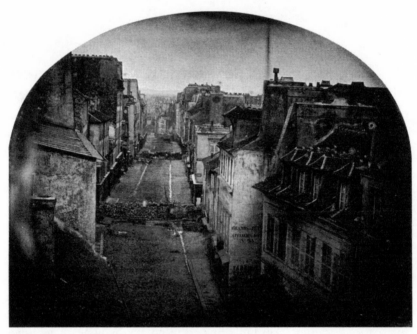

Barricades before the attack, rue Saint-Maur, June 25, 1848.

A photograph of the same barricade the following day shows the scene after a battle. The street teems with people, soldiers, shock troops, bystanders. They pass between the barricades, now riddled with holes, but largely intact. The insurgents are absent. Are they dead, taken prisoner, or have they fled? What is certain is that they have lost.

These two daguerreotypes, taken from a window on June 25 and 26, 1848, by a certain Thibaut—about whom we know very little—are among the first pieces of photographic evidence of a revolution.[2]

2 The photographs were created from a process invented by Louis Daguerre in 1839 that consists of fixing an image using mercury and an iodine-sensitized silvered plate.

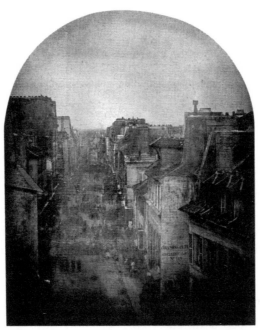

Barricades after the attack, rue Saint-Maur, June 26, 1848.

We have a third entry dated from this same epoch taken by Hippolyte Bayard of a demolished barricade on la rue Royale. It is a melancholic image. All that remains of the insurgents' utopian dream are piles of scattered stones. The street seems deserted, but the presence of some carts and wheelbarrows suggests that someone is preparing to repave it. The battle is over. Order reigns in Paris.

There is a sharp contrast between these first images of revolutionary barricades—magnificent, yet immobile, enigmatic, and distant—and those in Barcelona almost a century later. Sandbags are substituted for cobblestones. This time, the photographer isn't on a balcony, but closer up, or

even among the insurgents. And, most importantly, we see the faces of the combatants, their smiles, their untrained hands holding rifles, and their raised fists. Yet, despite these changes, the barricade is always present, synonymous with popular uprisings, with revolutionary initiative. It is no accident that the hymn of the CNT (National Confederation of Workers), the great anarchist union, begins with the call: "To the barricades! To the barricades!"

Another change of scene: we are in May of 2008. The paving stones are once again dug up from the street, and these rebels, who are almost all young people, are building a barricade in cheerful solidarity. But this time, unlike in Barcelona in 1936 or in nineteenth-century Paris, there are no rifles. They will not kill the enemy; instead they taunt and mock him, and once in a while a protester grazes a police officer with a stone. There is a lot of noise and smoke, but their defense of the barricade does not lead to the rebels' executions, or to them being gunned down by the forces of order. Rather, the fight ends with the youths' dispersal and their regrouping in another part of the city.

Let's return for a moment to the barricades of June 1848, the beginning of the photographic history of revolutions. These constitute a historic guide, what Marx called the start of the "civil war in its most terrible aspect, the war of labor against capital." And they introduce a significant new meaning to the word "revolution": it no longer implies simply a change in the form of the state, but an attempt to subvert the whole bourgeois order.[3]

What was the politico-military efficacy of a barricade? For Auguste Blanqui—of all nineteenth-century revolutionaries he undoubtedly considered this question most closely—barricades were indispensable for an uprising's triumph, as long as the lessons from the defeat of June 1848 were taken into account. As he explained in great detail in *Instructions for an*

3 Karl Marx, *The Class Struggles in France (1848–1850)* (New York: International Publishers, 1964).

Armed Uprising (1869), he thought it was imperative to organize a network between the barricades as well as to make them indestructible by using no less than 9,186 cobblestones in each wall.[4] Frederick Engels, in contrast, was more skeptical. In his well-known 1895 text, he insisted that barricades could have more of a psychological than material impact by rattling the government's troops' morale. From his point of view, the perfection of rifles and artillery, along with broad, straight, modern streets (Haussmann!) created unfavorable conditions for the use of barricades.[5]

These technical and tactical considerations did not prevent barricades from rising up at the heart of subsequent revolutionary crises. In Western Europe—and sometimes in Latin America and Russia, but not in Asia—they became almost synonymous with the notion of revolution itself. From the beginning of the nineteenth century until 1968 and beyond, barricades persisted as the material symbol of the act of insurrection. As the embodiment of subversion, the barricade appears in the city center armed with flags and rifles in an asymmetrical confrontation with the canons and machine guns of the forces of order.

A magical moment, unforgettable light, interrupting the course of ordinary events, the revolution can better be grasped by an image than a concept. It survives and spreads through images and particularly, since the end of the nineteenth century, through photographic images.[6]

Of course, photography can't be a substitute for historiography, but photos can capture what no text can communicate: certain faces, certain gestures, situations, movements. A photograph allows us to see, concretely, what constitutes the unifying spirit and singularity of a particular revolution. Some critics disparage the cognitive value of photographs of historical

4 August Blanqui, *Instructions for an Armed Uprising*, in *The Blanqui Reader: Political Writings, 1830–1880* (London and Brooklyn: Verso Books, 2018).

5 Fredrick Engels, introduction to Marx, *Class Struggles,* https://www.marxists.org/archive/marx/works/1850/class-struggles-france/intro.htm.

6 See Daniel Bensaïd, *Le pari melancholique* (Paris: Fayard, 1997), 281–83.

events. For example, the great film theorist Siegfried Kracauer was convinced that the medium of photography did not offer a total perspective of the past, but only a "momentary spatial configuration." In a 1927 article, he went so far as to denounce illustrated journals as "tools of protest against knowledge"![7] More than a century later, Susan Sontag echoed this opinion in her book *On Photography*. Citing Brecht, according to whom photos of the Krupp factory revealed almost nothing about the reality of this capitalist institution, she reaffirmed that only narrative has the power to impart comprehension. For her, "the limit of photographic knowledge of the world is that, while it can goad conscience, it can, finally, never be ethical or political knowledge."[8]

This point of view, I believe, is debatable. It is true that photographs cannot substitute for narrative history, but this does not prevent them from being irreplaceable instruments for conveying historical knowledge. They make visible particular aspects of reality that frequently escape historians. A photo of Krupp's factory may add nothing, but one showing Krupp himself posing with Hitler alongside other industrialists and bankers is a fascinating demonstration of the complicity between German capitalists and Nazism.

Photographic documentation's specific contribution is put into sharp relief by anthropologist and historian Marc Augé:

> Press or agency photos ... bring History into the present, restoring its depth, contingency, unpredictability. The individual, the event, the anecdote occupies the whole space, but this doesn't mean that History is without importance. One of the historian's tasks, if they wish to understand any

7 Siegfried Kracauer, "Die Photographie," in *Schriften*, vol. 5.2 (Frankfurt: Suhrkamp, 1990), 92–93. See Enzo Traverso's salient commentary about this essay in his book *Siegfried Kracauer: Itinéraire d'un inellectuel nomade* (Paris: La Découverte, 1994), 92–96.

8 Susan Sontag, *On Photography* (New York: Rosetta Books, 2005), 18.

given epoch, is precisely to imagine its present, to make an inventory of its possibilities, to escape from the retrospective illusion.[9]

Affirming the value of photographs for the comprehension of revolutionary events does not imply that we are dealing with purely objective records. Each photo is at the same time both objective—as an image of reality— and profoundly subjective because it bears, one way or the other, its author's mark. In 1925, it required all of Hungarian photographer, painter, and theoretician Láslò Moholy-Nagy's naivety—tinged with positivism—to posit photography's total objectivity: "The camera's mechanism is the surest tool for allowing us to begin to see objectively. Each of us will be obliged to see from a truly optical point of view that which is self-explanatory, that which is objective, before being able to form a subjective opinion."[10] This method abstracts the subjective responsibility arising from personality, culture, and political choices on the part of the photographer. As Cordelia Dilg writes in reference to her photographs of the Nicaraguan Revolution, "No photo is produced without intention. I choose an object, I choose the instant to take the shot, I determine the aesthetic form, and I complete my pictures with a caption (a text)."[11]

The choice of what to document in this work is sometimes arbitrary, as is true for all choices of this type. But, in its diversity and richness, this work presents a multifaceted image of each revolution, both its universality and

9 Marc Augé, *Paris, années 30 (Roger-Villet)* (Paris: Hazan, 1996), 10. See also page 11: "A photograph's instantaneous force also sustains itself by presenting before our eyes scenes not shown by the historians ... not only the attitudes, the fleeting expressions in which one can read joy or fear, the doubts of a person chosen by history to act, but also, and still more, their gestures, their movements, the energy or puzzlement of all those through whom history is built." [Translations from Portuguese citation by TC.]

10 Láslò Moholy-Nagy, cited in Sontag, *On Photography*. [Translations from Portuguese citation by TC.]

11 Cordelia Dilg, *Nicaragua, Bilder der Revolution* (Cologne: Pahl-Rugenstein, 1987), 2. She adds the following explanation, which is hardly insignificant: "These captions can change the meaning of a photograph and are, therefore, a part of the information it contains." [Translations from Portuguese citation by TC.]

its national, cultural, and historic specificity. Revolutions appear to us not as an abstraction, an idea, a concept, a "structure," but as an action taken by living human beings, men and women, rising up against an order that has become unbearable.

Within this body of work, we find both real works of art and simple spontaneous images, both professional and amateur contributions. Should we privilege the work of a few famous photographers when authors of the most surprising, most beautiful, most "historic" scenes are in general anonymous? We have relied on a variety of resources to produce this book: press agencies, most assuredly, but also on museums, archives, private collections, not only in Paris, but also in Budapest and Mexico, Amsterdam and Berlin and by way of Prague and Munich. Altogether, two years of intense research has opened up a path through revolutionary time and space, a plunge into a history that is far from over.[12]

Photos remain more polysemic than texts—they can mean many different things. They can be interpreted in different ways, only requiring a caption to alter or even reverse their meaning.[13] Many of the records we find are mislabeled, and an important part of the research consists in attributing proper titles to them. Walter Benjamin insisted, with reason, on the importance of titles and captions and saw in John Heartfield's captions an example of using text as "a fuse guiding the critical spark to the image."[14]

The birth of photography in the nineteenth century, as a new discovery, horrified the more conservative sectors of the dominant classes. The *Leipziger Stadtanzeiger*, a German daily with a chauvinist streak,

12 I say "we" but that's just a figure of speech: this work was accomplished by our documentarist, Helena Staub.

13 One well-known recent example is a photo of a pile of victims of the Samoza dictatorship being burned that, thanks to the French daily *Figaro*, was transformed into an image of indigenous Miskito people killed by the Sandinistas.

14 Walter Benjamin, "Pariser Brief (2): Malerei und Photographie," in *Gesammelte Schriften* (Frankfurt: Suhrkamp, 1980), 505.

denounced this new diabolical art from France: "Desiring to capture fleeting images from a mirror is not only an impossibility, as demonstrated by German science, but the attempt itself is blasphemous. Man was created in the image of God and his image cannot be fixed solid by any human machinery."[15]

Those on the other side of the barricades were not without their doubts, though for other reasons. Until the 1920s, the practice of photography was extremely rare in working-class, socialist, and revolutionary circles: more often than not, they were the objects and not the subjects of the art. The majority of the images from the Paris Commune, the two Russian Revolutions, and the German Revolution of 1918–1919 were taken by professionals who were usually working for the bourgeois press. This explains the suspicion sometimes seen in the faces of combatants being photographed. Moreover, in the case of the insurrectionists' defeat, this was exactly the type of material that could easily serve the forces of repression in identifying revolutionaries. Roland Barthes referred to photography's "deadly power" and cited an example from 1871: "Some of the Commune's partisans paid with their lives for the pleasure of being photographed on top of the barricades: defeated, they were recognized by Thiers's police and almost all shot."[16]

Some of the professional photographers sympathized with the revolutionaries' cause, but their work was subject to external restrictions. For example, there were dozens of photos of the ten hostages executed by revolutionaries in Munich in 1919, while there are only two photos of the fifteen

15 *Leipziger Stadtanzeiger*, cited in Walter Benjamin, "Petite histoire de la photographie" (1931), in *Oeuvres*, vol. 2, *Poésie et révolution*, Maurice de Gandillac, ed. (Paris: Denoël, 1971), 16.

16 Roland Barthes, *La Chambre claire: Note sur la photographie* (Paris: Cahiers du Cinéma/ Gallimard, 1980), 25.

hundred people killed by state repression between January and March in Berlin of that same year.[17]

As time passed, photography became a mirror—although necessarily deformed—held up to revolutionary events, but it also became a historical actor, a weapon of war. Each camp, during confrontations and civil wars, used photography to produce propaganda, symbols of unity, and signs of recognition. And, as is obvious, pictures from previous revolutions inspired new ones.[18]

Some pictures show leaders, or commanders, or the "heads" of revolutions. These emblematic personalities are almost always the defeated: Auguste Blanqui, Emiliano Zapata, Rosa Luxemburg, Leon Trotsky, Ernesto "Che" Guevara, Carlos Fonseca. Walter Benjamin was not wrong when he insisted on the messianic force of victims, those beaten by history, martyred ancestors, who serve as a source of inspiration for future generations. But the majority of the images found here are populated by anonymous multitudes, by the unknown, and their subject is the insurgent people itself: Parisian artisans, Russian sailors, German or Hungarian workers, Spanish militias, Chinese peasants, indigenous Mexicans. If, as Trotsky emphasized in his *History of the Russian Revolution* (1932), "the most indubitable feature of a revolution is the direct interference of the masses in historical events," then this feature ought to imprint itself on a medium as sensitive as film.[19] What is captured is movement, the masses in action as the protagonists of their own history, the subjects of their own emancipation.

17 See Dietehart Krebs, "Einleitung" and "Revolution und Fotografie," in *Revolution und Fotografie, Berlin 1918/1919*, Thomas Friedrich et al., eds. (Berlin: Dirk Nishen, 1989), 9–24.

18 Walter Benjamin described this quality: "This most exact technique can give the presentation a magical value that a painted picture can never again possess for us . . . finding the indiscernible place in the condition of that long past minute where the future is nesting, even today, so eloquently that when looking back we can discover it." Benjamin, "Petite histoire de la photographie," in *Poésie et révolution*.

19 Leon Trotsky, *History of the Russian Revolution* (Chicago: Haymarket, 2008).

Photographs catch, in black and white, that precious historical moment in which a long chain of domination is interrupted. A discontinuous sequence of revolutionary eruptions constitutes the tradition of the oppressed, a tradition that arose long before Daguerre's intervention.

Photographs of revolutions—especially if they were interrupted or defeated—possess a powerful utopian charge.[20] They reveal to the observer's watchful eye a magical or prophetic quality that renders them permanently contemporary, always subversive. They speak to us about the past, and about a possible future.

20 Could a photograph be a decisive factor in a revolution? This is exactly what is suggested, if in fictional form, by a recent US film inspired by the Nicaraguan Revolution, *Under Fire* (1983), by Roger Spottiswoode. In the film, the main leader of an insurrection is killed in a confrontation with the army (drawing from the example of Carlos Fonseca, the founder of the Sandinista Front for National Liberation [FSLN] in Nicaragua). The dictatorship triumphs and declares the insurrection subjugated. The leader's comrades, who manage to rescue his corpse, ask a friendly photographer to help them pull off the following: he is photographed sitting, reading a magazine, giving the illusion that he is still alive. The photo, published in all the newspapers, inspires the insurgents and the people, who then defeat the tyrant. The scenario is imaginary, but no less provocative for it.

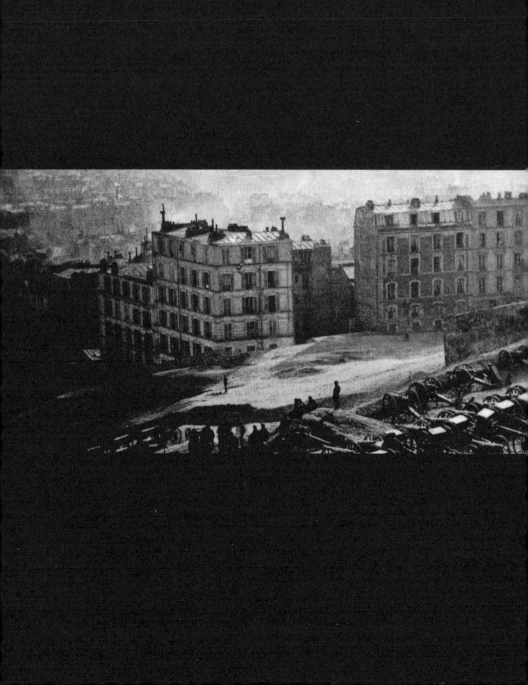

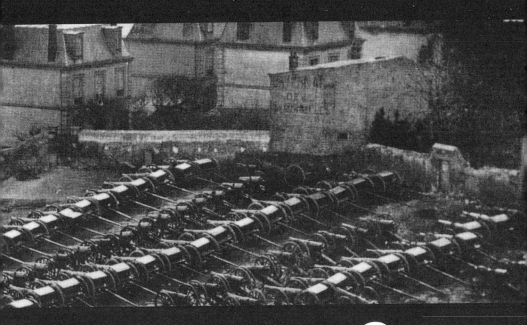

1871

The Paris Commune

Gilbert Achcar

The Paris Commune

The Paris Commune of 1871 is certainly the most prestigious and mythical of all aborted revolutions. And it was also the first of the great revolutionary episodes to be photographed raising the red flag. In fact, the Paris Commune was contemporaneous with the advent of (relatively) instantaneous photography, the mechanisms of which required only a brief period of time to capture the atmosphere of an occasion or event, so long as it was possible to have the participants pose for a few moments. However, even the short time needed was significant, and photography equipment was too heavy and awkward to be able to capture images naturally.

These technical limits had two consequences for the representation of the Commune's image: the graphic arts (painting) generally imposed on photography the iconography of numerous consecrated illustrated works, while photomontages were added, sometimes very roughly, in order to disguise the limitations of early photography through artificial reconstitution. The combination of two representational techniques and their conflation with the visual materialization of two great epochs in historical memory, to a certain degree, provide a sensible answer for a passionate debate among the Commune's historians: Was 1871 the swan song of the revolutionary cycle initiated in Paris in 1789, or the harbinger of twentieth-century revolutions? The answer is simply that the Commune itself, as well as its iconography, pays tribute to two epochs at the same time.

The Commune's story began in the early hours of March 18, 1871, when troops loyal to the government of Adolphe Thiers attempted to seize cannons positioned by National Guard units in the north and east of Paris, and especially those situated on the hill of Montmartre. These cannons, designated to protect Paris against the occupying Prussian army, were acquired mainly through contributions from the National Guard itself. Already upset by the humiliating peace terms agreed to by France's central government and the invading Prussians on February 26—ratified by the recently elected monarchist majority in the National Assembly on March 1—the majority of the radical republican Parisian population had suffered political and economic catastrophes. This culminated in the loss of Paris's status as the capital city when the Assembly decided to install itself some fifteen miles to the west in the Palace of Versailles on March 10.

On March 18, Paris erupted in rebellion. The National Guard—organized federally under the two principles of open eligibility and revocable leadership under the command of a central committee—along with the population of the neighborhoods from which its troops were mobilized, put a stop to the governmental troops' operation. In Montmartre, National Guard units and Assembly troops fraternized, their rifles held high in front of the camera, bearing testimony to this moment of insurrectional euphoria. Two generals—Lecomte, distinguished for his brutality at the front and for leading one of the brigades during the assault, and Thomas, reviled for his role in the bloody repression of Parisian workers after the uprising of June 1848—were put up against a wall and shot by the exuberant crowd. Thiers ordered the government's overnight evacuation of Paris and transferred all state powers to Versailles, which was followed closely by the majority of the wealthy classes fleeing the western part of the city.

On March 18, the Parisian barricades took on a new significance. The people were no longer rallying around mounds of cobblestones against the

occupying Prussian army, but against the reactionary French army—and no longer in the name of saving an endangered nation, but in the name of the Republic, and even the "Universal Republic," and most of all in the name of the Commune. "Vive la Commune!" echoed throughout the city; the slogan unified Parisians, who were determined to achieve autonomy for themselves and to raise the possibility of local collectives throughout France winning their own autonomy in the context of a federal republic.

How proud and confident the Communards appear atop their barricades: the National Guardsmen show off their trumpets and drums, red flags unfurled, in a variety of poses, on guard or at rest, standing upright with their sabers pointing to the sky. They do not inspire fear with their improvised barricades or their good-natured and naive looks. On this occasion, curiously, men and women join the scene as if to underline the festive mood. The friendly climate that emanates from these first moments is illustrated by a boy holding the hand of a guard on a barricade on rue Saint-Sébastien. These images clearly show what the Commune was all about: abundant enthusiasm and very little discipline, good feelings and doubtful efficacy—a people with arms, but not a "people's armada."

Of all the barricade photographs in which plebeian Paris bristles, none are more theatrical or (unintentionally) symbolic than those taken at the intersection of Boulevard de Belleville and rue Ménilmontant, where a variety store displays a sign reading "for the workers." This is working-class Paris—laborers, office clerks, artisans, and the petty bourgeoisie—in revolt under the command of the Central Committee of the National Guard, a majority of whom were workers and two-fifths of whom were members of the International Workingmen's Association, the infamous IWA, directed from London by an exiled German by the name of Karl Marx.

But was this newborn Paris Commune "the house that Marx built," as another photo seems to suggest? We ask ourselves if this photographer wasn't aiming for symbolism, since there is no other apparent justification. In reality, the Parisian "internationalists" were far from being Marxists.

The majority adhered to anarchist ideas closer to Proudhon or Bakunin. A minority in the Central Committee declared themselves partisans of Blanqui, while the other members were simply more or less radical republicans, and many of them were nostalgic for Jacobinism.

During the night of March 18, bit by bit, the National Guard occupied all the administrative and military sites in Paris that had been deserted by the national government. The National Guard's headquarters on rue Basfroi, not far from the Bastille, were protected by barricades and reinforced by cannons, such as those situated on rue de Charonne. The Guard decided to install itself in city hall, the traditional site of Parisian power, until elections for a new municipal government could be held. The square in front of city hall, in turn, was transformed into a westward-facing fortress, enclosed by barricades, such as those on avenue Victoria, with dozens of canons deployed.

The Commune's victory was fast and surprising—unexpected, to put it simply. Thiers did not want to risk his troops being contaminated by the Parisian revolt. He chose to relocate the national government's troops to Versailles, leaving Paris trapped between his army on the one side and the Prussian army on the other, allowing him to prepare for the reconquest of the rebel city. He wanted to prevail over the capital to once and for all smash the people's disagreeable tendency to rise up in revolution. (Thiers was a specialist in these matters. As the minister of the interior during the July Monarchy, he gave an order in April of 1834 to repress insurgent workers and republican masses in Paris who had taken to the streets to protest Thiers's decision to deprive them of the freedom of assembly. Under his orders, troops directed by General Bugeaud, the future bloody conquistador of Algeria, massacred demonstrators on rue Transnonain on April 14, a grisly day reproduced by Honoré Daumier in one of his most famous lithographs.)

Originally organized as a supplementary militia, over the course of a single day the National Guard came to see itself as responsible for replacing the entire state apparatus, both military and administrative. Thiers

deliberately ordered the evacuation of all his forces, counting on anarchy as one of the factors that would contribute to the Parisians' subjugation. This tremendous expansion of responsibility, along with the democratic principles of the insurgents, explains the haste with which the Central Committee transferred its power to an elected commune.

The communal elections were held on March 26, after a brief weeklong electoral campaign in which the Central Committee of the Federation of the National Guard and the IWA explained the objectives for which they were fighting.

Central Committee: "What do we demand? The maintenance of the Republic as the only possible and indisputable government. Common law for Paris, that is, an elected communal council. The suppression of the high command of the police The suppression of the standing army and the right of the National Guard to be the sole guarantor of order in Paris. The right to appoint all our own officers."

Federal council of the Paris section of the IWA: "What do we demand? The organization of credit, commerce, and association with the aim of guaranteeing workers receive the full value of their labor; free, secular, and comprehensive education; freedom of assembly, absolute freedom of the press, and the right of citizenship; the municipal organization of all services including police, armed forces, cleaning, statistics, etc."

This was the program of the "communal revolution." The March 26 elections provided for eighty seats, of which one was set aside for Blanqui, who was held prisoner by the national government in the provinces. Considering the new Assembly to be too revolutionary for their tastes, nineteen moderate republicans resigned their seats soon after, leading to new elections on April 16 to fill their posts. In the end, seventy-nine elected officials took their place in the Commune, of which twenty-one were laborers, sixteen office employees, nine artisans, and twenty-five intellectual or liberal professionals. Thirty-four members of the IWA were elected, in equal

proportion to the "internationalists" represented in the National Guard's Central Committee, reflecting the different political opinions of the rebellious people of Paris. The rest, that is to say, the majority, was composed of Blanquists and neo-Jacobin republicans or moderate socialists.

The Commune set itself to work in the midst of a cacophony that only grew louder from its first days. Essentially, it attempted to implement the double program upon which its members had decided, relying on improvisation and tremendous devotion, and some hesitation—making a variety of mistakes along the way—to achieve the (symbolic) suppression of the standing army, a moratorium on debt payments and rents, separation of church and state, establishment of a maximum salary for public officials, requisition of unused houses, suspension of fines and salary withholdings, as well as nightwork in bakeries, and forgiveness of small debts with pawnshops, etc. The Commune's administrative and social work was absolutely remarkable, especially if we take into account the conditions under which it acted and the lack of qualifications of the majority of its staff.

A political or social revolution spearheaded by a militia hardly conforms to the criteria for the art of war. The Commune wagered principally and above all on its example spreading a revolutionary contagion, as well as on the indignation roused among republicans of all stripes by the course of action pursued by the Thiers government and the royalist National Assembly. The Communards dispatched messengers to cities in the provinces and even equipped hot-air balloons to drop leaflets in the countryside addressed to "the workers in the fields" that ended with a proclamation with three objectives: "Land for the peasants, tools for the laborers, work for all."

The Communards' hopes were not in vain. In the wake of the March 18 uprising in Paris, communal movements and uprisings were declared in Lyon, Marseille, Saint-Étienne, Toulouse, Narbonne, Le Creusot, and Limoges in quick succession. Yet all of these attempts ended in more or less disastrous failures. From the early days of April on, it was clear that Versailles was winning out in the rest of France. And as a large majority of

the members of the Commune believed that capitulation was not an option, an isolated Paris had no other choice but to stand firm and prepare itself for an inevitable confrontation with Versailles.

The conflict would inexorably occur on the terrain chosen by the reactionaries, who held certain advantages, including an army that had steeled itself during colonial expeditions and in combat against its Prussian enemy, and this army needed a scapegoat in the wake of its humiliating defeat at the hands of the latter. As Versailles's preparations strengthened Thiers's government forces, the Parisian defenders fell into an ingenuous anarchy that successive delegates named to lead the Council of War—Gustave Paul Cluseret, Louis-Nathaniel Rossel, and Charles Delescluze—were unable to overcome. The first two, military commanders by training, resigned one after the other, exasperated by the complete lack of discipline in the National Guard, where every man wanted to be in charge; and since they could elect their own officers, those in command knew nothing more than those voting, including the Commune itself, the delegates to its council of war, its executive committee, its military commission, and even the Central Committee named by the Federation of the National Guard, to say nothing of the regional councils. Meanwhile, the Commune accumulated defeats by Versailles's army, as it tightened its circle around Paris.

In Paris itself, the National Guard relaxed and posed for the camera. One exemplary picture shows a group resting, some with military attitudes and others with the air of vacationers; some clean-shaven, some with black beards, some with some beards, and some even female regimental cooks. The guards in the first row lounge indolently on the ground. Are they dreaming of a past century while they lay on a cobblestone beach?

There are also those who pose by themselves for the photographer, sometimes in front of a backdrop: an official, a regimental cook, the commander of the Commune's flotilla, an anonymous Parisian woman, one of those whom the reactionaries in Versailles called *pétroleuses* (incendiaries), accusing them of lighting fires in Paris during the Commune's last week. We see a

Communard named Tranquil posing in a Turkish hat, his formidable expression and defiantly crossed arms evoking a remarkable parallel with the previous picture of the anonymous *pétroluese*. Tranquil, an elected member of the Commune, was appointed to round up draft resisters after the Commune decreed that all men between the ages of nineteen and forty must join the National Guard. We see citizen Hortense David, the very picture of quiet strength, and we have to wonder, if the Commune had been forward-thinking enough to incorporate women into the Guard, might it have changed the course of events? Few of the Commune's combatants distinguished themselves in battle as memorably as some of its female members did, of whom the most celebrated was the heroic Louise Michel.

Excluded from the right to vote and to be elected to political posts by men still imbued with the prejudices of their time, the women of the Commune still succeeded in playing a remarkable role, not only in their traditional work as military cooks, but also through their own organizations and committees, of which the best known are the Union of Women for the Defense of Paris and Care of the Wounded and the Citizens Vigilance Committee of Montmartre, as well as certain mixed-gender political clubs and organizations such as the Club of the Revolution, where Michel presided over the debates in the Church of Saint-Bernard in the 18th arrondissement.

The National Guard established its headquarters in a hotel facing Place Vendôme, and here we see a photograph of swaggering Communard Commander Simon Meyer. Each of the two access points to the square is blocked: to the north, on rue de la Paix, stands a no-nonsense barricade and its guardians; to the south, on rue de Castiglione, the road down which Versailles's troops might suddenly appear, stands a formidable fortification that is altogether more imposing. The area to the west of Place Vendôme and the 1st arrondissement are similarly dotted with impressive fortifications, such as those on rue Royale and, the most massive of all, those in Place de la Concorde, which cuts across rue Saint-Florentin and

rue de Rivole, Paris's central artery leading directly to city hall, the seat of the Commune's power.

The principal attraction of Place Vendôme was, however, a giant stone column at the center of the square that was erected in honor of Napoleon I. The Commune, the "antithesis of the Empire" (as Karl Marx wrote), decreed its demolition on April 12, considering it a "monument to barbarism, a symbol of brute force and false glory, an affirmation of militarism, a negation of international law, a permanent insult by the victors to the vanquished, a perpetual offense against one of the three great principles of the French Republic, *fraternité*." A whole program for the demolition was drawn up under the direction of, among others, the painter Gustave Courbet, one of the members of the Commune most active in the teaching of fine arts.

The engineer in charge of executing the sentence, a member of the "Positivist Club," prepared to topple the column on May 5, the anniversary of Bonaparte's death. In the meantime, he posed for a photograph, and posterity, at the foot of the condemned column in front of the scaffolding that would serve to bring it down. He posed again in the aftermath. We see guardsmen and civilians standing together. Their expressions are more serious, not only because the occasion is solemn, but also because it is already May and they can sense the denouement of the communal epic. Civilians in these photographs at the foot of the column confirm the social diversity of the Parisians who took part in the Commune: from hard hats to top hats, from bowlers to felt hats, we find hats belonging to every social category.

The column's demise was postponed until May 16. In the interim, the Commune carried out another demolition, that of the hotel owned by Thiers himself, in Place Saint-Georges, a symbolic, if useless, vengeance. After all, there was no doubt that the National Assembly would generously compensate the hotel's own chief executive for the loss. Its destruction paid testimony to the impotent rage that overtook Parisians in the

face of Versailles's intransigence and the cruelty of its troops, who shot any Communard who fell into their hands.

When May 16 arrived, it became the most photographed day during the brief history of the Commune. A series of images taken on this day show the stages in which the Vendôme Column was toppled. Once it hit the ground, the crowd used its base to raise the red flag. The stature of Napoleon I, prostrate but undamaged, set the stage for more photos of groups who posed for posterity. Over the next few days, after the column's wreckage was tidied up, people from all over Paris came to admire the symbolic show of defiance against tyranny, a satisfying, if meager, final demonstration before Versailles's assault. The emperor dead on the ground. "Placing the master back on his pedestal required a scaffolding of 30,000 corpses," Prosper-Olivier Lissagaray wrote.[21]

When Versailles's troops took Forts Issy and Vanves on May 8 and 13 after subjecting them to a deluge of fire, it was clear that an attack was imminent. It began on Sunday, May 21, at 3 p.m. in the southeast of Paris. The "Bloody Week" lasted from Monday, May 22, until Sunday, May 28, at 11 a.m. Versailles's forces advanced methodically and implacably against the city, from west to east, preceded by heavy artillery barrage, massacring Parisians by bayonet, rifle, and machine gun, by the tens, hundreds, and thousands of combatants and noncombatants (Lissagaray claimed that three-quarters of those who died were the latter), including men, women, children, and the elderly. On May 24, the Commune's first district's main defense installation was taken; it was the central link in a chain of defenses that crisscrossed Paris from the north to the south on both banks of the Seine. The Communards were pushed back in the evening along an axis leading to city hall, the seat of the Commune's power, which was taken the following day. Over the next four days, Versailles's troops moved forward, closing like a vice on

21 Prosper-Olivier Lissagaray, *History of the Paris Commune of 1871* (London and New York: Verso Books, 2012), https://www.marxists.org/history/france/archive/lissagaray/index.htm.

the rebel Parisians' last stronghold, the barricades along Boulevard de Belleville, before these finally fell on May 28 at midday.

As they retreated from the Versailles steamroller, Paris's defenders set fire to sites of wealth and power—noble neighborhoods, the Ministry of Finance, the Palace of Justice, the police headquarters, etc.—igniting a number of blazes that merged with the fires caused by the aggressors' bombardment, creating one giant inferno. Paris burned. The enraged members of the Commune executed the small number of hostages they had held since the beginning of April. The fighting claimed the lives of a few hundred among the invaders' ranks, altogether perhaps almost 1,000, compared with approximately 20,000 dead Parisians, of whom at least 17,000 were executed after being judged in kangaroo courts during this Bloody Week. If we consider the number submitted to military "justice," that means that nearly 3,000 Communards died in combat.

The few photos taken after the events of this apocalyptical week provide testimony to the devastated neighborhoods, buildings, and streets of Paris—probably the first photographic documentation of a city destroyed by war—similar to pictures we would see in the twentieth century. If there were an aesthetic of desolation, the photograph of the devastated rue Royal would take first prize. It is a remarkable scene: a ruined cannon to the left, an oddly upright lamppost and kiosk stand straight amidst the ruins in the center, and a scorched tree and some planks and windows are off to the right. The visible part of a sign reads "liquor." Would rue Royale have been rebaptized rue de la République under the Commune?

The only remaining photographs of the deceased, given the technical limitations of the era, are those of corpses in hospitals or coffins. Rows of dead bodies initiate a photographic martyrology of the revolutionary movement, whose supreme mythological image of the twentieth century would be Che Guevara's body, shot dead in Bolivia. Here, there are countless martyrs, displayed in a macabre arrangement. Those who had the "privilege" of being buried in improvised coffins bear numbered tags. The

others, the great majority of victims, were dumped, sometimes while they were still alive, into common graves.

> The burying of such a large number of corpses soon became too difficult, and they were burnt in the casemates of the fortifications; but lack of ventilation meant the cremation was incomplete, and the bodies were reduced to a pulp. At the Buttes Chaumont the corpses, piled up in enormous heaps, inundated with petroleum, were burnt in the open air and for days a thick, nauseating smoke adorned the monuments. (Lissagaray)

At least forty thousand men, women, and children were arrested, a third of them held near Paris in prisons and forts, as we can see in the photograph of women in the Chantiers prison at Versailles where Michel was incarcerated. The remaining two-thirds were deported on barges to forts and islands across the French Atlantic coast.

> The prisoners were transported by rail, often in abysmal conditions. The prisoners were packed into cars used to haul freight or animals in groups of thirty of forty with a jug of water and two rations of bread for each, locked up tight. The trip lasted between twenty-four to thirty-two hours during which hunger, thirst, the lack of air, and the impossibility of lying down to sleep drove some of the prisoners mad, provoking sometimes fatal fights. (Serman)

Prisoners had to wait their turn, enduring brutal conditions, to be "judged" in Versailles or Paris where they were then transported back to their prisons in the same manner. Another photograph shows the Council of War at Versailles meeting under a crucifix. The trials continued until 1874. The so-called war councils issued 13,450 sentences (of which 3,313 were held in absentia), including 270 condemning prisoners to death, 410 to hard labor, 3,989 to incarceration in fortified prisons overseas, and 3,507 to deportations from France. The prisoners who survived transport disembarked in the French colony of New Caledonia after a voyage of five months in the hold of a ship, confined in cages, in chains.

Without doubt, the Commune was a precursor for twentieth-century revolutions, but it is also incontestable that the repression meted out by Thiers

prefigured the worst of the atrocities we would come to know in our own tragic century.

Timeline

1870

9/02: Napoleon III capitulates at Sedan.

9/04: Proclamation of the French Republic. Government of National Defense.

1871

2/08: Election of the National Assembly.

2/17: Thiers elected head of government.

3/01: Peace treaty ratified by National Assembly.

3/10: Assembly establishes itself at Versailles Palace.

3/18: National Guard refuses to surrender its cannons. Paris rebels. The national government deserts Paris for Versailles.

3/19: Central Committee of the National Guard convenes elections for the Paris Commune.

3/26: Communal elections.

3/29: Commune decrees the abolition of the standing army.

4/16: Supplementary elections to the Commune.

4/30: Resignation of Cluseret, chief of the Commune's War Council. Rossel takes his place.

5/08: Versailles's forces overtake Fort Issy.

5/09: Rossel resigns. Delescluze replaces him.

5/12: Destruction of Thiers's hotel in Paris.

5/13: Versailles's forces overtake Fort Vanves.

5/16: Vendôme Column torn down.

5/21: Versailles initiates assault against Paris.

5/22–28: Bloody Week. Paris burns: 20,000 Parisians killed, with 17,000 executions. Forty thousand Parisians detained, resulting in 13,450 convictions.

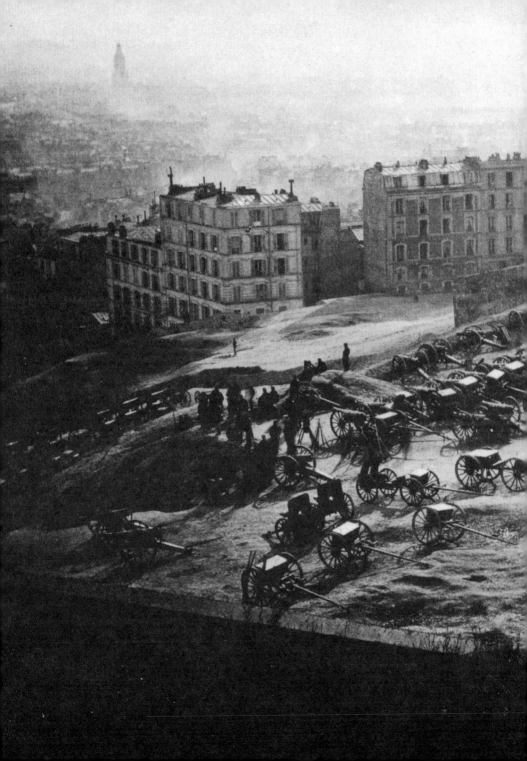

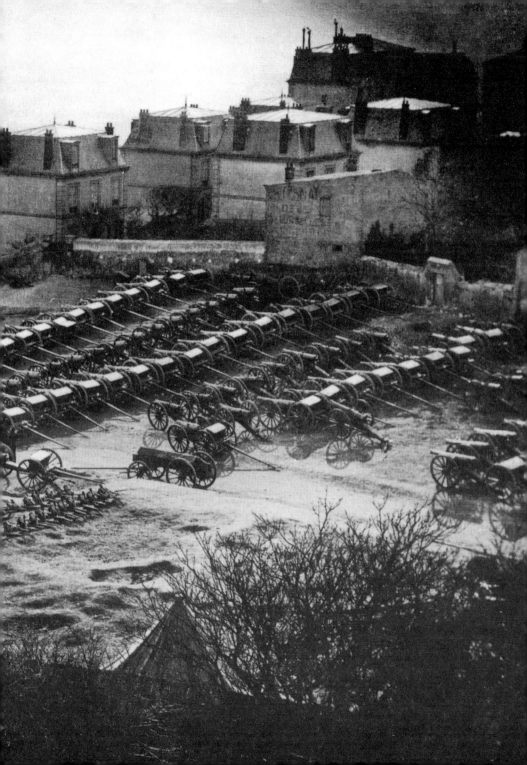

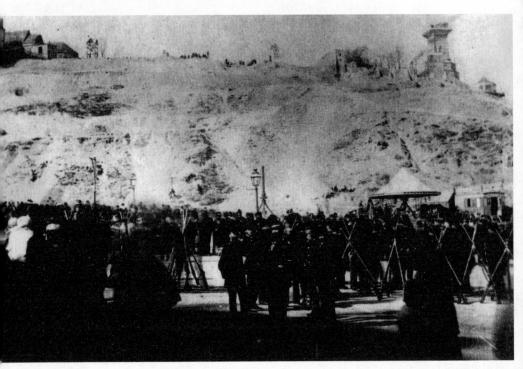

Above and on the next page: The National Guard, the driving force behind the Commune. **Above**: A National Guard company at the bottom of the hill. **On the next page**: An artillery battery on the top of the hill.

Previous double page: Artillery camped on the hill of Montmartre in Paris on March 18, 1871. Thiers attempted to seize these cannons purchased by contributions raised by the National Guard, detonating the insurrection. The generals in command of the government's troops, Lecomte and Thomas, were executed by firing squad.

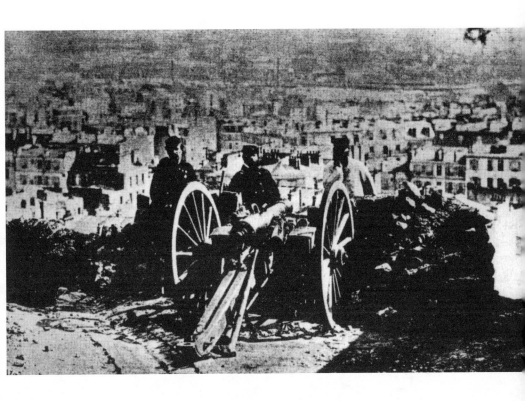

Next double page: Barricade on rue Saint-Sébastien on March 18, 1871. In the Temple de Saint-Antoine, poor and working-class neighborhoods are the heart of the action from beginning to end. In the first days, the Central Committee of the National Guard sets itself up on rue Basfroi, and after the prefecture of Paris is overrun by Versailles's troops, the surviving Communards occupy the sub-prefect of this district.

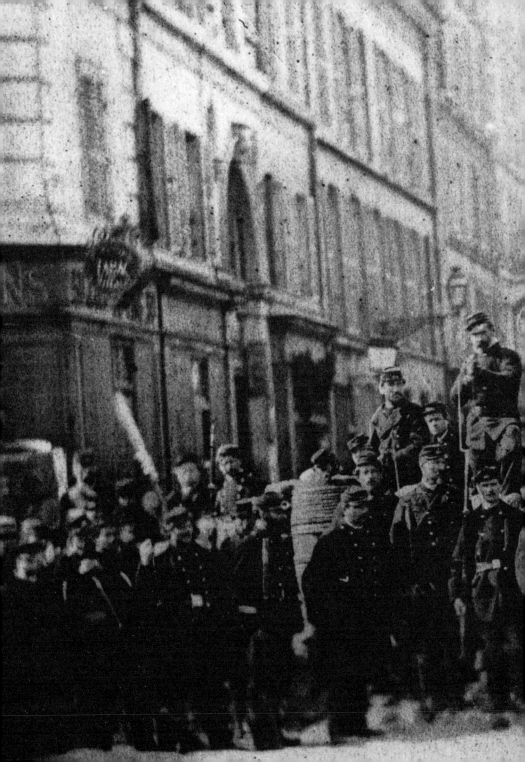

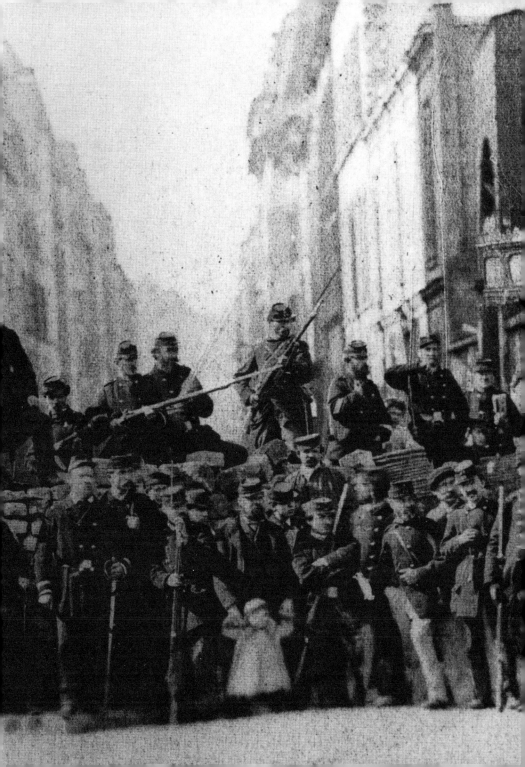

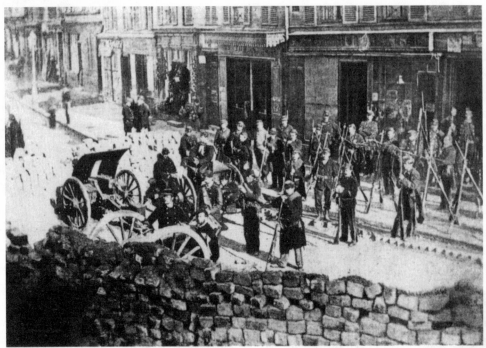

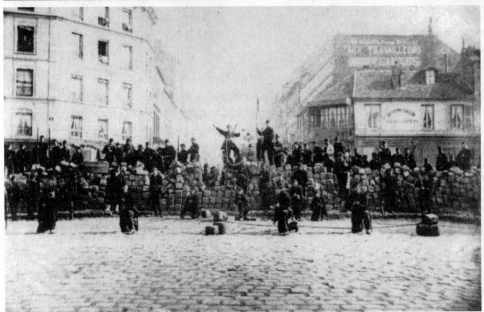

Insurgent barricades on March 18,1871. **Above**: Rue de Abbesses, in Montmartre. **Below**: Corner of rue Ménilmontant and Boulevard de Belleville.. (On the next page: in detail.)

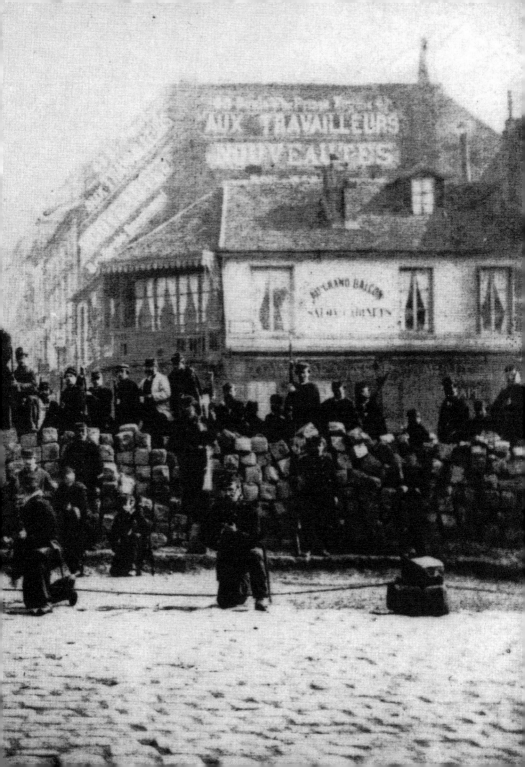

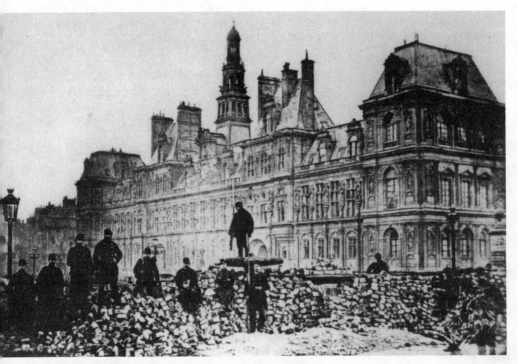

Barricade in the prefecture's central square.

Barricade artillery battery (perhaps in Place Saint-André-des-Arts).

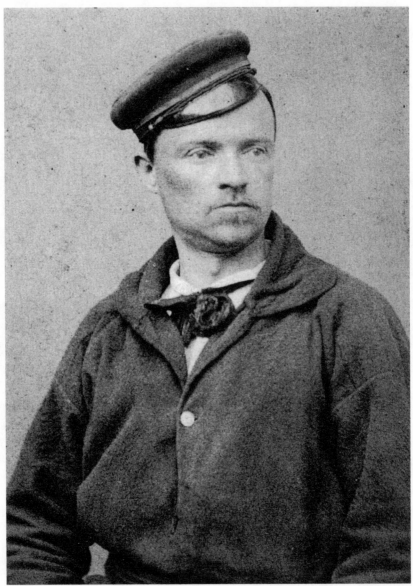

Berneart, chief of the Commune's fleet.

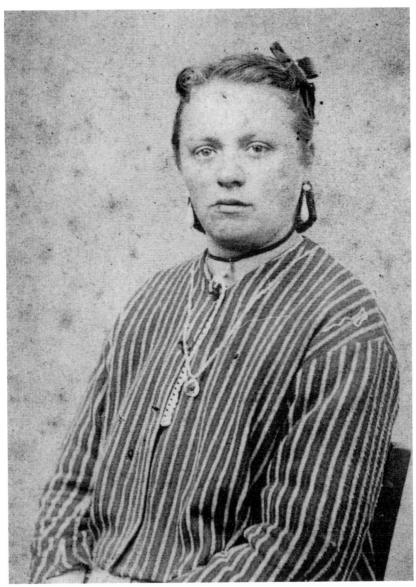

Hortense David.

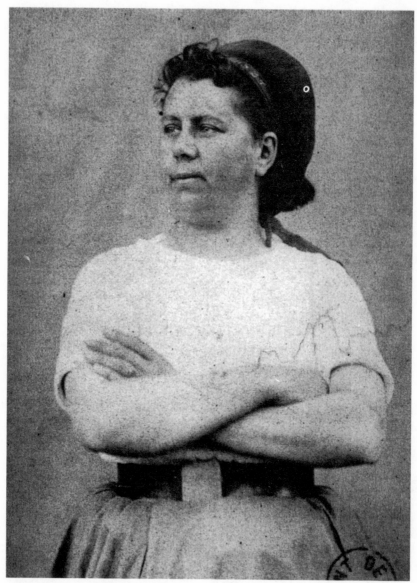

An incendiary.

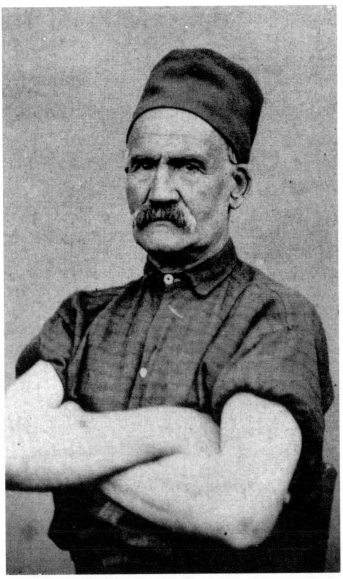

Tranquil, a member of the Vigilance Committee.

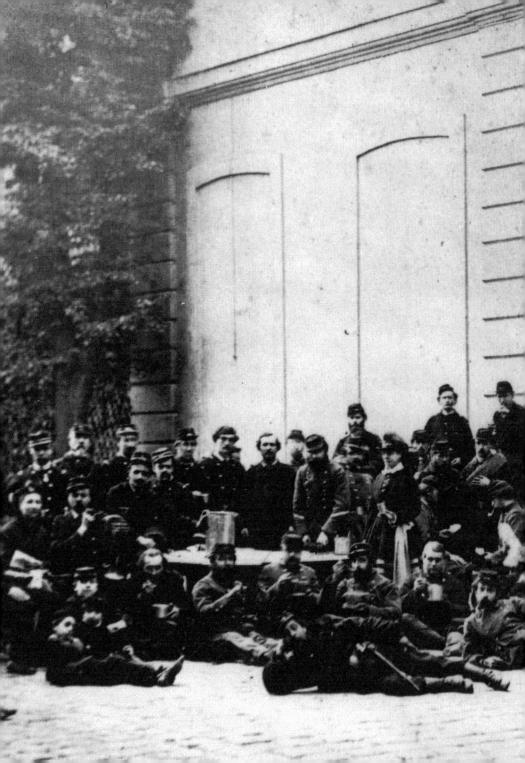

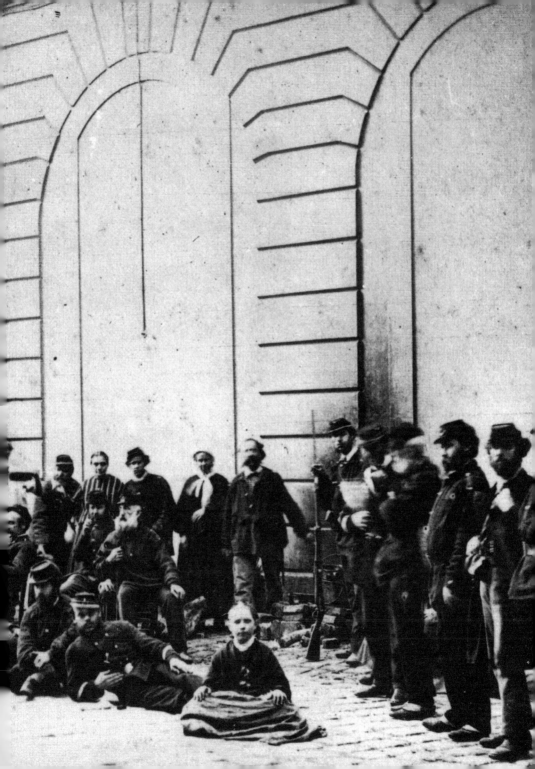

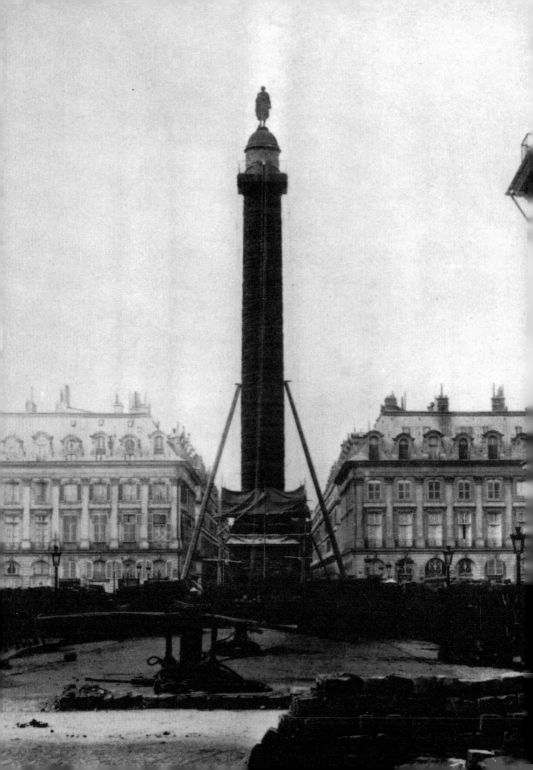

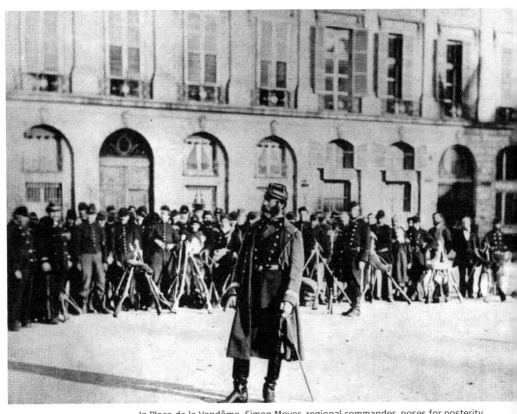

In Place de la Vendôme, Simon Meyer, regional commander, poses for posterity.

Previous double page: A group of National Guards.

On the previous page: Preparations to demolish the Vendôme Column on May 16, 1871.

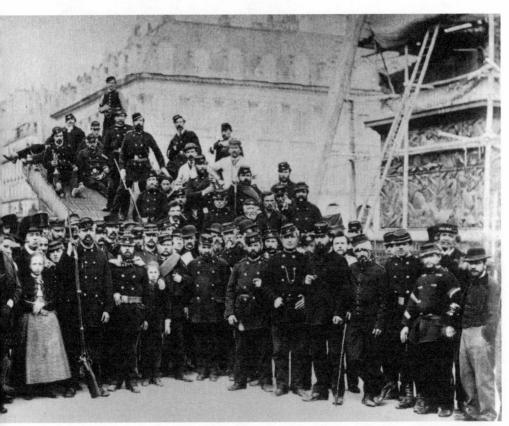

A group of National Guards at the base of the Vendôme Column during preparations for its demolition.

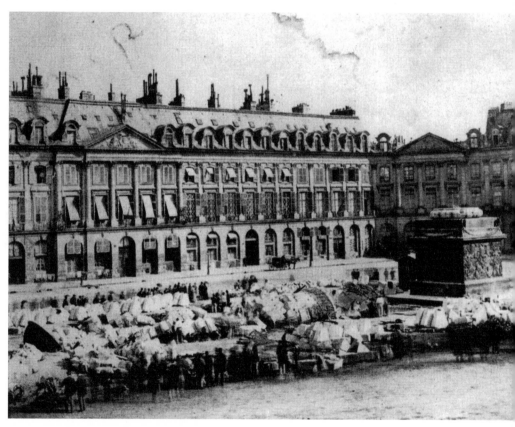

The Vendôme Column in pieces on the ground.

Next double page: Posing with Napoleon's statue and ruins of the Vendôme Column.

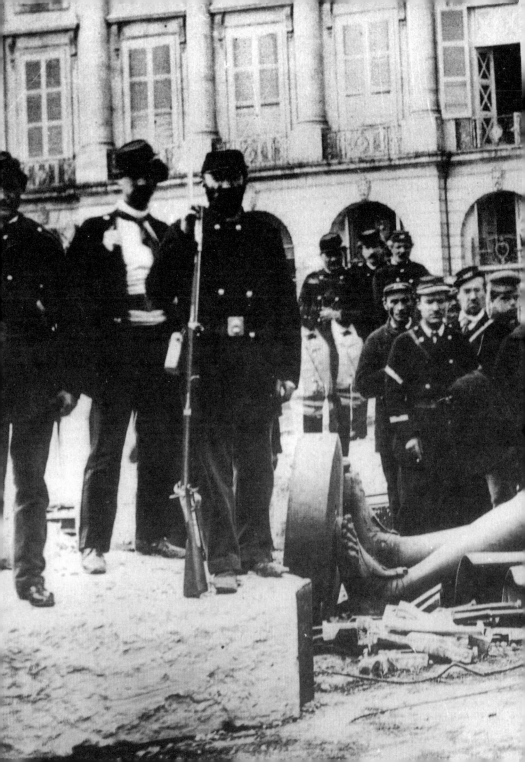

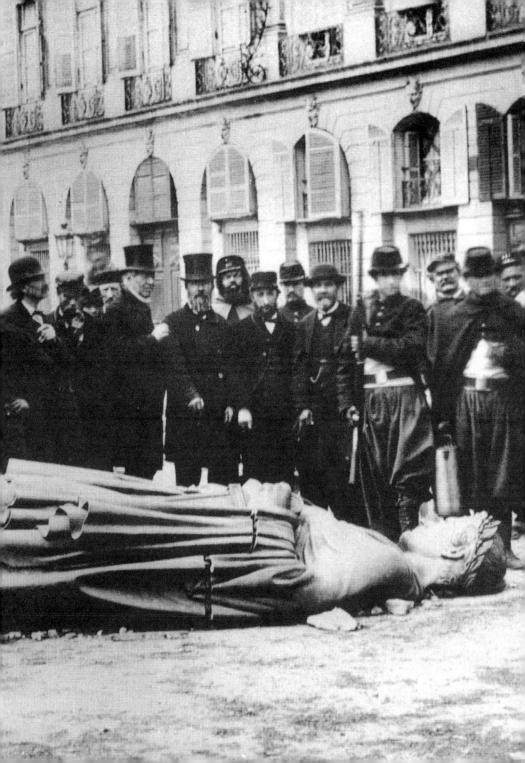

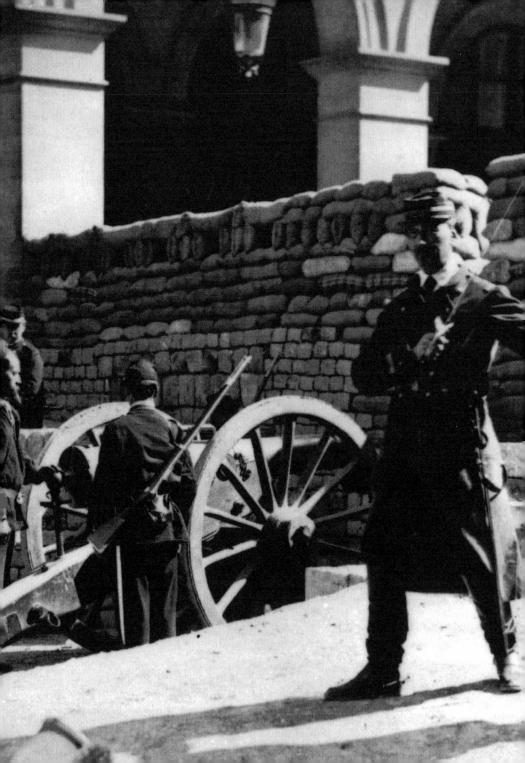

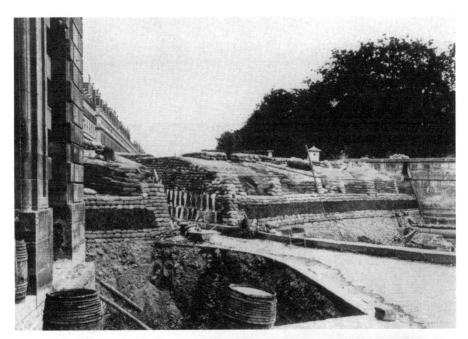

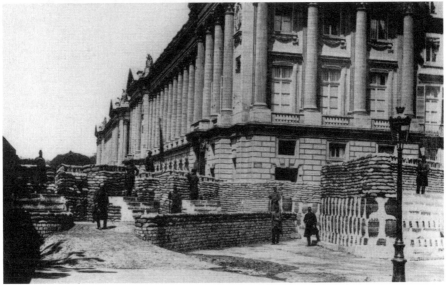

Defense of Paris against Versailles's forces.

Above: The corner of rue de Castiglione and Rivoli.

Below: Elaborate barricade at the corner of rue Saint-Florentin at the entrance of Place Concorde.

On the opposite page: Barricade on rue de Castiglione.

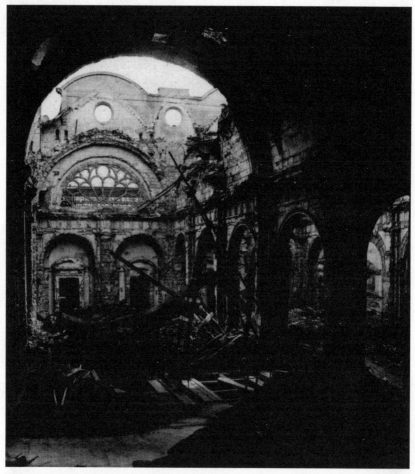

Remains of the Commune.

Above: Sacking of the Palace of Justice.

On the opposite page: As a reprisal, the Commune orders the destruction of Thiers's mansion on Place de Saint-George.

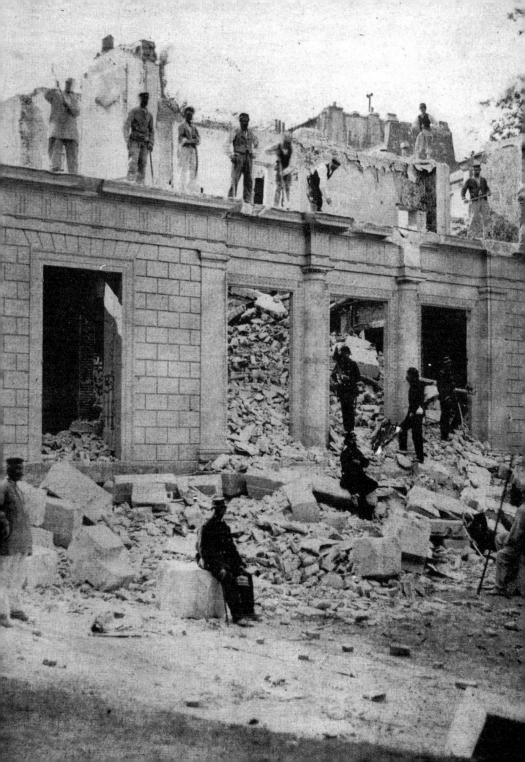

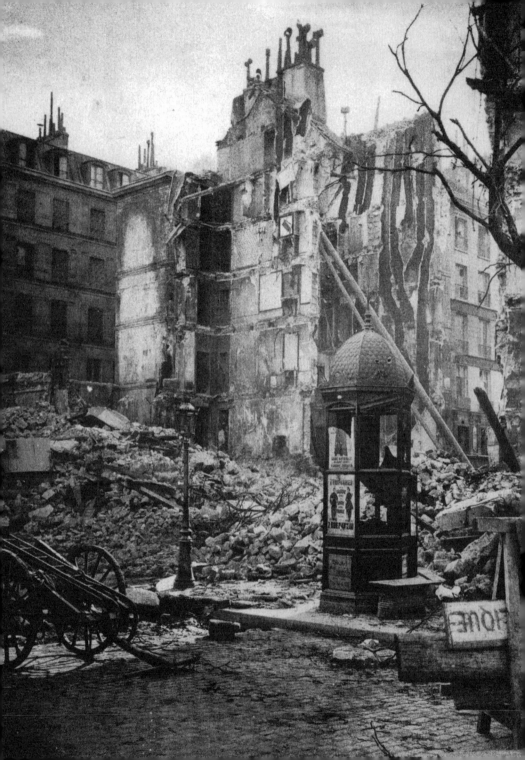

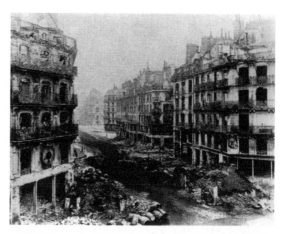

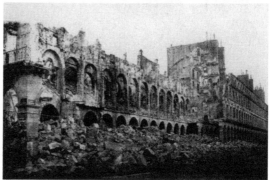

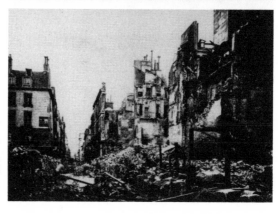

Remains of the Commune.

On the opposite page: Rue Royale.

From above to below: Corner of rue de Rivoli and Pont Neuf, rue de Rivoli facing west, rue de Lille.

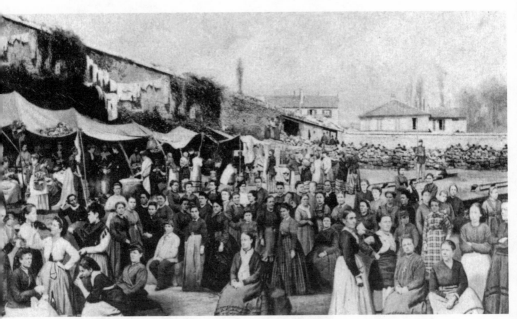

In the Chantiers Presidio in Versailles on August 15, 1871. Among the prisoners is Michel Louise (on the opposite page) who will be deported to New Caledonia.

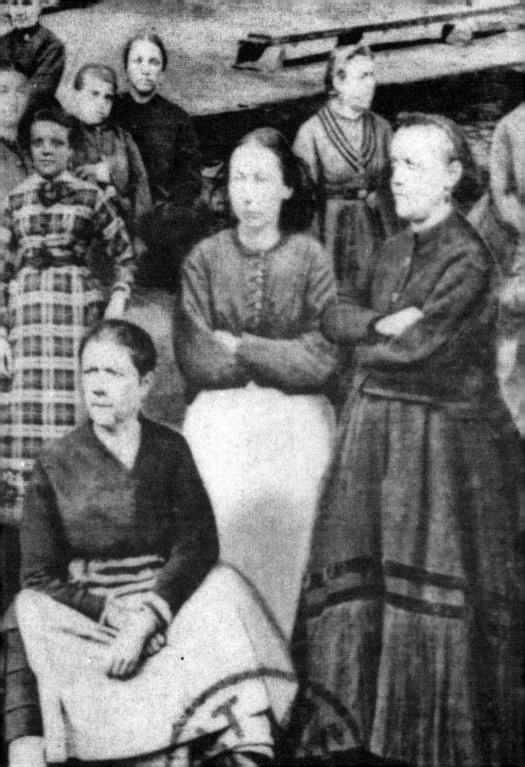

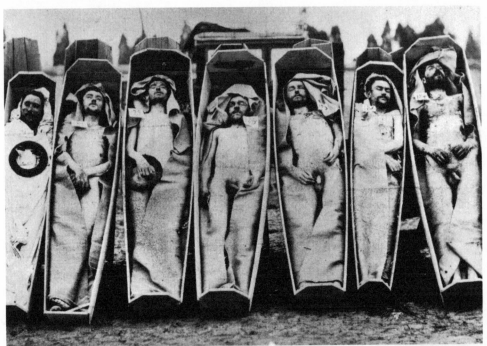

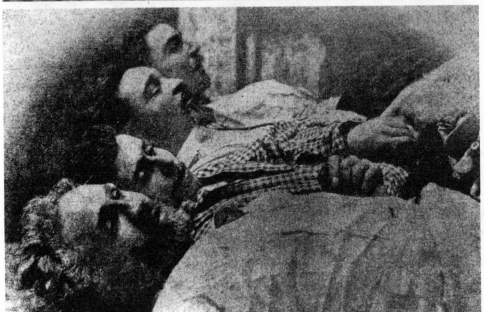

Above: Coffins of members of the Commune executed by firing squad. **Below**: A corner of a room in a hospital on May 17, 1871, where bodies of the executed were stored.

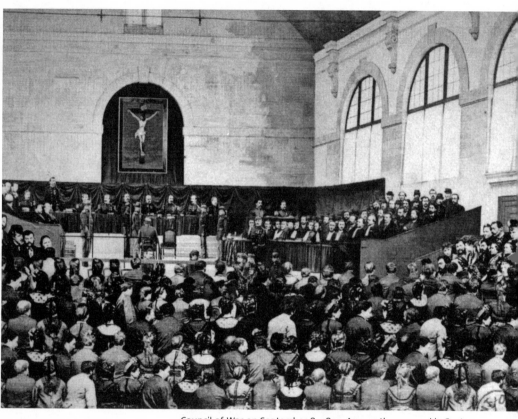

Council of War on September 8, 1871. Among the accused is Gustave
Courbet, sentenced for the destruction of Vendôme Column.

1905

The Russian Revolution

Gilbert Achcar

The Russian Revolution (1905)

Military defeats suffered by ruling classes tend to facilitate insurrections by oppressed classes. Confirming this rule, the Russian Revolution of 1905 was the product of one such defeat. Specifically, it was the reversals of the tsar's army and navy starting in 1904 during the Russo-Japanese War that incited discontent in Imperial Russia's cities and the countryside, where there was terrible suffering. Social revolt burst out in 1904, like a bolt of lightning that precedes a crash of thunder, which was not long in coming.

The capitulation of Russian forces at Port Arthur on December 20, 1904, after a long and disastrous encirclement by the Japanese navy, provoked an enormous commotion throughout the country. In the middle of this intense moment, managers at the Putilov metal factory—one of the most important factories in St. Petersburg—finding no better reply to demands made by their workers, fired four of them, accusing them of being movement leaders. Exasperated by this move, workers struck against the plant on January 3 and called on workers throughout the city to join them.

In less than a week, a general strike gripped St. Petersburg. Organizers planned for the movement to culminate in an immense workers' procession on January 9, starting from various points in city and the working-class suburbs and converging on the Winter Palace. There, the leader of

this vast movement, a charismatic priest named Father Gapon, head of the Assembly of Russian Factory and Mill Workers of the city of St. Petersburg—an organization originally set up by the tsar's police—would deliver to Tsar Nicholas II a petition signed by more than 150,000 workers, drawn up in a manner that was at once both imploring and threating. Civil liberties, free land for the peasants, an eight-hour work day, mandatory public education, and the convening of a constituent assembly elected by universal (male) suffrage were all included in the petition on a list of explosive demands addressed to the tsar "as to a father," in the absurd hope that he might acquiesce. Otherwise, concluded the petition, "we are ready to die here in this square in front of Your palace."

That is exactly what happened. The peaceful demonstrators, some even carrying icons and portraits of the tsar, were greeted with murderous salvos that left many hundreds dead. Workers' blood, set in contrast with the white of the Russian winter, transformed January 9, 1905, into "Bloody Sunday." The photo in which we can see the multitude fleeing—as if blown backward by a strong storm—from a line of troops with their rifles raised starkly illustrates one witness's testimony from that terrible day:

> Pushed back slightly by each salvo, like a gust of wind, partly trampled, suffocated, crushed, the immense multitude recollected itself, amidst the dead, the dying, and the injured, pushed forward by newly arriving waves of marchers, continuously filling in from the rear. . . . New salvos, time after time, shook this living mass like a dying shiver. . . . This went on for a long time until the side streets finally cleared out enough for the crowd to be able to escape. (Voline)

Trains carried the corpses out of the city in the dead of night, and they were buried in mass graves, making it impossible to count the number of victims. The general strike continued for a number of days in St. Petersburg, spreading to various other cities and regions throughout Imperial Russia in the following weeks. The moment arrived when workers who were charged with distributing funds to strikers and Bloody Sunday victims—the collection was organized by a law clerk by the name of Georges Nossar, who went by

the alias Khrustalev—hit on the idea of holding elections in each factory for workers to participate in a representative committee that would baptize the soviet of workers' delegates. But in the face of state repression, the soviet was forced to suspend its activities after a few days.

The strike wave of January and February was followed by another one in the spring, during which the textile workers of Ivanovo-Voznesensk in the Moscow region—the "Russian Manchester"—launched their strike on May 12. Three days later, they created a soviet of workers' deputies, which many historians inaccurately consider the first of its kind. However—and about this there is no doubt—it was the first soviet in history to be photographed. This photo is a beautiful image, taken against a backdrop of trees in full spring bloom, with workers posing for the picture: the front row is lying on the ground, others are crouching or kneeling, and those behind are standing. The photographer could only fit two-thirds of the 151 members of the Ivanovo-Voznesensk Soviet in the frame: by the way the photograph is arranged, we suspect that a group was cut off from the left side, leaving some of the delegates outside the frame. The presence of a number of women in the group—although certainly a smaller number proportionally compared with the number women working in the textile industry—indicates an advance relative to the Paris Commune.

At the same time as the Ivanovo-Voznesensk Soviet was formed, the Russian Baltic fleet, sent to relieve Port Arthur, was destroyed along the Tsushima Islands in the Korea Strait, a crushing defeat that signaled the end of war between Russia and Japan. The next chapter of revolutionary ferment naturally affected the fleet itself, or at least what remained of it. Alongside the Putilov factory, the *Potemkin*—the tsarist fleet's most advanced battleship—became legend during the Revolution of 1905. More than the event itself, whose significance more than anything demonstrated the extent of the revolt among armed forces, it was the magnificent film directed twenty years later by Sergei Eisenstein that added the revolt on the battleship *Potemkin* to the revolutionary myths of modern times. The film inspired images that immortalized the event.

We see a sharp contrast between the officers and the sailors in two group photos taken on the bridge of the *Potemkin*. On one side, the officers strike a haughty pose, joined by the ship's chaplain; on the other side, the sailors' expressions display their humble origins. In the center of two of the photos, the admiral stands in for the figure of the tsar, the chief of the aristocracy, the father of the people. This image provides an eloquent summary of Russian society at the time, and effectively illustrates the meaning of one contemporary's insight: "The antagonism between common sailors and the closed upper-class caste of naval officers is even deeper than it is in the army, where half the officers are plebeians."[22]

The mutiny on the *Potemkin* broke out on June 14, offshore from Odessa, exactly one month after the defeat at Tsushima. Refusing to eat the rotten meat their officers tried to force on them, the sailors moved from insubordination to insurrection. Exasperated by their commanders' brutality, one of whom had killed the sailors' spokesman, the mutineers threw some of the officers overboard, along with their loyal chaplain, and then raised the red flag. These insurgent sailors, whom one photo shows gathered together under the battleship's big guns, elected a committee headed by a socialist sailor named Afanasy Nikolayevich Matyushenko. The next morning, the *Potemkin* docked at Odessa, and the city and the port erupted in strikes and disturbances that would last for several days and culminate in a general strike, started in the wake of a riot. A group of sailors disembarked from the *Potemkin*, carrying the body of a murdered comrade. One photo shows Matyushenko on shore with one of his comrades, both wearing serious expressions.

The crowd at the port kept growing until violence erupted, and a large fire broke out when a warehouse was looted. Following instructions from the tsar, the city governor declared martial law and ordered the army to intervene during the nights of June 15 and June 16. Harsh repression followed, even

22 Leon Trotsky, "Red Fleet," in *1905* (Chicago: Haymarket Books, 2016), https://www.marxists.org/archive/trotsky/1907/1905/1905.pdf.

more deadly than Bloody Sunday had been in St. Petersburg, with an estimated two thousand killed and three thousand injured. Isolated, with no possibility of spreading the mutiny to the rest of the Black Sea fleet, the *Potemkin*'s sailors put back out to sea. On June 25, as their provisions ran out, and several days adrift without direction, the mutineers surrendered to Romanian authorities at the port of Constanta after being guaranteed their freedom. Here we see Matyushenko again on land; a photo shows him with a mix of bravado and sadness, surrounded by Romanian officers and officials, who we can guess were curious to get a look at this revolutionary leader.

The bloodbath in Odessa put a temporary stop to urban agitation, but the social unrest spread into the countryside at the beginning of the summer. In order to head off this unrest, the tsar issued his August 6 Manifesto announcing the convocation of a new state duma (Russian for a congress or national assembly) in January 1906, to be elected by indirect suffrage based on social estates (nobles, clergy, peasants, workers, etc.) as determined by the census. But the electoral rules only privileged to an even greater degree the aristocracy and the bourgeoisie, and it did so to the detriment of workers and peasants, two classes that the rulers feared would be closely allied. The demeanor of a shoeless peasant pictured standing before his Duma deputy, who is seated on a bench, provides strong testimony for the survival of the rural custom of servitude. What a contrast with Matyushenko's attitude!

But it was not long before events unfolded with greater force in the cities in October, ringing in the beginning of what would be called the 1905 Revolution in the strictest sense of the word. This time, the spark was lit in Moscow; more precisely, print workers launched a strike on September 19 in a typography shop. The movement soon spread to all print workers in the city, and then to workers in other sectors, who raised red banners at demonstrations before the Cossacks—the tsar's mounted cavalry—intervened. The movement spread from Moscow to St. Petersburg by the beginning of October: print workers struck first, followed by rail workers. However, the strikes remained sporadic and the movement struggled to grow, as seems clear from photographs showing workers meeting in small groups in front

of the entrance to a firm in St. Petersburg. Soon enough, Putilov workers would once again place themselves in the vanguard of the struggle. But in the interim, the rail workers' strike gained new force and, driven by rumors of repression, it progressively spread to the entire national rail network.

Inspired by the rail workers' example, workers in city after city went on strike. Starting on October 10, the movement took on the features of a pan-Russian political general strike adorned with red banners. The movement's central demand was the election of a constituent assembly, elected by direct, universal suffrage, and strikers did not hesitate to demand the end of the monarchy. On October 13, the soviet of workers' delegates reconstituted itself in St. Petersburg and, within days, soviets had sprung up in the majority of Russian industrial centers.

Pushed along by the course of events, the tsar found himself obliged to grant concessions. He issued a new manifesto, published on the night of October 17, promising basic freedoms and gesturing towards the possibility of universal suffrage and parliamentary control over the government's legislative authority. On the following day, the capital's inhabitants, torn between astonishment and exhilaration over the victory they had won, marched en masse to the imperial university, which had become the most popular location for public political meetings.

> A huge bottleneck of people formed on the quay, through which a countless mass poured. Everyone was trying to push their way through to the balcony from which the orators were to speak. The balcony, windows, and spire of the University were decorated with red banners. . . . The students' blue caps and the red banners were bright spots among the hundred-thousand-strong crowd. The silence was complete; everyone wanted to hear the speakers. . . . There were two or three more speakers, and all of them concluded with a call to assemble in the Nevsky at 4:00 p.m. and from there to march to the prisons with a demand for amnesty.[23]

23 Leon Trotsky, "October Eighteenth," in Trotsky, *1905*, https://www.marxists.org/archive/trotsky/1907/1905/1905.pdf.

Photographs taken on October 18 testify to both the meeting at the imperial university and the sea of humanity on the Nevsky Prospect.

Another decisive moment during these October days occurred in Moscow, which was a bastion of the Bolshevik faction of the Russian Social Democratic Workers Party, unlike St. Petersburg, where the Menshevik faction was more influential. After a Bolshevik militant named Bauman was assassinated on October 18, only days after being freed from prison, a funeral was held for him. On October 20, a long procession of several tens of thousands of workers marched through the streets of Moscow, with red banners in front emblazoned in gold letters with the famous concluding exhortation from the *Communist Manifesto*, for workers to unite, alongside the party's name. Bauman's coffin is carried on the shoulders of fellow organizers and surrounded by a guard forming a cordon. The Bolsheviks demanded that the police force be withdrawn from the streets on the day of the funeral.

Only a few days later, mobilizations showed signs of apathy and the strike petered out. Tsarist forces mobilized to confront the October movement, relying on, as was customary, bands of criminals organized from the scum of society, whose specialty was launching pogroms, especially against Jews who were demonized and accused of conspiring against the tsar. Hundreds of grisly anti-Semitic pogroms took place in October, instigated by local authorities and zealous tsarist supporters who were lauded as "patriots." Hundreds, and perhaps even thousands, were massacred, and thousands were mutilated. The deadliest pogrom took place between October 18 and 21 in the city of Odessa, where as many as five hundred people were murdered.

Photos preserve the terrible spectacle of charred victims lined up in the dirt, images that evoke Paris's own Bloody Week in 1871. The "patriots" massacred a large number of people who opposed the tsar, specifically targeting protest marches, as well as Jews. In Baku, they attacked non-Orthodox Armenians, accusing them of aiding the opposition, killing sixty people and transforming the city into a battlefield.

A mutiny that broke out on October 26 at the Kronstadt Naval Base near St. Petersburg was crushed two days later. Soon after, the tsar declared a state of emergency in all Polish territories, along with other regions where peasant uprisings had taken place. The repression was particularly harsh in the Baltic provinces, where entire villages were burnt by tsarist troops as reprisals against rebellious peasants setting fire to nobles' estates.

It was in this context that the workers' soviet in the capital reconvened on November 1, declaring a general strike in solidarity with the mutineers condemned to death as well as with Poland. The strike was interrupted on November 7 after the government provided guarantees to preserve the sailors' lives. Four days later, a new rebellion broke out in the Black Sea fleet, this time in Sebastopol. The city had been at the boiling point for some time, as contact increased between workers and sailors. An attempt to repress the movement on November 11 failed and a riot broke out. From that day on, the entire city was paralyzed by a general strike, facilitated by the unity of workers, sailors, and soldiers. Red flags were raised on the fleet ships that had joined the insurrection. Among these, we find the battleship *Potemkin*—which had been rebaptized the *Panteleimon* by the navy—as well the cruiser *Otchakov*.

The mutineers from the ex-*Potemkin*, detained on a barge anchored in the Bay of Sevastopol, were freed on November 14 and greeted with hurrahs from the fleet's sailors. The following day, however, after they had regained power, came the counteroffensive. The government declared a state of emergency and loyal troops occupied the streets. Mutinous sailors were forced to surrender and then suffered an intense bombardment from onshore artillery and from ships under the admiralty's control. The *Potemkin*, in no shape to respond, waved the white flag, but the *Otchakov* attempted to resist and suffered a deluge of volleys, the violence of which is clearly reflected in the photograph of sailors' parents on the beach, some of them kneeling, begging for the sailors to be spared. Although the cruiser was quickly forced to surrender, the bombardment continued until the ship

ran aground. The sailors who survived the bombardment and the fusillade were detained. Some time later, some of them were executed.

Martial law was imposed across wide sections of the country. Its confidence restored, on November 26 the government ordered the arrest of the president of the St. Petersburg Soviet, Khrustalev. He was replaced by a temporary secretariat composed of three members, whose most prominent figure was a certain Lev Davidovich Bronstein, aka. Trotsky, who worked closely with his mentor Alexandre Helphand, aka Parvus. In a manifesto financed and inspired by Parvus, and supported by the Peasant Union and socialist parties, the soviet declared it would take fiscal and tax matters into its hands in retaliation against the tsar's government. The next day, the state replied by ordering the arrest of 267 members of the soviet during its meeting on December 3. Those who were able to escape met under the leadership of Parvus and proclaimed a general strike.

At the same time, disturbances reached the garrison in Moscow, whose soviet had also decided to declare an insurrectionary general strike. The strike spread quickly and soldiers sent delegates to join the soviet. Moscow was covered with improvised barricades. With the exception of the materials used, Moscow's barricades closely resembled those of Paris in 1871, especially in the visible pride of the insurgents raising the red flag.

As in Paris, although on a smaller scale, the repression that followed was terrible. Moscow was surrounded by troops sent as reinforcements from the capital and from Warsaw, and was then systematically bombarded, its streets strafed, as "patriotic" militias made their own contribution to the massacre. The working-class neighborhood of Presnia, the insurrectionaries' last holdout, was invaded on December 17 after a vicious bombardment. On December 18, it was over: the soviet decided to call off the general strike and the troops began to dismantle the barricades and clear the streets. A parade of troops demonstrated that tsarist order had been restored.

The "pacification troops" of the Semyonovsky regiment, who were sent to "pacify" the railway, were ordered not to make arrests and to proceed without

mercy. They met with no resistance anywhere. Not a single shot was fired against them, yet they killed approximately 150 persons on the railway line. The shootings were carried out without investigation or trial. Wounded men were taken from ambulance wagons and finished off.[24]

One image shows a firing squad in action in a forest. The photographs convey a sense of the horror of the massacre, depicting families who had to identify their loved ones among the dead that cover the ground and women in tears standing in front of an improvised morgue.

The repression carried out against the Moscow insurrection left nearly one thousand dead and several thousand injured among the insurgents and the population as a whole. The events in Moscow sent shock waves across the Baltic provinces and certain industrial regions in the Caucuses, where repression was also severe. One photo shows the viceroy of the Caucuses surrounded by Cossacks in view of factories that lay in ruins after troops attacked insurgent workers.

The main thrust of the 1905 Revolution came to an end in December. Of the fifty-one members of the St. Petersburg Soviet who were put on trial, fifteen were condemned to permanent exile in Siberia, among them Trotsky and Parvus. Another photo shows this group of detainees accompanied by family members and guards as they are marched off to their deportation sites. Parvus is shown with a beard, in a black suit and white beret; to his side is an older man with a white beard and black hat named Lev Deutsch, a veteran Russian Marxist. We see both men facing the camera and in profile. We also see a woman wearing a black Orthodox scarf, who has turned to the photographer to stick out her tongue with a malicious look. The next photo shows Trotsky in Siberia in a Napoleonic pose in the first row of a group of exiled political activists. He would soon escape for the second time in his life, followed by Parvus and Deutsch— for whom this would be his fourth escape!

Not all of the participants in the 1905 Revolution shipped to Siberia were destined to have such tolerable outcomes as these key leaders. Some fared

24 Leon Trotsky, "December," in Trotsky, *1905,* https://www.marxists.org/archive/trotsky/1907/1905/1905.pdf.

much worse, especially the mutineers, rebellious peasants, and those deemed "terrorists." This was the case in the photograph of prisoners of all ages who were kept in degrading conditions, caged like animals on Sakhalin Island. They don't appear defeated; on the contrary, their faces display great dignity. This is a sign that the 1905 Revolution, although it was aborted, left an indelible mark on the consciousness of the masses, legitimizing combat against the abhorrent tsarist regime. And for this, the revolution would appear retrospectively as a "great dress rehearsal."

Timeline

[The dates below are given according to the old Julian calendar then in use in Russia, and are therefore thirteen days behind the Gregorian calendar used in the West.]

1904

12/20: Russian forces capitulate at Port Arthur.

1905

1/03: Putilov factory strikes, followed by a general strike in St. Petersburg.

1/09: "Bloody Sunday" in St. Petersburg.

5/15: Russian defeat at Tsushima.

6/14–15: Mutiny on the *Potemkin*.

6/15–16: Bloody repression against riots in Odessa, killing two thousand.

6/08: Tsar's Manifesto calls for a new duma in January 1906.

9/19: Typographical workers strike in Moscow.

10/10: All-Russian general strike.

10/13: Soviet of workers' delegates convenes in St. Petersburg. Soviets spread across the country.

10/17: New manifesto from the tsar makes democratic promises.

10/18–21: Anti-Semitic pogrom in Odessa.

10/26: Mutiny in Kronstadt Fortress.

10/28: Mutiny repressed. State of emergency declared in Poland.

11/7–11: General strike in Kronstadt and Poland in response to call from St. Petersburg Soviet.

11/11–15: Mutiny on the fleet in Sevastopol.

11/26: Arrest of the president of the St. Petersburg Soviet.

12/3: Members of the St. Petersburg Soviet arrested.

12/07–18: Moscow insurrection. Bloody repression leaves one thousand dead.

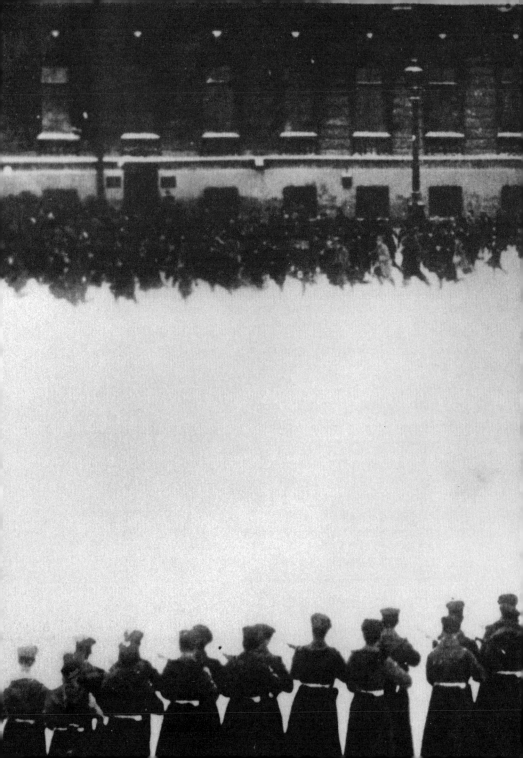

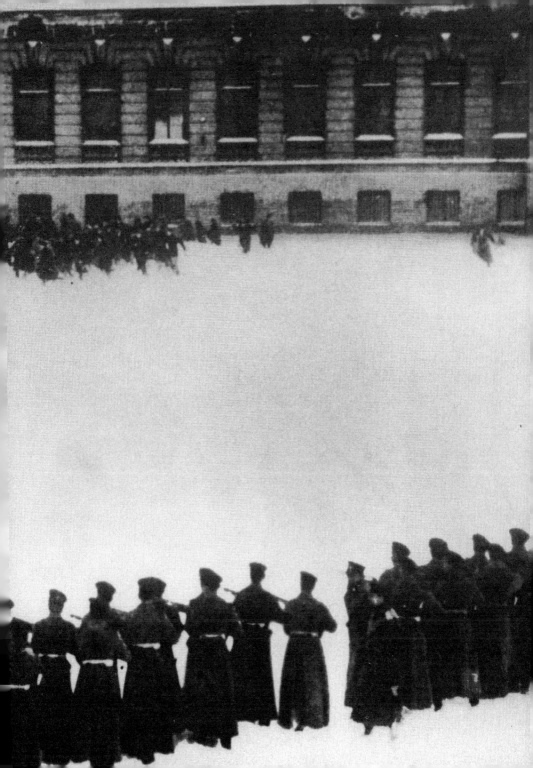

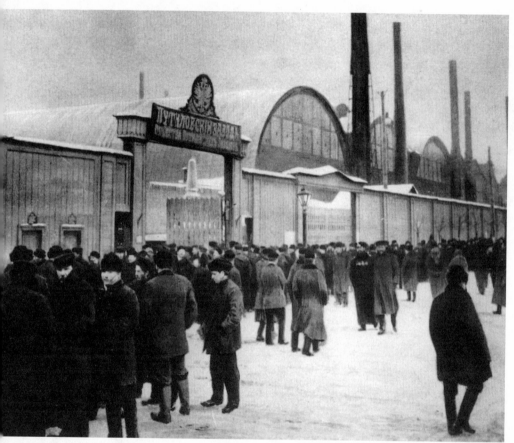

Strike at the Putilov metal factory in St. Petersburg in January 1905.

Previous double page: In St. Petersburg, during a demonstration on January 9, 1905, that marked the beginning of the revolution, troops fired on demonstrators, leaving hundreds dead or wounded. This day became known as Bloody Sunday.

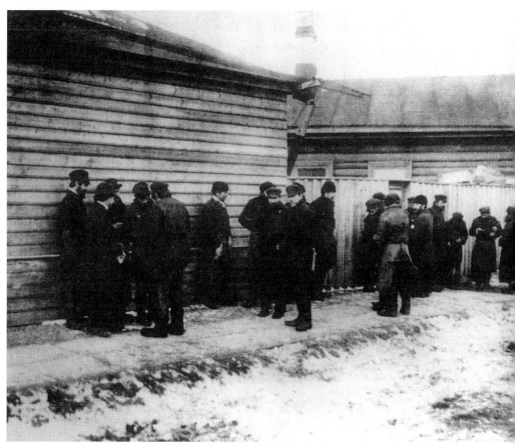

A group of workers in St. Petersburg before the beginning of confrontations in January 1905.

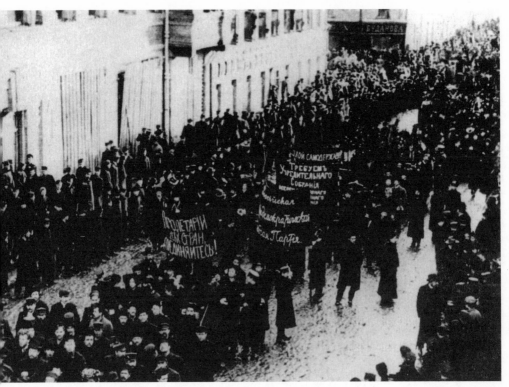

Demonstration in October 1905. The banners read: "Down with the monarchy!" and "Workers of the world, unite!"

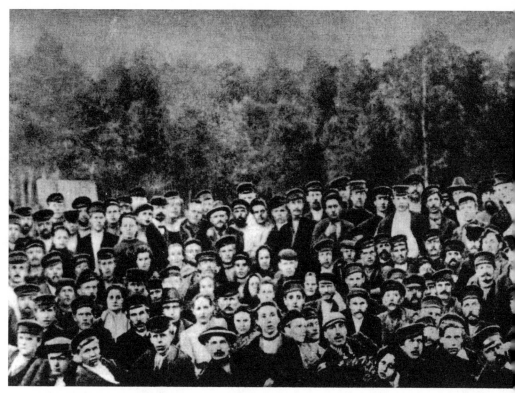

The soviet of textile industry workers in Ivanovo-Voznesensk
in May 1905 (montage photo).

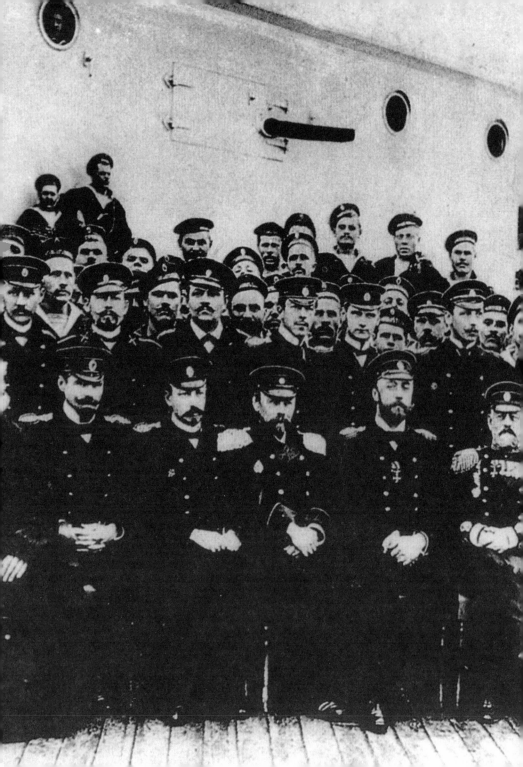

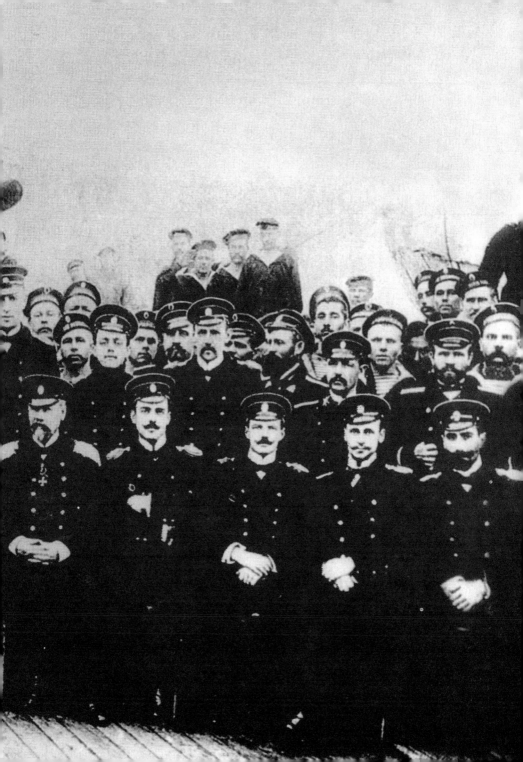

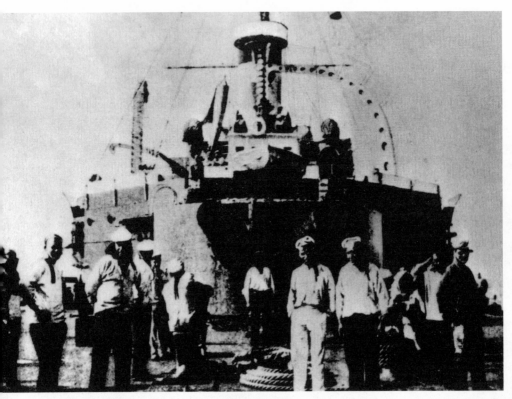

Previous double page and above: Sailors (above) and officers (previous pages) on the battleship *Potemkin* before the mutiny in June 1905.

Next page: A group of mutineers on board the battleship *Potemkin* on June 15, 1905.

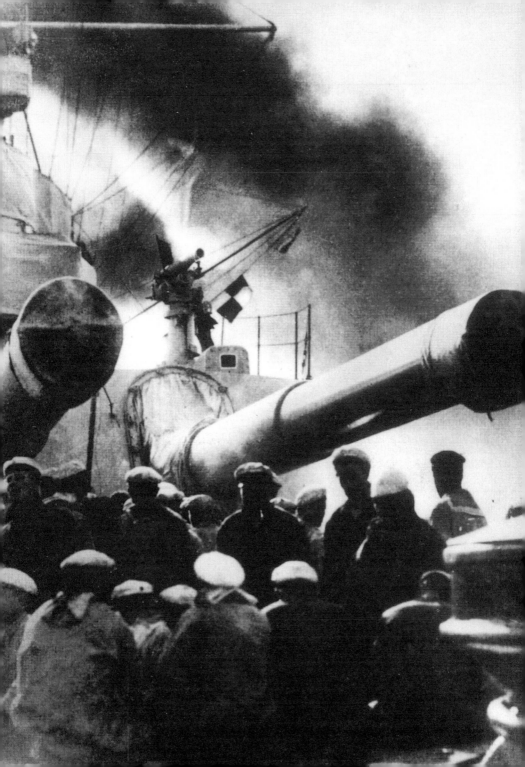

Above and to the side: Fighting in Moscow in October 1905.

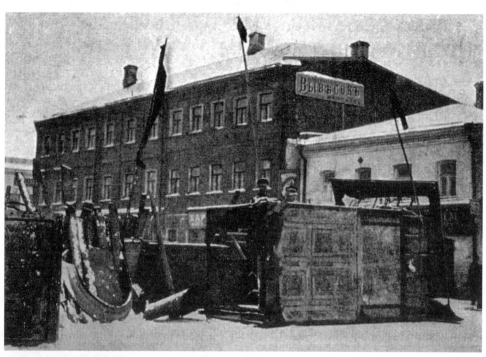

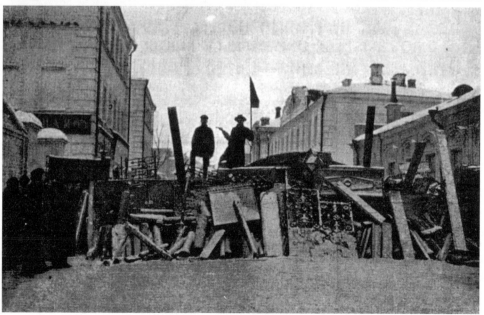

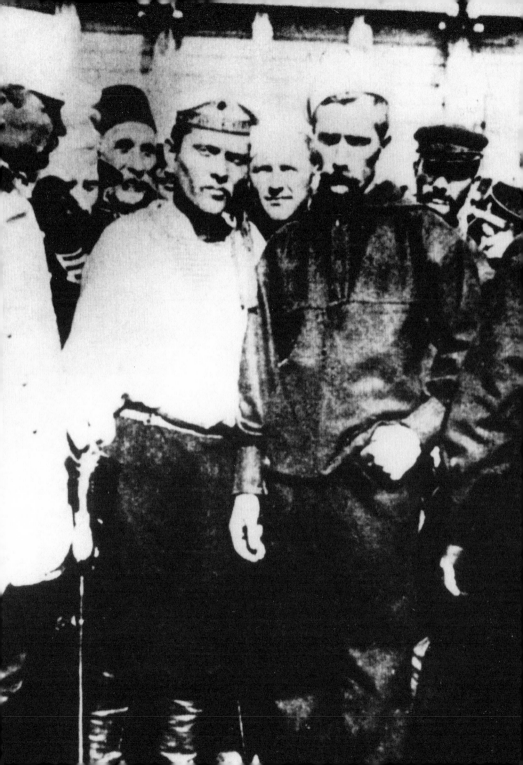

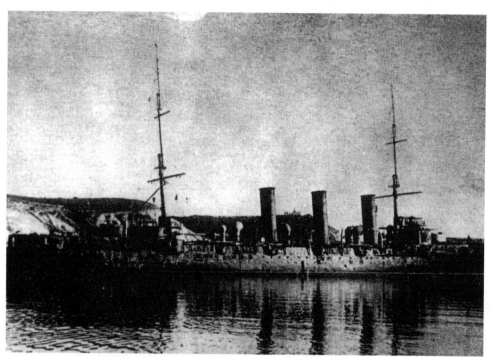

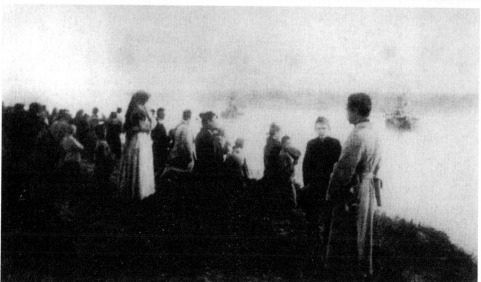

Above: The battleship *Otchakov*, whose crew mutinied in November 1905 off the coast of Sevastopol.

Below: The population of Sevastopol prays during the bombardment of the *Otchakov* in November 1905. The mutineers surrender themselves after the ship caught fire.

Previous page: The sailor Matyushenko, leader of the mutiny, and his comrades on the battleship off the coast of Odessa on June 15, 1905.

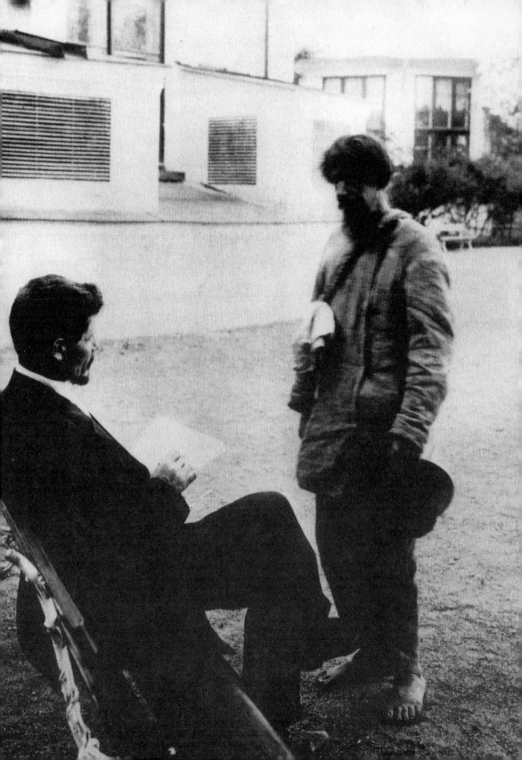

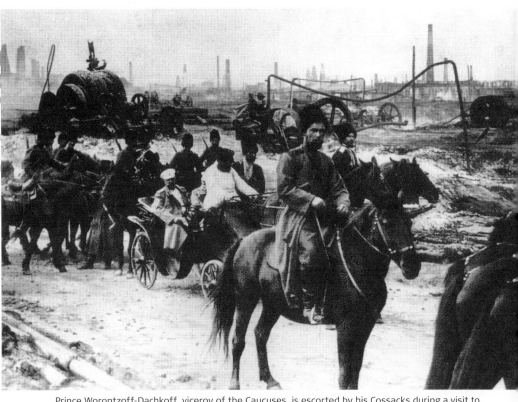

Prince Worontzoff-Dachkoff, viceroy of the Caucuses, is escorted by his Cossacks during a visit to the ruins of the industrial city of Balakhmy after fighting between workers and the army.

Previous page: A barefoot peasant delegate delivers complaints to a deputy in 1905.

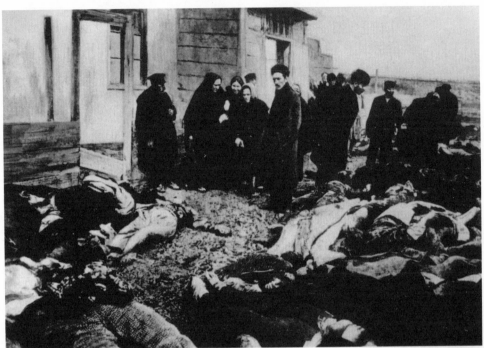

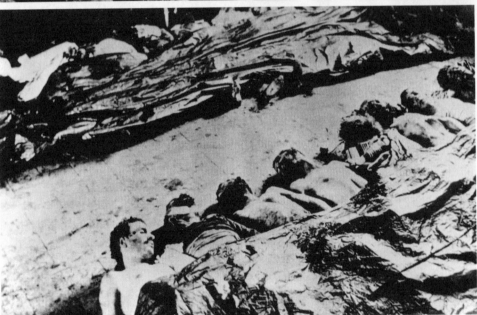

Above: The population contemplates the cadavers of victims of confrontations with the police.

Below: Victims of anti-semitic pogroms in Jekaterinoslaw on October 11, 1905.

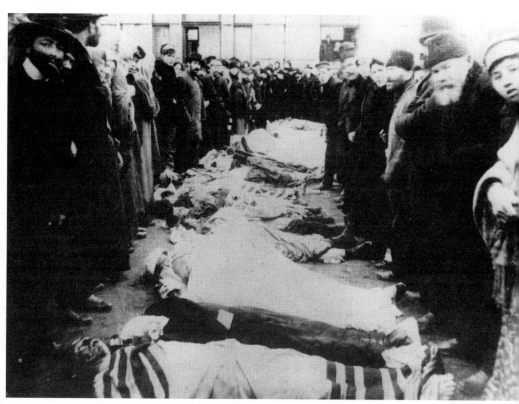

Victims of an anti-Semitic pogrom in Odessa between November 18 and 21, 1905.

Next double page: Women crying in front of a makeshift morgue after a confrontation between workers and the army.

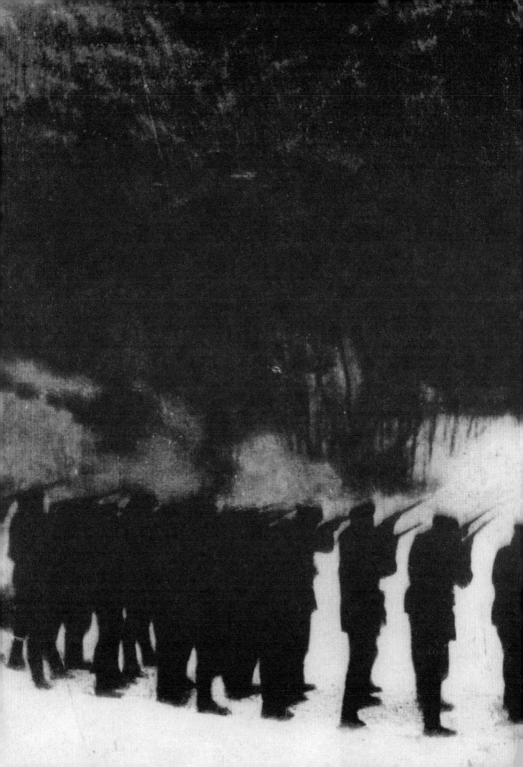

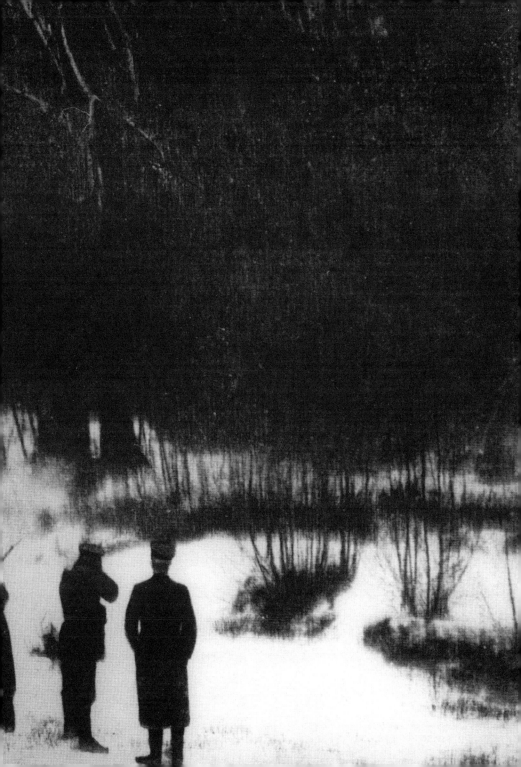

Above and next page: Prisoners condemned to exile leave for Siberia. The German Social Democrat Parvus is pictured in the center, dressed in black and wearing a white cap.

Previous double page: Firing squad in a forest in November 1905.

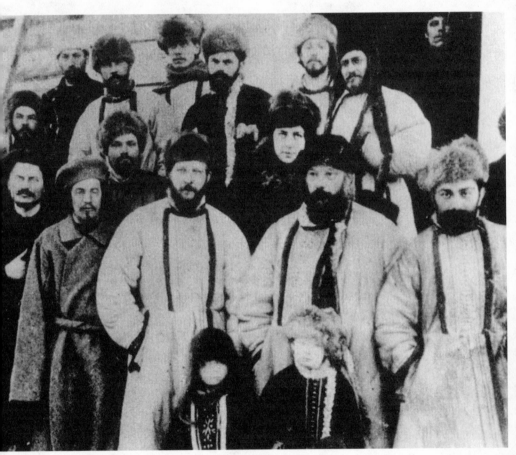

A group of prisoners during the repression following the revolts of 1905.
Leon Trotsky is first from the left.

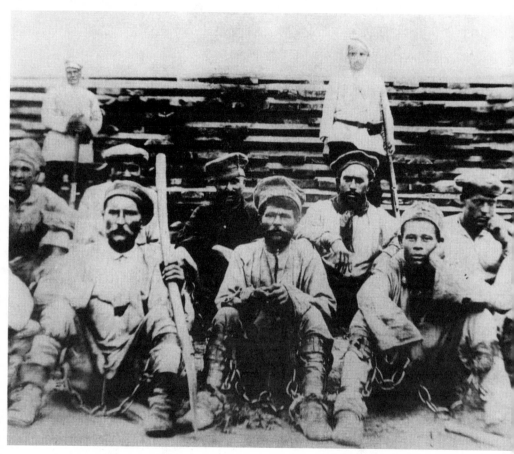

Prisoners on the island of Sakhalin.

1917

The Russian Revolution

Rebecca Houzel and Enzo Traverso

The Russian Revolution (1917)

Soviet Russia valued the image, locating it at the center of its system of representation and transforming it into one of the pillars of the socialist order. Statues, iconography, and design privileged symbols and myths. More than ninety years later, the 1917 Revolution's aura still resonates to a considerable degree, even if its meaning has suffered a radical inversion by the dominant trends of public opinion: in contrast to 1789, October has been converted into a date marking the birth of totalitarianism. Returning to the images from the critical year of 1917, from the fall of the tsarist regime in February to the seizure of the Winter Palace in October eight months later, may have a salutary effect. Examining these fragments in time and analyzing the instants that constitute history helps us revisit the events themselves and allows us to strip away a thick layer of retrospective projections, first hagiography and later demonization.

The only figure who escaped these memory wars, at least until a relatively recent period, was Tsar Nicholas II. He was absent from St. Petersburg at the moment of the February uprising, leading to an underestimation of his importance. Unaware of the dynamic of events, he was finally forced to abdicate. It was a surprising and sudden collapse following the bloody repression from which it sprang. One celebrated photograph, dated from early 1917, in which Nicholas is surrounded by his family, including his

wife Alexandra and his five children, became a symbol of the ancien régime. A strange impression of calm, of tranquil assurance, almost confidence, radiates from the figures. There is no trace of worry darkening the tsar's face, nothing that allows us to foresee the upheavals that will annihilate him and his family some months later. Another photo shows him in military uniform, walking alongside an imperial train. He does not know that he will soon sign his abdication decree in this very same place. He appears alone, beside the train that has stopped in the middle of the countryside. The conductor waits for him, observing him through a glass door; the tsar represents no one but himself. His execution, in July 1918, would mark a point of no return. Yet, except among a minority of the exiled aristocracy, his death would not produce the same commotion that swept through Europe after the decapitation of Louis XVI. Nicholas II would not inspire an Edmund Burke or a Joseph de Maistre to idealize his legacy and celebrate his memory. This may be the reason why he never appears to us in a tragic light in these antiquated records; instead, he looks like a piece in a museum.

Apart from a few of these records, the tsar is practically absent from the images of the revolution, and his portrait is engraved in our memories as a symbol of a past epoch. The photos of 1917 are, in the first place, those of an uprising, as grandiose and tragic as any other revolution: the victims from the February marches, laid out on the street covered with snow, then buried and mourned over, and later transformed into heroes; vestiges of the tsarist past, which collapsed all at once after the February insurrection, discarded, in the Fontanka Canal; the imposing Nevsky Prospect, covered with dead bodies after the suppression of a June demonstration; the storming of the Winter Palace, an event that concentrated the totality of revolutionary process in the collective consciousness; the cruiser *Aurora*, firing at the tsar's fortress late in the game. From a more distant and considered view, these records that form our memory of the twentieth century reveal the harshness of the social, political, and even the geographic context of the revolution: the cold, misery, war, repression. In the first place,

we become aware of the cold because the weather takes on a particular importance in this region; it sets the rhythm of everyday life in Russia, it envelops the mass of soldiers and workers who are dressed in overcoats, their heads covered by *chapkas*, the traditional Russian hat with earflaps to guard against the cold, trampling through the snow in boots. The North American journalist John Reed, who witnessed the insurrection in St. Petersburg, described how the city celebrated the arrival of the first snow on November 18:

> In the morning we woke to window-ledges heaped white, and snowflakes falling so whirling thick that it was impossible to see ten feet ahead. The mud was gone; in a twinkling the gloomy city became white, dazzling.... In spite of a Revolution, all Russia plunging dizzily into the unknown and terrible future, joy swept the city with the coming of the snow. Everybody was smiling; people ran into the streets, holding out their arms to the soft, falling flakes, laughing. Hidden was all the greyness; only the gold and colored spires and cupolas, with heightened barbaric splendor, gleamed through the white snow.[25]

October and November are difficult months: the rain can be constant and freezing, the mud dense and sticky, and the sky is a constant grey. February 1917 passed under a heavy covering of snow that made any movement difficult, but which gave the city a special glow, in contrast with the grey fall and the humid and muddy summer. The photos thus show us how the climate shaped the Russian mind with a temporality distinct from that of Western Europe—there was a different perception of the passage of time.

Cold and misery. At the beginning of 1917, the country fell into economic crisis and rationing was introduced, especially for flour; from February on, we see huge sacks in front of Tauride Palace to be distributed to the poor. Every day people who hoped to get something to eat would form interminable lines. The country was weak but had plunged into a war that was not

25 John Reed, *Ten Days That Shook the World* (Chicago: Haymarket Books, 2019), https://www.marxists.org/archive/reed/1919/10days/10days/ch12.htm.

its own. The signs of the war during this memorable year were all around. It weighed down on the whole life of the country, a country that cried out for soldiers killed at the front. It sat at the heart of the various crises that shaped the revolutionary process in Russia and at the center of the debates between partisans and adversaries.

The Kerensky government understood the disorganization of the army to be the cause of the sequence of the February events that led to Nicholas's abdication. The soldiers rapidly latched onto the idea of peace without annexations. During March and April, fraternization between the troops of different nations intensified, and these encounters were often broken up with cannon or rifle fire by Russian artillery officers. In May, the Second Army counted almost eighty thousand desertions. In the image of a soldier raising the butt of his rifle against a deserter, we see the intensity of conflicts spreading throughout the troops. In June, a protest was organized by soldiers who wanted to oppose Kerensky's policies (including a Russian offensive against Germany) and his willingness to take the disintegrating army by the reins. In July, after hearing news about Germany's counteroffensive, soldiers in the St. Petersburg garrison decided to prepare an insurrection. Two enormous marches took place on July 3 and 4: one to Tauride Palace, the seat of the Duma; the other uniting workers, soldiers, and sailors from Kronstadt in front of the soviet. As a consequence of the crisis, the government was reorganized once more by Kerensky. One photo shows his triumphal return to St. Petersburg. His car proceeds slowly, surrounded on all sides by an immense multitude who have come to greet the savior of the nation, which had been under threat from the Bolsheviks. It is a compact mass, disorganized, completely disarmed, and visibly more elegant than the workers and soldiers who have taken ownership of the streets since February. Some uniformed officers are mixed in with a crowd that appears preeminently bourgeois, dressed in summer clothes and carrying umbrellas to protect themselves from the sun, as if taking a walk. This image captures an atmosphere that was also to be found earlier in the year, in which the upper layers of society appeared,

finally, to have recovered faith in governing institutions, and were celebrating their own elite heroes before being swept away by revolutionary turbulence. But this was only an ephemeral parenthesis.

Conflicts soon developed between the soldiers' committees, whose attitudes hardened, and the provisional government that tried to regain control of the armed forces by relying on hand-picked shock troops, such as those it positioned in front of the Winter Palace. Originally composed of women, various units of these shock troops were later made up of men inspired by boundless patriotism. One photo immortalizes the last of Kerensky's defenders on the eve of the fall of the Winter Palace. The women, motionless before the camera, are hardly recognizable in their heavy, masculine uniforms; only their faces reveal their gender. Officers displaying their medals dominate the scene at a moment in which they have been called upon to defend a nonexistent power. Besides this small group of officers and the Women's Battalion, the bulk of the army appears to have evaporated.

General Kornilov, who had been promoted to head of the army in July, was unquestionably the principal military figure of 1917. A photo shows him beside his troops in the countryside. He has a martial air about him, standing straight as a rod, dressed in a plain uniform without ostentatious trappings. He aimed to reunify an army that, until then, had acted more like a band of rebels. Sure of his position, he attempted to impose himself and failed, provoking a political somersault. Cadet ministers in the provisional government who had pledged to help Kornilov instead renounced him, and the Bolsheviks, who led the resistance to Kornilov's attempted putsch in August alongside the majority of the soviet, were suddenly able to extend their influence.

The sequence of crises that disorganized the army now attained their highest point, strengthening and cohering alliances between soldiers, workers—among whom Bolshevik ideas were advancing—and peasants. The images of fraternization between the different protagonists of the revolution paint a picture of the dynamics of the events of 1917. The army

merged with society, which thereby armed itself. Photographs show cities awash in rifles. Between February and October, armed soldiers and workers remade the urban landscape. The Red Guards, created during the 1905 Revolution and reorganized in March of 1917, marched through the streets of St. Petersburg and Moscow. Try as he might, Kerensky's provisional government could not disarm them; their movements and training became part of the capital's everyday life. Certain visual clichés revealed the pleasure taken by the Red Guards in posing in parts of the city that were under their control, conscious of their importance. We see images of determined workers who assume contorted positions on the running board of a car. Their silhouettes form a sharp, if hardly practical, choreography that is nevertheless impressive. A convoy passes through the city's streets, making its entrance in the revolution. In other pictures, we see workers and soldiers photographed unawares while they relax, hardly solemn—they are smiling and at ease, sitting with rifles at their sides. The Red Guards also keep watch over the imposing Smolny Institute—formerly a convent and school for young women, supported by the tsarina herself—now occupied by revolutionaries. Another photo shows soldiers posted behind a heavy machine gun, posing carefully as if they were taking a class picture.

The demonstrators are also armed. Rifles point out from the front of a crowd that is taking to the streets. As in all revolutions, the masses—a human sea—are at the center of all events and invade all spaces. They march, justified, pouring forward as in February to the Tauride Palace, where they meet in an assembly and then, as is their custom, continue on to take over St. Petersburg's streets, clinging to the trolleys whose clamorous passage marks the rhythm of the city's life. The crowd seems at times ecstatic—men appear transfixed under their hats—and at times agitated—hands reach out for leaflets or newspapers—but never indifferent. The faces in the crowd are, in general, serious. According to several historians and chroniclers, the collapse of Tsarism provoked an explosion of joy and hope throughout the country. However, images of jubilation are rare;

it's as if, when they came before a photographer, the demonstrators were conscious of the historic moment unfolding around them, and this consciousness conferred a certain solemnity to their postures. The revolution was not lived as a kind of party. Not a single photograph captures an instance of transgressive elation; after all, we are in St. Petersburg, the antipode of a tropical revolution. Certain photos quickly reproduced in the Western press demonstrated excesses being carried out during the February Revolution (repeated in October), when insurgents sacked certain aristocratic residences, destroying furniture and paintings which then seemed inseparable from the tsarist regime's emblems. But these excesses were absolutely marginal; they merely demonstrated the chaos of the situation, the spontaneous impulse of the masses that their leaders found difficult to control. These events did not mark the start of the revolutionary terror— that would only commence with the beginning of the civil war.

The photographs of mass assemblies in St. Petersburg—the soviet of soldiers in the Duma chambers, the congress of peasants receiving a delegation of soldiers who've come from the front, the House of the People, where a meeting of soldiers and sailors takes place in the salon of Catherine the Great—all testify to the effervescence of civil society throughout that extraordinary year. These images reveal how democracy is learned in a fog of action by workers and peasants who throw off a crushing social and political yoke and discover that they are the agents of history. "Democracy" took on a very particular meaning in the mass assemblies. Within an electric atmosphere, orators took to the tribune, eloquence and demagoguery sometimes mixed, and decisions frequently took on a plebiscitary character, but they also revealed irresistible forces at work that never relegated the mass to the role of passive object. The speakers were applauded in rooms crowded past capacity because they found the words to give voice to what the mass wanted to hear, establishing complete osmosis. In his autobiography, Trotsky gave an impressive description of the meetings that took place inside the Modern Circus:

My audience was composed of workers, soldiers, hard-working mothers, street urchins—the oppressed under-dogs of the capital. Every square inch was filled, every human body compressed to its limit. Young boys sat on their fathers' shoulders; infants were at their mothers' breasts. No one smoked. The balconies threatened to fall under the excessive weight of human bodies. I made my way to the platform through a narrow human trench, sometimes I was borne overhead. The air, intense with breathing and waiting, fairly exploded with shouts and with the passionate cries peculiar to the Modern Circus. Above and around me was a press of elbows, chests, and heads. I spoke from out of a warm cavern of human bodies; whenever I stretched out my hands I would touch someone, and a grateful movement in response would give me to understand that I was not to worry about it, not to break off my speech, but keep on. No speaker, no matter how exhausted, could resist the electric tension of that impassioned human throng. They wanted to know, to understand, to find their way. At times it seemed as if I felt, with my lips, the stern inquisitiveness of this crowd that had become merged into a single whole. Then all the arguments and words thought out in advance would break and recede under the imperative pressure of sympathy, and other words, other arguments, utterly unexpected by the orator but needed by these people, would emerge in full array from my subconsciousness. On such occasions I felt as if I were listening to the speaker from the outside, trying to keep pace with his ideas, afraid that, like a somnambulist, he might fall off the edge of the roof at the sound of my conscious reasoning.[26]

Yet Trotsky's meetings in the Modern Circus represented only one of the mass's many faces. There is a haunting photo of May Day in Moscow in 1917 in front of the Kremlin, in what would become known as Red Square. It's a kind of temporal intersection of the revolutionary multitude, with a mixture of soldiers, mounted troops, and workers on foot, reflecting a familiar profile of the traditional choreography of socialist realism. The scene only lacks tanks, a platform for Communist Party apparatchiks, and giant portraits of Lenin and Stalin hung from the facades of buildings

26 Leon Trotsky, *My Life*, 2nd ed. (London: Wellred Books, 2018), https://www.marxists.org/archive/trotsky/1930/mylife/ch24.htm.

to remind us of what is to come. Tsarism celebrated its own glory in this way. However, the revolution appropriated this form, changing its meaning, even if the marches' geometry portended an image of the future and, at the same time, the force of a historical atavism undeniably intruding into the year 1917, against the general will, over a long Braudelian period. This is the only photo that suggests a continuity between the emancipatory spirit of 1917 and Stalinist totalitarianism.

These photographs certainly contributed to the creation of revolutionary myths, but they also reveal what was going on backstage. For example, they remind us that behind the resplendent revolutionary scenery with its protests, its spontaneous actions, the masses in motion and, as we have seen, its own visual aspects, there existed a more tepid and prosaic reality of perpetual misery, despite the society revolting against it, denouncing it. One moment shows a somber popular cafeteria, without windows, where a cook stands next to an enormous pot doling out bowls of *kacha*, a Russian buckwheat stew. Some of the men looking directly at the camera have the appearance of starving and exhausted beggars, but in fact they are workers who earn only a few rubles a month. There is a strong contrast between this sad picture and others that captured the electric atmosphere on the streets. It took the critical sensitivity of an unknown photographer who chose to bring his camera into this place, scorning the streets where everything seemed to be decided, in order to illuminate the underbelly of the revolution so mercilessly.

Outside, the revolutionary leaders recently returned from exile in Siberia were not the only orators. In the popular assemblies there were organizers, workers', soldiers', and peasants' delegates, and rank-and-file leaders who spoke up the majority of the time. The historian Isaac Deutscher interpreted these interventions as proof of the awakening of history's vanquished. The revolution, wrote Deutscher, is precisely "this brief moment, full of meaning, when the humble and the oppressed, finally, have the right to speak, redeeming centuries of oppression."

The multitude was boisterous in assemblies and meetings throughout the city and, for the most part, was composed of men even though women played critical roles throughout all of 1917. For instance, February 23, the first significant date of the revolution, went down in history as "working women's day." The women who protested alongside male workers at the Putilov factory were fired after a strike. The demonstration pulled along many white-collar workers, who all left their neighborhoods to march to the center of the city to present their demands: bread, work, peace, and the end of Tsarism. Women workers played an equally decisive role in the demonstration the following day, participating in marches that drew workers from the Vyborg neighborhood and from Vasilyevsky and Petrogradsky Islands to the center to amass on the Nevsky Prospect. In the following days, workers from the outlying districts continued to inundate the capital's streets until Sunday, when they were met with repression. The victims, nearly 150 on this one day, were honored and buried. The ceremony took place on March 23, 1917, on the Field of Mars, a public square in St. Petersburg, to the sound of a funeral dirge. Moisei Markovitch Goldstein, also known as Volodarsky, wrote the following description:

> By rhythmic and heavy steps, the funeral procession advanced slowly. The militias led the way for the coffins, draped in red flags, carried upon workers' shoulders. Next, in perfect order, eyes forward, came the workers' organizations, the students, a multitude of family members, friends, and the unknown, marching almost in step in a long, calm column, religious but without any priests. This was the first civil burial in Orthodox Russia. The revolutionary funeral included its very own musical phrases whose every word was repeated in each soul with an intense emotion, although without any tears.

The militia members of the Red Guards tried, but without success, to maintain their martial posture. They advanced in closed files, but despite their efforts, they did not appear capable of a disciplined military exercise; they were far from drilled and submissive to any hierarchy. Obviously, this was a new sort of activity for them, unimaginable only a few weeks

before. Their rifles seem long and slender, like sticks, or maybe some other kind of unfamiliar object; they carry them as if they were rakes.

The crowd once again encountered the leading figures of the revolution. It pressed around Lenin, who had returned from exile after the February Revolution. After his return, he appeared elegant, wearing a well-kept coat and an umbrella in one hand, amidst those who have come to welcome him back. This is very different than the picture painted by John Reed, who described him wearing a "worn-out coat and pants that were too long for him." But after years in exile, his clothes seemed more fit for the streets of Zurich than for insurgent St. Petersburg. From here on, we see him more often in a traditional Russian coat and *chapka*. Throughout the city, we see his silhouette atop wooden stages constructed for mass meetings. There were no microphones, no loudspeakers. All eyes were directed towards this small figure who agitated in the distance. Imagine the frames of a silent movie: his words cannot have possibly reached the great majority of people meeting in the plaza. The image of Lenin—like that of Dzerzhinsky, the militant Polish socialist who would later be trusted with organizing the revolutionary terror and the creation of the fearsome Cheka—would be made sacred in Soviet iconography, while Trotsky's image would be wiped from memories and events during the Stalinist period.

The symbol-image of the Russian Revolution—permanently engraved in twentieth-century memory—is composed of a multitude of armed silhouettes seizing the Winter Palace at dawn on October 25 (November 7 by the Gregorian calendar). Smoke rising from the great doors of the palace indicate canon fire, but the insurgents rush ahead, rifles in hand, out of formation. There are no bodies lying on the ground. Over several decades, this photograph would illustrate for millions of men and women the ideal of what was both a possible and necessary assault on heaven, what Ernest Block would later call a "concrete utopia." For others, first among them the Italian writer Curzio Malaparte, whom Trotsky would treat sarcastically in his *History of the Russian Revolution*, this moment provided proof that

October was a putsch, not an insurrection, but only a coup d'état executed with admirable technique. In another photo, a group of Red Guards, obviously posing to recreate a battle scene, pretend to shoot at the Winter Palace. In fact, all firsthand reports underline that October 25 was among the calmest days of 1917. For the protagonists of the time, who we see here brandishing their arms, the day was a turning point, like so many others that occurred during the year. It was only later that the myth would raise up these figures to be lionized by some and vilified by others. The moment is important—the Red Guards who posed for the camera knew they were providing testimony for the archives—but none of them could possibly have known what would happen in six months or in two years' time. The long wave of 1917 had been building for decades, but the social explosion it brought forth would quickly be smothered. However, the images reproduced here would be prolonged aesthetically by Eisenstein, and they would inspire many pages written by Reed, Trotsky, and Sukhanov. As for the Russians, they would perform monumental and caricatured parodies of these images in yearly parades in the Red Square in Moscow.

Timeline

[The dates below are given according to the old Julian calendar then in use in Russia and are therefore thirteen days behind the Gregorian calendar used in the West.]

1917

2/27: Fall of Tsarism. Insurrection in St. Petersburg. Formation of the first soviets of workers and soldiers.

3/02: Creation of the provisional government, under the leadership of the liberal Prince Lvov, after the abdication of Nicholas II.

4/03: Lenin returns from exile in Switzerland and publishes his *April Theses*, in which he proposes radical opposition to the provisional government.

4/06: United States enters First World War.

4/24–27: Bolsheviks approve Lenin's *April Theses* at their Seventh Party Congress.

5/04: Trotsky returns from exile in the United States.

6/02–21: First All-Russian Congress of Soviets, where Socialist Revolutionary Party predominates over the Bolsheviks.

7/03-04: Revolt led by the Bolsheviks is repressed by the provisional government under the leadership of the Socialist Revolutionary Kerensky, who assumed power on June 27. Lenin seeks refuge in Finland.

8/27–30: Failure of counterrevolutionary coup attempt led by General Kornilov. The soviets organize defense of St. Petersburg.

9/12–14: Lenin campaigns within Bolshevik Party to launch an insurrection against opposition from Kamenev and Zinoviev.

10/10: The Bolshevik Central Committee approves decision to organize an insurrection.

10/25: Winter Palace seized by Red Guards. Members of the provisional government arrested. Kerensky flees.

10/26: Second All-Russian Congress of Soviets approves insurrection and confers power onto the Council of People's Commissars led by Lenin.

11/02: Declaration of the right of self-determination of nations for all peoples in the Russian state.

11/25: Elections for the Constituent Assembly. The Bolsheviks win nine million votes out of thirty-six million votes cast.

12/02: Armistice signed between Russia and Germany. Beginning of the Brest-Litovsk talks.

1918

1/06: Dissolution of the Constituent Assembly.

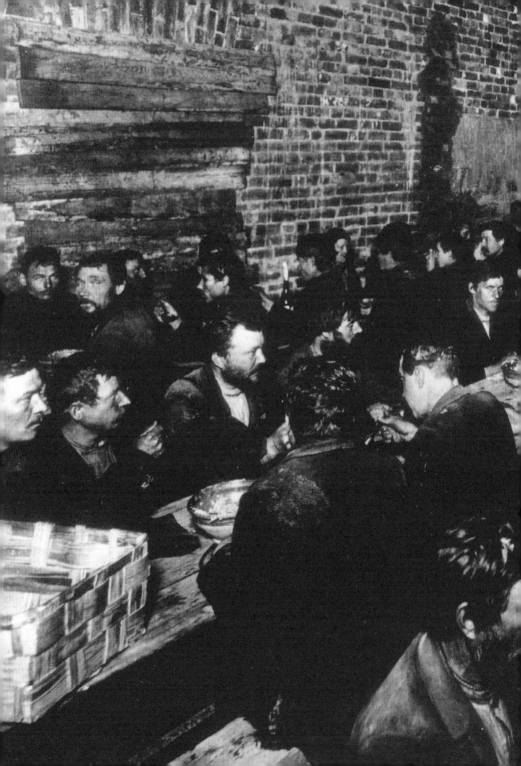

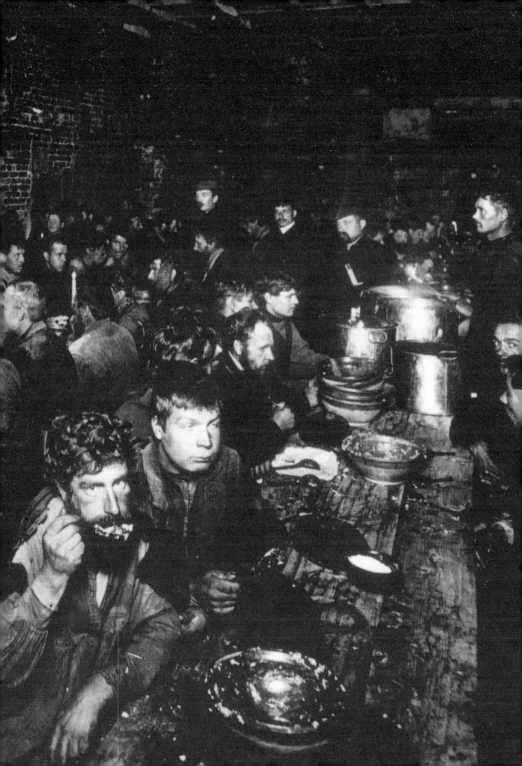

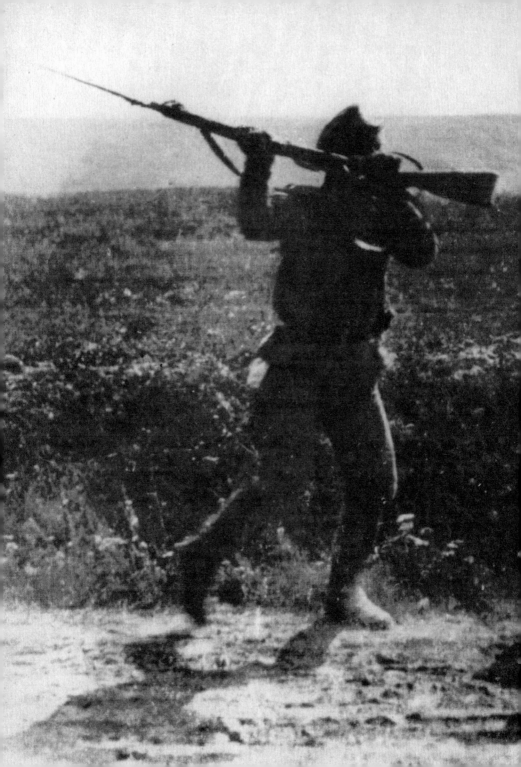

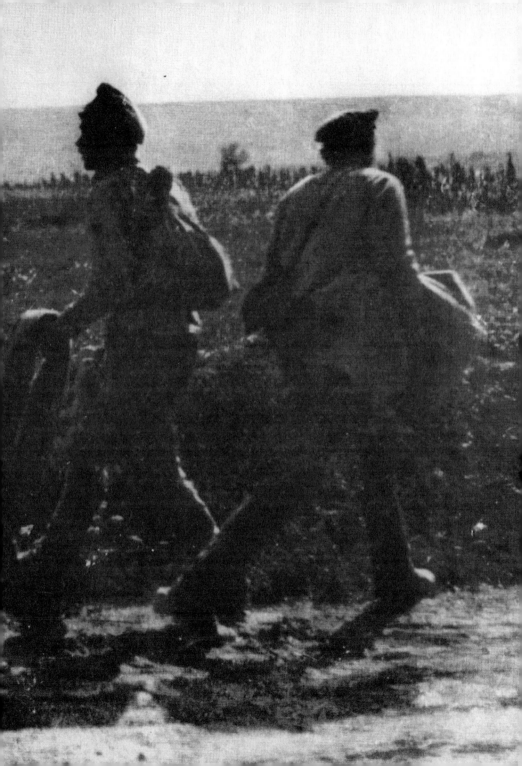

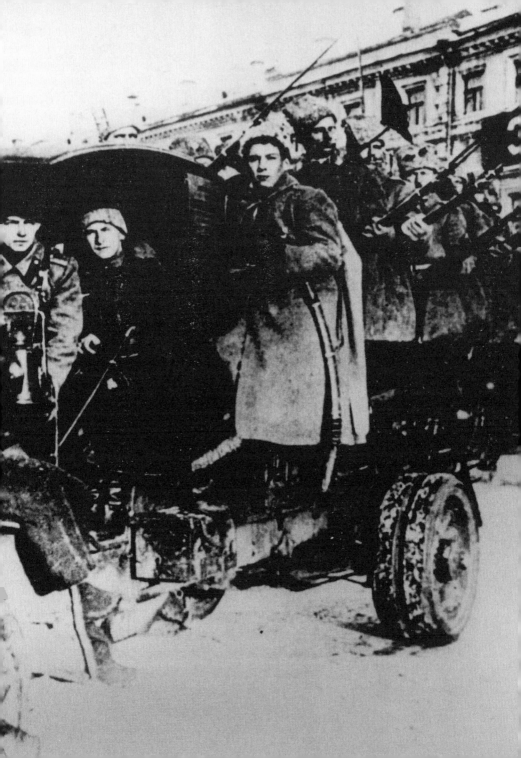

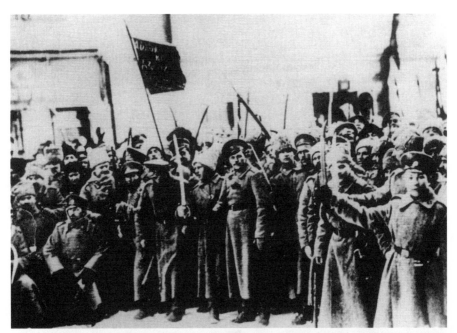

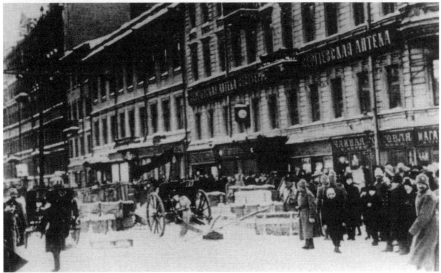

Above: Fraternization between people and soldiers in the streets of St. Petersburg.

Below: Barricades erected in Moscow.

Previous page: Soldiers on a truck in 1917.

Pages 122–23: Men who earn a few rubles per month eat plates of *kacha* stew.

Pages 124–25: A Russian soldier threatens deserters with the butt of his rifle.

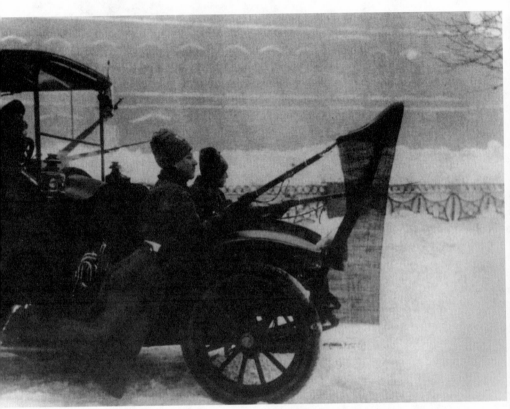

During the April crisis, soldiers patrol the streets of St. Petersburg flying red flags.

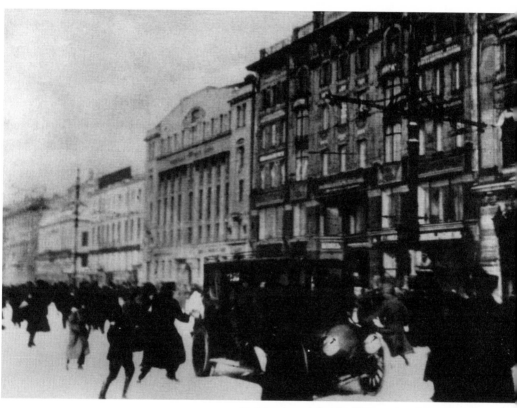

St. Petersburg during the February Revolution. A volley
of shots has just been fired from a window.

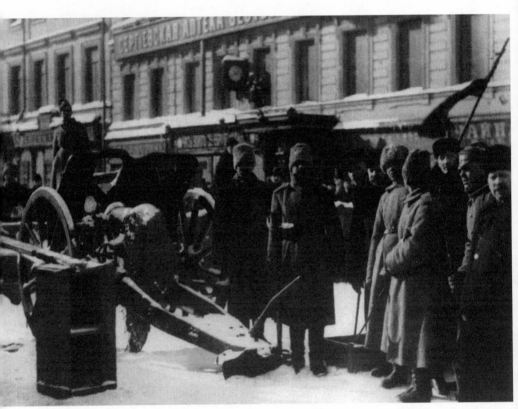

Soldiers join a barricade in St. Petersburg.

Soldiers invade the reading room of the Duma in St. Petersburg in April 1917.

Next double page: Burial of victims of the February Revolution in the Field of Mars in St. Petersburg.

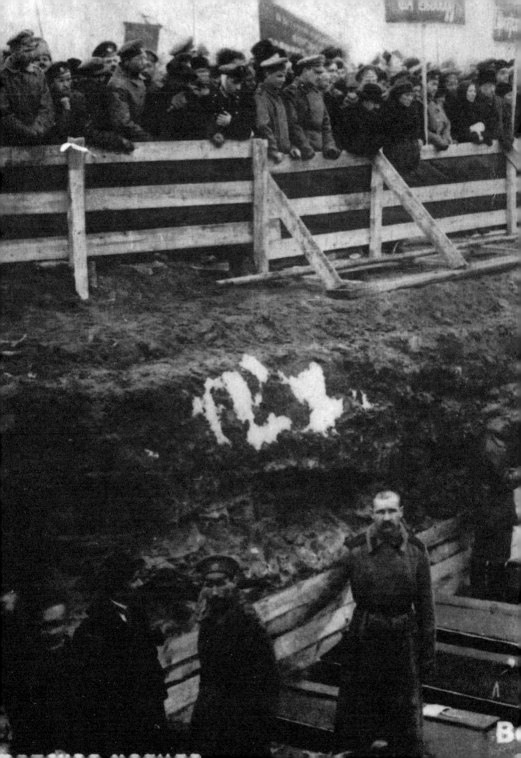

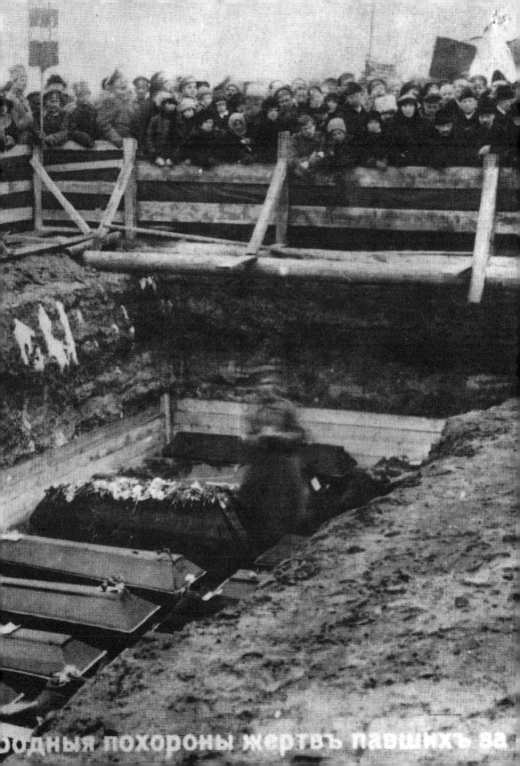

одныя похороны жертвъ павшихъ за

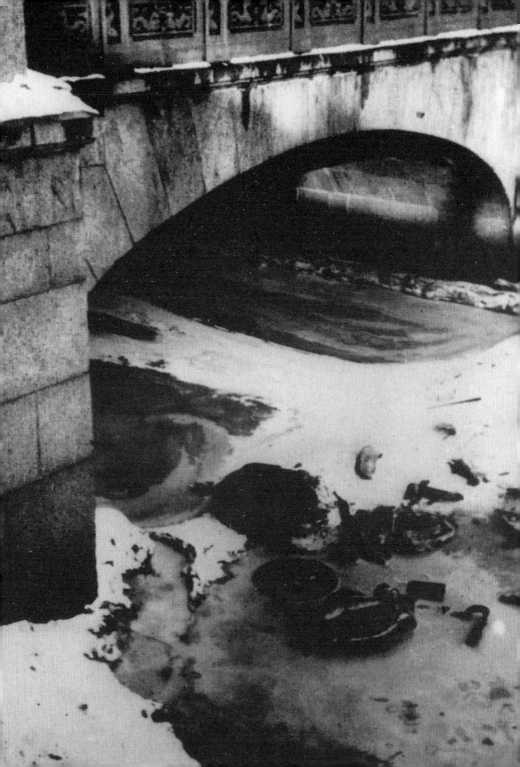

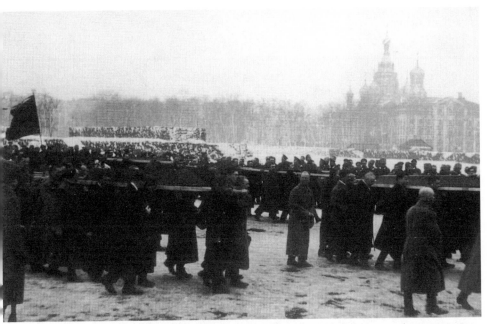

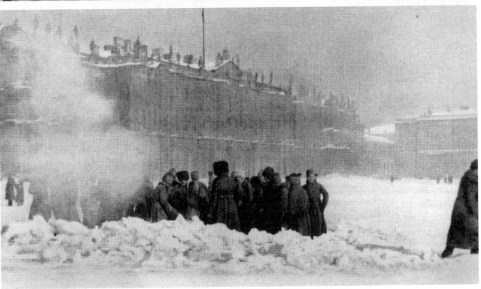

Above: Burial of victims of the February Revolution in Moscow in March 1917.

Below: Solders dig a grave in front of the Winter Palace in St. Petersburg to bury victims of the February Revolution in March 1917.

Previous page: Official portraits and imperial eagles tossed in the Fontanka Canal in St. Petersburg.

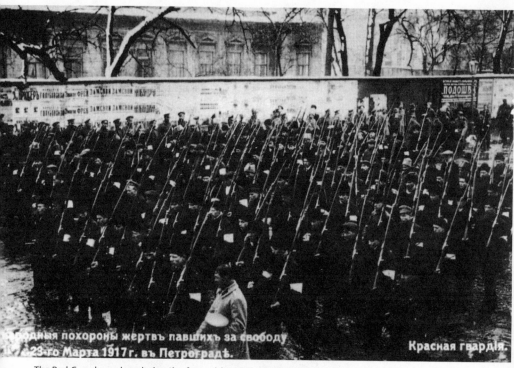

Народныя похороны жертвъ павшихъ за свободу 23-го Марта 1917 г. въ Петроградѣ.

Красная гвардія.

The Red Guard marches during the funeral for victims of the February Revolution in St. Petersburg on March 23, 1917.

Next page: Street scene in St. Petersburg during the February Revolution.

Pages 138–39: Sacks of flour distributed to the poor in front of the Tauride Palace in St. Petersburg in March 1917.

Pages 140–41: Soldier delegates from the front greet peasant delegates during a soviet congress in the House of the People.

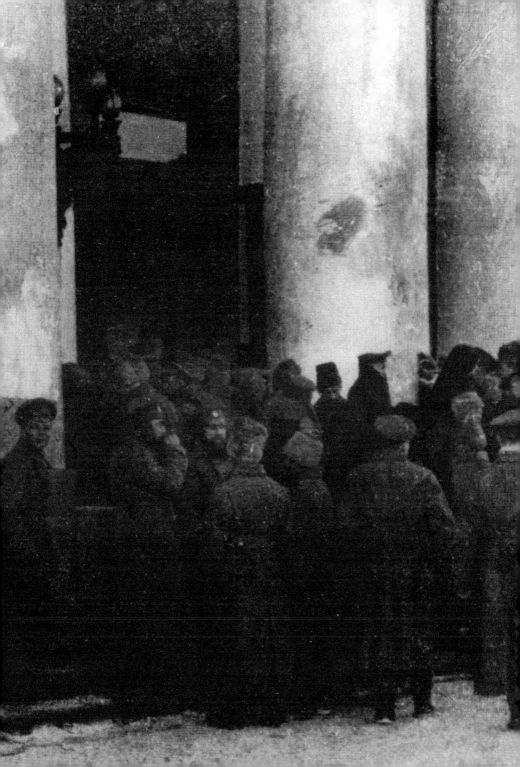

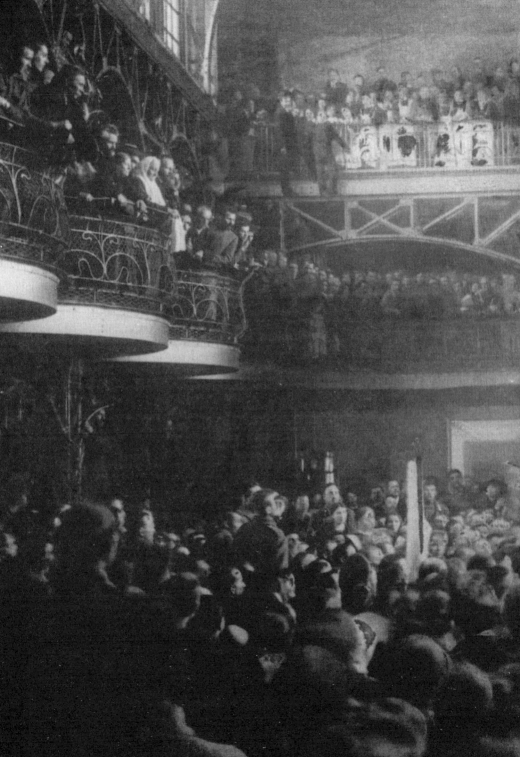

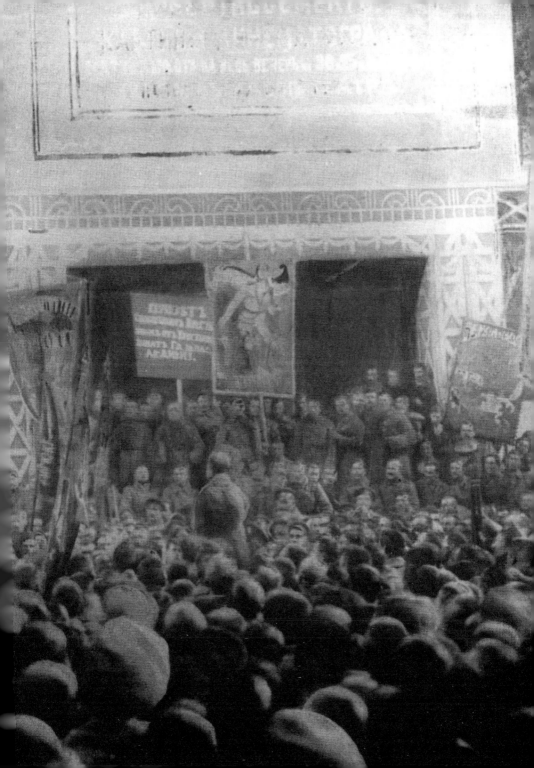

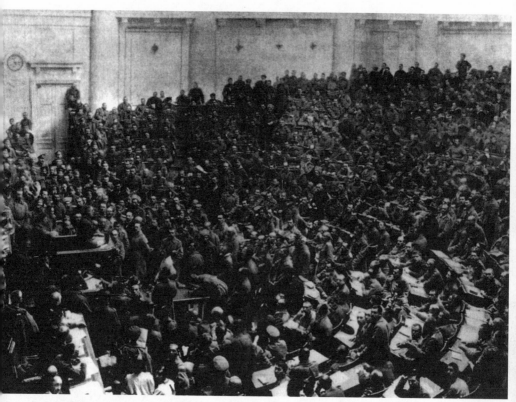

St. Petersburg Soviet meets in the Duma chambers in March 1917.

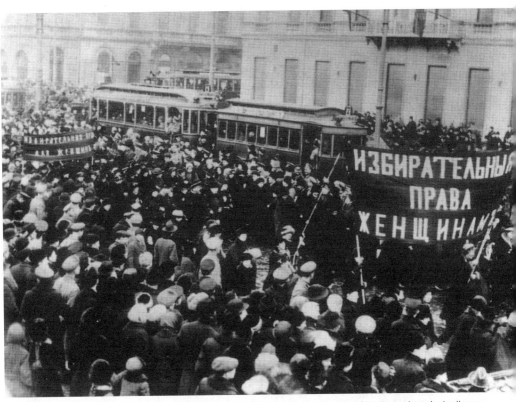

Women's demonstration in the streets of St. Petersburg in April 1917.

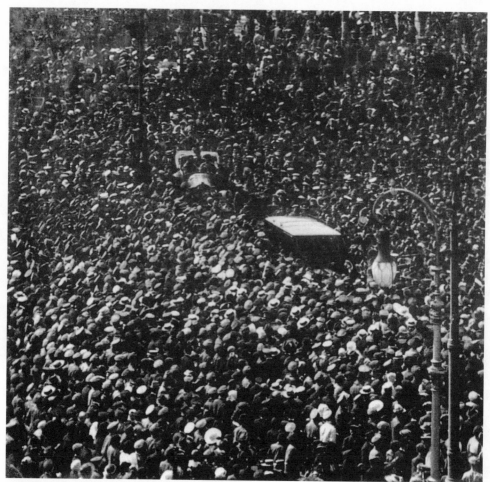

After the success of the Russian offensive in the beginning of July,
Kerensky is greeted by a crowd upon his arrival in St. Petersburg.

At the front, soldiers swear an oath to the provisional government.

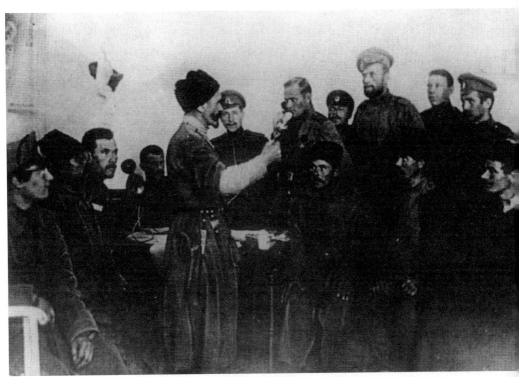

A Bolshevik agitator argues with a soldier in General Kornilov's army.

Previous page: General Kornilov, the
supreme commander of the White Army.

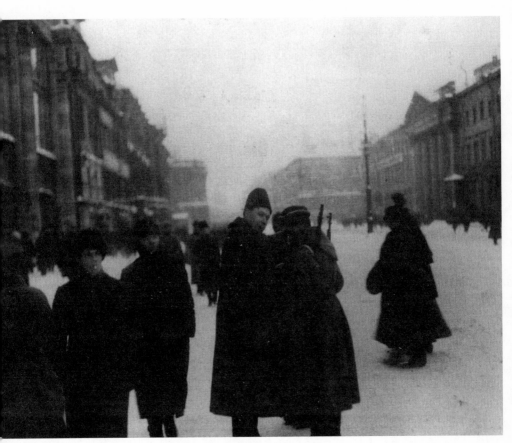

Civilians are searched in March 1917 in St. Petersburg.

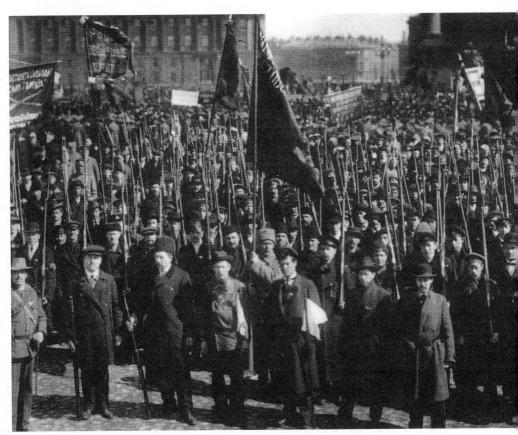

During the revolution in March, national militia and working-class Bolsheviks arm themselves by robbing the arsenal. Despite repeated appeals from the government, they refuse to surrender their arms.

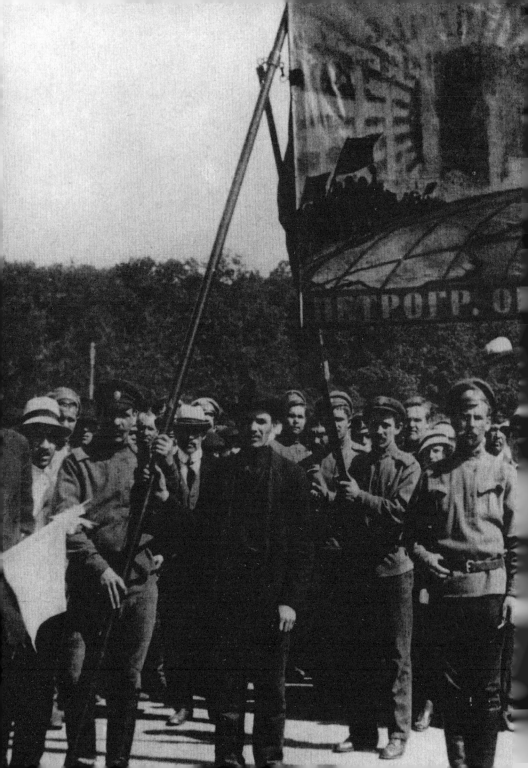

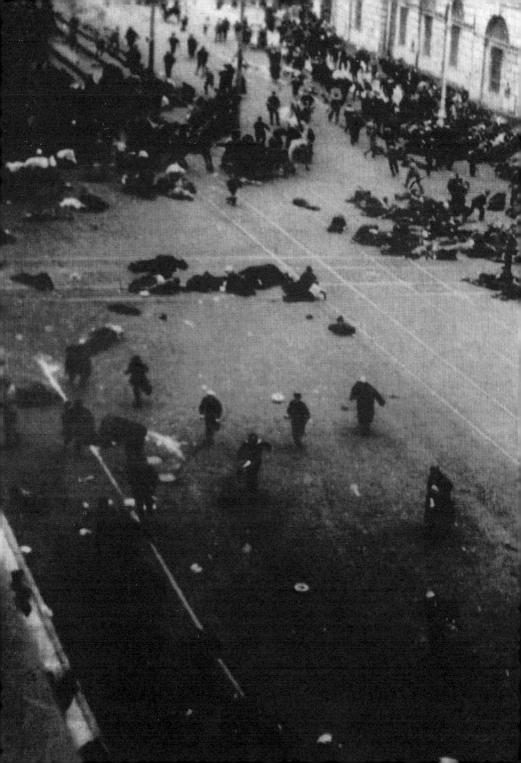

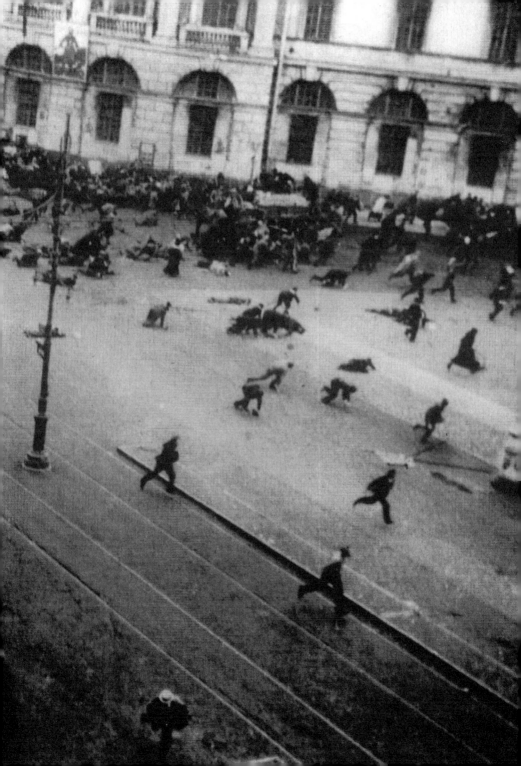

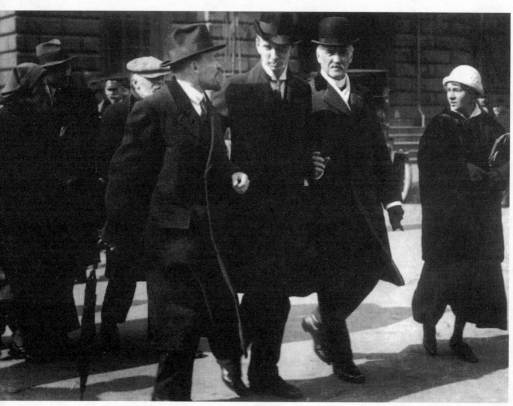

After exile in Switzerland, Lenin passes through Stockholm
in April before returning to St. Petersburg.

Pages 150–51: Workers from an arms factory
demonstrating in St. Petersburg in July 1917.

Pages 152–53: A demonstration is dispersed by artillery
fire on the Nevsky Prospect in St. Petersburg in July 1917.

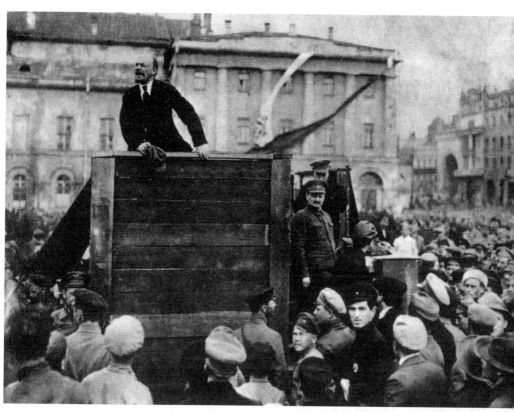

Lenin speaks to a crowd in St. Petersburg.

Tsar Nicholas II in front of his headquarters on the imperial train where he will sign papers abdicating the throne.

The tsar working.

Previous page: Floor of the Putilov
factory in St. Petersburg in November 1917.

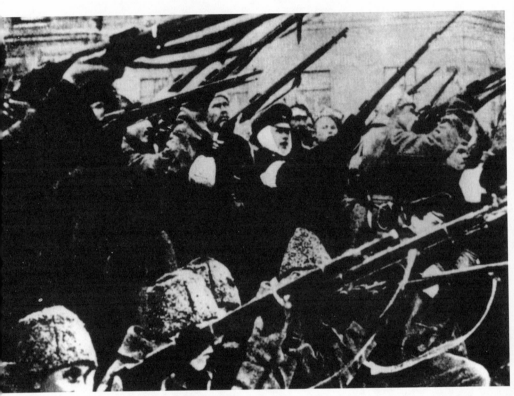

The attack on the Winter Palace in October 1917.

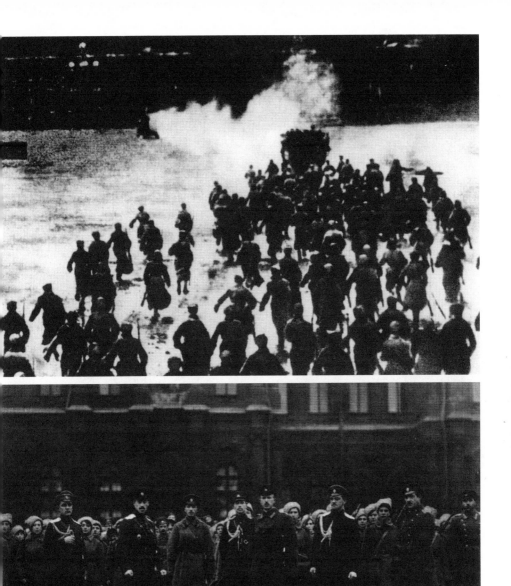

Above: Storming of the Winter Palace on October 25, 1917.

Below: Women's Battalion, last line of defense for the Winter Palace in October 1917.

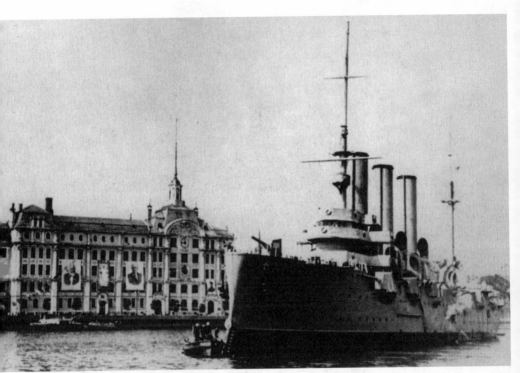

The cruiser *Aurora* on October 25, 1917, anchored in front of the Winter Palace.

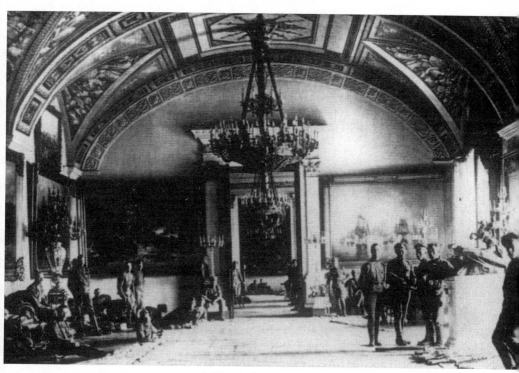

Soldiers in the Great Room of the Winter Palace in October 1917.

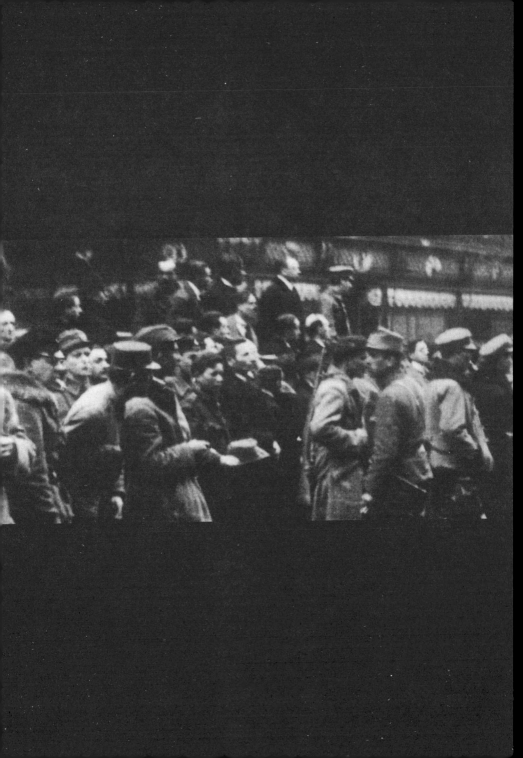

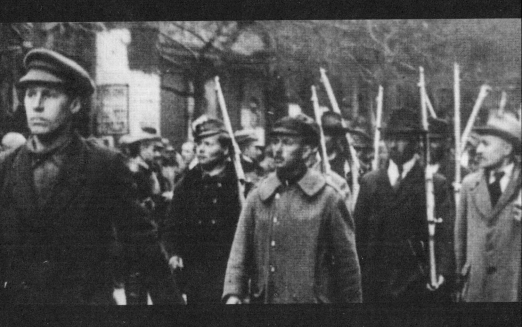

1919

The Hungarian Revolution

Michael Löwy

The Hungarian Revolution

A man speaks to the multitude from a platform. He is József Pogány, a social democrat, and now the people's commissar of war, exhorting workers to join the Red Army. We are in the month of May of 1919 as Czechoslovakian troops, aided by the Entente, enter the outskirts of Budapest, threatening the young Hungarian Republic of Workers Councils. The scene is somewhat theatrical, set against the grandiose (maybe even a bit pretentious) Millennium Monument—built in 1896 to celebrate the conquest of Hungary by the Magyars ten centuries prior—which serves as a backdrop and platform with a stage and curtains for orators and various leaders, who don't seem to know what role they have to perform in the play. A mass of workers, soldiers, sailors, and gentlemen in Sunday hats and white collars listen intently . . . no women are visible. A banner, which we assume is red, stands out in the middle of the crowd. The speeches are not without effect and, thanks to the new volunteers, the Red Army will succeed in repelling the invaders for some weeks to come.

We see these volunteers—Red Guards, workers' guards, and other armed civilians—in various images, cutting through the capital's streets in trucks or proudly marching in formation with their rifles at the ready behind a young worker in a beret who appears to be in command. But neither the oratory of Pogány—who would end up a Communist and

eventually a fatal victim of the Stalinist purges in 1937—nor the enthusiasm of the proletarian militias could hold off the more numerous and professionally trained armies of the counterrevolution or the neighboring countries supported by the Entente.

The revolution was theatrical, but the theater itself also joined in the revolution in the streets. We see an actress from the National Theatre standing on a small platform in Parliamentary Square, reciting revolutionary poems—"communist hymns." According to *La Petite Illustration*, which published this photograph in May 1919, the poems were most likely written by Endre Ady, Hungary's great poet who had died earlier that month but whose poetry had inspired the entire revolutionary generation of 1919. The crowd, made up of soldiers and intellectuals, listens in a religious silence.

Elsewhere, in the halls of a theater, the founding congress of the Unified Socialist-Communist Party was underway. One photo shows Béla Kun in front of a theater building in between sessions of the congress talking to typographical worker Lajos Kiss, a communist leader.

The streets appear as scenery in a previously unseen play. Thanks to the artists supporting the revolution, including Béla Uitz, whose children pose in front of one of his creations, city walls and columns were festooned with inventive posters, of symbolist, realist, or expressionist inspiration celebrating the Red Guard or the fighting proletariat. On the occasion of the first of May, the graphic artist Mihály Biró composed a stunning poster while other artists erected a sort of Arc de Triomphe featuring busts of Karl Liebknecht, who had recently been assassinated, and Karl Marx (though I might be wrong as the resemblance leaves something to be desired), by which a huge crowd of workers passed coming from the outlying neighborhoods on bicycle.

All this was begun, in a manner just as theatrical, with a proclamation of a regime change by the "Red Count," Mihály Károlyi, from atop the steps of the same parliament building back on November 17, 1918. A large

landowner and aristocrat, but known for his democratic convictions, Károlyi's destiny presents an interesting case. After the victory of the Republic of Councils in 1919, he left Hungary and emigrated to France; however, in the context of the antifascist alliance in the 1930s, he would move closer to the communists. After the war, he would serve as Hungarian ambassador to France before retiring from public life. A tall and impressive figure, we can imagine him pronouncing the historic words that put an end to the Habsburg Monarchy. An immense crowd extends out of sight and wraps around the palace like a revolutionary human wave decorated here and there with banners and streamers.

It was probably at this moment that ordinary people started attacking the statues honoring the Habsburgs that decorated the Millennium Monument. We can see them silently observing an imperial effigy lying on the ground, as soldiers, workers in caps, children, intellectuals in their ties, are united in joy—mixed with a certain superstitious worry—at seeing the centuries-long symbol of despotism torn down.

Yet the government in coalition with the moderate Left would soon be overcome by events to follow. Presented with an ultimatum in March 1919 by the representative of the Entente in Budapest, Colonel Vyx, that threatened an invasion of the country, the socialists decided to seek out the communist leader Béla Kun in his prison cell to form a revolutionary government with Kun and his comrades. This marked the beginning of the ephemeral—133-day-long—Hungarian Republic of Councils. A former Hungarian soldier who was captured during the war and held prisoner in Russia, where he was won over by the Bolsheviks' ideas, Kun and a group of workers and intellectuals founded the Communist Party of Hungary in November of 1918. He would later become the people's commissar of foreign affairs, while left-wing socialist Jenö Landler became the commissar of internal affairs and the Marxist philosopher Georg Lukács became the commissar of public education.

The main weapon of the "Reds" seemed to be the word. We can see them incessantly preaching, arguing, speechifying. Kun, with his hands in his pockets—is he intentionally imitating Lenin?—speaks to a crowd on the steps in front of the palace, while Pogány shouts from a balcony with all his strength to share the revolutionary message, hammering home every word like a fist. Landler stirs up the soldiers on their way to the front until Lukács takes over, abandoning his Hegelian jargon and brilliant philosophical exercises to offer some simple and concrete words.

Whether in uniform or civilian dress, standing on tables or atop stairs, the revolutionaries discuss, declare, agitate, and propagandize. They have neither microphones nor loudspeakers, only their own voices, and they are utterly unable to make themselves heard beyond a few dozen meters and, therefore, to reach the great multitudes.

All this drama must not obfuscate the essential: this was no mere play, but rather a genuine historical drama. It was a real revolution—that, for the first time, allowed poor children to know the delight of swimming in Lake Balaton—and it was a real war. In the face of the military cadets and high-ranking officers who had risen against the revolution, the Reds hastily constructed barricades, creating an environment of fraternity where civilians armed with revolvers—recognizable as civilians by their felt hats—mingled with soldiers carrying rifles and submachine guns. High up on a decaying balcony, a young Red Army soldier with a grenade in hand surveilled the street with an air of uncertainty. Soldiers departed for the front in trains, buses, or even taxis, all crowded to the ceiling. The socialist and communist workers knew that victory by the counterrevolution would mean a bloodbath.

At the end of July 1919, the defeat of the Hungarian Red Army by foreign troops sounded the tolling of the bells for the Hungarian Republic of Councils. At the beginning of August, Kun and many of his comrades went into exile, first in Vienna and later in the USSR (Kun would also end up a victim of the Stalinist purges in the 1930s). The conservative forces

took power and soon installed a reign of white terror: those suspected of having Red sympathies were hung from trees without any semblance of a trial. In a few sinister images, we can see the assassins, posing with satisfied smiles before their executed victims. Some months later, the nationalist, authoritarian, and anti-Semitic regime of Admiral Horthy would be installed and would last until 1945.

Timeline

1918

10/29–31: Budapest is in a state of insurrection. Count Mihály Károlyi forms a coalition government that includes social democrats.

11/16: Proclamation of the Hungarian Republic by Károlyi.

1919

2/21: Béla Kun and several communist leaders are taken prisoner by the government.

3/21: Entente delivers its ultimatum. Negotiations between the socialists and communists end in an agreement to merge the parties. Kun and his comrades are freed from prison. Proclamation of the Republic of Councils.

3/22: Messages are exchanged between Lenin and the Revolutionary Governing Council.

3/23: Call from the Revolutionary Council for workers around the world to assist the Hungarian Republic of Councils. Founding of the Socialist Society for Literature and the Arts and Sciences.

3/25: Decree for the formation of the Hungarian Red Army.

3/26: Nationalization of transportation, mining, banking, and construction industries. Formation of the Red Guard.

3/28: Requisitioning of housing and reduction of rents.

3/31: Beginning of socialist education courses for secondary education teachers.

4/02: Publication of the Provisional Constitution for the Republic of Councils. Nationalization of wholesale industry.

4/03: Nationalization of property of medium and large landowners.

4/16: The Romanian Royal Army attacks Hungary.

4/17: Decree guaranteeing freedom of religion.

4/27: General offensive of the Czechoslovakian army against the Republic of Councils commences. The military commander of Budapest decrees the organization of factory workers' regiments.

5/02: Interventionist troops threaten Budapest. The revolutionary government sounds a call to arms. Enlisting of volunteers.

5/03: Opening of the Marx-Engels Workers' University.

5/21–24: The Hungarian Red Army repels the Czechoslovakian offensive.

6/07: French premier Clemenceau demands an end to the Red Army offensive against the Czechs.

6/12–13: Founding of new unified party that takes the name of the Socialist-Communist Workers Party of Hungary.

6/14–23: National meeting of councils that adopts Constitution of the Republic of Councils and elects an executive committee.

6/17: French socialists protest against Entente intervention in the internal affairs of Russia and Hungary.

7/24–26: Armed Romanian and Czech offensive against Hungary supported by the Entente.

7/30: Red Army evacuates Budapest.

8/01: Resignation of the Revolutionary Governing Council. The Republic of Councils lasted 133 days.

8/07: Occupation of Budapest by Romanian troops.

11/16: Budapest in the hands of counterrevolutionary Hungarians commanded by Admiral Horthy.

1920

2/29: Restoration of the monarchy.

3/01: Horthy carries out coup d'état, proclaiming himself regent of Hungary.

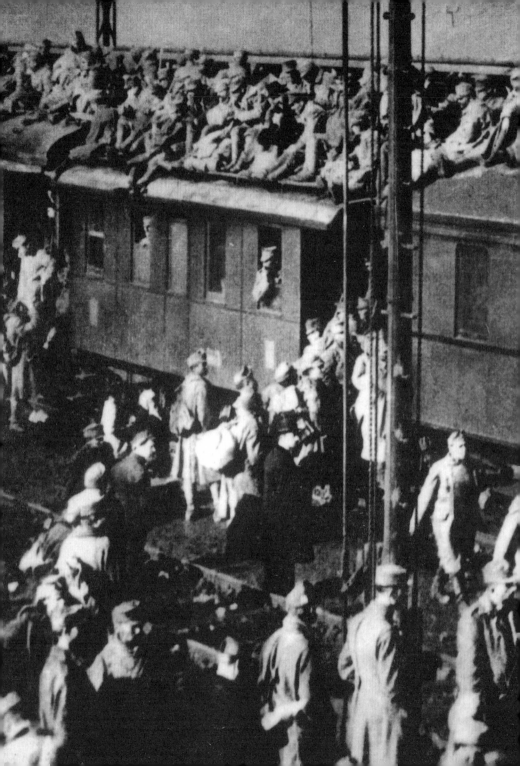

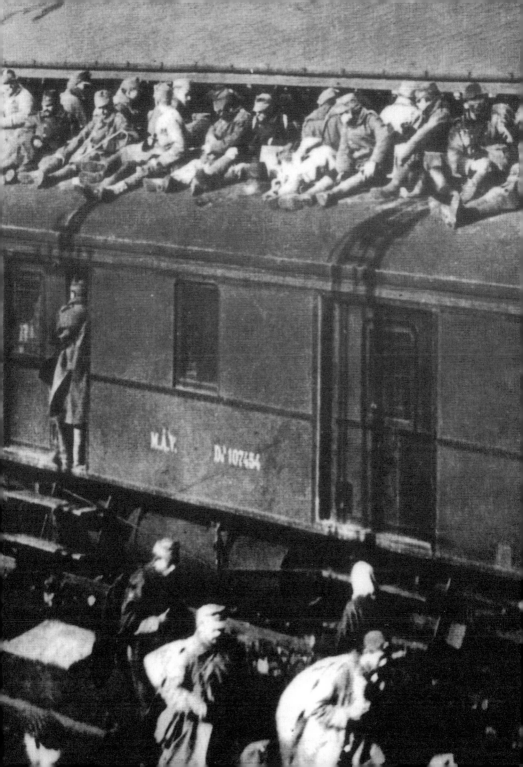

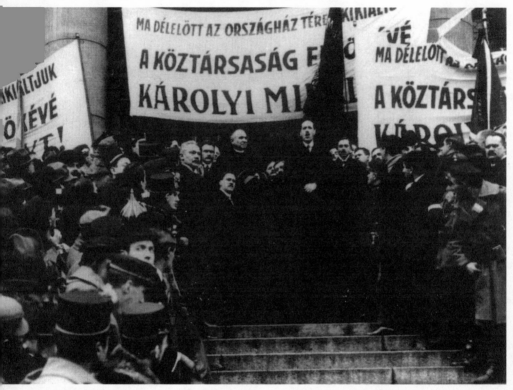

From the steps of Parliament in Budapest, Mihály Károlyi announces the proclamation of the Hungarian Republic on November 16, 1918.

Next page: In Budapest during the October 1918 insurrection for a democratic revolution.

Previous page: After signing of the armistice, soldiers return from the front, November 1918.

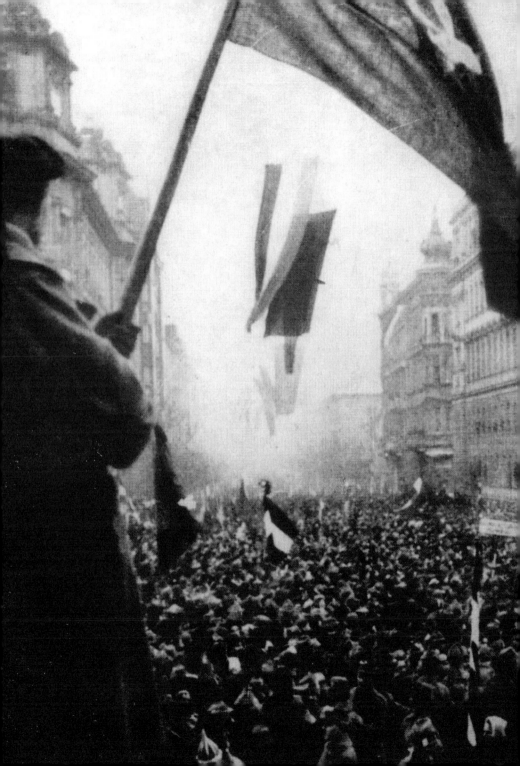

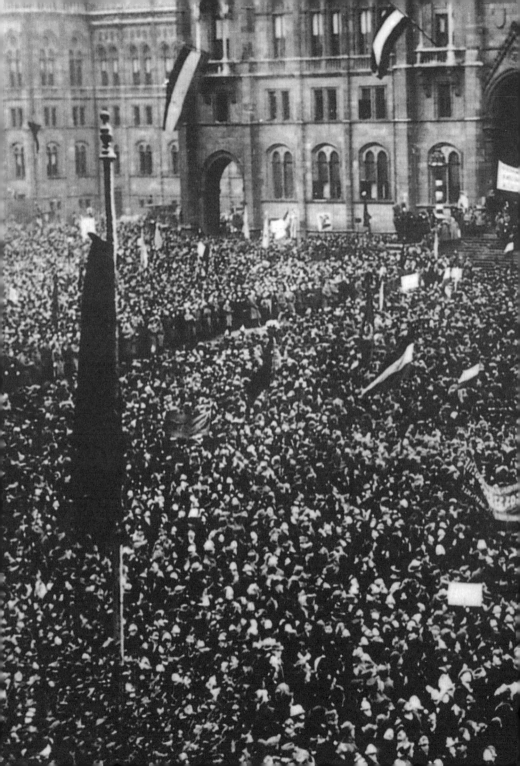

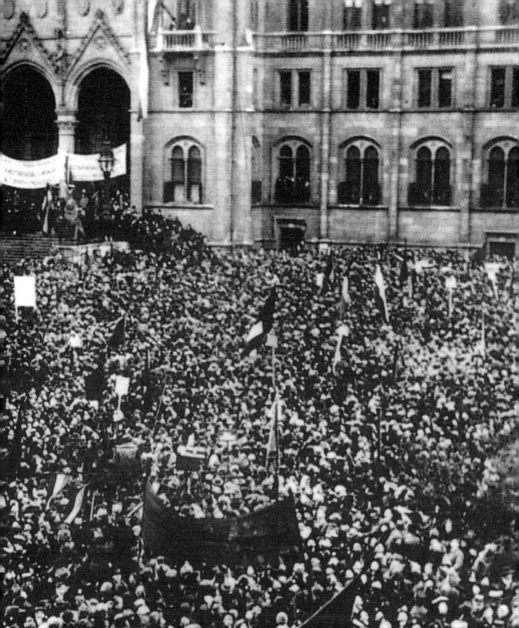

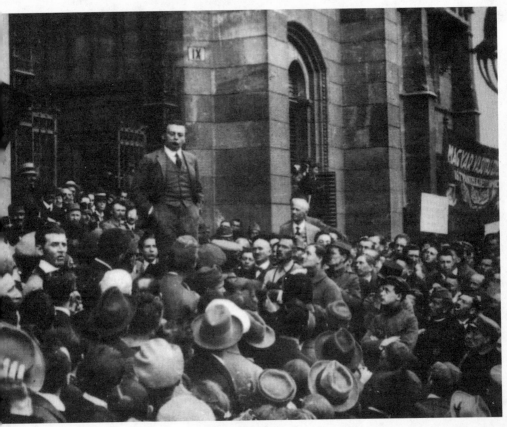

Béla Kun speaks to a crowd in front of Parliament in 1919.

Previous double page: An immense crowd gathers in front of Parliament demanding the proclamation of a republic and the appointment of Mihály Károlyi as president of the council of state, October 27, 1918.

Above: Members of the government, Hungarian Republic of Councils, May 17, 1919. Béla Kun, in the center, founder of the Hungarian Communist Party and the people's commissar for foreign affairs.

Below: Béla Kun and Lajos Kiss, a communist leader, talk in front of the Budapest Theatre during a break in the founding congress of the Unified Socialist-Communist Party in 1919.

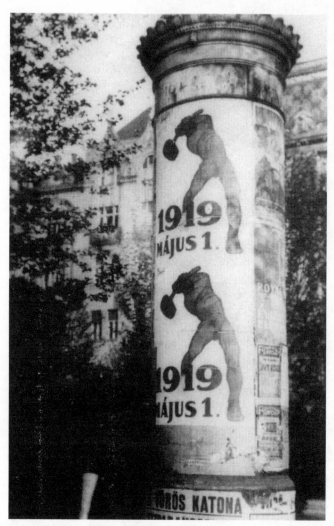

Poster created by Mihály Biró for May 1, 1919.

Next page: Street scene in Budapest, 1919.

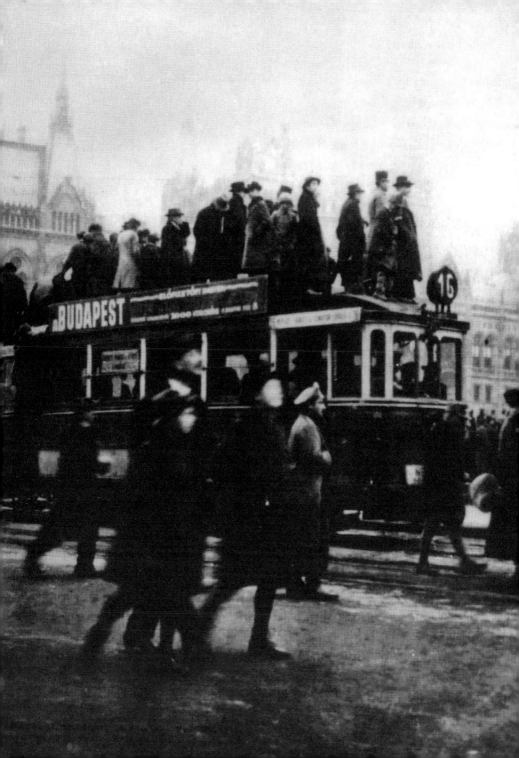

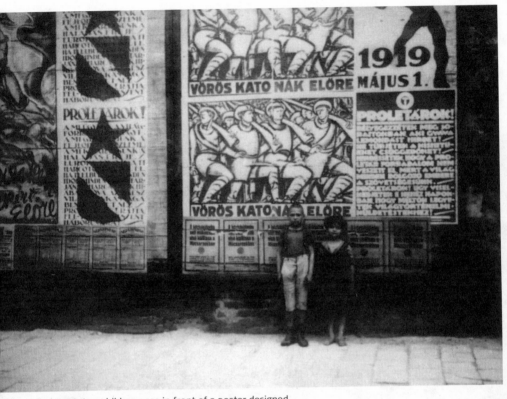

In Budapest, two children pose in front of a poster designed
by Béla Uitz that pays homage to the Red Guard.

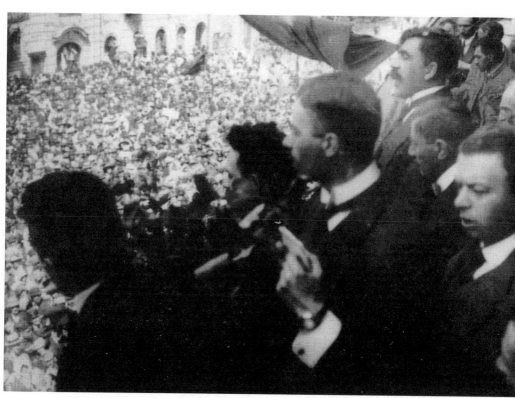

Members of the government during a mass meeting
in Kassa (now Kosice, Slovakia) on June 10, 1919.

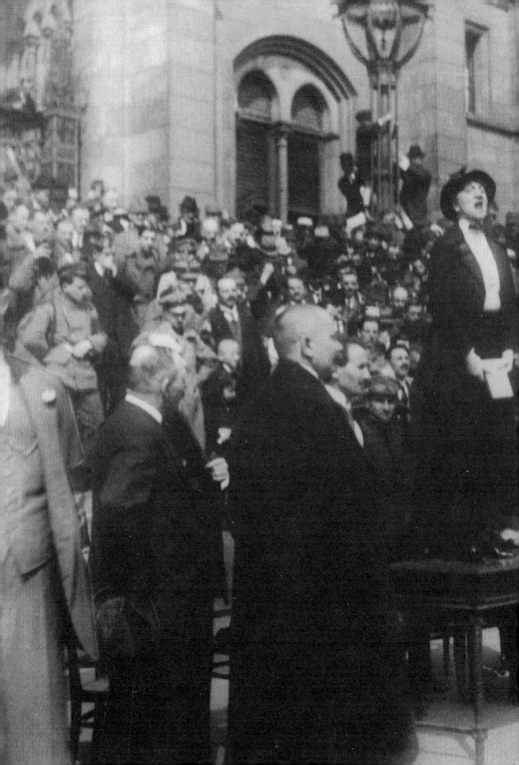

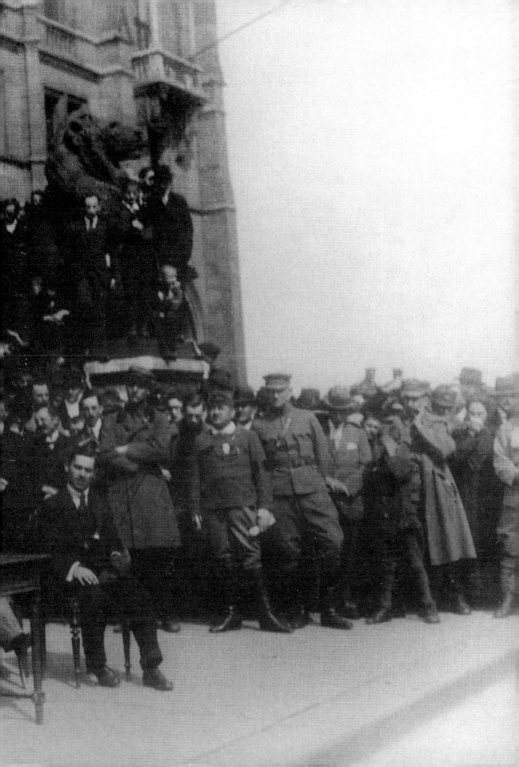

Distribution of food ration coupons in Budapest, May 1919.

Previous double page: In Parliament square, an actress from the
National Theatre reciting revolutionary poems on May 31, 1919.

A communist official speaks in the
courtyard of a military barracks in 1919.

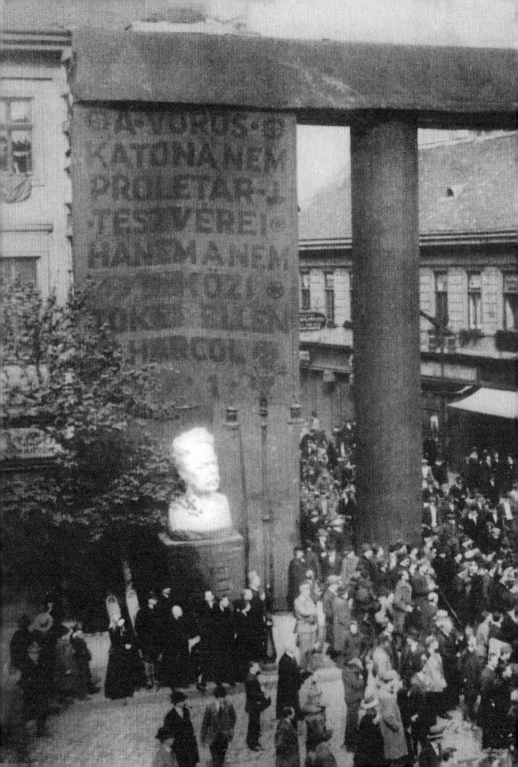

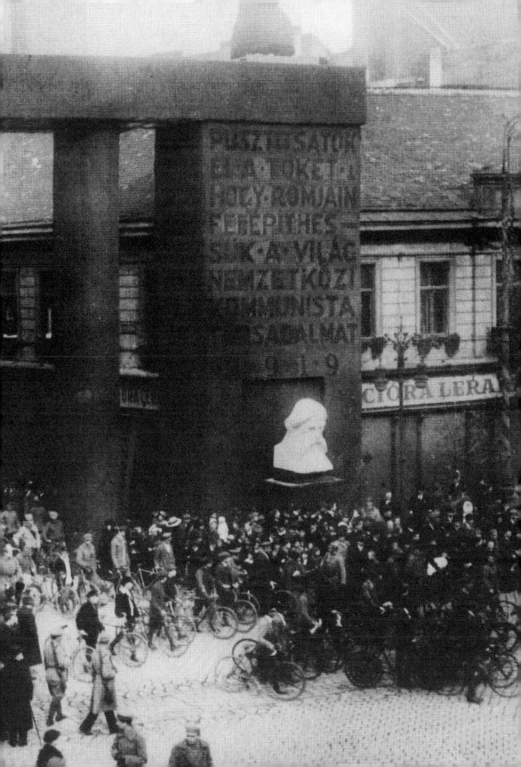

Young students sell revolutionary books in 1919.

Previous double page: May 1, 1919, people pass the Arc de Triomphe in Andrassy Square, which is decorated with busts of Karl Liebknecht and Karl Marx.

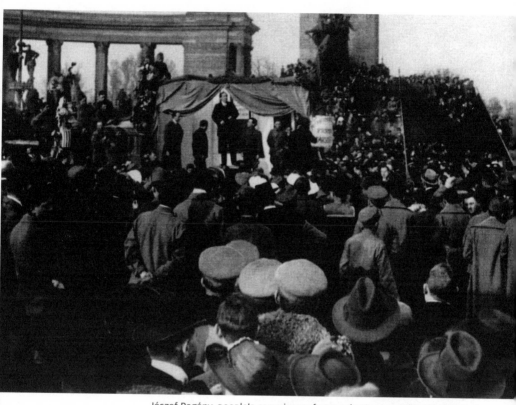

Jószef Pogány, people's commissar of war, exhorts a crowd to join the Red
Army in front of the Millennium Monument in Budapest in May 1919.

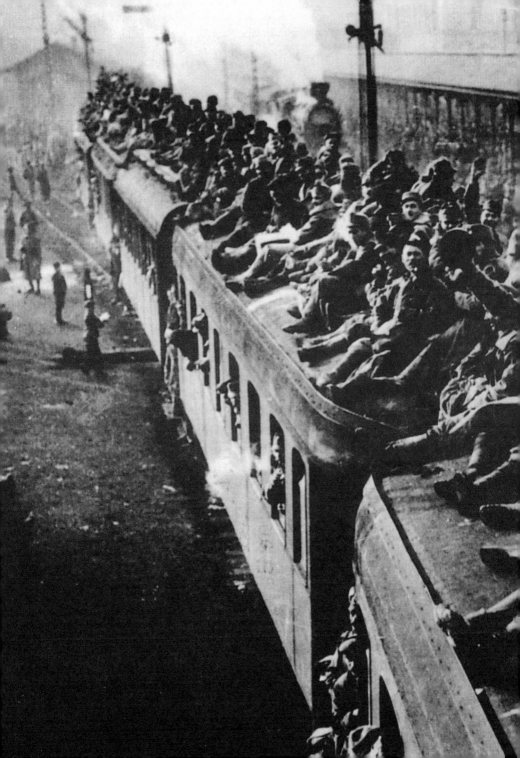

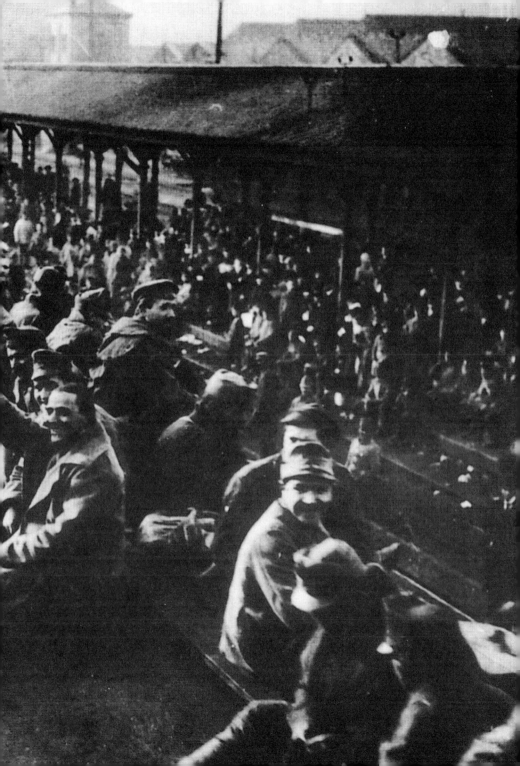

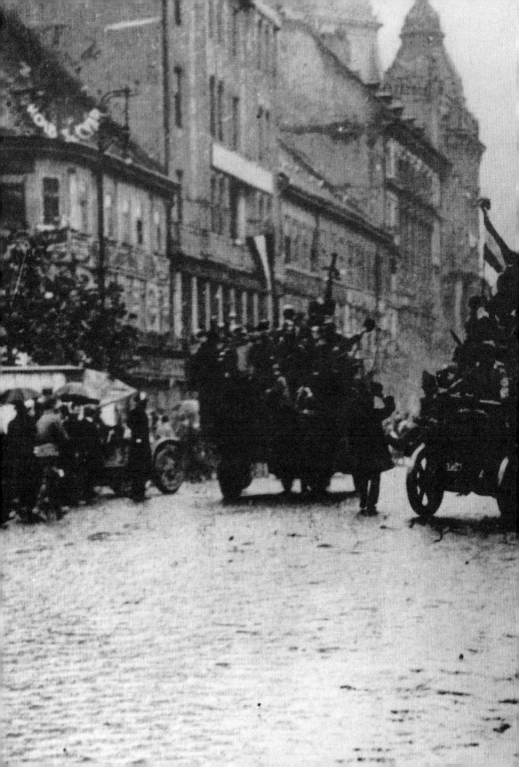

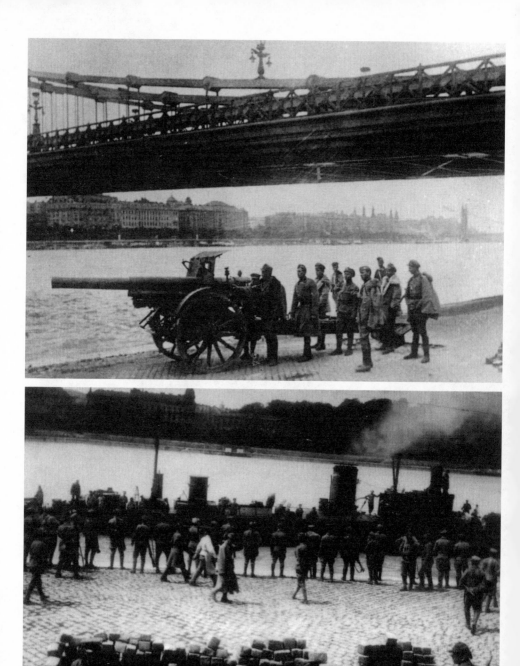

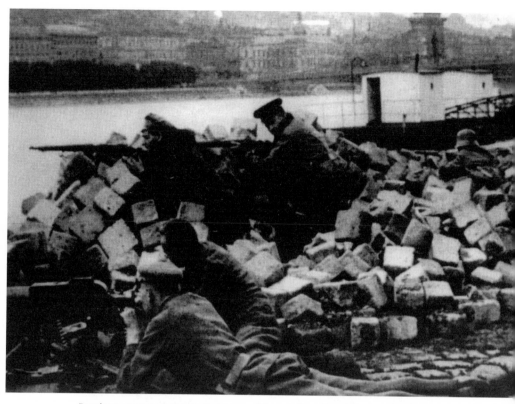

Previous page and above: Red Army soldiers on the edge of the Danube River.

Pages 194–95: Red Army soldiers leave to fight the Romanian and Czech armies, which were supported by the Western powers in 1919.

Pages 196–97: Red Army volunteers march through the streets of Budapest in 1919.

Pages 198–99: Revolutionary soldiers in the streets of Budapest in May 1919.

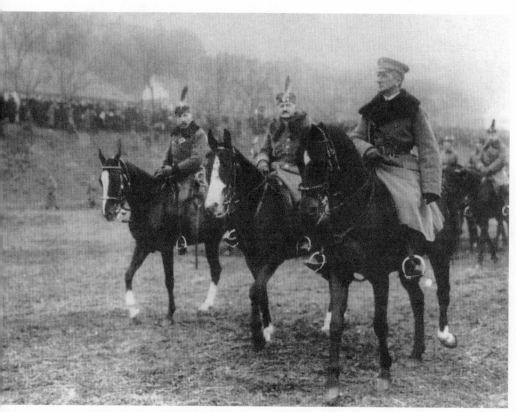

Hungarian regent Horthy pictured here on March 5, 1920. After the coup d'état, he established an authoritarian regime that would last until 1945.

In occupied Budapest, Romanian soldiers equipped by
France patrol the streets in August 1919.

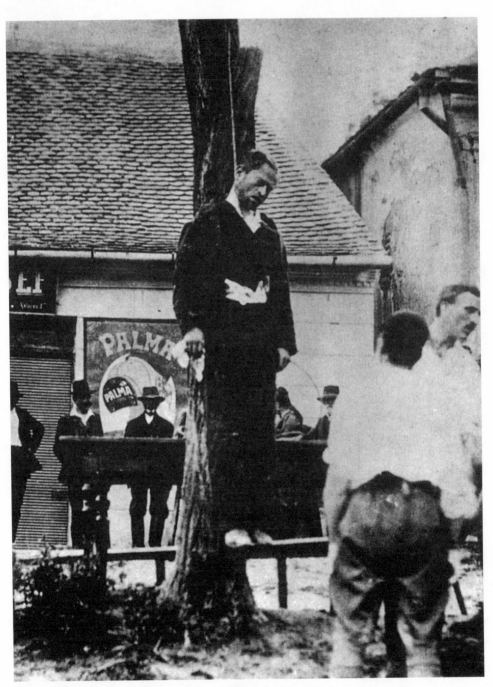

Above and next page: After the overthrow of the Republic of Councils, those suspected of sympathy with communism were persecuted by counterrevolutionaries: the "white terror" would begin at the end of 1919.

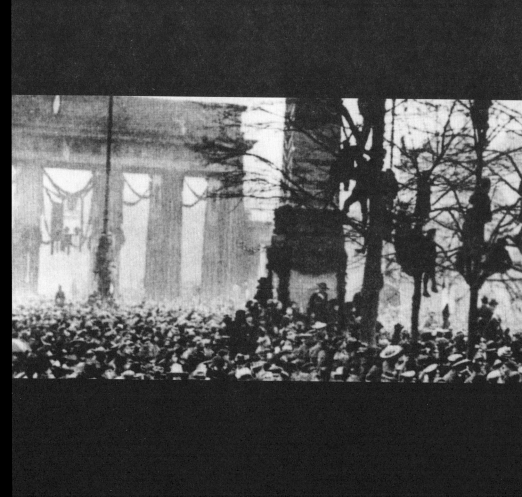

1918–1919

The German Revolution

Enzo Traverso

The German Revolution

Berlin, December 24, 1918: Christmas Eve. A small crowd of curious onlookers is posing for a photograph at the Potsdam castle, from which rebellious sailors would expel government troops the following day. In the foreground of the scene, the ruined columns of the imperial monument to Kaiser Wilhelm, lie at their feet. Children stand in the front row while women are situated off to the side, almost hidden. Some soldiers pose in the middle, but the majority of this group are passive observers of the events: gentlemen in hats, immobile, with their hands in their pockets, trying to assume a distinguished air. The setting is solemn and grave—almost no one dares to smile. They did not participate in the fighting, nor were they protagonists in this extraordinary historical moment. Here they merely observe the aftermath, trying to understand the importance of everything that has taken place. The old imperial Germany no longer exists: a new order, even if it is still uncertain and precarious, is ascending. They are conscious of this and want their presence registered. Thousands of photos taken in Berlin during the winter of 1918–1919 record many such faces among the multitude of indecisive, hesitant, or even stunned witnesses who, in a certain way, were split between soldiers and workers, on the one side, and the army charged with repressing them on the other.

These were the faces of those who were, in fact, present for the beginning of a revolution. Of course, all revolutions commence with the defeat of the old order—the complete upending of all institutions, social hierarchies, and ways of living—and then open new paths by means of chaos and confusion. All revolutions shake the totality of society powerfully: the old has disappeared, while the new has yet to take a clear form because it is still being constructed. Visions of the future diverge, conflicts grow, confrontations continue. Revolutions are very often bloody. Between November 1918 and May 1, 1919, the date marking the end of the Bavarian Soviet Republic, Germany passed through one such transition period that was violent, traumatic, exalting, and terrifying all at once.

Which date marks the beginning of the Weimar Republic? The moment of Emperor Wilhelm's fall in November 1918? Or February 1919, when Friedrich Ebert ascended to the presidency? Or August of that same year, when the new constitution was promulgated? The revolution's social and institutional course can be linked, of course, to still other events, including the suppression of the Spartacist uprising in January 1919 and that of the Bavarian Soviet Republic some four months later. The collapse of the old imperial regime, the birth of the Republic, and the crushing of the revolution all tangle together. The birth of a new order occurs in the unfolding of events; revolution and counterrevolution move together, stalking, clashing, and confronting each other before one smashes its opponent. Many people hesitate for a long time before choosing their side.

In November 1918, anything was still possible. On November 9, at two in the afternoon, the social democrat Philipp Scheidemann proclaimed the Weimar Republic from the top of the Reichstag; two hours later, the Spartacist leader Karl Liebknecht announced the beginning of the Free Socialist Republic from the balcony of the castle of Berlin. The Weimar Republic would be born from the bloody defeat of the social revolution heralded by Liebknecht and Rosa Luxemburg, who wanted to follow the example set in October 1917—a move which might have broken Russia's

isolation and prevented that revolution's decline. But the republic had to rise from the ruins of an empire and the ashes of an annihilated revolution as if, at the beginning of the twentieth century, Germany could not renew itself unless it carried out its own history, following a unique path. This idea, dubbed the *Sonderweg* thesis by many historians, promoted avoiding any rupture "from below" as had occurred in 1848 or 1870. However, these photographs do not focus on the institutional mechanisms of the newborn republic, its men and its seats of power; rather, they capture, describe, record, immortalize, and, to a certain degree, interpret the aborted social revolution, the radical transformation of German society "from below." These photographs captured a critical turning point in Germany's history, and their subject matter shaped our memory of events and became, to retrieve Pierre Nora's formula, "sites of memory." They do not portray parliamentary debates, but debates carried out in front of revolutionary crowds, street fighting, and barricades. The hero of the revolution certainly was not Friedrich Ebert, the first president of the republic, but rather Luxemburg and Liebknecht, its martyrs.

The German Revolution was the first of the century—along with those in Russia and Mexico—to be shaped by the media. Even before the Weimar Republic, under Emperor Wilhelm, Germany was a center of European publishing. In Berlin, there were several dozen daily newspapers, many of which were quite austere at the time, using gothic fonts and very few images, as well as various illustrated weekly journals. All the news agencies used front-page photos. Images of mass protests, barricades, street fighting, and armed detachments of workers marching through Berlin and occupying old imperial palaces all made headlines in the *Berliner Illustrirte Zeitung* or the *Weltspiegel*. News photographers shot history *in fieri*, therefore becoming an incontrovertible part of the revolution itself. Published images contributed to the production of events, shaping viewers' perceptions of the facts and allowing protagonists to see themselves in the mirror—thus giving hope, fear, and terror a face.

Images publicize events and amplify their impact. They are not neutral, because they interpret the facts they depict, and they orient and mold the reception of those facts. The photos from the workers and soldiers' Council Congress, which met in December in the immense halls of the Prussian parliament building on Prinz-Albrecht-Strasse, did not circulate as widely as the images of the Spartacist occupation of the huge Mosse publishing house, the old bastion of the *Judenpresse* (the "lying press," according to the old clichés of German nationalism), which is now presented as a victim of Bolshevik pillage. The press presented the insurgents as "Liebknechtian fanatics," paid agents of the Soviet Union, and even as Jewish anarchists. This campaign of hate against rebellious workers would be described by Luxemburg in words that said it all: "a pogrom atmosphere."

The illustrated left-wing press would not develop until some years later, after the end of hyperinflation and the stabilization of the Weimar Republic. The same images of huge crowds and armed masses would then be used to celebrate another epoch within the revolution, that of the German Communist Party (KPD), which was "born in the struggle." "Im Kampf sind wir geboren" (We were born to fight) *Der Rote Stern* announced in December 1928 under a photo of a January 1919 meeting, celebrating the tenth anniversary of the KPD's founding.

However, it was not necessary to wait for the communist press of Willi Münzenberg for the revolution to take on an epic, we might even say mythical, dimension. From November 1918 forward, Germany was conscious that it was living through a sharp curve in its history. Photography recorded this twist and, at the same time, revealed that the protagonists know perfectly well that they were living through an extraordinary event, something out of the ordinary, which was breaking up linear time, confounding regular chronology, and marking the eruption of a qualitatively different temporality. The empire fell, the war ended, the people took to the streets; those who paid the highest price for the war and for the defeat would no longer submit to the old dominant elites—they wanted to

assume control over the nation's future. Photographs from November and December 1918 show both confusion and euphoria.

One week after the fall of Emperor Wilhelm, it was already possible to purchase images of the revolution in the form of 3-by-5-inch postcards in the streets of Berlin, with prices varying from five to twenty-five *pfenning*. From the end of the nineteenth century, postcards were widely available in Germany. During the war, soldiers of the Reich sent many millions of these cards back home. It's not surprising that the revolution was immediately depicted and memorialized in postcard form by the society that gave rise to it. Thus, photography contributed—thanks to still embryonic, but nevertheless real, structures of a modern mass society—to generating image archives in real time. These postcards captured an epic historical moment, one that was lived as such by its protagonists. Very often we get the impression that the multitudes in motion are aware of photographers' presence on the scene, that they are looking into the lens. In fact, it would be difficult for these photographers to go unnoticed. Most times, photographers worked with quite awkward equipment, which had to be positioned on a tripod and located in strategic places during decisive events. Sometimes Ica-Rekord portable cameras—one of the era's easiest to manage—were used, but even these were bulkier than today's equipment. Without a doubt, the presence of a photographer contributed to the solemnity of any action they recorded. Some barricades, built out of rolls of paper from one of the huge printing presses occupied by workers, seem incongruent, as if they were constructed to satisfy the demands of a photographer. The workers and soldiers at the scene pose for the camera. After building the barricade, but before the onset of any real confrontation, the workers and soldiers simulate combat, standing stock-still in artificial, war-like postures. This revolutionary pantomime accompanies the real revolution as it proceeds with blood and death. It is precisely because they are dealing with a serious event that it is necessary for them to immortalize it, and because they are conscious of the situation's historic character, it is necessary for them to demonstrate its epic and heroic dimensions,

even sometimes by creating a stereotyped image. With this in mind, we see a group of revolutionary sailors surrounding a tank that is being used as a rostrum in front of the Potsdam castle posing for a photograph, some of them with their hands in their pockets or tucked into their belts, their legs slightly apart, as if they are in a portrait studio. Others brandish swords or grasp their rifles, ready to shoot, as if the battle has already begun. Standing before the camera lens, the revolution's protagonists literally turned themselves into actors in the "theater" of history.

Photographs from November's marches show masses invading the streets and plazas, consumed by euphoria and worry, in a state of feverish agitation. The page has turned; the future is unknown. Images from January's uprising—initiated against the advice of the Spartacist League's leaders (first among them Luxemburg), who felt they could not abandon the movement and so therefore assumed leadership over the movement even though they believed sufficient conditions for a socialist revolution were lacking—show a tragic and desperate revolt. With no one smiling, and tense faces, the armed workers patrolling the streets of Berlin give the impression of large-scale disorganization and of being unable to decide what to do—it's as if no one felt up to seizing control of events. We don't see faces beaming with joy, as in Paris under the Popular Front, or in Barcelona at the start of the Civil War; no girls kissing the liberating soldiers as in 1944 Paris or in Italy a year later. In short, we do not see the transgressive and joyous streak associated with historic events lived as emancipatory ruptures. The German Revolution of 1918–1919 was born from military defeat, and the republic that this revolution brought into the world was born of another defeat, the defeat of the revolution itself. No one reveled in these circumstances, not the people whose living conditions declined, not the *Vernunftrepublikaner* (the Republicans by reason) who resigned themselves to the new institutions but at heart missed the empire, not the revolutionaries drowned in blood who dreamed of a democracy of the councils, not the social democrats who, after having fought for the republic, assumed principal responsibility for subsequent repression,

and, lastly, not the counterrevolutionary armed bands, such as the Freikorps (the Free Corps), who unleashed murderous violence against the Reds, the anarchists, and the "Jewish-Bolsheviks" in their frustration over a lost war. The images of the corpses of executed Spartacists—very often presented by the press as common criminals—sent shivers down the spine, revealing the terror's most ferocious face. Between January and March 1919, there were nearly two thousand victims of the repression in the capital alone.

One photo shows members of the Freikorps posing for a group picture at the Eden Hotel the day after Luxemburg's assassination. As for heads of government, they rarely appeared in public. The photos we have of them do not portray charismatic leaders acclaimed by the masses, but good men of state: they are always exceedingly serious, meeting to find the means to control events that escape them. The contrast between Gustav Noske and Scheidemann, who are photographed wearing coats in the pompous interior of the governmental palace, on the one hand, and Liebknecht or Georg Ledebour, on the other, is particularly sharp as the latter are captured in photos leading huge crowds, and standing beside a truck or a machine gun, or on the balcony of an occupied building. This tragic picture is rarely illuminated by images of happy people. We find only one example of revolutionary fraternization in Berlin's main square between German and French soldiers, who stand arm in arm for a picture. The soldiers are surrounded by a small crowd in a cheerful atmosphere. Among them stands a Senegalese infantryman showing off a timid smile.

The tragic character of this revolution—and it is necessary to insist on its tragic aspect—is underlined by the austerity of the images' backgrounds. At the end of the First World War, Germany presented a more Wilhelmian than Weimerian face. The grand Berlin of the 1920s—the most lively and modern of all European capitals, the city of lights, of propaganda, of theaters of every kind, of nightclubs, cafes, cinemas and leisure, the Berlin described by Walter Ruttmann in his 1927 film *Berlin: Symphony of a*

Metropolis and analyzed by Siegfried Kracauer in his essay "The Mass Or- nament"—had not yet been born. The images of the revolution show an impoverished city, grey, dreary, still permeated with the sterile pomposity of the epoch of Kaiserreich, with very few automobiles, illuminated signs, large shops, or billboards. Buildings ruined by cannon fire have been oc- cupied by workers and soldiers who are defending them from governmen- tal troops, lending an air of the nineteenth century to all this. The sharp- shooters positioned atop the Brandenburg Gate, hiding behind its irredeemably outdated monuments, seem to embody the anachronistic defense of an order that has already ended.

The charming sense of these events belonging to another epoch also emanates from the revolutionary masses themselves. We only rarely see workers in their work clothes standing beside uniformed soldiers and sailors; unlike in St. Petersburg or Turin, there are few factory occupations in Berlin. The Spartacist processions in Berlin's streets hardly evoke classic Italian painter Giuseppe Pelizza de Volpedo's *The Fourth Estate*. We don't see ragged masses, the excluded. German workers are not the "wretched of the earth," abandoned to their own luck with nothing to lose. Neither are the Spartacists composed of the unemployed masses who will join the ranks of the KPD after the great crisis of 1929, but rather, they are made up of specialized workers, highly skilled artisans. Their professions give them a sense of dignity and a very strong social identity. We can see this clearly in all the revolution's images: whether they are kneeling next to a machine gun, standing on top of a barricade, or marching with a rifle strapped to their shoulder, they almost seem to be dressed in their Sunday best. They make a point of demonstrating their dignity in how they dress, displaying a certain respectability, as if they couldn't give up their bowler hats, coats, and ties. Rare are the men without moustaches. Of course, they do not possess the arrogance or glibness of the wealthy classes; in- stead, their gestures reveal the self-assurance of the working class, the self-confidence of those who work with their hands.

We know that women played important roles in the German Revolution, roles relayed through the press in articles and testimonials; however, they appear in the epoch's photos only very marginally. It does not appear that they were stationed at barricades or that they participated in street fighting. We can see them in processions and in large assemblies, but only as extras. The workers and soldiers must have thought that the revolution was not an affair for skirts, at least not in its military dimension. And the photographers, apparently, went along with this "common sense." Even if we are not surprised to find an absence of women among the Freikorps or among the troops sent to guard the Reichstag in their uniforms and helmets, we should be very surprised not to see women intervening in the struggle. There are no armed militias as there are in Spain, no partisans carrying machine guns, as we see in photos of the insurrection in Turin and among Latin American guerrillas in the second half of the century. The independent and emancipated women that we are used to identifying, in our representations, as the heritage of the Weimar Republic—the first in Western Europe to extend the right to vote to women—have not yet been born. There is nothing yet like the *Bubikopf* (bob) haircuts à la Louise Brooks. One image shows four Red Cross women who appear taken aback by attention from the photographer. Their faces betray sincere and spontaneous surprise in response to this unexpected invitation into a collective dramatic scene—although except on the most superficial level they had to remain outside this scene.

The paradox between the central place occupied by Luxemburg in our imagination of the German Revolution of 1918–1919 and her almost total absence from photographs of the time is especially notable. We never see her speaking to a crowd or leading a demonstration. The only photo, published in *Illustrierte Familienzeitung* in the beginning of 1919, shows Luxemburg some months before, leaving prison wearing a hat and carrying an umbrella. Her influence was subterranean. It was she who edited *Die Rote Fahne*, the Spartacist League's daily newspaper, in which her inflammatory editorials were published. Luxemburg's role in the revolution is only revealed in

photos of her funeral: first, on January 25, 1919, when, after her executed body had been thrown in the Landwehr Canal, her empty coffin was placed next to Liebknecht's coffin, and then, on June 13, about five months later, when the waters of the canal returned her body. All of Berlin's workers were there; the Frankfurter Allee road was black, packed with mourners.

As for Liebknecht, he is omnipresent in photos from the most exciting days. Immense crowds heard him in Tiergarten, in front of the arsenal, in front of the Interior Ministry palace, during a protest against the firing of Eichhorn, the Berlin chief of police who favored the workers' uprising. At this time, there were no loudspeakers and, no doubt, the majority of those present could not hear his words, but we see various people perched in trees to get a glimpse of him. Liebknecht himself is perched on the roof of a trolley, with eyes on him from all directions. The photos of this gathering testify to his speech's impact, underlining the power of a great orator's gestures. We can get a vague idea of the electric atmosphere of these assemblies by reading the texts of his speeches, frequently published in *Die Rote Fahne*, in which he invokes universal judgment, comparing the revolution to a volcanic eruption and calling on the proletariat to avenge its martyrs and to rescue the defeated from history. He speaks the names of those responsible for the repression—the trio of Ebert, Noske, and Scheidemann—who have already been found guilty in the court of proletarian justice. The same day he is assassinated, January 15, 1919, he is already a martyr. A photo shows his corpse, in the Moabit prison, shortly after his execution by the Freikorps. He lies, spread out on a wooden table, naked under a blanket covering his body up to his shoulders, his head raised, his face and chest riddled with bullets. One immediately thinks of a photo of another corpse, that of Che Guevara, taken in the mountains of Bolivia fifty years later. The same martyr's aura emanates from the image of Liebknecht's inanimate corpse.

The emotion that we feel when faced with this photo of Liebknecht in the Moabit morgue may be related to the current trend—especially noted by

Tzvetan Todorov—of shifting attention from heroes to victims. Liebknecht and Luxemburg are each both at the same time. Thus, from that moment henceforth, we can only see them as portraits of two heroic sacrifices. Those responsible for their deaths do not arouse the same emotion, to say the least. Gustav Noske, whose portrait was taken by Willy Römer and printed in the *Berliner Illustrierte Zeitung* on March 2, 1919, just after the Spartacist revolt was suppressed, appears like a figure carved from marble, a congealed man of state, displaying a cold and ruthless attitude. The soldiers posing around tanks, machine guns, and artillery during street battles in January 1919 in the neighborhood where most of the press was located, give off an impression of organization and discipline—the exact opposite of the air of improvisation and amateurism that was attached to workers who were unaccustomed to handling weapons. Just as the Prussian officers appear a bit comical with their pointed helmets—which at the same time evokes for us Grosz's paintings and the portraits of Bismarck—the government's troops, whose helmets remind today's observers of the Wehrmacht—and therefore of the Second World War and the German occupation—solicit our immediate and spontaneous antipathy. We see several photos containing a menacing warning: "Halt! Wer weitergeht wird erschossen!" (Halt! If you don't stop you will be shot!) Surely, the message addressed to soldiers in the Oulans barracks by Berlin workers on November 9 is preferable: "Brüder! Nicht schiessen!" (Brothers! Don't shoot!) The workers are armed but would prefer to fraternize with the troops.

The repression brought down on the Spartacists in Berlin between January and March spread at the beginning of May to Munich, where the workers' councils had taken power one month prior in a desperate attempt to launch a national putsch. After the assassination of Kurt Eisner, the charismatic leader of Bavarian republicans, by a far-right officer, power fell into the hands of the communists, who capitalized on the anger and indignation in the wake Eisner's murder, even if they remained an isolated minority. The experience of *Rätedemokraie* (council democracy) would be even more ephemeral in Germany than in Budapest, where Kun was

leading the movement of workers' councils at exactly the same time. Both would be drowned in bloodbaths. However, the formation of the Bavarian Soviet Republic proved that the revolutionary tremor was felt over the entire nation, well beyond the capital city. If the nationalists recruited voluntary troops from all over the country to smash the soviets in Bavaria, it was because, to their eyes, they personified the specter of "Jewish-Bolsheviks." After all, among the peoples' commissars of the improvised revolutionary government, the majority were Jewish intellectuals.

In 1919, the independent daily socialist newspaper *Die Freiheit* published a series of revolutionary postcards, among them portraits of the two leaders of the Bavarian Soviet Republic, the playwright and Red Army commander Ernst Toller, who would be taken prisoner, and the literary critic Gustav Landauer, one of the first to be assassinated. Behind two small metallic eyeglass rims, we see a fine, sharp face, framed by long hair and the beard of a Jewish prophet from a bygone era. We see in his stare the spiritual tension that gave rise to his political activity and his sacrifice. Along with photographs of Luxemburg and Liebknecht, Landauer's portrait was distributed starting in 1919 as a *Freiheit-Postkarte* and became a kind of revolutionary icon. The post–Second World War German Democratic Republic would use these insurgent images from 1918–1919 to legitimize and ennoble their sad cohort of epigones. The Berlin and Munich revolts would come to play the role of guardian angels for the official ideology; photos of the two revolts were hung next to those of Walter Ulbricht and Erich Honecker. But now that time, too, has come to an end. These images today are points in the memory of an estranged Germany, one that was foreign to the mental landscape of end-of-the-century Europeans, a Germany from 1918–1919 where the Deutschmark had no value, where armed workers took over the streets, and where the revolution, to remind ourselves the words of Ernst Bloch, became a concrete and possible utopia.

Timeline

1918

10/29: Agitation among sailors in the Baltic fleet in Wilhelmshaven.

11/03: Sailors mutiny in Kiel.

11/08: Revolution in Munich; proclamation of the Bavarian Soviet Republic under the leadership of socialist Kurt Eisner.

11/09: Revolution in Berlin. Creation of workers' and soldiers' councils. Wilhelm II flees to Holland. In the Reichstag, the social democrat Philip Scheidemann proclaims the Republic. Creation of a provisional government led by social democrat Friedrich Ebert. At the same time, Karl Liebknecht, who has just been freed from prison, proclaims the creation of the Socialist Republic before a huge workers' demonstration in Berlin.

12/04: Formation of the Freikorps.

12/07: Spartacist armed demonstration in Berlin after an aborted counterrevolutionary putsch.

12/25: Spartacist workers in Berlin occupy the offices of social democratic daily newspaper *Vorwärts*.

12/29: Members of the Independent Social Democratic Party (USPD) resign from the government. The social democrat Noske is named minister of war.

12/30: Founding Congress of the German Communist Party (KPD) that unites Rosa Luxemburg and Liebknecht's Spartacists with other revolutionary currents.

1919

1/04: The Berlin chief of police, the independent socialist Eichhorn, is fired. Beginning of uprising.

1/05: Beginning of Berlin insurrection led by the Spartacists.

1/06–12: The army and the Freikorps establish order in Berlin.

1/15: Luxemburg and Liebknecht are assassinated.

1/26: Elections to the National Assembly.

2/11: Ebert becomes president of the Republic. The social democrat Scheidemann presides over a coalition government.

3/8: Suppression of daily communist newspaper *Die Rote Fahne*. General strike brutally repressed in Berlin during the Bloody Week.

3/10: Arrest and assassination of communist leader Leo Jogiches. Paul Levi takes over leadership of the KPD.

3/31: General strike in the Ruhr.

4/7: Proclamation of the Bavarian Soviet Republic, where the communists rapidly assume leadership. Creation of a Bavarian Red Army led by the communist writer Ernst Toller.

5/1: The Freikorps occupy Munich. Repression of revolutionary forces.

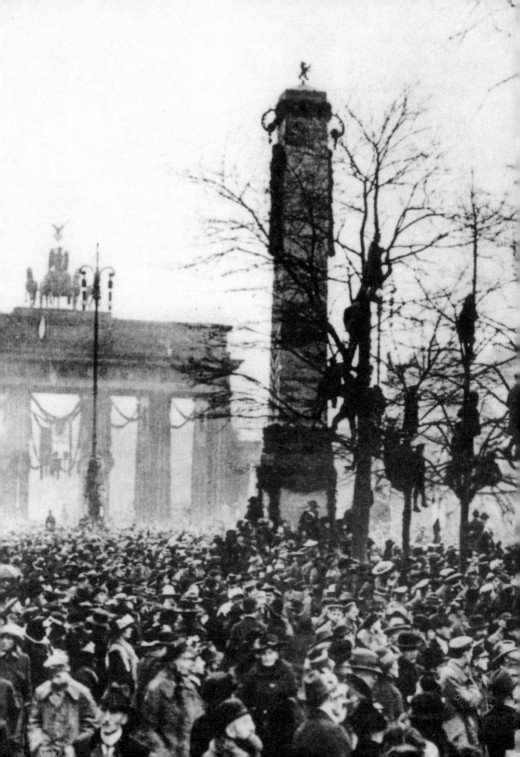

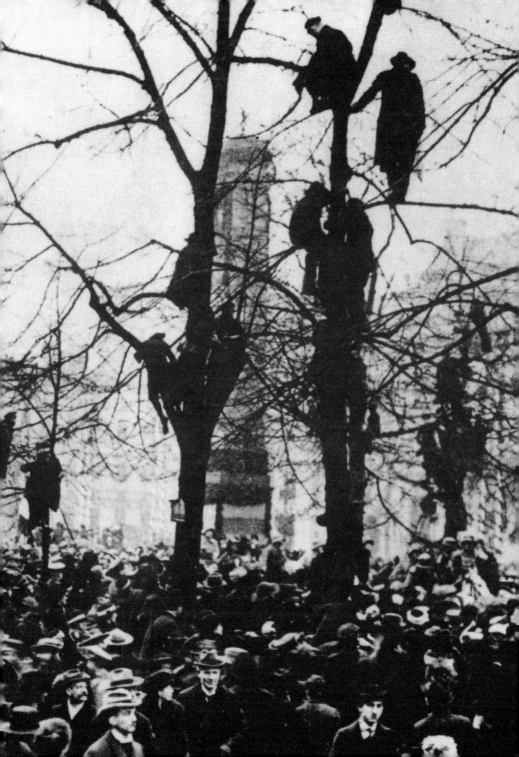

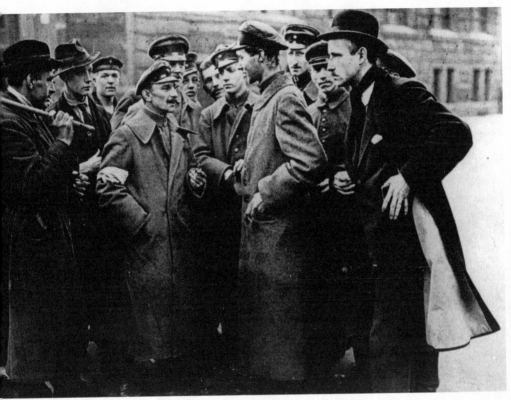

Conversation between revolutionary workers and soldiers in December 1918.

Previous two pages: A crowd receives troops returning from the front in December 1918.

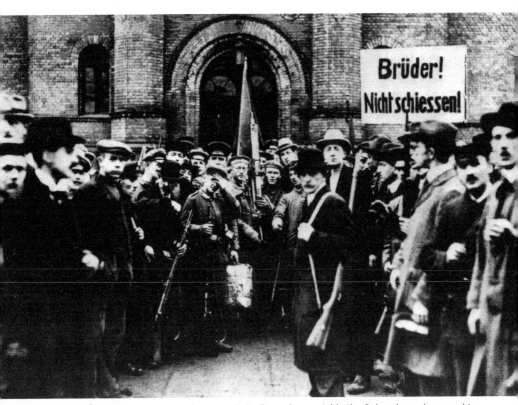

November 9, 1918, Berlin workers outside the Oulans barracks appeal to soldiers: "Brüder! Nicht schiessen!" (Brothers don't shoot!).

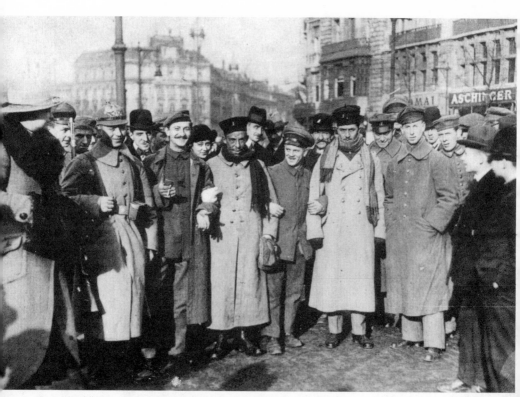

German soldiers and French prisoners of war in Berlin in November 1918.

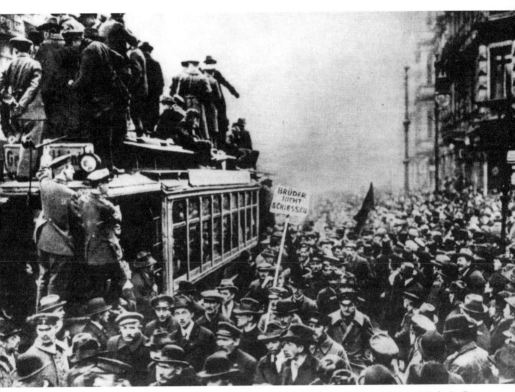

November 9, 1918, thousands of workers demonstrate in Berlin.

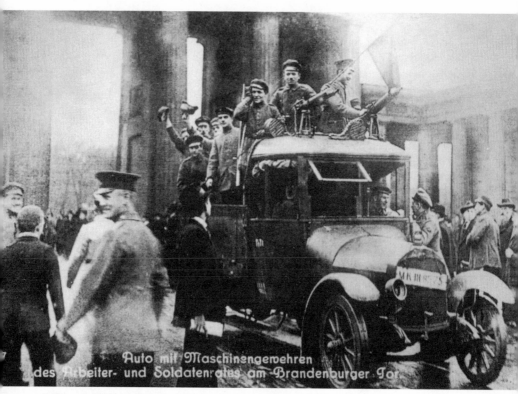

Soldiers and workers in front of the Brandenburg Gate on November 9, 1918.

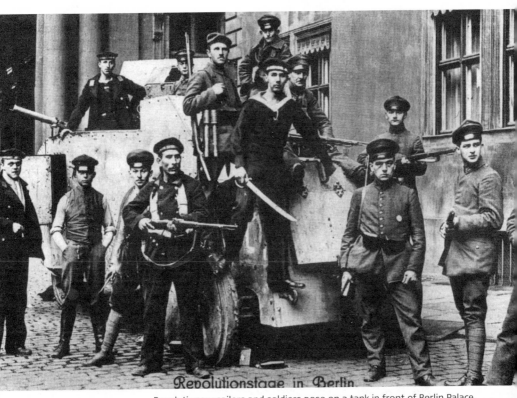

Revolutionary sailors and soldiers pose on a tank in front of Berlin Palace.

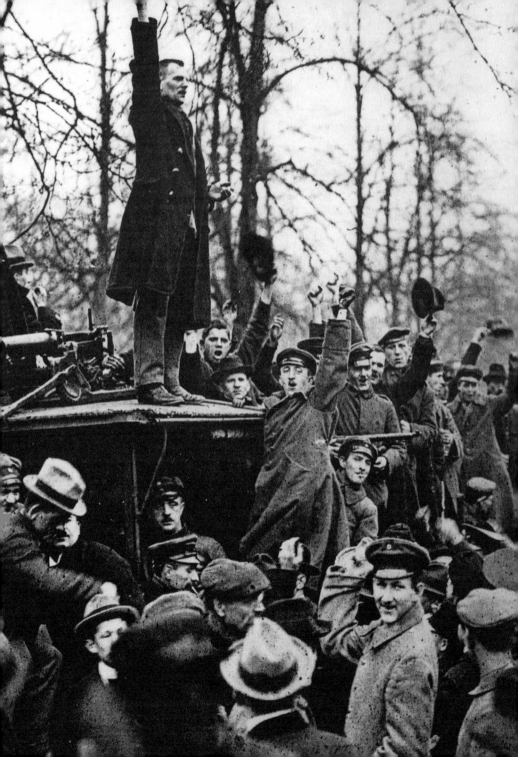

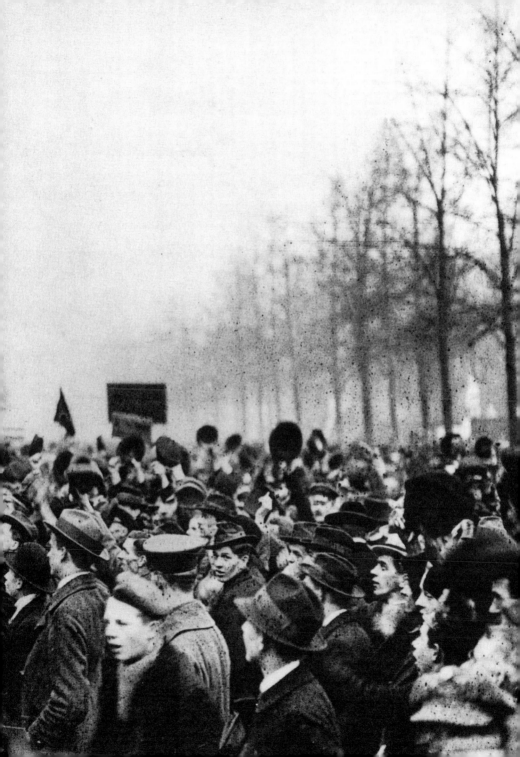

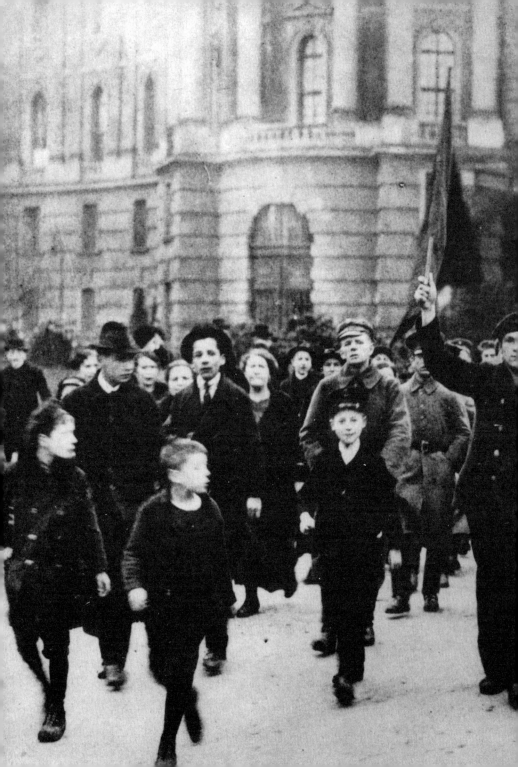

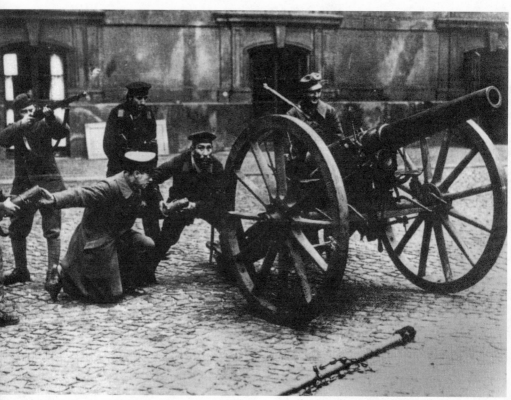

Revolutionary soldiers and sailors in a defensive position inside Berlin Palace on November 24, 1918.

Pages 230–31: A soldier speaks during a huge demonstration in January 1919 to celebrate the founding of the German Communist Party (KPD).

Pages 232–33: Demonstration on November 9, 1918. A sailor carries a red flag during a march. During the demonstration, Karl Liebknecht, a future founder of the KPD, proclaims the Socialist Republic.

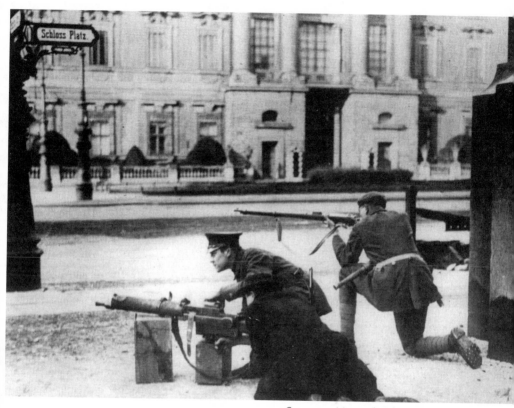

Government troops lay siege to Berlin Palace.

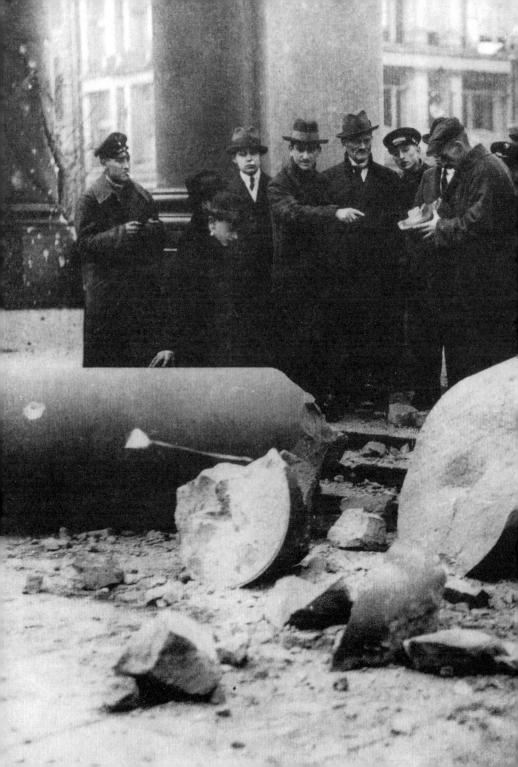

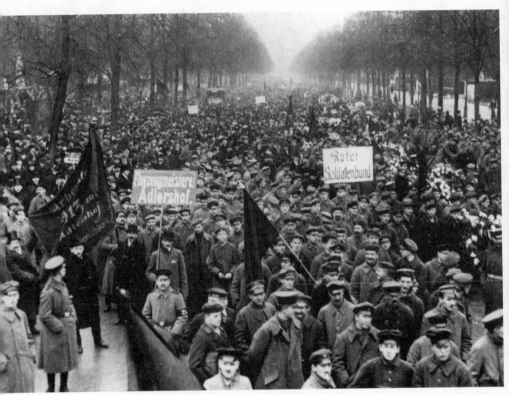

Funeral for sailors killed during the fighting, November 29, 1918.

Previous two pages: People observe the columns from Berlin Palace that were destroyed in the fighting of December 1918.

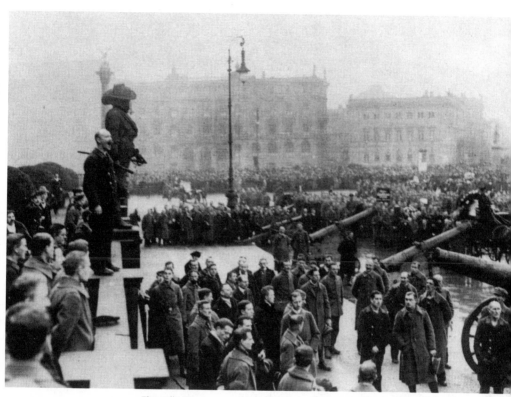

The sailor Tost, a member of the Independent Social Democratic Party (USPD), speaks during the funeral for sailors killed in street fighting.

Next two pages: Revolutionary sailors' dining hall in the Berlin Palace stables.

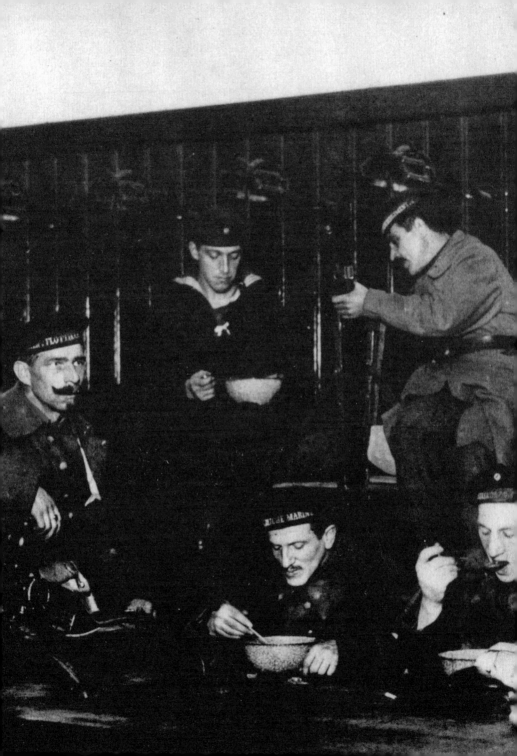

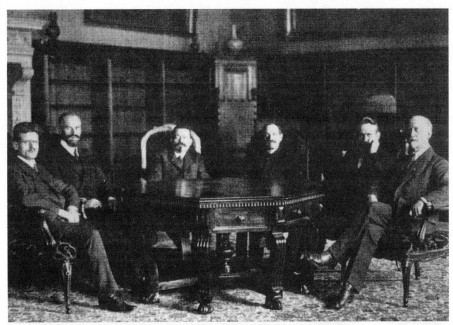

Above: The Council of People's Ministers on November 11, 1918. *From left to right*: Emil Barth, Otto Landsberg, Friedrich Ebert, Hugo Haase, Wilhelm Dittman, and Philipp Scheidemann.

Below: *From left to right*: Friedrich Ebert, chief of the government, a socialist who will later repress the Spartacist insurrection; Scheuch, minister of war; Generals Lequis and Wermuth; Berlin prefect.

Previous page: Karl Liebknecht, founder of the KPD, speaks in front of the Interior Ministry during a demonstration of soldiers demanding immediate demobilization on January 4, 1919.

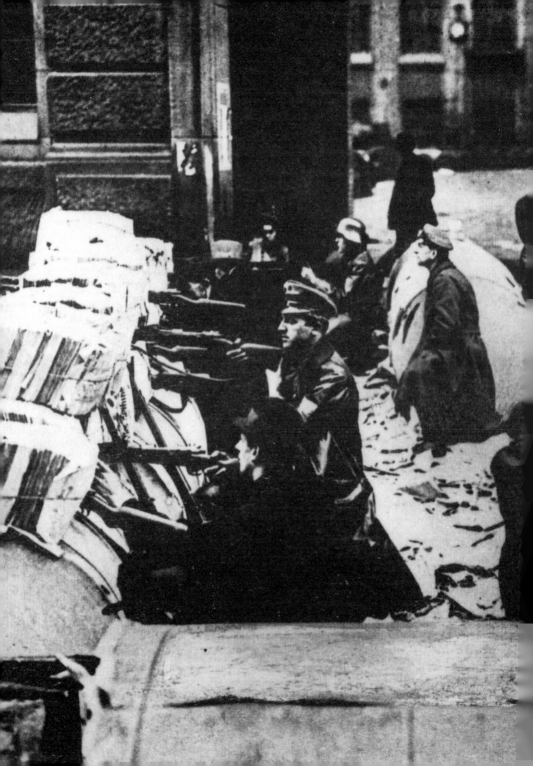

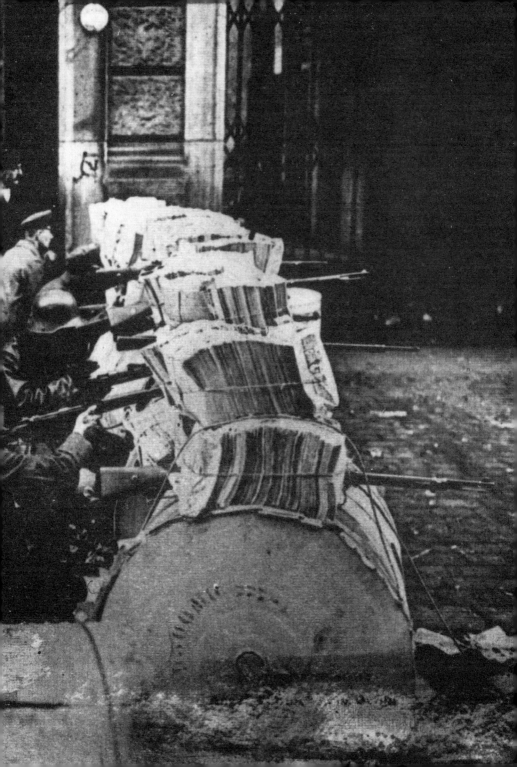

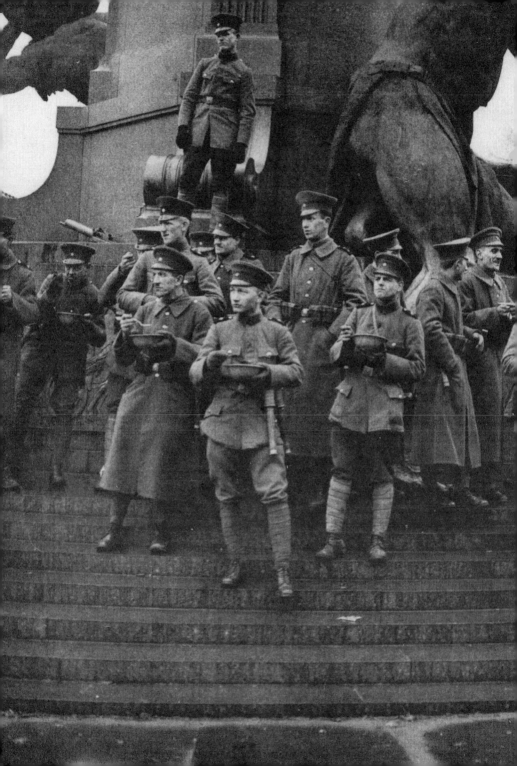

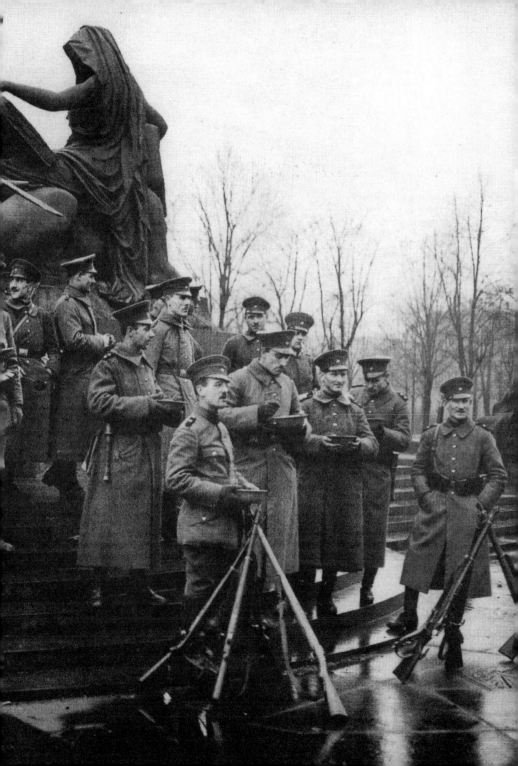

Berliner Strassenkämpfe

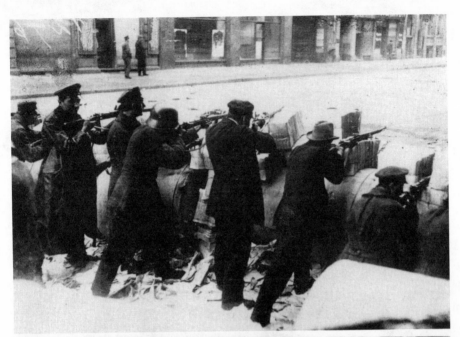

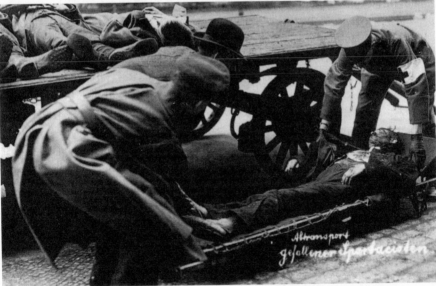

Above, next page, and pages 248–49: Street fighting in Berlin during the Spartacist uprising in January 1919.

Pages 244–45: Spartacist uprising. Barricades in the printing industry's neighborhood in January 1919.

Pages 246–47: Government troops in front of the Reichstag during the insurrection in March.

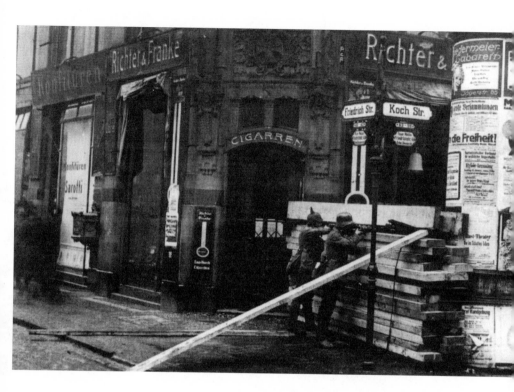

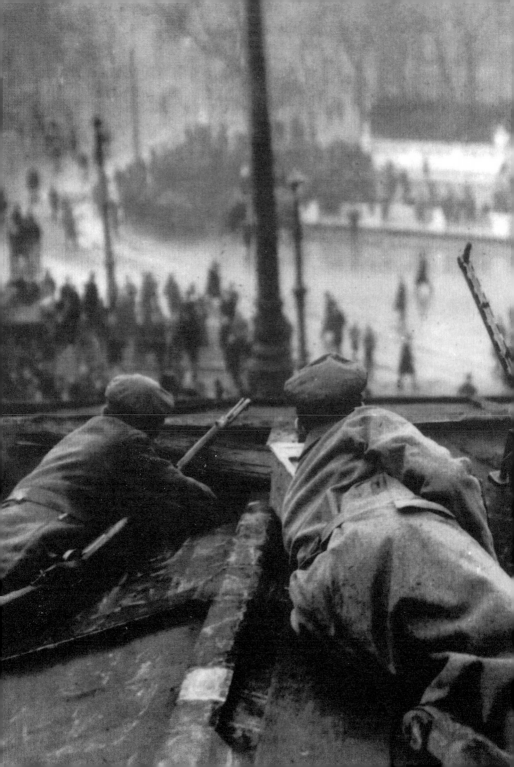

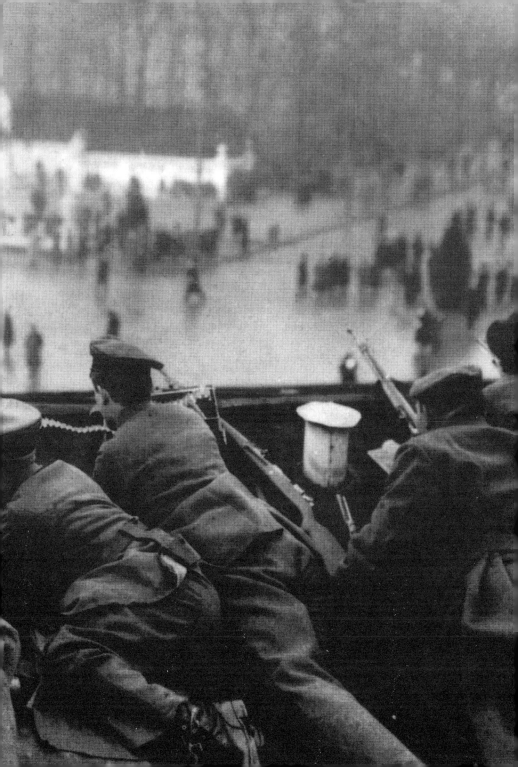

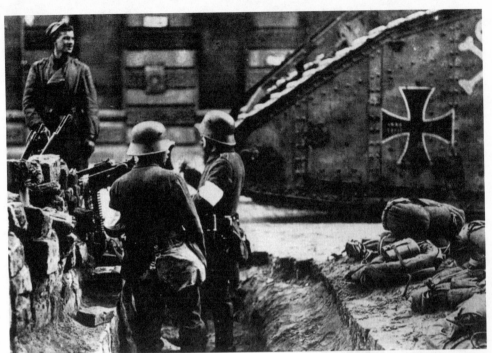

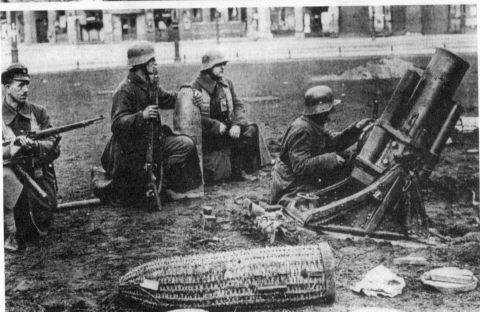

The government's army suppresses the Spartacist uprising.

Previous two pages: During the Spartacist insurrection, government troops in position on top of the Brandenburg Gate in January 1919.

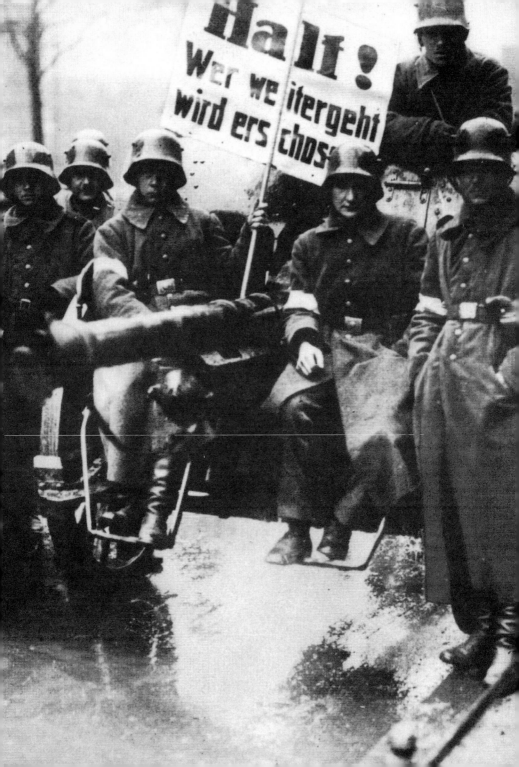

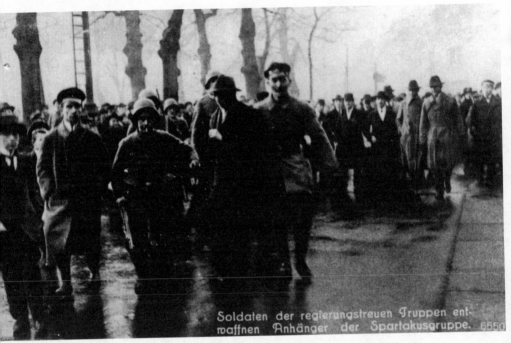

Soldaten der regierungstreuen Truppen entwaffnen Anhänger der Spartakusgruppe. 6550

Previous page: Government troops with sign that reads: "Halt! Stop or you will be shot."

Above and next page: Repression of the Spartacist insurrection.

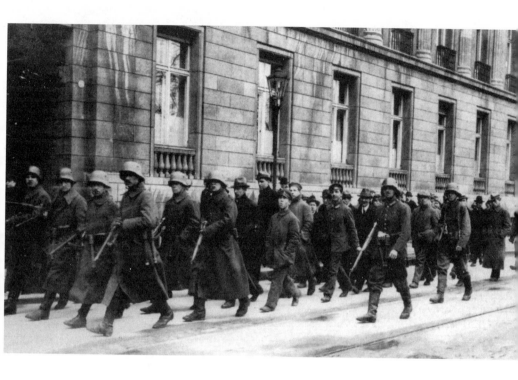

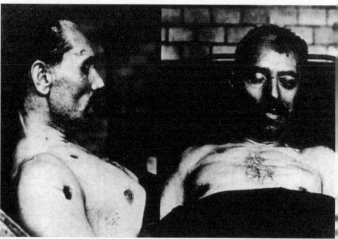

Above left: Gustav Landauer, literary critic and people's commissar of culture in the Bavarian Republic.

Above right: The corpse of Karl Liebknecht in Moabit prison soon after his assassination on January 15, 1919.

Above: Rosa Luxemburg.

Next page: Funeral of Karl Liebknecht and Rosa Luxemburg (whose coffin is empty) in January 1919.

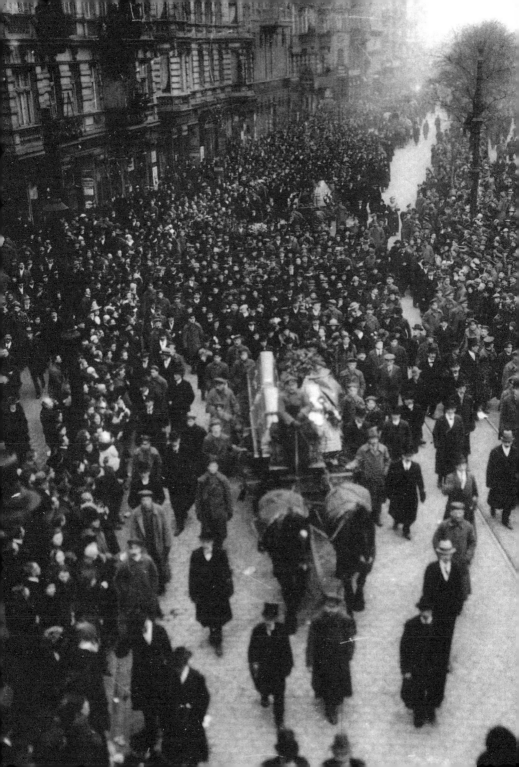

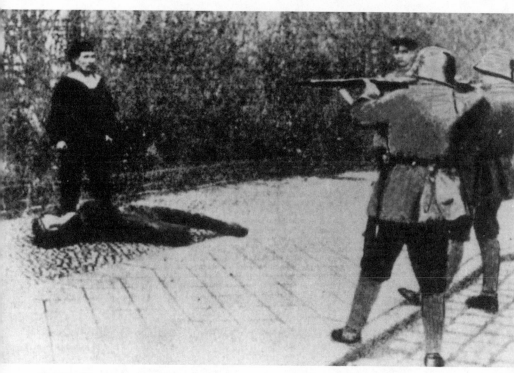

Above and next page: Revolutionary sailors and soldiers executed by the army in March 1919 in Lichtenberg.

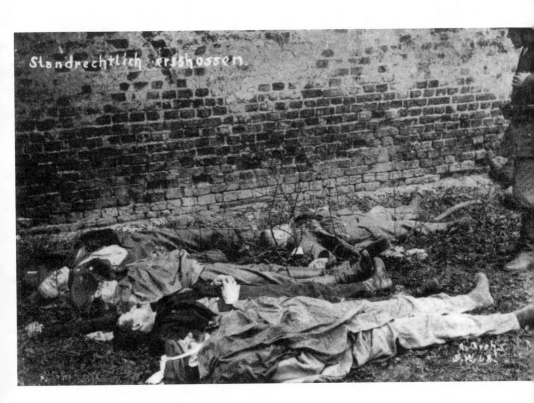

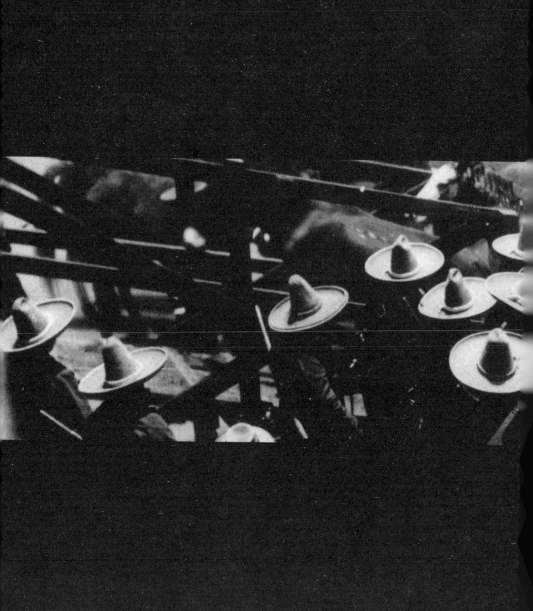

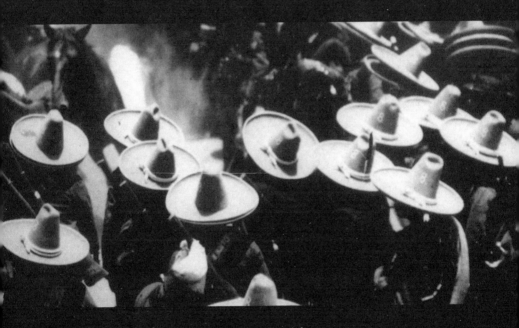

1910–1920

The Mexican Revolution

Bernard Oudin

The Mexican Revolution

The photos are all in black and white, but what is immediately shocking is their color. The Mexican Revolution is a revolution in color. Blue sky, ocher and arid land, horses, sombreros, bandoliers crisscrossed on chests, all this exuding passion, noise, stampedes—it's almost a festival set to the image of its accompanying music. If Russia's revolutionary songs bring to mind a procession through the snow, "La Cucaracha" sounds more like a Latin American dance than a military march. Yes, it was a party, but a tragic one. After all, the Mexican Revolution was also colored by blood, sweat, misery, hate, and betrayal. One million out of a total population of fifteen million fell victim: a terrible and deadly balance sheet over these years detracts from what might have otherwise seemed almost playful and picturesque—even if cavalcades in the desert and attacks carried out from trains made it feel like a Western, something the movies never failed to exploit.

Color, but also movement: thanks to advances in photography, the movement of a crowd or a galloping horse could finally be captured. Mixing authenticity and beauty, the great artist Agustín Víctor Casasola (1874–1938) brings us the most celebrated images of the Mexican Revolution, such as those taken in Mexico City in May 1914 of horses being loaded on a military train. Everything is there: the violent contrast of white sombreros and shadows cast by clothing and train wagons, framed almost too perfectly, as if a director had placed each actor in their

precise location; the effect is the perception of an extraordinary truth. We feel the power of each face; we hear the animals whinny. It is as if we are the young boy off to the left, perhaps the son of the officer, whose age and bourgeois appearance clearly indicate that he is there out of curiosity, that he is watching the scene, fascinated.

Here the majority of the people have their backs to the camera. But when they face the camera, how will they comport themselves? Some maintain old customs, especially the officers. They pose for the camera in order to satisfy both the journalists and, at the same time, their egos. They even know, when necessary, to be diplomatic and to play the role of the world's best friends; the Mexican Revolution is nothing if not a long sequence of sharp turns and changing alliances. And quickly, we are lost. For instance, there is a photo taken in August of 1914 on the Mexico–United States border in which Obregón, Villa, and US general Pershing all pose side by side. Everyone appears very happy. The tyranny of General Huerta, Madero's assassin, had just fallen under the crushing attacks of Obregón and Villa's legendary Division of the North. For once, Uncle Sam bestowed the coup de grâce to a local dictator, Huerta, by landing troops in Veracruz. The next year, Villa and Obregón would cover this same ground, but as foes. Obregón would lose an arm but win the battle. Two years later, in 1916, furious with the United States for providing support to his adversary, Villa would make a bloody incursion into US territory. And it is Pershing who would respond, penetrating into Mexico but failing to get his hands on Villa.

However, cheerful scenes are rare. When an officer strikes a pose, it is with a martial air. We are in a Latin country; machismo in the Spanish sense of the term is obligatory. In the contemporary West, "macho" has acquired an almost pernicious sense. In Mexico, the term is synonymous with virility and courage, the opposite of *manso*—that is, weak. This is what produces the most bellicose postures, even if they are the most caricatured. In many of his photos, Villa displays an impressive set of armaments, and

Zapata even more so with a revolver and a machete tucked in his belt, and a bandoleer of machine-gun bullets strung on his shoulder.

Orozco, the leader of the *colorados*, a militia that vacillated between the warring factions, who would later betray the revolution and ally himself with Huerta, likewise cuts a macho figure, posing with his rifle and cartridges, but a gentler version. These yellowed photos remind us of famous Wild West outlaws, even if they are different than Hollywood's images. More moving is a photo of a uniformed child, provisioned and armed from head to foot, who stares proudly right into the camera, simulating the nonchalance of a courageous soldier. Is posing just pretending? Not necessarily. One day in January 1917, a Captain Samano, smiling, hands in his pockets, smoking a cigar, no longer had any time to pretend: he was up against the wall in front of a firing squad. Who was he? To which side did he belong? What had he done? It hardly matters. He has become a symbol of a brutal epoch, in which the value of human life had reached its lowest: a symbol that also defies destiny. Did he only want to mock his executioners? Or did he say to himself that this moment of truth was the most interesting of his whole existence? Moreover, it is impossible not to consider this photo's Mexicanity, and the strange relation that this people cultivates with death. Captain Samano's righteous grin is the same as those that belong to snickering skeletons and figurines of the Day of the Dead.

Even if they do not always have the same intensity as the face of this man who is about to die, Mexican faces, be they well known or anonymous, are always expressive. For instance, there is the face of the one against whom the rebellion has erupted: General Porfirio Díaz, an old man and a great soldier, reminds us a bit of Philippe Pétain, the head of state during the Vichy regime. In his youth, he basked in the glory won in the ranks of Benito Juárez's troops, retaking Puebla from French emperor Maximilien's occupation troops. In 1910, at the age of eighty, he still commanded a strong presence. He was only some months away from his downfall, but he believed himself to be immortal. There are few excuses to be made:

thirty-five years of holding personal power does not predispose a dictator to cultivating doubts. Even his indigenous features, visible in older portraits, faded with age and his white moustache. But in his favor, he still had a varnish of grandeur and retained a not entirely negative reputation. Almost illiterate, he had the good sense to entrust the economy to technocrats—known as *científicos*—who succeeded in guaranteeing peace and, especially for capital, the beginning of modernization and industrial development. But the rest of the Porfiriato was a nightmare, marked by the tyranny of a senile dictator and a handful of great landlords. The term "social inequality" could hardly serve to describe the status of semi-servitude in which the *hacendados* (landowners) held their rural workers, many of whom were poor peasants thrown off their own land.

Facing Díaz are the three men who will put an end to his reign in the coming months. The most important is not the most well known. Alongside Villa and Emiliano Zapata, with their more flamboyant personalities, is Francisco Madero. Madero suffered an "image deficit" that was in the first place physical. This short, goateed man, with a reserved attitude and proper clothing, seems out of place. He looks like a professor who is lost and stuck in the middle of ferocious cowboys who just might stick their knives into this large-headed thinker. The last photo of him is telling: it depicts him in the street attempting to rally his last supporters. He is on horseback, as if trying to better establish the authority that is rapidly escaping him. He is still wearing his dark, fitted coat, and is waving his bowler hat in a derisory manner. Politically, Francisco Madero has few things in common with Salvador Allende, but their tragic endings draw them closer together: both were betrayed by a military chief whom they held in total confidence, both were besieged in their presidential palace, and both were murdered by killers in uniform.

Did Madero's fragile appearance disguise a sectarian and purist ideologue? Not at all. He was certainly a man of conviction, but he was a moderate, who came to be radicalized by Díaz's intransigence. Despite this, the conservatives hated him. He came from an idealist, wealthy family of

Jewish descent and was sent abroad to study, which brought together three good reasons to be scorned: he was an intellectual, Jewish, and a traitor to his social class. These same three reasons, in a different place and different time, would inspire hatred for Léon Blum and for Pierre Mendès-France. Yet even the more radical activists wasted little time in rejecting him. Who was he then? A man filled with good intentions, but one who was timid and maladroit, and who did not understand the extent and urgency of the reforms that had to be implemented? Or the cynical representative of a "bourgeois" revolution, firmly committed to maintaining it within strict limits as analyzed by pure Marxists? What is clear is that he was the opposite of a revolutionary. Legalist to a fault, he refused to directly succeed Díaz and waited for the votes to be counted before assuming the presidency. What about reforms? Without doubt, but within the framework of order and legality. This was a discourse that the dispossessed campesinos and starving hordes could not understand. Quickly, Madero found Zapata blocking his path and, in order to fight him, made the senseless decision to ally himself with his own worst enemies, the conservatives and the army, both of which took advantage of the first opportunity they had to overthrow him.

Once again, the photographs are eloquent. When Madero makes his entrance into Cuernavaca, posing in his automobile, Zapata is on foot, almost anonymous among his cortège. But when the latter visits Madero, the time for deference has passed. The meeting between the two was so tense that they avoided looking at one another. Madero bows his head with a tired look while Zapata stares directly into the camera, visibly angry.

It is said that Zapata was the "purest man in the Mexican Revolution." But this notion of purity should be used with care, especially when it comes to politics, where many fantasies and horrors lurk. But if we are dealing with the simple notions of sincerity and honesty, then these can be applied to Zapata, who remains one of the truly interesting figures of this period. Upstanding as he was, and that was rare enough (the cynic Obregón once said, "I never met a general who could resist a cannonade of 50,000 pesos"),

he was also one of the few who never betrayed his side or his ideals. It is not surprising that those around him remained profoundly loyal and that his state of Morelos became a fortified camp in which it was impossible to defeat him, except through betrayal and assassination.

Although he was not an intellectual or ideologue, he held forceful and coherent ideas. The "Plan de Ayala" proposed land reform and the confiscation of one-third of the hacendados' property under the slogan "Land and Freedom."

What his photos show us is more unexpected. Despite his very Mexican preference for giant sombreros, stitched coats, and crafted leather boots, Zapata's face offers a total contrast to his clothing. Modest, reserved to the point of exaggerating his "mystery," he seems bound in an eternal melancholy. None of his pictures show him smiling. Such introverted and solitary attitudes are rare in great leaders. Only his penetrating, almost feverish eyes convey a barely constrained passion, always ready to express itself.

These are the eyes of a man who has proven himself. Nothing about Zapata marks him as someone on the margins of society. A small property owner and the mayor of his village, he was pushed to rebel by the hacendados' abuses. But from then on, the extreme violence he employed led his rivals to call him the "Attila of the South." An irredentist, he fought every one of the presidents that took power without exception and, save for a few brief interludes, never laid down his arms between 1911 and his assassination in 1919. The last picture of Zapata is of his corpse; it was taken to put an end to any rumor that he had survived. Paradoxically, it almost gives the opposite impression: with his head upright, Zapata seems to be sleeping between the three men who squeezed to get into the photo next to him. Only a fourth man shows an appropriate expression, raising his eyes to the sky as if he is in a Renaissance painting by El Greco.

Zapata was a good strategist, but better still as an obstinate combatant. He left behind a double legacy as a warrior and a political leader. Little

wonder that in 1994 the rebels in Chiapas chose him for their banner, proclaiming themselves Zapatistas instead of Villistas.

Villa and Zapata: these two men whose names are so often associated had, in reality, very little in common. Villa's origins, like that of the rebellion he led, are obscure. According to some, he killed the son of a large landowner who "dishonored" his sister. According to others, this same sister and his mother were massacred by soldiers of the Federal Army. Villa is all brute force.

Hard on his men, and especially hard on his enemies, for whom he displayed no mercy, he had no program and still less of an ideology, but he was a tactical genius, which makes him one of the most fascinating commanders in history. He headed off to war against the dictator Huerta with eight comrades and, in less than a year, was leading a division that would destroy the Federal Army. Thirsty for glory and with an eye toward propaganda, he welcomed journalists and filmmakers from the United States. Long before Subcomandante Marcos, he understood that modern revolutions must be fought in the media. In December 1914, Villa and Zapata celebrated their moment of glory, parading side by side through the streets of Mexico City. The event was filmed. But the most famous photo of the two men, taken by Casasola in the National Palace, shows them posing with their respective general staffs. The contrast between Villa, ruddy and jovial, at ease in the presidential chair, and Zapata, somber and withdrawn, as if embarrassed to be there, jumps off the page. They never fought against each other, but neither did they ever reach a real understanding.

Behind these principal figures, men who would achieve little notoriety but who would hold more influential roles in the Mexican history lineup:

Venustiano Carranza, leader of the Constitutionalists and a veteran of the struggles against Díaz and Huerta, with his glacial look and his wise, old beard, could have provided the revolution with a more presentable face than the "Centaur of the North" or "Attila of the South." And, taking advantage

of the disunity between these two, this is what he did when his put his own cards on the table and won recognition from the United States. But appearances were deceiving. The Spanish writer Blasco Ibañez, appointed to Carranza's presidential cabinet, was amazed to see him carry a revolver in his coat—but even this could not prevent his own downfall and assassination.

Obregón hardly looked like a ferocious warrior, even when in uniform. However, he did not lack military talent and, contrary to what was expected of him, he defeated the invincible Villa. His ascension to the presidency marked a relative political stabilization and the Mexican Revolution's entry into a "Thermidorian" phase, although not a reactionary one. Social reforms, a certain economic prosperity flowing from petroleum production, and especially a notable effort to overcome illiteracy should be credited to his regime, whose most revolutionary measures were taken against the Catholic Church. This might be surprising today since priests, and even bishops, in Latin America make common cause with the region's most progressive elements. But this was not so in 1920, when faith and revolution settled their accounts with rifle shots. The Cristero War would be one of the bloodiest episodes of this period. Obregón himself would be assassinated during a banquet at the hands of a fanatical member of Christ the King.

These were the leaders. But what about the others, "the small players, the hidden ones, the underprivileged"? They also are present in these photographs, and what a presence! Even though most of them didn't even realize it. However, the photographers of the epoch, with their heavy apparatuses and tripods, were hardly discrete. At most, the combatants climbing in the back of a wagon cast in a photo taken by Casasola—him yet again—show an indirect look, devoid of any pose. Instead, it is we who are interested in them, and especially the main character, no doubt a volunteer, whose amazing uniform combines a warrior's bandoliers with civilian's black suit and bowler hat. As for the couple sitting on the tracks, they undoubtedly have better things to do than look at the camera. The same goes for the soldadera leaning out on the step of a train car—she is clearly

more interested in whatever is happening at the front of the train than in the man taking her photograph.

A word about these soldaderas that we see in numerous images. Their presence, unusual for us, was nothing exceptional at the time. Even the regular units of the Federal Army were followed by a multitude of women, young and old, soldiers' wives and girlfriends. They looked after and fed their men and did what they could to care for them given the, needless to say, lack of medical services. Among the revolutionary ranks it was not uncommon for them to take up arms, and Jack London, who covered the events for *Collier's*, painted an unnerving picture of them: "When a soldadera comes along I should not want to be a stray chicken on the line of march nor a wounded enemy in the field of battle."

Another element that leaps off the page is the frequent appearance of trains. The Mexican Civil War was a conflict fought out on the railways, in which trains did not merely provide transportation for troops. The Mexican Federal Army possessed armored trains that were attacked by Zapata several times. Like generals in the First World War, Villa installed his headquarters in a train car. His two campaigns, against Huerta in 1913–1914 and against Obregón, took place along the line that connected Mexico City to the north of the country via Guadalajara, Zacatecas, Chihuahua, and Ciudad Juárez. And how can we forget how he took this last city by surprise in 1915? Villa sent a telegraph message to the federal garrison there advising them of the arrival of reinforcements but, like the Trojan Horse, the train contained his own soldiers.

And finally, some astounding images remind us of the great absence in the Mexican Revolution: the urban proletariat. It is not that the working-class movement doesn't exist. During the time of Díaz there had already been strikes in the mines and in the textile industry, which were very often bloodily suppressed. But Mexico in 1910 remained under-industrialized and, many decades before China, provided the first example of an essentially rural modern revolution. Aside from the "ten tragic days" of 1913,

the capital city was spared by the revolutionary events. Even Villa and Zapata's entry into the city in 1914 took place without incident; the terrified bourgeoisie had locked themselves in their houses, but the Zapatistas contented themselves with knocking on their doors to ask for food. The strangest photo of the revolution (once again taken by Casasola) shows the fierce faces of the Zapatista campesinos now timidly seated at the counter of a Sanborns restaurant along with uniformed waiters. Urban and rural Mexico stood face-to-face.

Eighty years later, different "Zapatistas" have taken up arms against the government in a remote province, creating their own sanctuary, just as Zapata created in his state of Morelos. Certainly, Mexico today shares little in common with that of Díaz, but the gap between modernization in the capital and misery in the countryside remains abysmal. And it is not for nothing that the indigenous people of Chiapas are once again appealing to the distant heroes of the Revolution of 1910.

Timeline

1909: As the 1910 elections approach, Madero creates the National Anti-Reelection Party to oppose the eighth reelection of Díaz, the de facto dictator since 1876.

1910: In June, Madero is taken prisoner, but escapes in October, while Díaz is reelected without opposition. On November 13, heading off a Maderista uprising, the regime represses its opponents. Madero flees to the United States.

1911: The rebellion extends to the north where Madero, after returning to Mexico, finds allies (Villa, Orozco, Carranza), while a new site of insurrection surges in the south led by Zapata. In May, Villa takes Ciudad Juárez and Zapata takes Cuautla. On May 25, after the "Juárez Accords," Díaz officially resigns and departs for exile. On June 7, Madero enters Mexico City and is elected president on November 6. However, this same month, Zapata takes up arms against him, concluding that his program is insufficient.

1912: In March, Orozco, leader of the *colorados*, also rebels against Madero. In contrast, Villa remains loyal but enters into a conflict with the head of the Federal Army, General Huerta, who has Villa arrested. Villa escapes in December and crosses into the United States.

1913: The army and the conservatives who have supported Madero for several months now turn against him. In Mexico City, at the end of the "ten tragic days," General Huerta takes power and orders Madero's assassination. Huerta gains Orozco's support, but Villa returns to Mexico in March and assumes command of the rebellion. He takes Torreon and Ciudad Juárez by assault. For his part, Zapata continues the fight against Huerta that he began against Madero.

1914: Zapata takes over Chilpancingo and Jojutla and lays siege to Cuernavaca. On April 21, the United States lands the Marines in Veracruz. On June 23, Villa wins a decisive victory in Zacatecas and Huerta flees the country. Villa and Zapata enter Mexico City side by side on December 3. Eulalio Gutiérrez takes the oath of office as provisional president.

1915: Conflict breaks out among the victors. Zapata leaves Mexico City and returns to Morelos. Villa does the same and returns to Chihuahua. Carranza, who forms a provisional government in Veracruz with the help of Obregón, annuls Gutiérrez's presidency and assumes power. Civil war reignites between Villa and Obregón, who wins a series of victories and pushes Villa to the north. In October, the United States recognizes the government of Carranza.

1916: In March, Villa conducts an incursion into the United States. General Pershing tracks him into Mexico but is never able to engage his forces. In Morelos, the Federal Army recaptures the state capital, Cuernavaca, but Zapata blows up the Cuernavaca–Mexico City train line, killing four hundred.

1917: Zapata goes on the offensive in January. On February 5, a new constitution is proclaimed, mandating that the president shall serve a four-year term and cannot be reelected. On May 1, Carranza becomes president.

1918: The country is pacified except for Morelos, where Zapata continues to fight.

1919: On April 10, Zapata is killed in an ambush. Villa takes up arms again.

1920: Carranza, despite the Constitution, declares himself a candidate for reelection. On May 15, he is overthrown by Obregón and assassinated as he attempts to flee. On July 28, Villa agrees to give up his arms and retire with honors to his ranch in Durango. The next two years are relatively quiet under President Obregón.

1923: Villa is assassinated in Parral on July 23. In December, Obregón represses an attempted coup d'état by military officers.

1924: Plutarco Calles succeeds Obregón. The conflict between the government and the Catholic Church that will dominate the coming decade intensifies.

1925: Beginning of the Cristero War that once again plunges Mexico into bloodshed, this time for four years.

1928: Soon after being reelected president, Obregón is assassinated by a Catholic student.

1929: In June, the Cristeros are finally defeated and the country returns to peace.

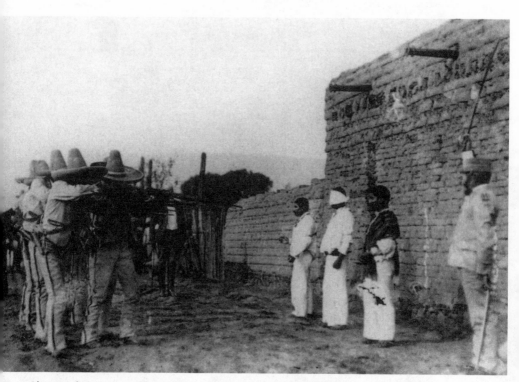

Above and next page: Although these photographs are dated from 1909, when the first disturbances occurred, scenes like this constituted part of the daily life of poor Mexicans for more than twenty years. There was no mercy on either side, and the civil war left one million victims.

Previous two pages: General Porfirio Díaz was permanent president-dictator of Mexico for twenty-five years. Here, in July 1910, he presides over a ceremony paying homage to Benito Juárez. It seemed he would stay forever, but within a year he was overthrown.

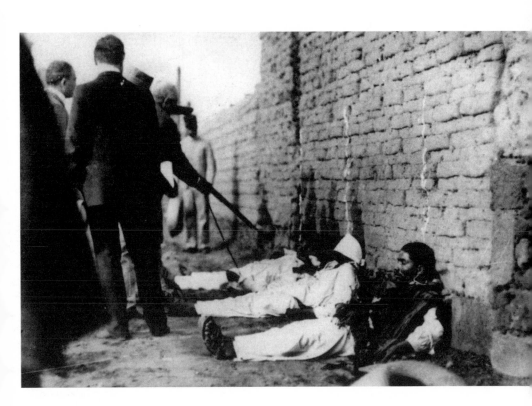

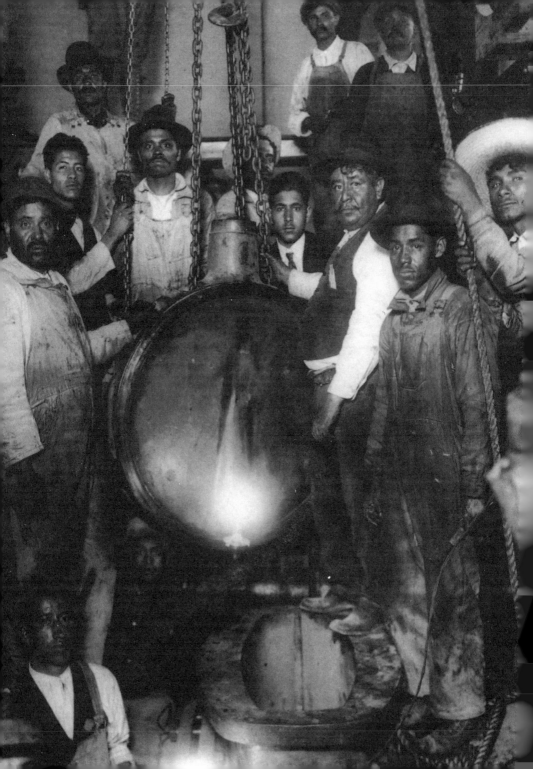

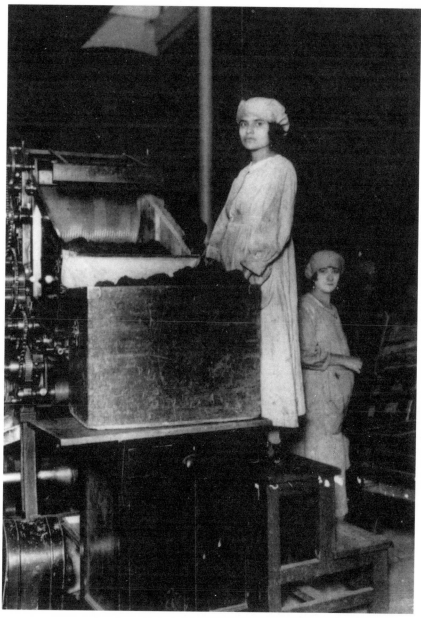

Images of Mexico before and after the revolution.

Above: Tobbaco factory, 1905.

Previous page: Workers in a boiler factory in 1930, evidence of the country's precarious level of development. In fact, workers hardly participated in the civil war, which played out largely in rural areas.

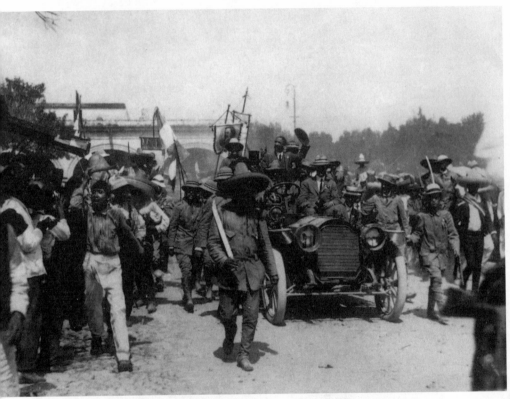

Liberal leader Francisco Madero, who overthrew Porfirio Díaz, is acclaimed by Zapatistas in Cuernavaca in June 1912. On the right side of the photo, Zapata himself can be seen wearing an enormous sombrero. He played a secondary role on this day but would soon take up arms.

Next page: Emiliano Zapata in 1912. His fiery expression mixes the rough energy of a man dedicated to pursuing his objectives and the melancholy of a leader marked by destiny.

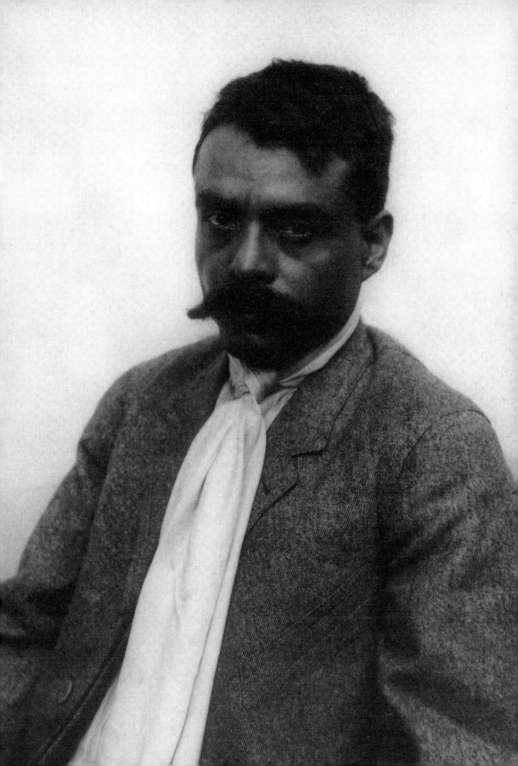

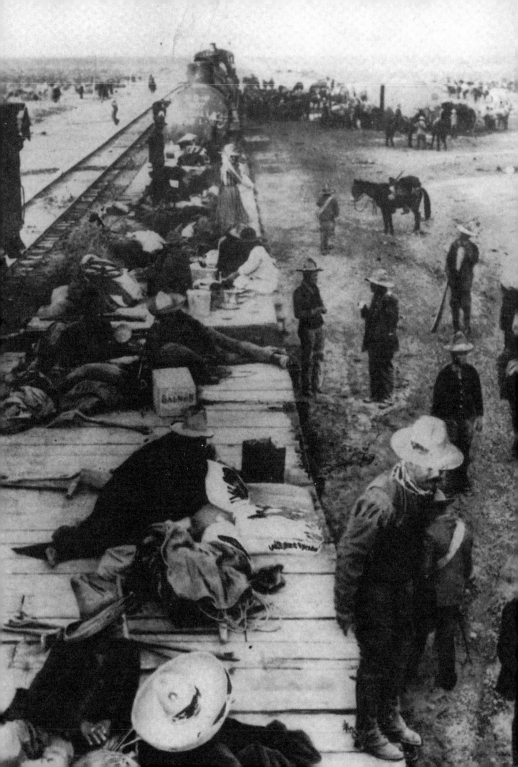

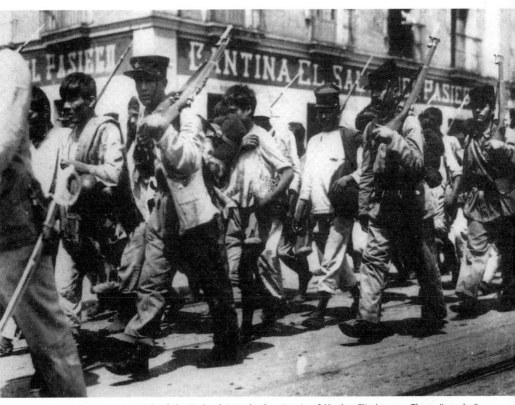

Unit of the Federal Army in the streets of Mexico City in 1912. These "regular" troops were no better disciplined or equipped than their enemies.

Previous page: Train filled with injured insurgents after the battle of Ciudad Juárez in December 1913. Pancho Villa would use trains to seize the city.

Next two pages: Loading of General Carlos Rincón Gallardo's horses in Aguascalientes in May 1914. Trains played a decisive military role in the revolution beyond simple logistics. The majority of battles took place along railroad lines.

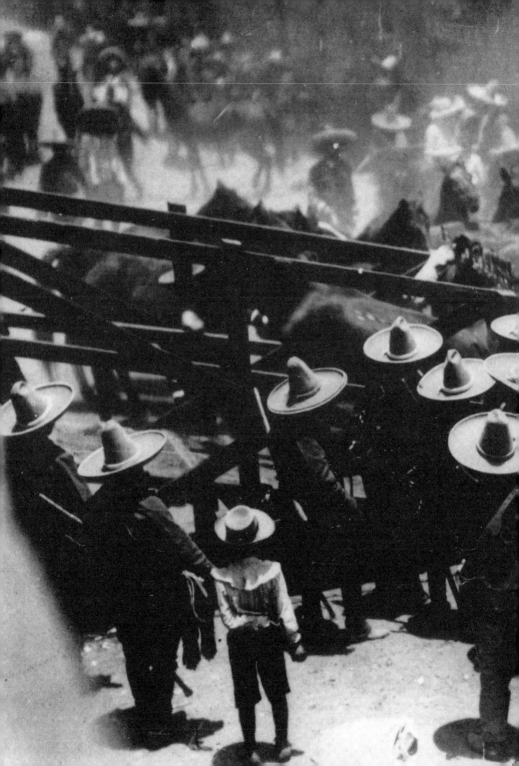

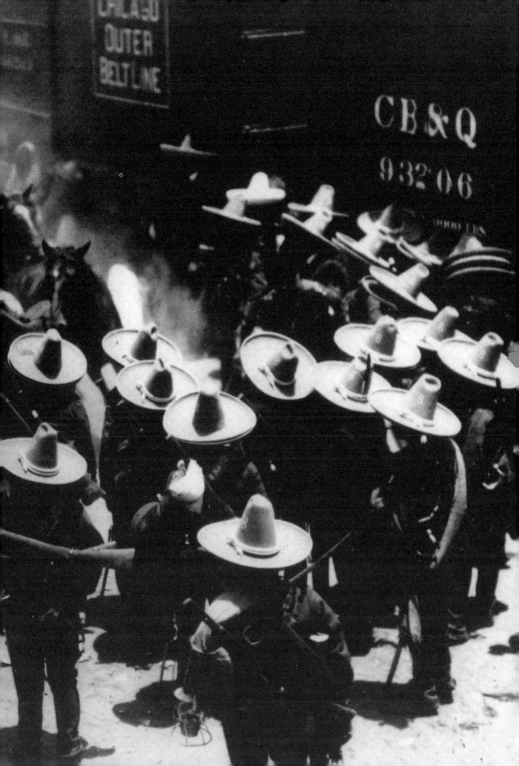

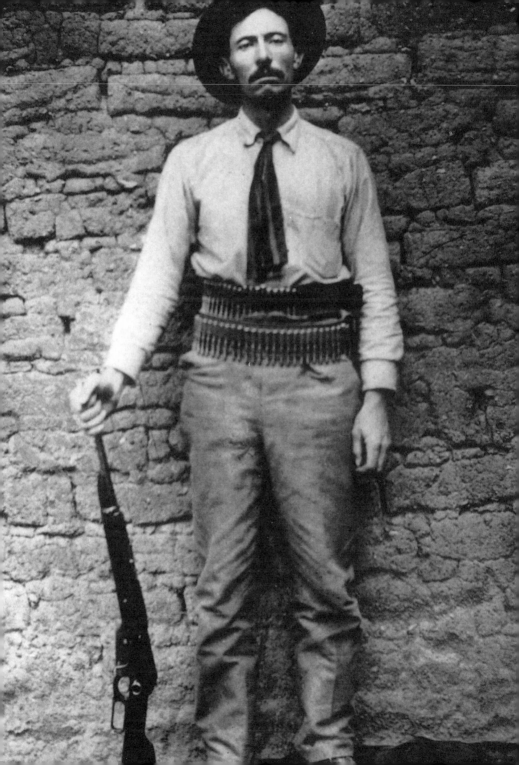

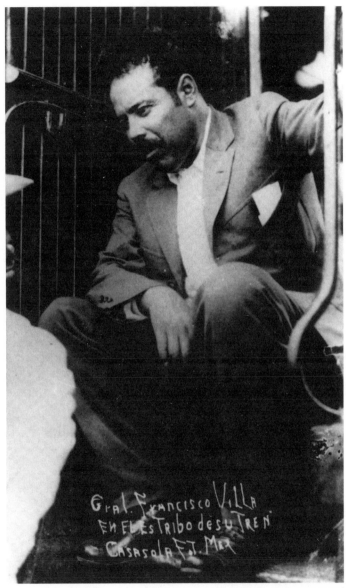

Pancho Villa, who disobeyed orders from his rival, General Huerta, and
was later dismissed and imprisoned in Mexico City in June 1912.
The following year, he would take his revenge.

Previous page: Pascal Orozco, leader of the *colorados*, betrayed the revolution by
allying himself with General Huerta. Defeated by Pancho Villa, he would be forced into
exile.

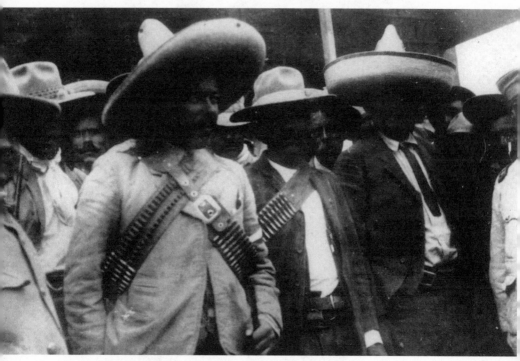

Pancho Villa in 1913 during the period of his greatest victories, in which he would become a legend.

Next page: During the "ten tragic days" in February 1913. Madero parades through the capital's streets in an attempt to unify his supporters. He has only a few days to live.

Pages 292–93: The renowned *soldaderas* (women fighters) accompanying troops to the civil war. Wives or partners of soldiers, they prepared food for the army and otherwise supported it, sometimes taking up arms themselves.

Pages 294–95: Federal troops gather in Mexico City's muddy streets before leaving for the front in April 1913. Carrying their packs, *soldaderas*, who fought on both sides, accompany them.

Pages 296–97: "General Eufemio Zapata and his general staff," the photo caption states incorrectly; Eufemio was Emiliano Zapata's brother. This photo was taken when the Zapatistas entered Mexico City in December 1914.

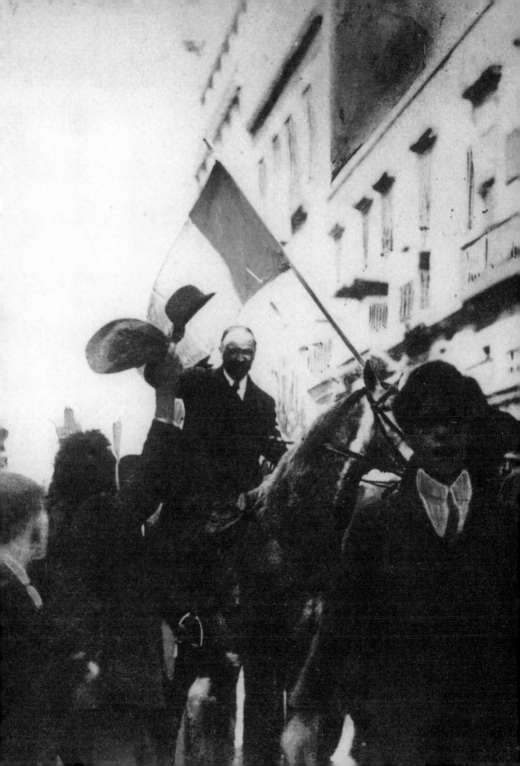

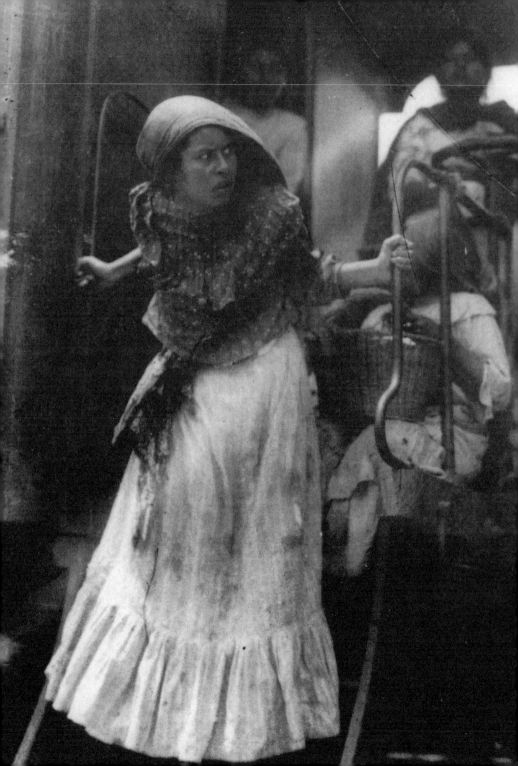

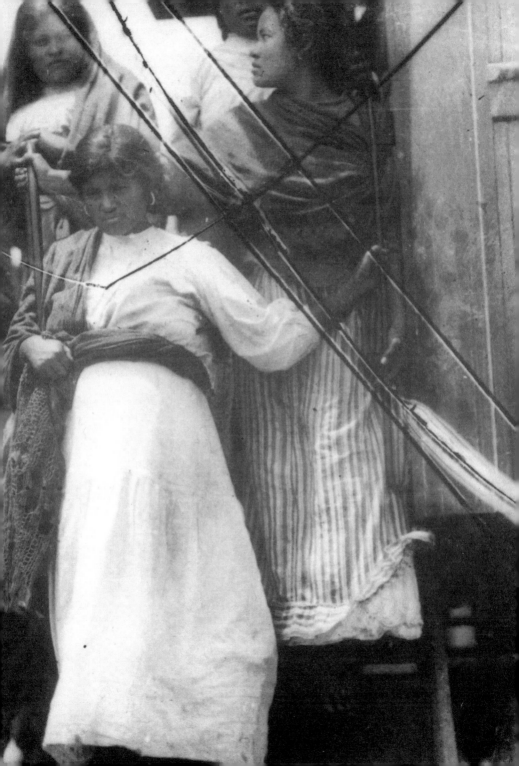

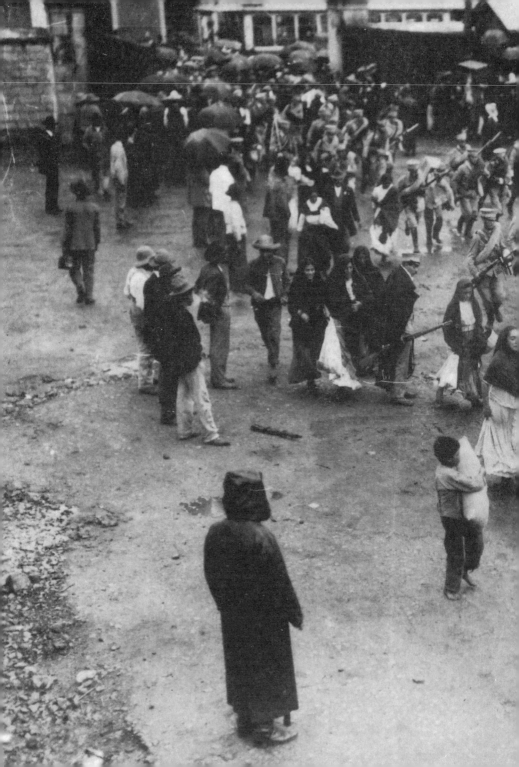

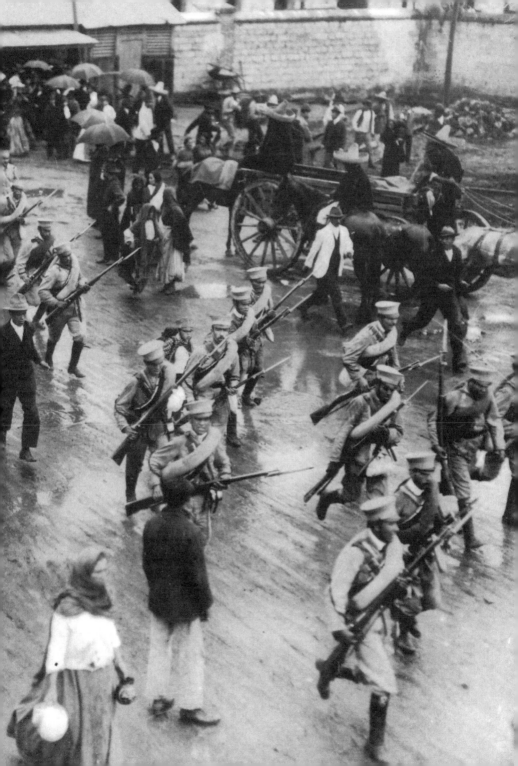

GRL. EUFEMIO ZA[PA]

SU ESTADO MAYOR

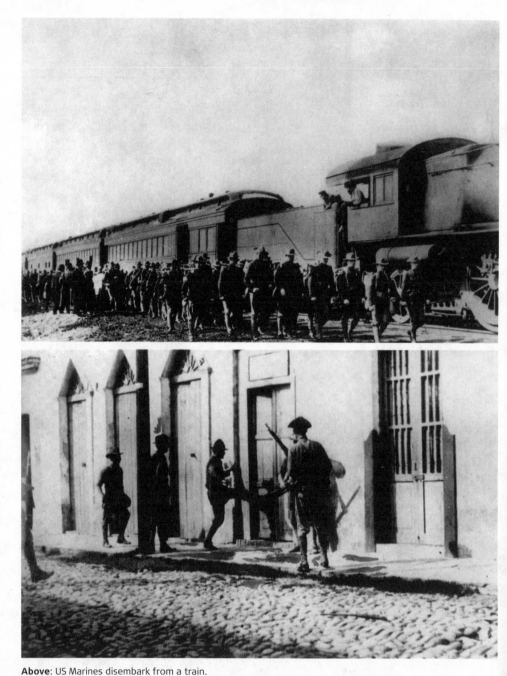

Above: US Marines disembark from a train.

Below: US Marines search houses in Veracruz.

Next page: Admiral Badger, commander of US naval forces in Mexico.

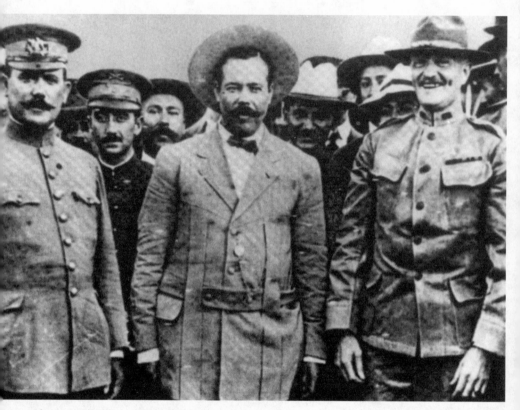

Above: Pancho Villa and some of his lieutenants in 1914. *From left to right*: Álvaro Obregón, Villa, and John J. Pershing. *Behind*: Rodolfo Fierro, the bloodiest of all, who will personally execute hundreds of prisoners.

Next page, above: A banquet in the government palace unites those who defeated Huerta in December 1914. *From left to right*: José Vasconcelos, who will play a critical role in literacy policies in the 1920s, Pancho Villa, General Eulalio Gutiérrez, a president with little power, seated uncomfortably between his allies Emiliano Zapata and Felicitas Villaneal.

Next page, below: The heroes post in the palace's great room. The expansive character of Villa, who spontaneously seated himself in the president's chair, contrasts sharply with that of Zapata, who appears to be weighed down by somber thoughts.

Next two pages: December 1914, Zapatista soldiers, armed to the teeth and making themselves at home, dine in a Sanborns luxury restaurant in Mexico City.

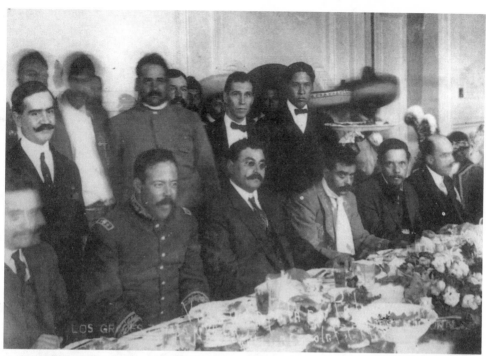

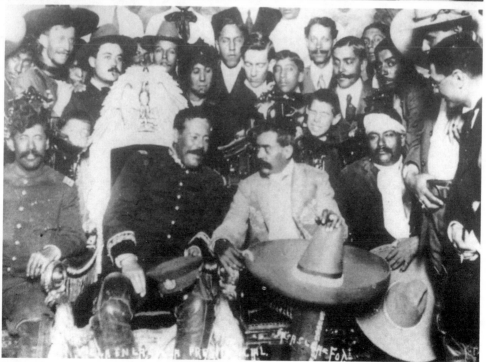

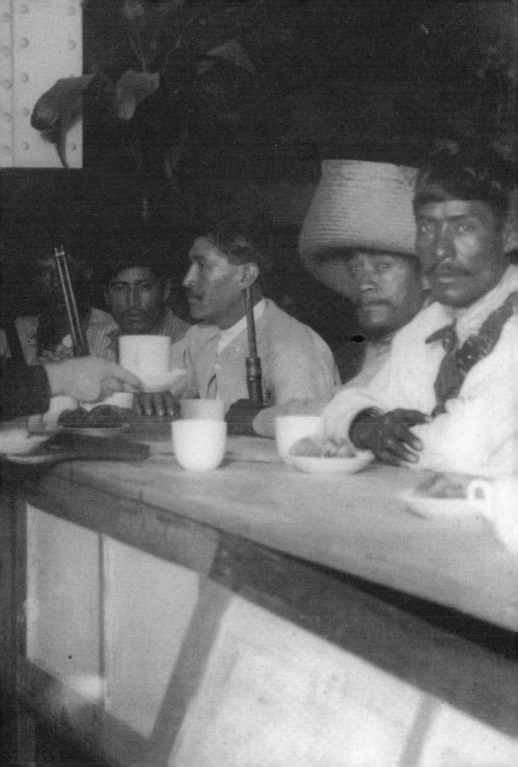

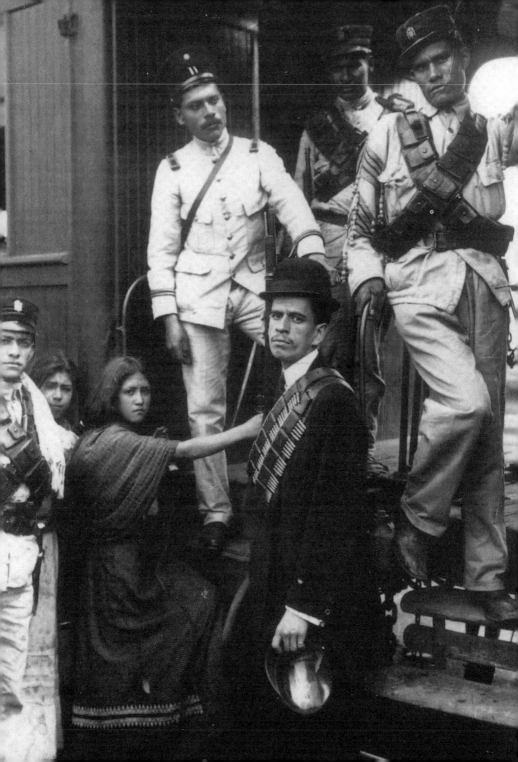

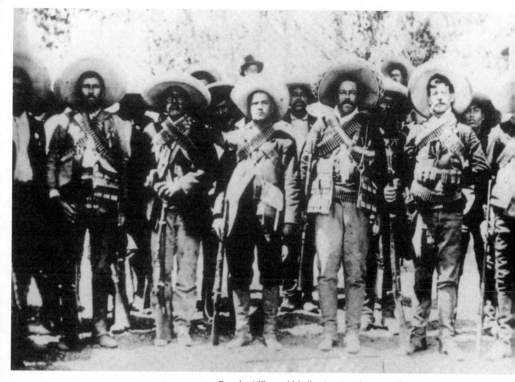

Pancho Villa and his lieutenants in 1915. The tide has begun to turn against them, but their determination remains intact.

Previous page: Departure of federal troops for the front in 1915. Probably for lack of uniforms, some of them are dressed in civilian clothing.

Pages 306–7: A child soldier enlisted in the Federal Army in 1915.

Pages 308–9: Indifferent to the photographer and the commotion around him, a Federal Army soldier sits with his family in 1915.

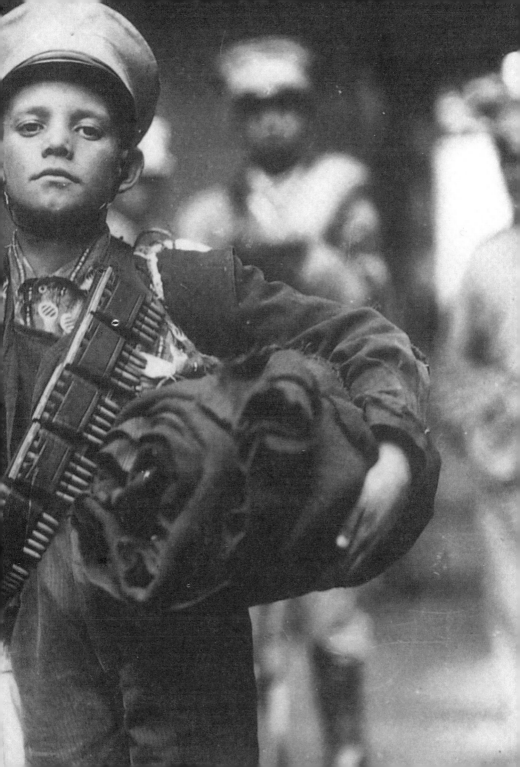

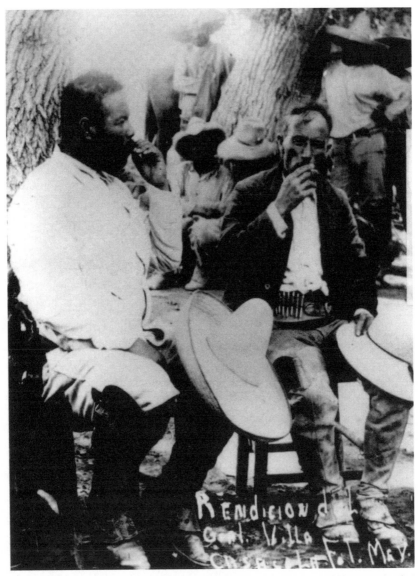

In July 1920, Pancho Villa negotiates with the government over terms of his surrender that allow him to hold his head high. However, he will be assassinated within three years.

Previous page: A famous image from the Mexican Revolution. Sentenced to death by the Federal Army in January 1917, Captain Samano smokes his last cigar while smiling for the firing squad.

A photo by communist photographer Tina Modotti taken some time after the Revolution is emblematic of this period. Here, a group of campesinos read the revolutionary newspaper *El Machete* in 1929.

Next page: Another famous photo by Modotti: *Woman with a Flag*, 1928.

Previous two pages: President Venustiano Carranza, visiting a uniform factory in 1918, offers a false sense of calm. He will order Zapata's killing in the coming year. He will be assassinated himself in 1920.

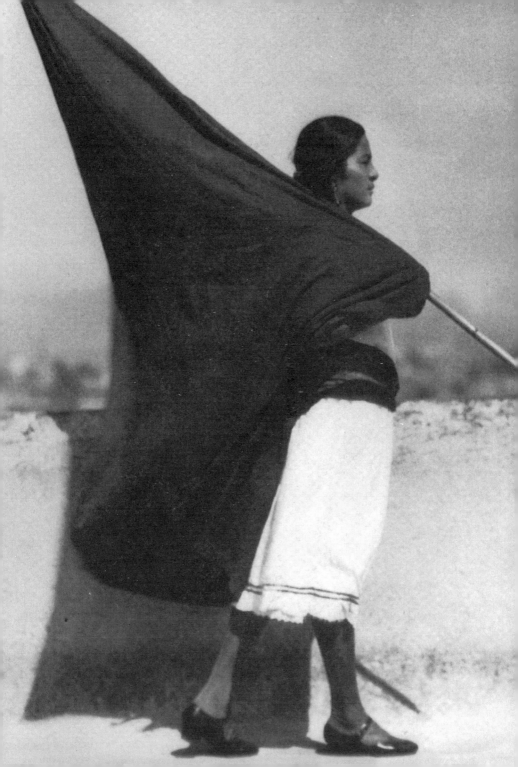

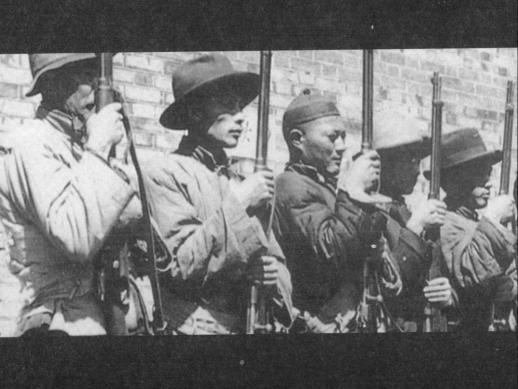

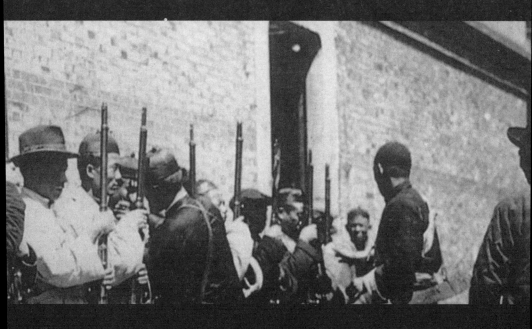

1911 and 1949

The Chinese Revolutions

Pierre Rousset

The Chinese Revolutions

Japanese cruisers and French and English battleships are anchored in Shanghai Bay as British troops embark; barbed wire fences protect international commercial concessions; in Hankou, passengers in flimsy Chinese vessels are trying to retrieve revolutionary pamphlets thrown into the water by His Most Excellent Majesty's naval guards. Clearly the Great Powers did not stand aside during the civil war that reached its apex in 1927 between the Guomindang (Chinese Nationalist Party) and the Chinese Communist Party (CCP), who had only yesterday been allies.

Colonial pressure had been felt in China for decades, even far away from its economic centers. The business of growing opium and brewing alcohol, kept under the radar but also clearly regulated by the colonial powers, was a daily part of life in the Burmese border regions. More than anything else, the opium trade brings to mind the long decline of the Manchu Dynasty, which, incapable of loosening the colonial yoke, submitted to the presumptuous establishment of Hong Kong, the nineteenth-century's "unequal treaties," and the opium wars pushed by Great Britain to open the Chinese market to the drug produced in its Indian territories. And even as France hoped to penetrate China through Indochina, new predators joined the conflict. The United States installed itself along the Chinese coast by acquiring the Philippines from Spain in 1898. And amidst

the great changes underway during its Meiji Era, Japan too affirmed its ambitions.

1911. No longer willing to tolerate mandatory queue hair braids, a sign of subjection to the Manchu order, some of the youth risked their necks to cut their braids. Two severed heads, placed flat on the ground, show there was no mercy for the rebels. This became one of the classic images of revolution and counterrevolution in 1911: a snapshot, and also a symbol of the cultural violence and social conflict that had erupted under certain circumstances—rather than proof of any particular cruelty specific to East Asia. The West more than measured up, from the Inquisition to the slave trade, and from Nazi concentration camps to the genocide of the Jewish people; and unfortunately, the second half of the twentieth century was not better than the first, with French torture in Algeria, thousands of skulls smashed in Cambodia by Pol Pot, disaster in Rwanda and the genocide of the Tutsis, mass rapes of women in Bosnia, and villagers slaughtered on the other side of the Mediterranean.

Swords cut through necks and machine guns cut down bodies. Headless corpses are left to lie in the street. Chinese soldiers—perhaps trained by German instructors—are perched on train cars. Archaic repression and modern war. Tradition and revolution. Modernity and counterrevolution. China's past and future are tied together in the present crisis. The theater is vast and the protagonists multitudinous. Social reality is being remade around the port cities; mechanized rice production and the cotton industry strengthen the traditional commercial bourgeoisie but also give birth to a new proletarian generation, thereby altering the relationship between the towns and the countryside. Students and intellectuals enter into contact with the outside world.

This play is not performed behind closed doors. Germany, Great Britain, France, the United States, Japan ... the Great Powers manipulated more than one of the actors. Western influence in Asia has grown slowly. But now it threatened the unity of the Middle Empire and the social cohesion

of civilization itself. National vitality demanded the modernization of this continental country, the overthrow of an imperial system incapable of updating itself. What social order would succeed the Manchus? What political and cultural forms would renew or reduce the influence of Confucianism? Would the Middle Empire bend to the colonial yoke or would it discover how to bring a new vigor to its unity and its independence? It would require two world wars, three revolutions, and four decades for these questions to be answered, albeit temporarily.

1912–1917. Group photographs—in which Dr. Sun Yat-sen, the civil reformer, appears isolated within a corps of high-ranking officers—summarize the total ambivalence of the first Chinese Revolution, which began with an uprising in Wuchang in October 1911 and ended on January 1, 1912, with the proclamation of the Republic.

Sun founded the United League in Japan, endowed with the political horizons of thousands of radical students who had been influenced by a cocktail of national and liberal, socialist and anarchist ideas with origins in the United States, Europe, and Japan. The downfall of the Manchu order opened a breach. The dynastic system was broken; the historic fracture had been consummated and the democratic ideal legitimated. A military caste took power and Yuan Shikai assumed political control, lending features of personal dictatorship to the new regime. With his death in 1916, despite a formal parliamentary restructuring, China entered into a period dominated by warlords. The country was divided between rival military powers, which was a gift to the imperialist powers, who were then free to make unequal alliances with the local potentates.

However, the range of possibilities widened during the First World War and after the Russian Revolution of October. The Western order faced a crisis of its own and the Bolsheviks gave Marxism a universal reach by extending it to a "backwards" country. This all made revolution in China conceivable, outlining an unexpected alternative in which anti-autocratic modernization could assume one of two faces: capitalism or socialism. If

the first implied a corollary of imperialist domination, might the second accompany national independence?

The Russian precedent did not offer a clear answer to this question. Russia was, first of all, European. Its leftist militants were familiar with workers' movements in the West, and the revolution's heart was urban and modern, even if there was an anti-autocratic element of the revolt that must not be underestimated in the Russian dynamic, and contradictions in the peasantry's conditions that must be appreciated. The Middle Empire, on the contrary, was home to an even more extensive ocean of peasants; and this time, it would be necessary to hurdle over the abyss of civilization.

For many Marxists, the fact that revolution in St. Petersburg had preceded the revolution in Berlin was already a great surprise. In China, the revolutionaries were truly taking a leap into the unknown.

1925–1927. A "starvation menu" underlines the cost of social inequality. A child in the street is shown carefully sweeping up grains of rice that have fallen on the ground using a small broom. Hunger tortures the poor. More scenes. A proletarian militia in the great Shanghai metropole. Communist workers, standing at attention, learn how to handle arms at the "soldiers' school." Unskilled, itinerant urban workers, referred to by the racist term "coolies," force open the doors of an English shop. The second Chinese Revolution began in the south in 1925. For a long time, the revolution was understood by several classic images: the rise of unions and peasant associations, strikes and pickets, mass demonstrations, regional insurrections. . . . But these were violently repressed by the warlords in Manchuria, in the center of the country, and in the Yangtze valley. In the south, the workers' movement saw its rights recognized in the republican zone in Guangzhou, or Canton, as it was commonly referred to in the colonial era. The Chinese Communist Party, founded in 1921, grew genuinely deep social roots.

The CCP and the Guomindang formed an alliance to launch an expedition to the north to unify the country under Sun's banner. Pushed along by popular uprisings, the southern forces made rapid progress. However, the martial figure of General Chiang Kai-shek better personified the "republican" side than Sun, who died in 1925. Chiang was better suited to these convulsive years of high hopes and abject terror, revolution and counterrevolution, that first empowered and then destroyed the progressive camp. With a severe face, shaved head, fine moustache, and high collar, Chiang calculated carefully. After directing the Wampoa Military Academy alongside the communist Zhou Enlai and two Soviet instructors, he ordered his army to exterminate the revolutionaries.

In the great coastal city of Shanghai, insurgent trade unionists took control and opened the gates to Chiang. There followed a massacre. The workers and militants were murdered by the nationalist army, which received help from illicit gangs. The anticommunist repression grew, claiming tens of thousands of lives. The failure of the second Chinese Revolution was finalized in December with the smashing of the Canton Commune that had risen up as a last act of despair.

The first Chinese Revolution closed a chapter. The second, asserting itself at both the social and national level, pointed to the question of the future. And of power. Communist influence grew. The bourgeoisie and the landowners of the south wanted to put a final end to popular uprisings and to ensure for themselves control over the nationalist political-military apparatus. But twice before, the republican unity had not been able to overcome the social polarization at the very heart of the national movement.

Who would lead, and for whose benefit, the fight for political reunification and Chinese independence?

These events burned a lesson into the bloodied Chinese communist movement: the national question could not be separated from the class struggle. Nor could the class struggle escape the national question.

1934–1936. Do the "Reds" have a future? Who would have thought so after eight successive years of defeat, each one more costly than the last? Shrunken by historic defeat, nonetheless, China's future leaders were produced during these years.

Starting, of course, with Mao Zedong. A second-rank leader during the early days of the CCP's expansion, Mao made his mark during the difficult hours of defeat. His authority was confirmed during the legendary Long March and was recognized at a party conference in Zunyi at the beginning of 1935. He was already more than forty years old. Posing on this occasion, he offers the photographer a confident look. At his side is Lin Biao, fourteen years younger, who was set to become one of the parties' two principal political-military leaders. Mao is attentive, wearing a beret with long hair. Two years later, when he was photographed by Helen Foster Snow in Yan'an, Mao had become the key figure in the communist political cabinet.

If Mao's tenacity was rewarded it was because he knew how to respond to the situation created by the bloody defeat of the second Chinese Revolution. The social struggles dissipated, and the militants were massacred. Now reconciled with the Western powers, Chiang persecuted the "red bandits" to the edge of annihilation. But the CCP still controlled considerable forces, the majority of which were gathered in the Soviet Republic of Jiangxi province. Out of the upheavals and defeats emerged a Red Army of some 300,000 soldiers at the beginning of the 1930s!

Mao understood the geopolitical conditions as a defensive retreat in a continent-sized country and perceived revolutionary struggle in the long term. His vision was audacious: to abandon the areas in which the communists had traditionally been implanted and to immerse them in China's heartland, in the largely unexplored rural interior of the country; to concentrate themselves in their northern stronghold, while developing a clandestine network across the entire national territory; to root themselves in class conflict while at the same time inciting a fight for national unity in

defense against external threats (by 1932, Japan had already occupied Manchuria and attacked Shanghai); and, finally, to ensure the independent decision-making power of the Communist Party without breaking with their Soviet mentors. In fact, in Moscow, the Stalinist bureaucracy was choosing lackeys to lead communist parties around the world. In China, they named Wang Ming; however, at the cost of an interminable faction fight inside the CCP, the Maoist leadership effectively neutralized Stalin's choice.

The soldiers of Mao's First Army left the south of China in October 1934 and marched 10,000 kilometers. One year later, of the 86,000 who began, only 4,000 reached Shanxi in the north. But other military units joined them in Yan'an and, by 1937, the Red Army counted among its forces approximately 30,000 men.

Through all the defeats, fifteen years after the CCP's founding, a generation of cadres had been born: hardened through many tests, trained under a variety of conditions, they would guide the revolution to victory. The Maoist mutation of the CCP took place in the heat of this extended retreat called the Long March. Over the course of military confrontations, political battles, and faction fights, Mao united around him (one of his many qualities) a real team of leaders consisting not of strawmen but strong personalities: Zhou Enlai, Zhu De, Lin Biao, Deng Xiaoping, Peng Duhuai.

As for relations between the CCP and their Soviet "big brother," they did not always see eye to eye. The break between the Guomindang and the CCP was clearly stated from 1926 on by Chiang himself. This was predicted, notably, by Chen Duxiu in China and by the Left Opposition in the USSR. But blinded by its own immediate diplomatic interests, Moscow practically prohibited the Chinese communist militants from preparing for the confrontation. Far from this being merely a policy for Chinese communists—although it was one with disastrous results—the Stalinist faction imposed its own control over the Communist International (Comintern) and thereby imposed its bureaucratic vision over the entire communist world.

The CCP was the first communist party to pay such a high price for the Stalinization of the Comintern, but it would not be the last.

1937. Cities devastated by air attack. Scenes of urban desolation. Women squatting, helpless, in front of their destroyed homes, or trying to put out a fire using only a pan of water. First aid teams. These were common images in the days after a bombardment.

The Second World War began early in the East. The Japanese invaded China. Control over the peripheral coast of Manchuria was not the only prize up for grabs. The occupation army penetrated deeply, imposing the same yoke on urban and rural worlds. Nationalist militants, beginning with students, joined the Guomindang and the liberated zone in the south and, in ever greater numbers, joined the Red Army as well as united front organizations directed by the CCP. The communist networks continued to operate from the coastal centers. The mass urban workers' movement— already exhausted by repression carried out by warlords and then the Guomindang—remained inert for a long time.

The two armies confronted the Japanese invasion, while continuing to fight one another. Even in the face of national emergency, the laws of civil war remained in effect. The two armies, in order to win, would have to mobilize the peasantry, that is, the most numerous class in China. The White Army, classically composed and under Chiang's command, embodied the status quo and all its injustices. The Red Army, reorganized in its northern stronghold in Yan'an, did not inspire confidence. Didn't its cadres eat their frugal meals while squatting on the ground, with a backdrop of some deserted hills in the Maoist political-military university? However, these outcasts also promoted land reform as well as national independence. They could respond to the poor peasants' aspirations, to the agricultural workers, to the high-spirited day laborer, to the servant on the farm who felt that change was finally possible and that the nation's liberation would also bring his or her own. This hope was what the anonymous peasant clung to throughout long years of war and revolution, the peasant whose carefully

calligraphed poster, perhaps written by someone without shoes, supported the will of the popular government to divide up the land.

Rather than incite villages against each other, as often happens in the rural world, the conflicts now pitted poor against rich, the dispossessed against the well-off. Victims of the most extreme misery demanded a settling of historic accounts. Gathered together in meetings to "speak bitterness," the poor became conscious of their common condition, and they overturned the ancestral order of the powers that be: a form of modernization that the Chinese gentry and bourgeoisie little appreciated.

A dozen silhouettes against a cloudy backdrop captured both the peasant multitude and the aurora of a new order: a whole iconography likewise immortalized the Red Army's worker-soldiers. They wielded shovels and hoes as well as rifles and machine guns. They constituted an army with whom the people could, for once, identify.

1937–1945. Forced together by patriotism, the Guomindang and the CCP ally their forces to confront the Japanese offensive. However, though dulled, the civil war continues within the war of national defense. Behind the façade of the anti-Japanese united front, leaders and armies, divided, preserve their independence.

Two strategies are asserted, simultaneously embodying two military concepts, two political ambitions, two social bases. Chiang's armies progressively withdraw to the southeast, and the CCP seizes on this to denounce the Guomindang's negligence, its abandonment of the nation. The generalissimo's plans are not without reason. He knows that one day the civil war will explode once again without constraint, and he uses China's vast space to conduct a long retreat maneuver in order to maintain his military capacity, true to his class perspective. He also anticipates the United States' entry into the war and counts on Tokyo's defeat in its Asian-Pacific operations happening in parallel with Germany's defeat in Europe. With this in mind, he plays for time. Time and space.

The Maoist leadership also puts these dynamics to good use. Instead of gathering in the southwest, their army infiltrates the Japanese rearguard in the northeast, at the risk of being once again cut off from its bases of support. As in 1934, the move is bold, the vision audacious—and advantageous. The CCP uses guerrilla actions all along the front line, actively seeking to confront Japan's forces and to thereby boost its own national prestige. Keeping themselves outside the reach of the Guomindang's troops, the communists are completely free to affirm their authority in parts of China less isolated than Yan'an. Thus, in 1945, they administer liberated zones populated by one hundred million inhabitants. And their call for land reform, at long last, gives social content to China's national liberation.

1945–1949. Bled dry by popular resistance in China and repulsed by the Allies, Imperial Japan suffers the carnage of a double nuclear holocaust in Hiroshima and Nagasaki. In China, the end of the global conflict leaves the Red and White Armies face-to-face. The armies' numbers match China's vastness: Chiang gathers four million very well-equipped men under his banner. But the CCP reemerges from the distance, its armed forces now including one million recruits.

Both camps know that war is inevitable, but in a country exhausted by the Sino-Japanese conflict, they must first propose peace talks. Negotiations begin in Chongqing. Washington represents the intermediaries. We see US ambassador Patrick Hurley received in "red" territory by Mao and Zhou Enlai, all smiles. However, there is little room for illusions. In another moment in 1945, we see Mao addressing his army, arm raised, finger extended, already evoking the march southward which, a few years later, will lead him to victory.

Chiang's military regime has more than one card up its sleeve. It enjoys advantages in numbers, material, and logistics supported by the United States, and maintains exclusive control of China's airspace, not to mention diplomatic recognition, and an active US presence, which guarantees

both air and sea supply lines to its armies in the northeast, preventing the cities taken from the Japanese from passing under communist control.

It is obvious that, after declaring war on the Empire of the Rising Sun, Soviet troops will enter Manchuria, but the objective is to increase the USSR's prestige and not to aid the CCP in coming to power. The Great Powers define their reciprocal zones of influence at the Potsdam and Yalta conferences. For Moscow, who never bothers to ask the opinions of its "brother parties," Indochina and China belongs to the "Western" camp. Stalin neither wants nor believes in the potential for revolution in Asia.

However, he is not counting on the independent decision-making power of the Vietnamese and Chinese communists. He forgets how revolutionary crises can change scenarios and invert the logic of the relationship of forces.

In a more typical war, the Guomindang would have emerged victorious, but we are dealing with a revolution. Economic crisis, autocratic nepotism, and corruption undermine Chiang's regime, draining its authority even in the great urban centers—where communist presence remains weak— and among the middle classes who fall into a panic over the inflation that has ruined the financial system. December 1946: there is a run on gold in Shanghai. Enormous lines of small depositors form in front of banks to withdraw the forty grams of the precious metal promised by the Guomindang before there is nothing left. No one dares risk losing their place in line. Bodies are jammed one against the other. Faces are tense. Curiously, a semblance of order appears to reign, although a dozen people will die in riots on this day.

The anti-imperialist student mobilizations resume: in 1947–1948, in effect, an international alliance forms between the Guomindang, the United States, and ... Japan! Once again, the CCP embodies national salvation as well as the answer to social demands. After a long period of quiet, workers (of whom there are two or three million with little political consciousness)

go on strike, winning a sliding scale of wages. The countryside is a powder keg, and uprisings for land reform spread from the north to the south.

Once hostilities are declared, the CCP emerges victorious in the brief three-year span from 1946 to 1949. The defeat of the Guomindang proves to be as political and social as it is military. The Red Army advances, swept along by levies raised during rural insurrections, welcomed hopefully in urban centers, where the population greets these revolutionary soldiers—who little resemble the forces at whose hands they have so often suffered—with curiosity. The soldiers sit cross-legged right on the ground along an avenue, carrying their ration of rice in white shoulder bags. Frugal, they carry everything necessary for their subsistence on their backs.

From Canton to Jiangxi, from Yan'an to the northeast, the communist leadership achieves is long-sought goal. On October 10, 1949, the People's Republic of China is proclaimed in Beijing.

Defeated, Chiang withdraws with weapons and supplies to the island of Taiwan. For a long time, in the eyes of the United Nations, his government would be the sole representative of China.

1919–1950. Thirty years have passed since the emergence of Chinese Marxism. It is a shame that such an intellectual ferment cannot be immortalized by photographers as readily as war. How can one visually do justice to the 1919 May Fourth Movement?

This movement has for a prelude the passionate discussions sparked in Chinese students' homes by the Japanese victory of 1905 in eastern Siberia during the Russian-Japanese War—the very spark that lit the first revolutionary fire in Russia. The East can defeat the West! At least on the condition that the East adopts the West's techniques and modifies its political regime. To what degree does this modernization also imply a Westernization? These questions go to the heart of the debates prior to 1911. And they return in 1919. Indeed, at the Versailles Conference the Great Powers

reject the demands of the Chinese delegation: German colonial privileges in Shandong are transferred to Japan instead of being returned to China.

How to reply to this humiliation?

The May Fourth Movement serves as a crucible for debates. Does the October Revolution in Russia prove that national salvation runs through social revolution? A new, defiant intelligentsia is forged and turns its gaze, in part, toward the Bolsheviks.

Chinese Marxism took shape around Chen Duxiu and Li Dazhao. The former, more of a universalist, saw in Western thought a force that could give flesh to a liberatory revolt against Confucianism. The latter, who was more nationalist, sought the means for anti-imperialist resistance in China's authentic culture. Must we see in the Chen-Li duo two irreducibly opposed choices or, rather, the expression of an inherent tension in all revolutionary Chinese communism? The introduction of a Marxist reference helped the intelligentsia define an alternative to the traditional order and understand how the contemporary world is shaped by capitalism. However, Marxism did not break out of its marginality and leave the confines of the modernizing intellectual circles; it could not take root in the Chinese universe and become a political reality without "becoming Chinese," that is, without finding roots in the civilization of its host country, for instance by discovering a dialectic in the Dao, a sociology of power in Confucianism, and a dynamic conception of action in Sun Tzu.

Throughout all this, there is a Westernization of Chinese thought and a de-Westernization of Marxism.

Yet once "sino-ized," communism in China was no less heterogeneous than in any other country. Before the defeats of 1927, the Communist Party was open to liberatory currents, and its internal regime was intended to be democratic under the impulse of Chen Duxiu. After the second revolution was smashed, Chen felt politically close to Trotsky, and a left opposition was born in China. During this era of military confrontations,

Trotskyism did not take off in China, instead suffering repression from three sides (the Guomindang, the warlords, and the CCP itself), fractured by internal divisions and struggling to find an adequate orientation given the situation. But it nonetheless embodies the diversity inherent in Marxist thought, including on Asian soil.

The CCP itself was never as monolithic as legend would have it, it always remained a theater for important factional struggles. For instance, the Hundred Flowers Campaign of the 1950s expressed a spectacular pluralist vitality—so much so that Mao had to put a brutal end to an opening that he himself had initiated.

The fascinating figure of Mao did not personify Chinese Marxism in general; rather, his Marxism was born in a concrete historical juncture, the decade between 1925 and 1935. Much less so did Mao embody Third World Communism from Africa to Latin America. No single model can definitively contain the diversity of experience in so many revolutionary lines.

The day after the victory in 1949, two principal laws were adopted by the new regime concerning land reform and marriage. In fact, the mobilization of women—and especially rural women—shaped, over many decades, the revolutionary struggle, including the fight for equality and the right to education, and the fight against domestic violence, sexual abuse at the hands of elites, and the patriarchal Confucian order. This is one of the numerous domains in which revolutionary aspiration led to radical modernization.

Today, the image of the guerrilla is in vogue, but there are few photographs that do justice to the Chinese struggle in the midst of the making of their revolution. Winter weather is harsh in northern China. The unit moves forward, bundled up tight, behind loaded mules: a Women's Association delegation inspects the military front in 1939. Shanghai students demonstrate against the black market ten years later. The camera lens picks them up as they pass the Soong Bank building, the country's

largest financial establishment, which was owned by Chiang's father-in-law. China from north to south. Rural and urban China. China of the poor and middle class. Women in struggle from all parts of China.

As the years passed by, Maoist conceptions oscillated—very liberal in Jiangxi, more conservative in Yan'an. However, women's party cells were created in the villages. Women peasants organized their own "Speak Bitterness" meetings where violent husbands were accused, and women armed with rods would sometimes arrange to severely beat a man who did not understand that times had changed. Engaged on all fronts, Chinese women had earned the new marriage law.

A genuine revolution, therefore, gave rise to the first people's republic of the Third World (soon after, it would be declared socialist). But one in which, at least after the 1927 massacres, peasants and women played a more central role than the working class.

The Maoist party frustrated predictions. Reconstructed in the interior of the Red Army, immersed in the countryside and largely distant from the cities, must it necessarily be strictly limited to a peasant guerrilla movement, threatened with degenerating into banditry and incapable of any national political vision, of any historical dynamism?

However, the party continued to subordinate the army—to maintain command over the rifle, to recall Mao's formulation. It managed its perspectives with finesse, both in national and international terms, including its conception of land reform, affirming a long-term point of view, immediately overcoming the closed horizon of the countryside. And when the occasion presented itself, it reconcentrated its forces in the great urban centers. The party spurred the development of trade unions (although, it is true, under its control) and guaranteed an important role for the working class—permanent workers in state-owned enterprises—the enviable status of having a guaranteed job and income for life.

Through many historical hazards, the CCP remained the party of the revolution—the party of the Chinese Revolution. However, it also became the party of a newly emerging state bureaucracy that governed the immense liberated zones administered before 1945 before later progressively imposing its rule on the young People's Republic. The intimate conflict between revolutionary dynamism and bureaucratic conservatism constitutes one of the central "internal contradictions" of Maoism in power, of the party-state. This clarifies many aspects of the crises that shook the regime, from the repression of the Hundred Flowers Campaign to the failure of the Great Leap Forward, the crumbling of the collective leadership around Mao, and the torments of the Cultural Revolution.

The country was covered with gigantic statues of the Great Leader. They were a symptom of a cancer that corroded the regime, a cult of personality; originally conceived to counterbalance Stalin, this cult flourished until the delirium of the 1960s.

Despite this, the international reach of the Maoist revolution was massive. This is true both for the questions and the partial answers it provided for the possible course of national liberation struggles and the paths to development for transitional societies in the global South. The same can be said for the transformation in the geopolitical balance of forces its victory provoked. As early as the mid-1930s, East Asia entered the world political arena: in the imperialist bloc, Imperial Japan affirmed its ambitions vis-à-vis the West; and in the Soviet bloc, the CCP established its political independence vis-à-vis Moscow.

The centrality of this region since 1949 cannot be denied.

Timeline

1839–1842: Opium Wars

1850-1864: Taiping Rebellion

1905: Japanese victory in the Russo-Japanese War

1911–1912: First Chinese Revolution (republican)

1914–1918: First World War

1917: Russian Revolution

1919: Versailles Conference. May Fourth Movement.

1921: Foundation of the Chinese Communist Party (CCP)

1923–1927: United Front of the Guomindang and the CCP

1925–1927: Second Chinese Revolution

1926–1927: Northern Expedition

1927: Shanghai Massacre

1927–1937: Civil war between the Guomindang and the CCP

1929–1934: Soviet Republic of Jiangxi

1931–1932: Japan occupies Northeast, attacks Shanghai

1934–1935: The Long March

1937–1945: Sino-Japanese War. Guomindang–CCP anti-Japanese United Front.

1939–1945: Second World War

1945: Atomic holocaust in Hiroshima and Nagasaki. Japan capitulates, Second World War ends.

1946–1949: Civil war between Guomindang and CCP

1949: Victory of the third Chinese Revolution (communist). Foundation of the People's Republic of China on October 1.

1950: The Guomindang retreats to Taiwan. Sino-Soviet Treaty.

1950–1953: Korean War

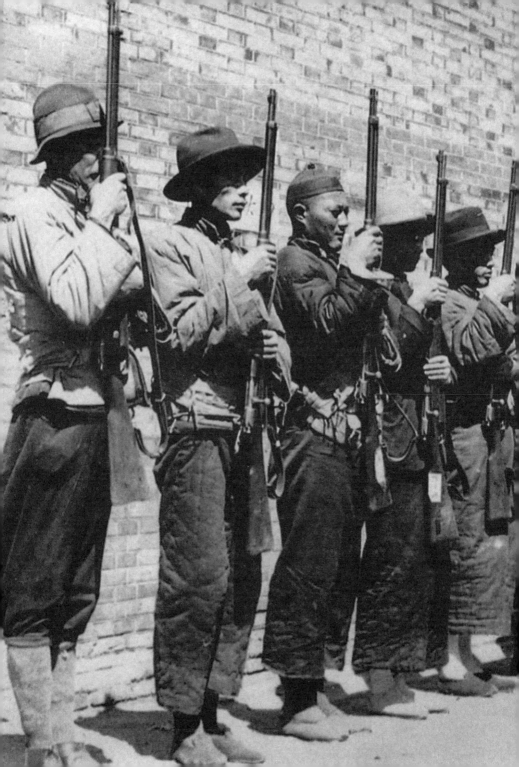

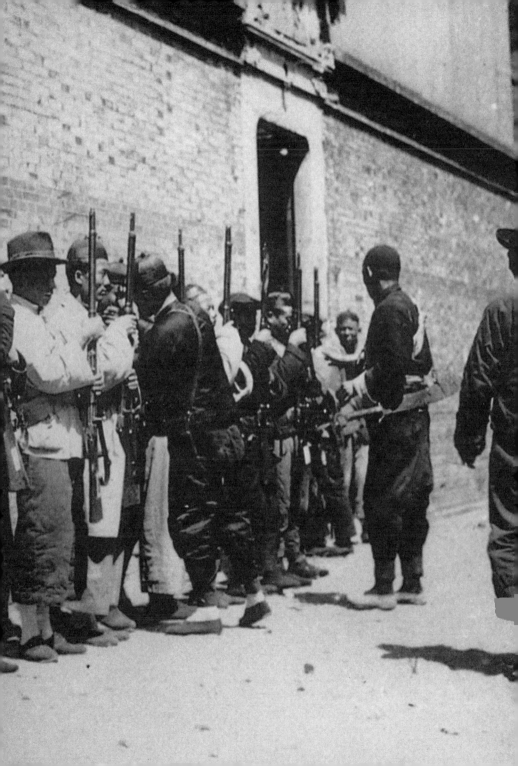

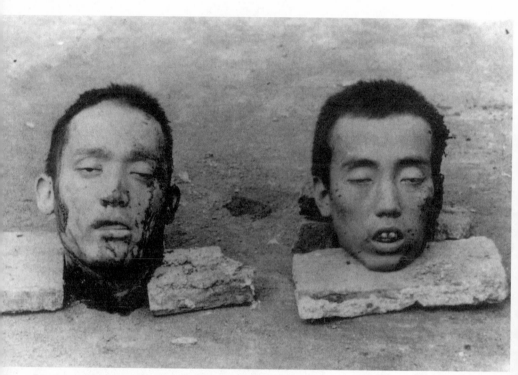

Two young Chinese men were executed for cutting their braids, which were a sign of subjugation to the Manchu order.

Previous two pages: In the "soldier school" in Shanghai, communist workers learn how to handle firearms in 1927.

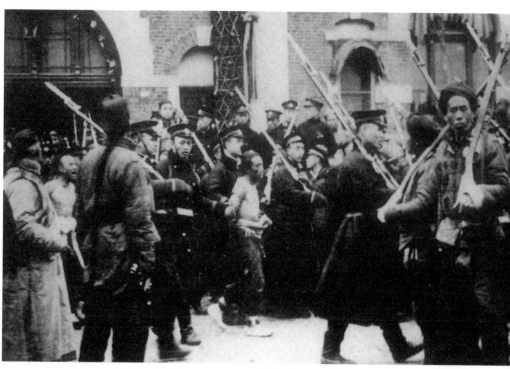

Delays in salary payment provoke looting in Nanjing. On April 12, 1912, the leaders of the revolt are sentenced to death and are led to their executions.

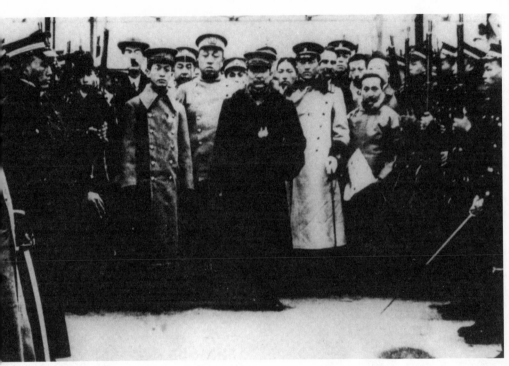

Inspection tour by Sun Yat-sen, president of the Republic, in Shanghai in 1912.

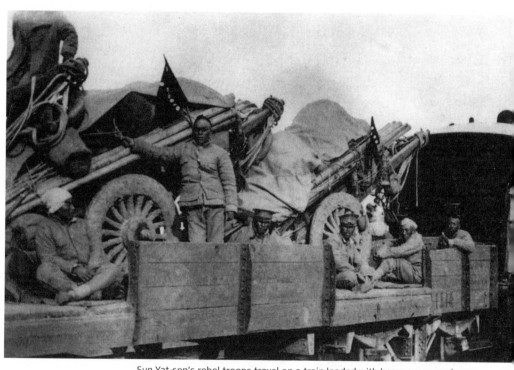

Sun Yat-sen's rebel troops travel on a train loaded with heavy weapons in 1911.

After the distribution of rice, a girl sweeps grains off the ground with her broom.

Next page: Chiang Kai-shek at a meeting of the Supreme Council of War in Hankou on July 4, 1938.

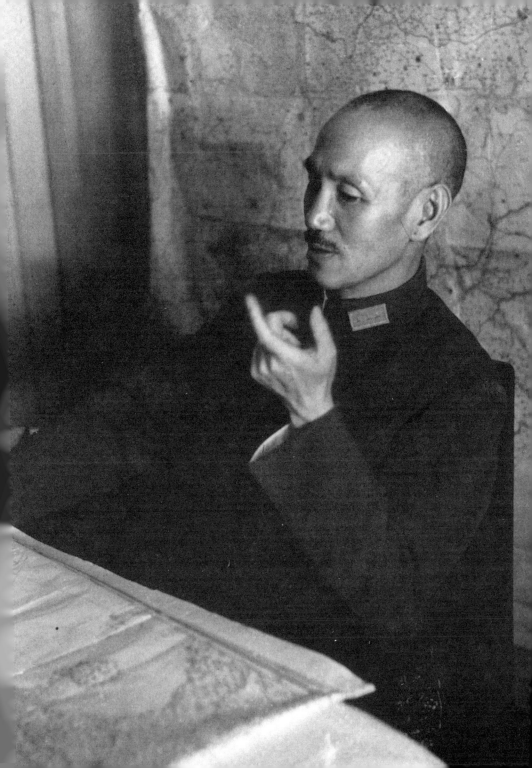

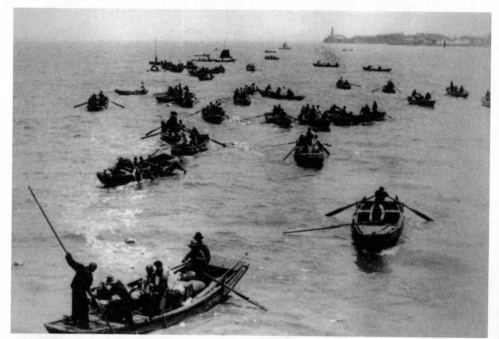

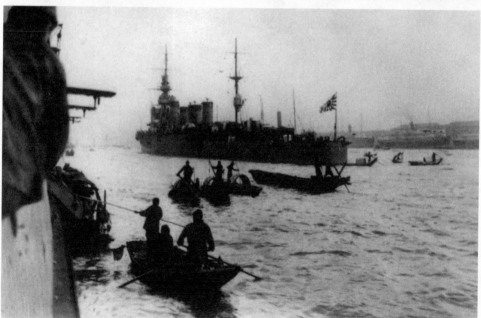

Above: Off the coast of Hankou, Chinese people try to gather revolutionary leaflets tossed overboard by English sailors in June 1927.

Below: A Japanese cruiser in Shanghai Bay in April 1927.

International concession zones in Shanghai protected by barbed wire in 1927.

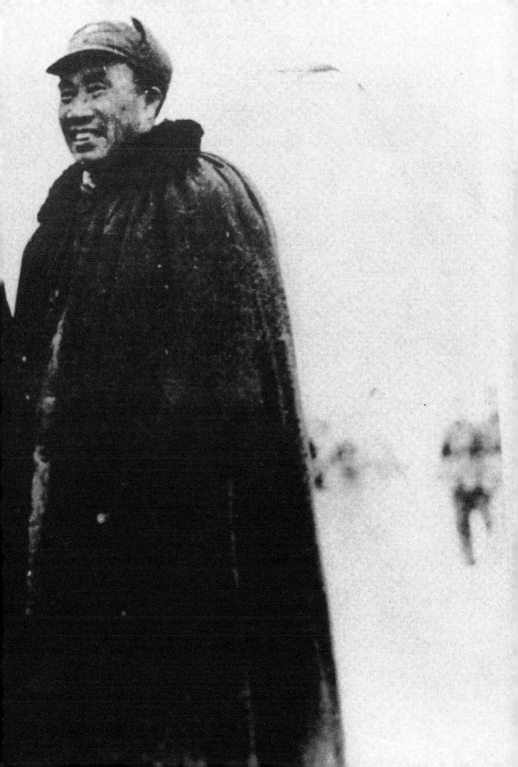

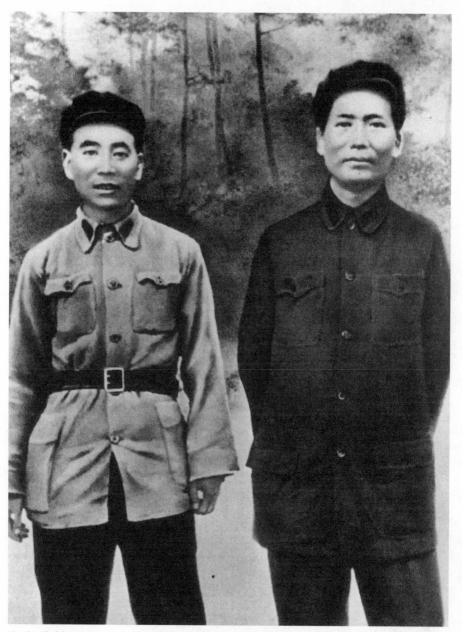

Lin Biao (left) and Mao Zedong at the Zunyi conference in January 1935.

Next page: In the spring of 1938, during the Sino-Japanese War, Deng Xiaoping calls on combatants in the county of Licheng in Shanxi province to mobilize.

Previous two pages: *From left to right*: Zhou Enlai, Mao Zedong, and Lin Biao in Yan'an city in 1939.

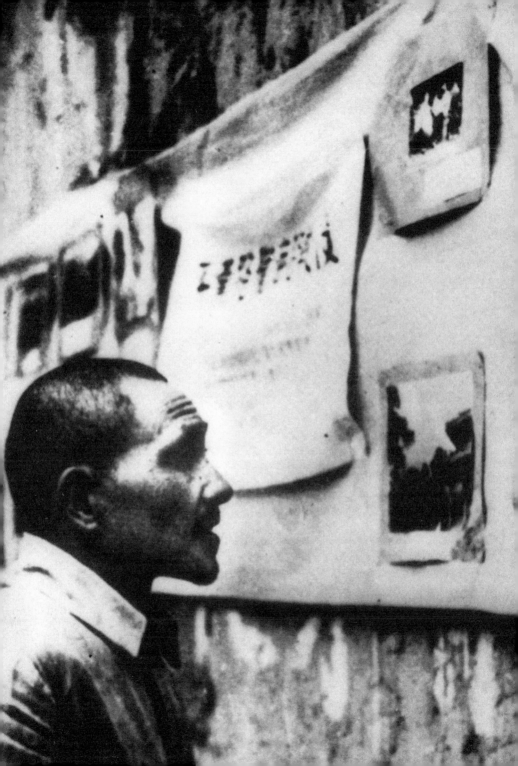

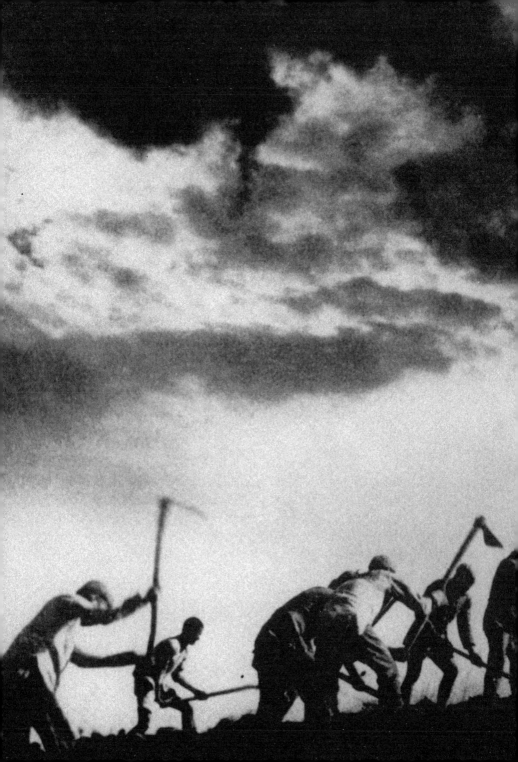

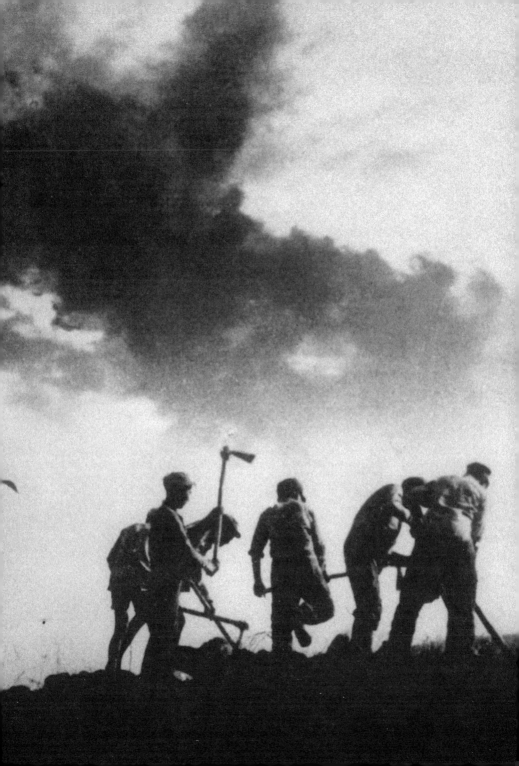

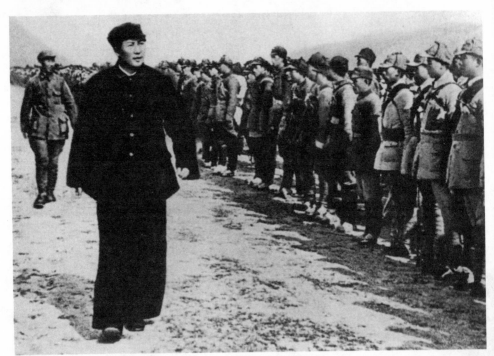

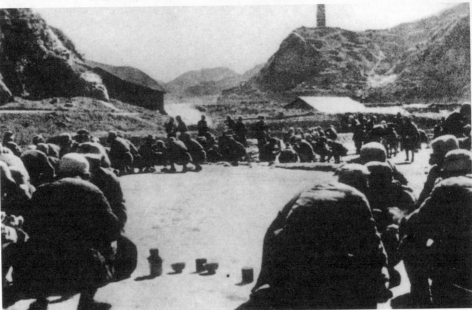

Above: Mao Zedong inspects troops of the communist Eighth Route Army stationed in Yan'an.

Below: Members of a special school for training Chinese Communist Party leaders and military officers during a break in 1938.

After the Japanese surrender, the United States oversaw negotiations between the Guomindang and the CCP. *From left to right*: Zhang Zizhong, Mao Zedong, Patrick Hurley, Zhou Enlai, and Wang Ruo-fei leaving for Chongqing in 1945.

Pages 350–51: Soldiers of the Eighth Route Army prepare desert regions around Yan'an for cultivation in 1941.

Pages 352–53: After aerial attacks by Japanese forces in Hankou, a resident attempts to put out a fire in 1938.

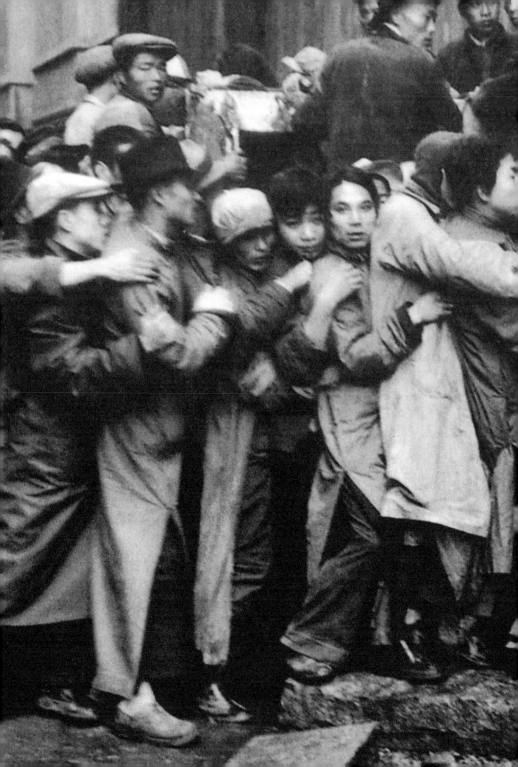

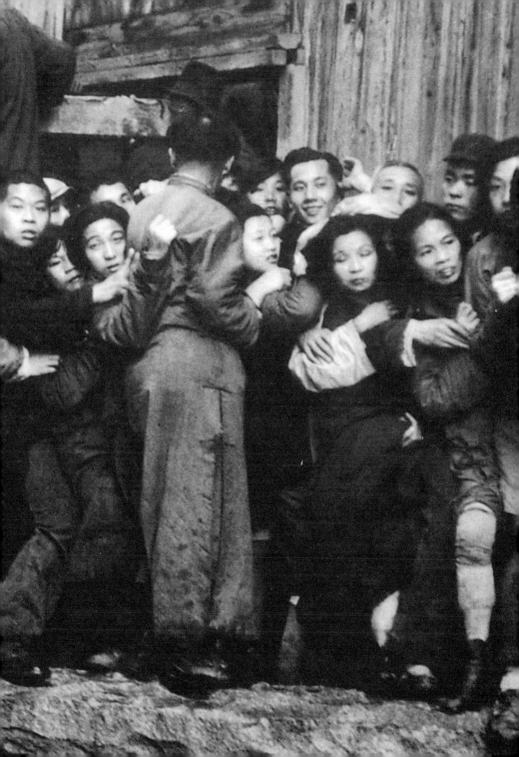

Two men read the daily news in Beijing in 1948.

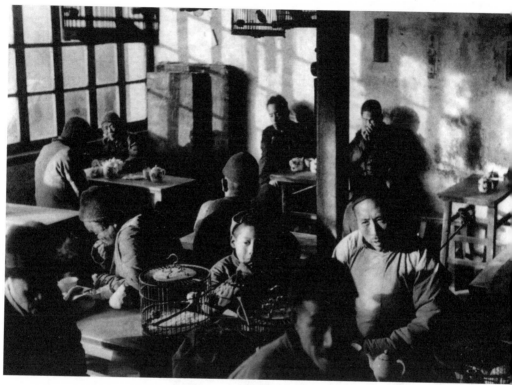

A teahouse in Beijing in 1949.

Pages 356–57: Volunteers and students from the Hebei province, armed only with lances decorated with red streamers, leave to join the Red Army in 1939.

Pages 358–59: Faced with inflation, the population panics and people crowd in line trying to withdraw gold from banks in Shanghai in 1948.

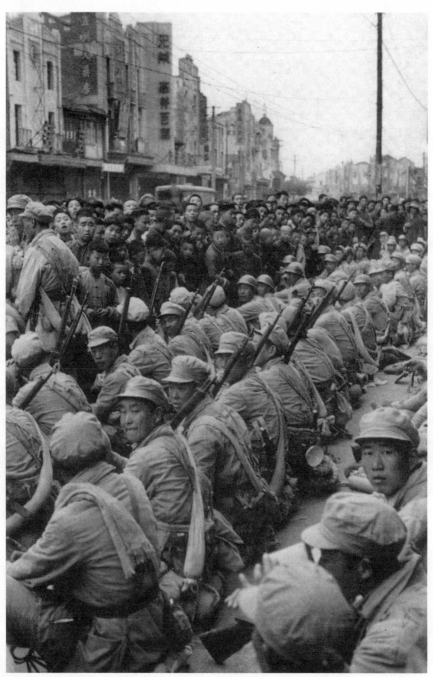

The People's Liberation Army is welcomed by the population in Shanghai in 1949.

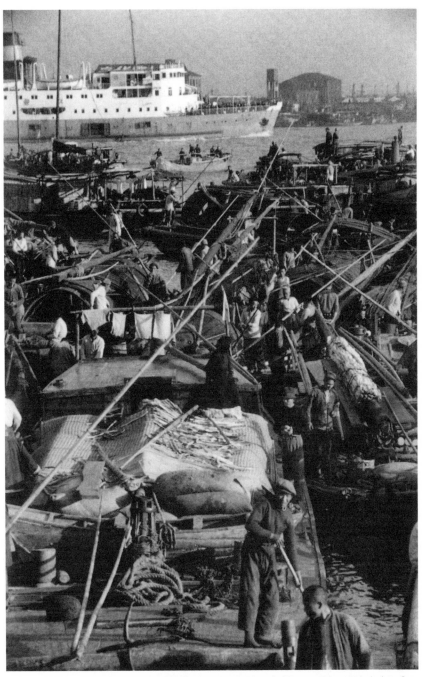

The arrival of the communist army in Shanghai forces Chiang Kai-shek to flee, leaving behind a city in ruins and tormented by hunger in 1949.

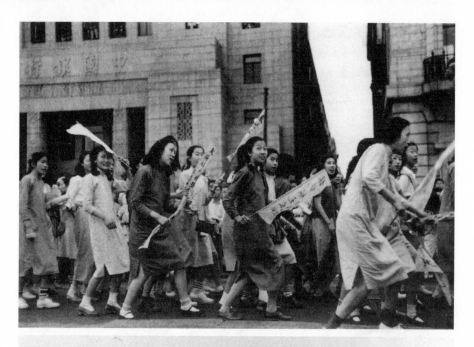

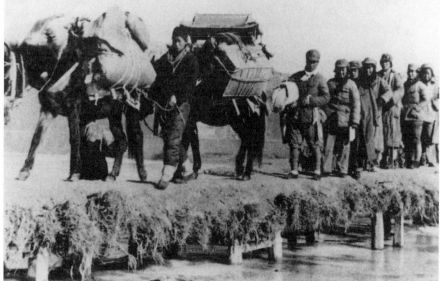

Above: Communists march in Shanghai in June 1949.

Below: Led by Madame Chen Poer, a delegation of Chinese women is on route to inspect the northern front in 1939.

Next page: A cult of personality develops around the figure of Mao Zedong.

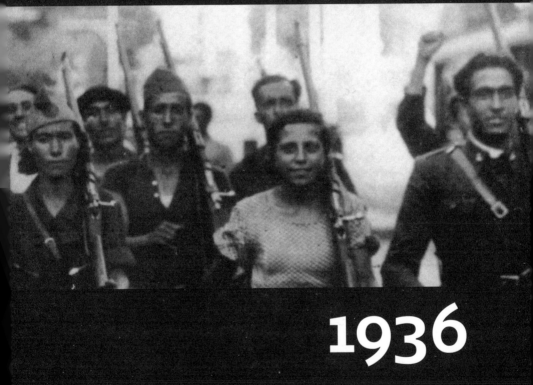

1936

The Spanish Civil War

Gilbert Achcar

The Spanish Civil War

The Spanish monarchy was in such poor shape in 1931 that results from municipal elections were enough to convince Alfonso XIII to give up power. An extremely heterodox republican coalition—ranging from the Spanish Socialist Workers Party (PSOE) and its affiliated General Union of Workers (CGT), to recently converted republican forces and separatists in Catalonia and the Basque Country—won the elections in urban centers, and soon after the April 12 elections the king left for exile, handing over power to those who won at the ballot boxes. This was a prudent decision because, as early as the following day, the strongest union federation in the country, the National Confederation of Workers (CNT) and its political nucleus, the Anarchist Federation of Iberia (FAI), convened a general strike to overthrow the monarchy.

A powerful tension gripped the nation, as we can see clearly in one photograph. In Barcelona's deserted streets, the members of the Guardia Civil and members of the political police search men at gun point who walk towards them with their hands in the air. The men are exiting a building that served as headquarters for a republican party, whose faith in victory was proclaimed by an electoral sign hanging from the second-floor balcony: "Victory: guaranteed."

The republican coalition won by a wide margin in the June 28 elections for the National Assembly, just at the moment when long-simmering social tensions reached a boiling point. From April forward, the anarchists—who refused to recognize the victories won at the ballot box, which they boycotted—carried on strikes as well as anticlerical actions. For the anarchists, the fall of the monarchy was only the prelude to a social revolution that they hoped to stimulate by means of direct action, undoubtedly embarrassing a republican coalition divided between a socialist left and a bourgeois right, which center-left republican leader Manuel Azaña could barely keep united.

Minister of war in the provisional government, Azaña was elected president of the governing council in October. One photograph shows him observing a military parade: he looks at his watch, seemingly bored among high-ranking officers, who belonged to a caste formed under the monarchy. Reassuring the army and businessmen would become Azaña's greatest concern. In this, he would be helped by Indalecio Prieto, the leader of the PSOE's right wing and minister of finance in the provisional government, whom we see surrounded by a detachment of police upon arriving at Madrid's city hall.

The great abyss between the social pressure from workers and peasants, which had been focused by the anarchists, and the demands of the military and the bourgeoisie would show itself to be unsustainable in the long run. This was the framework in which the Spanish Revolution unfolded. Social struggles continuously intensified, and the reforms introduced by the government under this pressure failed to pacify the workers and peasants. Thus, an agrarian reform law adopted in September 1932 could not stem the disturbances in the interior of the country. Neither could repression, no matter how brutal, stem the tide of revolution. In January 1933, in an anarchist commune named Casas Viejas in Cádiz, thirty militants died in a fire in a house in which they had sought refuge. We see their corpses laid out on the ground in the cemetery under the nauseated grimaces of reporters and police.

The Casas Viejas massacre accentuated divisions inside the left, as well as within the PSOE itself. The coalition ended up imploding, and the center-left republicans and the socialists ran on different tickets for the November 1933 parliamentary elections, in which they were defeated by the conservative right. From then on, social and political conflicts sharpened, while the right immediately began to dismantle reforms introduced by the previous government. Now freed from any inhibitions belonging to the previous left-leaning coalition, the government intensified its repression. We see a disturbing image of the *auto-de-fé* (act of faith), in which the Guardia Civil is overseeing the burning of "extremist" literature in December 1933—a direct echo of what was taking place at the same time in Hitler's Germany, as well as a more remote echo of the Iberian Inquisition and the origin of the term "auto-de-fé."

The cycle of strikes, insurrections, and repression continued to intensify, culminating in October 1934 in an uprising by Catalan separatists and an insurrection by Asturian miners, both of which met with severe repression. The revolutionary commune, proclaimed on October 5 by coal miners in the Oviedo region of Asturias—with the participation of the entire radical left, including the socialists, led by its left wing—was brutally suppressed some days later, with Foreign Legion and Moroccan units intervening. General Franco participated in the command of this terrible repression, which left more than 1,000 dead and many thousands from across the country imprisoned (between 20,000 and 30,000 according to some estimates). One photograph depicts the militants' response: leading a unit of miners wearing Basque berets who have been detained in a forest and are being guarded by men from the Guardia Civil, a woman in a striped apron marches with pride and determination, while in the fourth rank, a young miner shows off a wide smile; these are workers who still have faith in what the future holds for them.

In the coming months there would be military tribunals convened to judge detainees. Four militants who appeared before the Council of War would be condemned to live in prison. In another photograph, we see

Francisco Largo Caballero before the tribunal: the historic leader of the PSOE had become a leading figure for the left wing of his party. He assumed political responsibility for the Asturian insurrection. His detention would considerably boost his popularity, and he would come to be called the "Spanish Lenin."

In the meanwhile, the right-wing government had become wrapped up in ministerial crises and financial scandals. In the fall of 1935, the campaign of the unified republican left won enormous support, as was shown by the gigantic assembly in Madrid where Azaña led a crowd estimated at 350,000 people. In order to prevent further governmental instability, the parliament was dissolved in January 1936 and new elections were called for the following month. A Popular Front composed of republicans led by Azaña, socialists, communists, left-wing separatists, and even "Trotskyists"—or at least those taken to be—from the Workers' Party of Marxist Unification (POUM) was created in the midst of this situation. It promoted a moderate social program and demanded amnesty for all people implicated in the events of October 1934.

In the parliamentary elections on February 16, 1936, the Popular Front won a resounding victory, with a large majority of seats in parliament, allowing Azaña to once again lead the Spanish government before becoming president of the Republic in May. Amnesty was decreed on February 22 and, amidst widespread jubilation, political prisoners were freed, as we can see in the photo showing crowds in front of the Barcelona prison and in the triumphal procession of Lluís Companys, president of the Catalan government, who was imprisoned along with his ministers after the separatist uprising. Or yet again in the photo of Dolores Ibárruri, the celebrated communist known as La Pasionaria, speaking to a mass meeting in Madrid after her liberation—she had been sentenced to fifteen years in prison after the Asturian insurrection.

Once more, left-wing electoral victory served to catalyze social and political radicalization. This time, however, the radicalization immediately

divided the left's ranks: against the wishes of Prieto, the socialists led by Largo Caballero refused to participate in Azaña's government, or in that of his successor, Santiago Casares Quiroga, whom Azaña named to replace him after assuming the presidency. Thus, the cabinet was limited to republicans of the center-left while the Popular Front parties had to contest the terrain of social radicalization with the anarchists in a sort of political competition that began soon after the 1936 elections.

The Stalinists of the Spanish Communist Party (PCE), galvanized by La Pasionaria's popularity, also took advantage of the legitimacy that flowed to them as a result of the radical turn of the PSOE's left wing. The photo of a meeting in a movie theater, in which Largo Caballero appears to be speaking, clearly illustrates this fact: "Long live the united front," proclaims a red banner, with a likeness of Marx at the center, Lenin to the left, and Pablo Iglesias, the founder of the Spanish Socialist Party and the Spanish General Workers' Union (UGT), to the right. "Long live Marxist unity," professes another, and "Long live revolutionary Marxism," declares a third. Each is adorned with the communist hammer and sickle and the Socialist Youth star. This last organization would merge with the communist youth in April 1936, thereby founding the Unified Socialist Youth (JSU), which would fall under the control of the PCE shortly thereafter. A similar operation, with an identical political outcome, took place in Catalonia: in July, the Unified Socialist Party of Catalonia (PSUC) was launched and became the means by which the Stalinists absorbed Catalan socialists.

In the spring of 1936, social and political tensions escalated rapidly, and the Right hardened. The celebration of the fifth anniversary of the Second Republic was interrupted by an attempted bombing in Madrid and led to confrontations between left-wing militants and members of the Falange fascist party. Starting in May, worker and peasant struggles reached new heights in major cities and regions across the country. These workers— posing in front of a factory after having kicked out the managers, with raised fists and smiles—plainly illustrate renewed working-class

confidence. Working-class trade unions and political organizations were the only real bases of support upon which the government could count.

The situation was intolerable for the Right and the ruling classes, and this pushed the conservatives and reactionaries of all strikes to unite with the fascists in the military, risking everything. The Popular Front's electoral victory in France, in the spring of 1936, inflamed their anxieties and pushed them to act. On July 17, army units located in Spanish territories in Morocco rebelled against the government in Madrid. They were followed, on July 18, by a military insurgency in Spain itself. The mutineers were initially victorious in the west of Andalusia, taking Seville and Cádiz, in the north. They also seized control of the provinces of Galicia, León, Castile, and Navarre, as well as a part of Aragon. A photo of civilians lined up in the sun, hands over their heads, in the town of Utrera, outside of Seville, while soldiers search them, is a classic image of a twentieth-century military putsch.

The insurgency was held in check in other regions, especially in the country's two largest cities, its capital, Madrid, and the Catalan metropole Barcelona. In these, as well as in other regions that remained loyal, trade unions and militants of the left-wing parties played a decisive role in aborting the putsch. The same scenes were repeated everywhere, as shown in one photo, taken on July 18 in Madrid, in which two militia members pose in front of a car that has been requisitioned by a workers' organization and transformed into a military vehicle, while a woman sits in the front seat holding her raised first out the window. Or another image of a barricade constructed from paving stones in Barcelona, behind which stands a fairly representative sample of the age groups joining the popular militias: the young, the not-so-young, and the very young. The improvised militias seem to be enjoying themselves as if they were at target practice. When Prime Minister Casares Quiroga resigned, another member of the moderate Left succeeded him on July 19—José Giral, who accepted the conditions imposed on him by socialist leaders, namely, the distribution

of arms to unions and left-wing militias. Immediately, 50,000 rifles were put at the disposition of popular organizations in Madrid; however, cartridges were not. These were stored in the Montaña armory, which was occupied by military insurgents and Falangist militias. On July 20, the armory was taken by assault led by leftists in Madrid, producing reverse images in which, now, it was the uniformed soldiers—in this case, the officers of Montaña—who were raising their hands over their heads while they were being searched by civilians. In this photo, the man at the front of the march is holding his rifle in both hands and is dressed in a suit and tie! The armory's new occupants hardly look similar to its previous ones: in the courtyard, a militia member seems to be enjoying himself alongside a proud mother with a girl on her lap. The little one raises her left fist in the air and holds an automatic pistol with her right one, at least long enough to pose for a photograph ... one that made it all the way to us.

The deep intertwining of the church and the monarchist, conservative state in Spain, as well as the anticlerical thrust of the anarchist movement, ensured that revolutionary explosions in the 1930s regularly rebounded against clerics and religious buildings and symbols. The anguish created by the military insurgency of July 1936 accentuated the extravagances of this antireligious behavior to an even greater degree, which itself was subjected to superstition because it was manifestly associated with exorcism. This antireligious behavior was pronounced among militias, who in one photo seem to take pleasure in committing some form of sacrilege, exhibiting various objects tossed out from a church, and even more clearly in another photo in which a group of men take aim at an image of Jesus Christ, as if they are part of a firing squad, near Madrid. The woman with her hands on her hips who is observing them must be thinking that these are just overgrown children.

In this Spanish Civil War, which had only just begun and would soon produce horrendous massacres and abuses on both sides, women were on the front line from the beginning and they were active on the Left. However, this is not obvious from the line outside the workers' militia recruitment

center in front of the Havaí theater in Barcelona. We see mostly men and, as if to accentuate the photo's machista tone, the publicity posters on the wall are left over from the last hit movie screened there, entitled *Your Woman Is Mine*. These men, several of whom have their hands in their pockets, almost seem as if they are waiting in an unemployment line in front of an employment agency. In fact, with time, this would more and more often be the case: for many people who were unemployed because of the war, enlisting in the militias, and later the army, would be the only way to find some income, as modest as it might have been.

However, during these first days of the civil war, the workers' uprising against the military insurgency would turn into revolution. Formidable popular energy, especially in the Catalan capital, was channeled into the union and political organizations that would form the Central Committee of Antifascist Militias. The Barcelona commune, endowed with its own National Guard Central Committee, differed from the Paris Commune only in its lack of an elected and revocable council. A version of "War Communism"—but one that would have a much happier ending than the Russian original—would be installed during the first months of the revolution. In the midst of land and industrial collectivization, committees distributed food to the population. In one photograph, we see a truck filled with food in front of a CNT-FAI food committee distribution center.

During the first months, women did not limit themselves to this type of activity like the cooks and nurses in the Paris Commune; they fought in the militias from the beginning. Armed men look over a Catalan militia poster of a woman brandishing a rifle, encouraging the viewer to enlist with the slogan, "The militias need you." And we see determined women in a militia unit photographed as they march to the Aragon front, the main target of Catalan mobilization.

In order to pry Zaragoza from the insurgents and expel them from Aragon, Barcelona provided enormous reinforcements. All available forces were sent to the front, including both militias and loyal regular army soldiers. The

difference between both types of troops tended to diminish during the first phase of revolutionary mobilization. We see the regular soldiers on their way to the front, marching down Barcelona's great avenue as if they are in a military parade, surrounded by large crowds huddled on the sidewalks, some individuals even hanging from lampposts or trees. The scene hardly appear martial or disciplined. The militias are also on the march with their improvised equipment, as are the anarchists who are transporting an artillery piece in a civilian truck, not to mention mattresses instead of sleeping bags. The diversity of berets and hats caught the eye of George Orwell, who observed that the kinds of hats serving to cover the militia members' heads was nearly as numerous as the people who wore them.

At the head of the first unit of reinforcements leaving Barcelona for the Aragon front on July 24, we see legendary anarchist hero Buenaventura Durruti riding in a beautiful convertible (another requisitioned car) painted with the CNT-FAI letters. He would command this unit that will be named for him. In the background, we see trucks transporting militias and mattresses. Durruti, whom we see one more time among the militia with binoculars around his neck, understood his unit's double objective: fight the insurgency militarily and revolutionize the liberated regions where "free communes" would be created.

Still, the support provided to the fascist insurgents by the German and Italian air forces starting at the beginning of August permitted a massive transfer of Moroccan troops and Foreign Legion units to advance towards Andalusia, where General Franco would take command. The famous photos of the Foreign Legion's taking of the village of Constantina, to the northeast of Seville, gives one goosebumps. They show the villagers— mostly women because many men have probably fled or else are in hiding to escape the slaughter—pleading with the soldiers, as is the case with the woman we see holding up a white sheet out in front of her door. Perhaps she thinks that this type of bull, which the smallest red flag would enrage, might be calmed by the sight of a white cape. In another photo, we see a

truck returning to Seville, probably carrying prisoners guarded by Moroccan soldiers.

The Moroccan infantrymen of the Spanish army developed a terrible reputation for massacres and rapes during the Civil War. Poor, uneducated draftees, they were recruited for a fight that was not their own; in fact, the war served the interests of their immediate oppressors. The violence was taken further because the Moroccan soldiers were encouraged by their officers, and they found for themselves a kind of compensation in attacking the compatriots of those who had conquered their own country. The revolution didn't know how to win the poor Moroccan soldiers over to their own cause; they failed to affirm their will to end Spain's colonial domination of Morocco because they feared displeasing the friendly colonial powers, France and the United Kingdom.

At the head of the Moroccan troops, the fiercest in the Spanish army, Franco would begin his inexorable advance towards the north. The still-enthusiastic mobilization in the republican camp would not be able to do anything. The trains departing for the front, filled with volunteers, like the young militia members we see with their fists in the air in the Barcelona station, returned each time loaded with more and more wounded and maimed. The insurgent troops were not only better trained, they were also much better equipped, thanks to support from Nazi Germany and fascist Italy.

Not even the improvised armored vehicles built by metal workers—like the CNT tank we see in Barcelona that seems like it might be destined for a science-fiction B-movie—can compensate for the technical inferiority of the Left's forces. Still less effective are the militias' magnificent cavalry animals, which Orwell lamented were not spared. (Orwell wrote something similar with regard to the Belgian militia commander Georges Kopp, who might be the rider in the background of the photo, looking at the rider carrying the POUM banner.) And what can be said about the donkeys and mules that the militias in rural regions used because they lacked other

means of transportation? The photo of a militia woman mounted on a donkey as she checks passengers in a vehicle only goes to show the revolutionary militia's poverty, which is also illustrated by the image of an anarchist militia unit passing through the Arc de Triomf in Barcelona.

Some days after, hardly a month after the beginning of his offensive, Franco managed to meet up west of Madrid with insurgent troops from the north who were advancing in the opposite direction under the command of June's most important rebel, General Emilio Mola. A photo shows the two generals reunited in Burgos, the provisional capital of the insurgency. Franco sports a satisfied smile, while Mola appears more worried. A month later, Franco was promoted to generalissimo and provisional head of the reactionary junta, and proclaimed himself head of state, to Mola's detriment.

The gravity of the situation at the beginning of September convinced the socialists and their Stalinist allies to assume the responsibility of taking power. The popular Largo Caballero—who we see carrying a rifle, at age sixty-seven, amongst a group of smiling militia members at the Guadarrama front to the north of Madrid in a photo designed to raise the morale of the republicans—formed a new government in which socialists, center-left republicans, and two communist ministers participated. For their part, the CNT and the POUM joined the Governing Council of Catalonia, after acting as parallel powers from their base in the Central Committee of Antifascist Militias.

The new government would be put under immense pressure when the Stalinists launched campaigns for "republican" order and moderation. Their influence did not extend as far as their strength—they remained a secondary political force despite growing rapidly—but they had a close link with the USSR, the only external support on which the Spanish Republic could count. The considerable crowd that stood on the wharf in Barcelona's port in October to welcome the Soviet cargo ship *Zirianin*, one of the first Soviet ships to bring aid to the republicans, clearly

demonstrates the prestige Moscow's local partisans gained from their support.

In the same way, the combatants of the International Brigades, who began to arrive in great number after the Comintern decided to organize them, reinforced the PCE's influence because the majority of them were Stalinists under the command of Stalinists, like those in the German Thaelmann Brigade, named after the German Communist Party leader imprisoned by the Nazis. The PCE was relatively stronger in Madrid than in Barcelona. In a parade of children recruited in the capital city, a three-foot-tall girl seems to have difficulty carrying a banner dedicated to the Union of Proletarian Brothers and Sisters (UHP) that is bigger than her. Behind her, an adolescent carries a portrait of La Pasionaria that illustrates the religious character of the Stalinist faith: emerging from a shining aura, the communist leader is crowned by a sickle that appears to trace a halo over her head.

In the early days of November, shortly before the military offensive against Madrid, the anarchists decided to join Largo Caballero's government. Madrid would valiantly resist this offensive during an epic battle in which the International Brigades would stand out for the support they provided. The reactionary offensive would be defeated. The republican camp needed this victory after suffering a series of devastating defeats, and the joy we can see on the faces of Madrid's militia fighters testifies to this. How many flamencos must have been danced by militia men and women with rifles slung over their shoulders to celebrate a victory that would soon become legendary!

But the battle of Madrid also cost the life of the illustrious Durruti, who came to the city's aid at the front of his unit of militias. The death of the anarchist leader, who was assassinated in obscure circumstances, marked a symbolic turn in the Spanish Civil War. Barcelona would provide a hero's burial. In the photo, we see his coffin, covered in a red and black anarchist flag, carried on his comrades' shoulders. Their expressions are somber: a living legend has been extinguished, taking with him a part of

the extraordinary, liberatory hopes of the first months of the Spanish Revolution. The list of leading personalities who participated in the funeral procession includes a man with a long nose and heavy rimmed glasses walking arm in arm with Lluís Companys: this is Vladimir Antonov-Ovseyenko, the prestigious coleader of the October insurrection of 1917 and a former collaborator of Trotsky's—before he turned on him and was sent by Stalin in 1936 as the Soviet general consul to Barcelona. He was later recalled to Moscow and "judged" in the "Rightest and Trotskyist" trial and executed in 1938.

And it was this same Antonov-Ovseyenko who secured the dismissal of Andrés Nin, the leader and theoretician of the POUM, from the governing council in Catalonia, culpable in Stalin's eyes for condemning . . . the Moscow show trials! The following months would bear witness to the Stalinist's dominion spreading to the central institutions of the Spanish republican state, charting a course that certain Eastern European countries would come to know after the Second World War. It is in this period, beginning in December, that George Orwell lived in Catalonia, which he so vividly described in *Homage to Catalonia*. We see him at the end of the line, a head taller than the other militia members, in a photo shot in front of the POUM's "Lenin barracks" in Barcelona.

Pressure from the PCE and Moscow on Largo Caballero's government intensified during the first months of 1937, when the prime minister himself became the target of Stalinist attacks. This pressure was concentrated in particular on a demand for the "militarization of the militias" for the benefit of the regular army, which the Stalinists defended in the name of improving the efficacy of the antifascist fight, receiving support for this policy from Prieto, the minister of the navy and aviation. The same argument served, more generally, to demand the reestablishment of the state, social, and economic bourgeois order. And since the principal obstacle to these policies was the revolutionary axis constituted by the anarchists and the POUM, it was necessary to liquidate the latter and force the former to

bend because they were too strong to be eliminated. The site for this operation was Catalonia, the bastion of the extreme anti-Stalinist left.

After confrontations in April with the anarchists over control of border-crossing posts in the Pyrenees, the fight would turn to control over the central telephone exchange in the Catalan capital, which would be attacked by government troops, which were deployed on May 3, 1937, under orders from the councilor of public order of the Generalitat—Catalonia's central government—and a member of the PSUC. This would result in intense confrontations between anarchists—aided by the POUM—and the police, reinforced by shock brigades from Valencia, the seat of the republican government since it had fled Madrid. The May Days were written about by George Orwell, and they are some of the central scenes in Ken Loach's movie *Land and Freedom* (1995). The paving stone barricades, photographed on May 7 after the confrontations, were not raised against an attack from the reactionaries, but from an attack within the republican camp itself—an attack whose nature was clearly revealed by the ranks of shock troops signaling the reestablishment of "order" in Barcelona's streets some days after the fighting. Everything is there in the moving contrast between this image and the images of revolutionary militias on parade.

The May Days precipitated the unraveling of events. The Stalinist ministers pressured Largo Caballero to ban the POUM and repress the anarchists. Faced with the old socialist leader's refusal, the Stalinist ministers resigned, forcing the government's collapse. On May 17, a new cabinet is formed under the socialist president Juan Negrín, who was allied to the PCE, and Prieto is named minister of war.

In June, the POUM leaders, considered responsible for the May confrontations and accused of "espionage" by the Stalinists, were detained by police controlled by the Stalinists with support from "special" agents sent from Madrid. Nin would be assassinated by Moscow's agents soon after his kidnapping, while his comrades would be subsequently "judged" and condemned to prison. Albert Camus would describe the POUM founder's

death as a "turning point in the tragic twentieth century, the century of the betrayed revolution."

The Council of Aragon, dominated by the anarchists and recognized by the previous government, was dissolved in August 1937. Decollectivization measures were adopted, while the sinister Military Investigation Service (SIM) was created, controlled by the PCE and agents from Moscow.

The Spanish Revolution, strangled in the name of the Republic, entered its final agony. In less than two years, it would succumb in turn.

Timeline

1931

4/12: The republicans win urban municipal elections.

4/13: The anarchist CNT calls a general strike.

4/14: The provisional government is formed. The republic is proclaimed. King Alfonso XIII departs for exile.

6/28: The republican Left takes a majority of seats in the Constituent Assembly.

10/14: Azaña is named head of government.

1932

September: Catalonian autonomy. Agrarian reform.

1933

January: Repression of a liberated commune in Casas Viejas.

1934

October: Miners' insurrection in the Asturias. Bloody repression, in which more than 1,000 are killed, and more than 20,000 detained, across the country.

1935

July: Seventh Comintern Congress in Moscow. Adoption of antifascist Popular Front policy.

1936

1/15: Founding of the Popular Front (center-left republicans, PSOE-UGT, PCE, POUM).

2/16: Victory of the Popular Front in parliamentary elections. Azaña forms new, exclusively left government.

2/22: Liberation of political prisoners.

4/07: Azaña becomes president of the Republic and names Casares Quiroga prime minister.

May–June: Wave of strikes. Tension between the Right and the Left.

7/17–18: Military insurrection in Morocco and Spain.

7/19: Giral becomes head of the government. Arming of the militias.

7/21: Central Committee of Antifascist Militias created in Catalonia.

August: Large transfer of troops from Morocco to Spain.

9/03: Insurgent fascist troops converge from north and south in Talavera.

9/04: Largo Caballero forms a new government of the PSOE, PCE, and center-left republicans.

9/26: The CNT-FAI and the POUM join the Catalan government. End of the Central Committee of Antifascist Militias.

10/01: As the generalissimo and head of the insurgent government, Franco declares himself head of state.

11/04: The CNT enters the government of Largo Caballero.

November: Battle of Madrid. Intervention of International Brigades. Defeat of Franco's offensive.

11/10: Defeat of Durruti at the Madrid front.

12/17: Expulsion of POUM from the Catalan government.

1937

5/03–05: The CNT-FAI and the POUM confront the Catalan Generalitat.

5/17: Largo Caballero is forced to resign. Negrín forms new government.

6/16: POUM leaders are imprisoned following Nin's assassination.

8/11: Dissolution of the Council of Aragon, controlled by the anarchists.

8/15: Creation of the SIM, political-military police controlled by the PCE and Moscow.

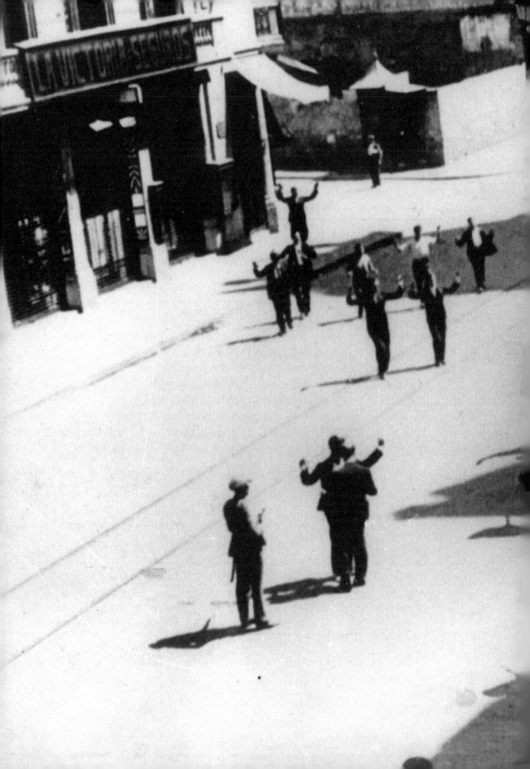

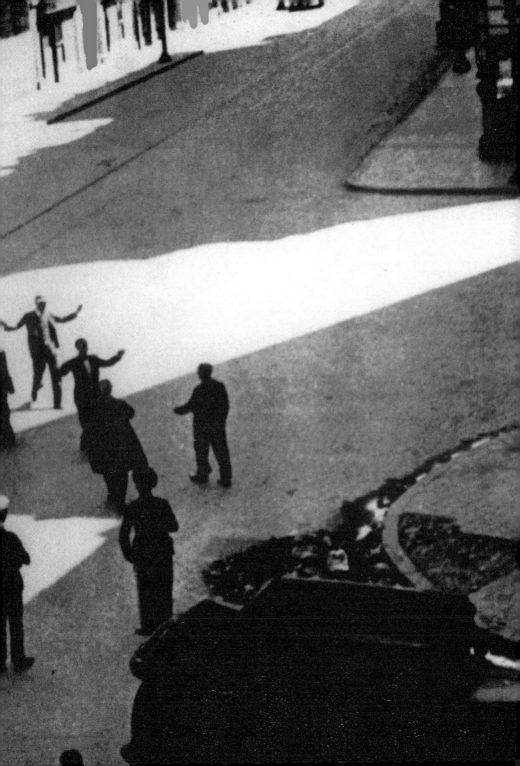

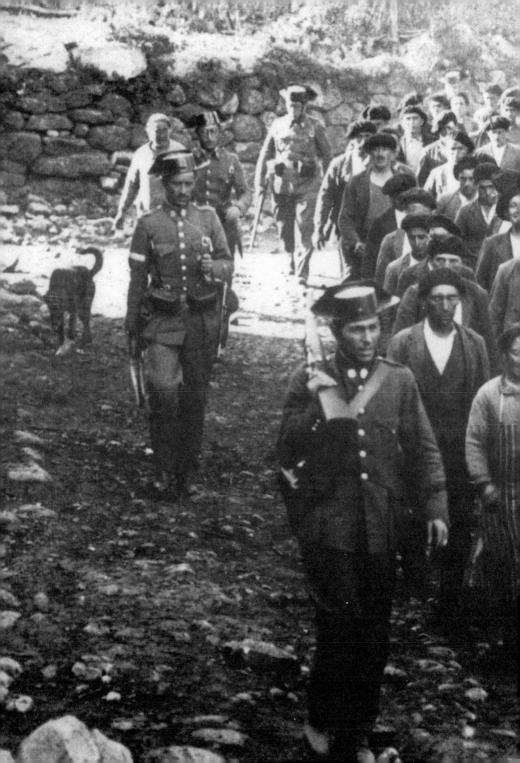

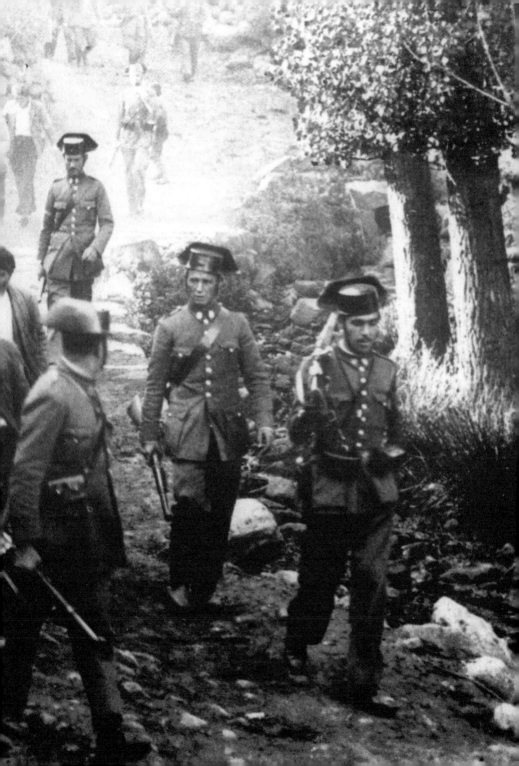

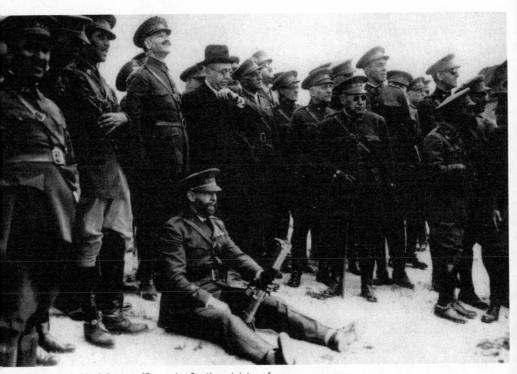

Surrounded by infantry officers, Azaña, the minister of war,
attends a military exercise.

Pages 386–87: In Barcelona, people are searched by the Guardia Civil and members of the
political police in 1931.

Pages 388–89: In a forest in the outskirts of Las Bransoreras (Asturias), a group of miners is
marched at gunpoint by the Guardia Civil after insurrectional strikes in October 1934.

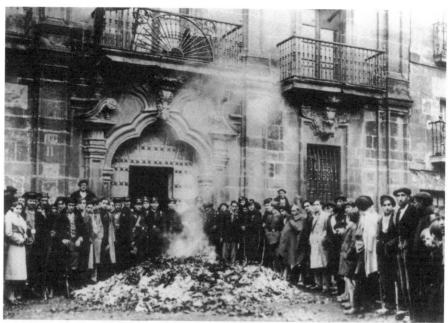

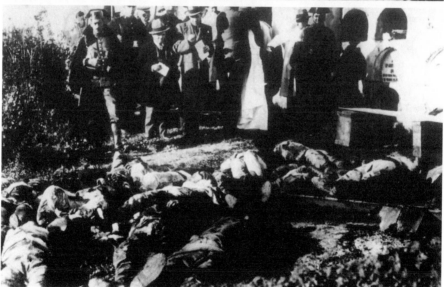

Above: A book-burning of "extremist" materials supervised by Guardia Civil in Briones on December 23, 1933.

Below: After repressing a revolt, corpses are laid out in the Casas Viejas cemetery in the province of Cádiz as police and journalists look on in January 1933.

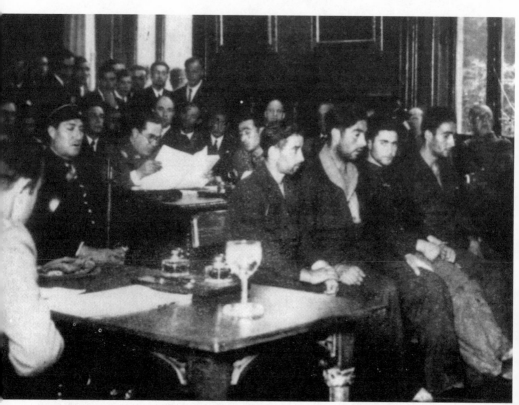

Four Asturian militants are tried by a council of war in October 1934 and are sentenced to hard labor for life.

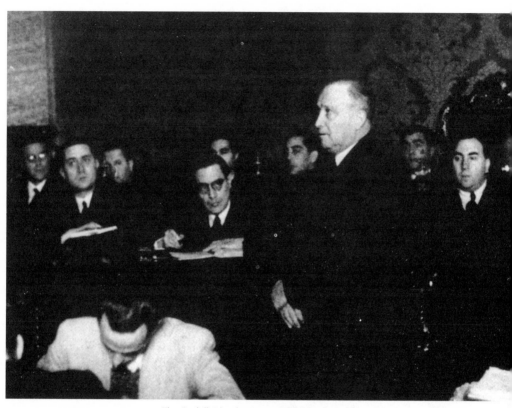

The Socialist leader Largo Caballero during interrogations in Madrid, 1935.

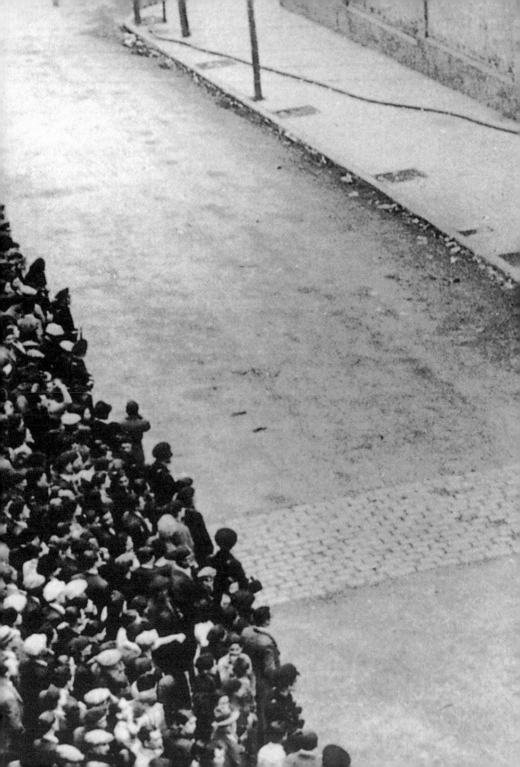

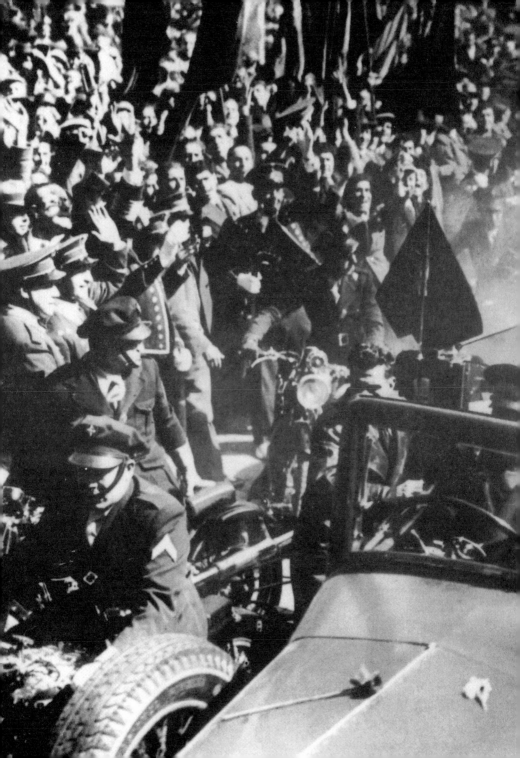

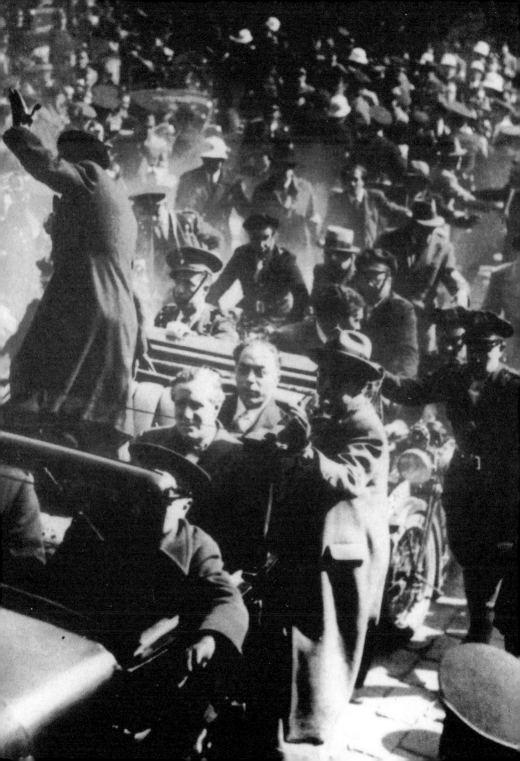

Mass meeting in the Cinema Europa in 1936.

Pages 394–95: Anti-Falangist demonstration in Barcelona in April 1936.

Pages 396–97: Lluís Companys receives a triumphal welcome in Barcelona on March 7, 1936, and is elected president of the Generalitat of Catalonia after his release from prison.

Shortly after her release from prison, Dolores Ibárruri—La Pasionaria—speaks to a rally in Madrid on February 29, 1936.

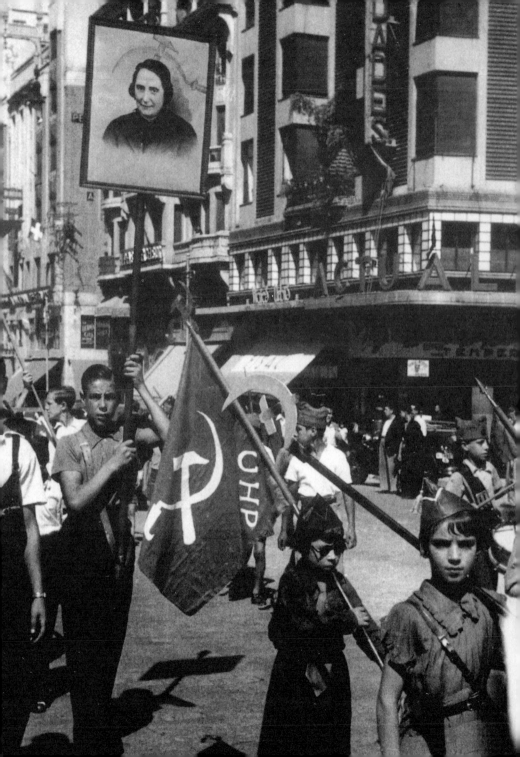

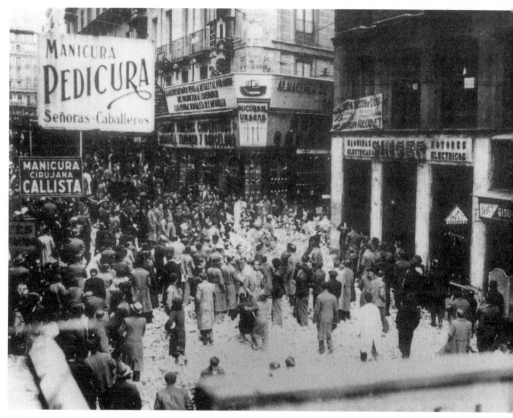

Anti-Falangist demonstration on April 17, 1936.

Previous page: In a communist march in 1936, a girl carries a red flag for the Union of Proletarian Brothers and Sisters (UHP) while a teenager carries a portrait of La Pasionaria.

Tram service is nationalized in Ciudad Lineal on the outskirts of Madrid in 1936.

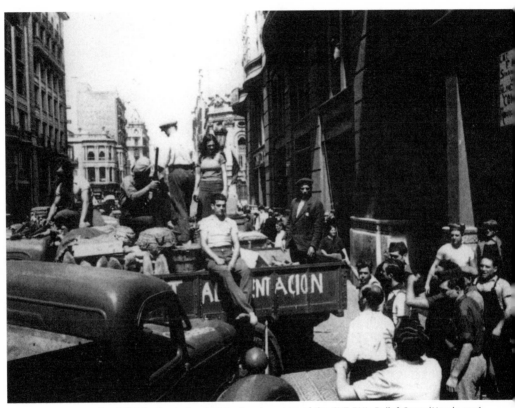

Food distribution in front of the headquarters of the CNT-FAI's Relief Committee in 1936.

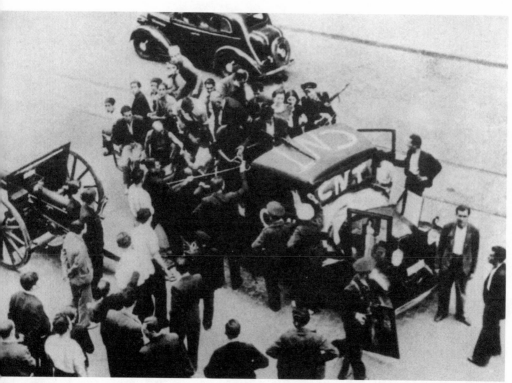

A truck confiscated by the mass anarchist union, the CNT, distributes arms to the population in Madrid in 1936.

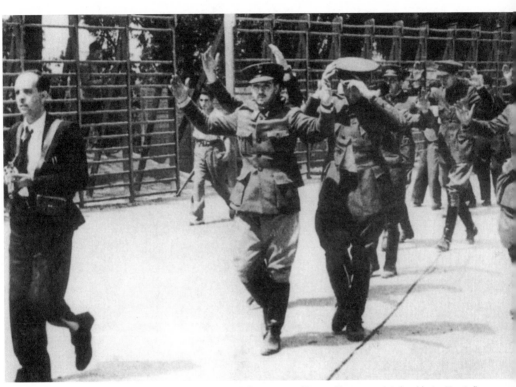

In Madrid, insurgent military officers are detained in La Montaña
by armed volunteers in the people's militia in June 1936.

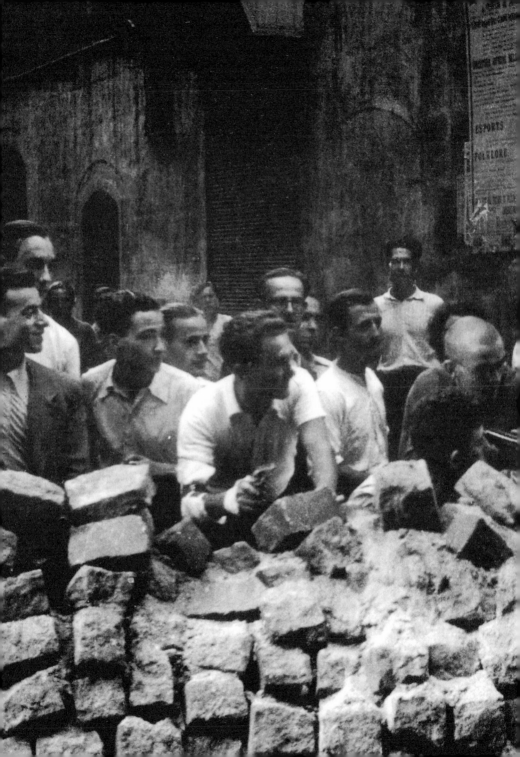

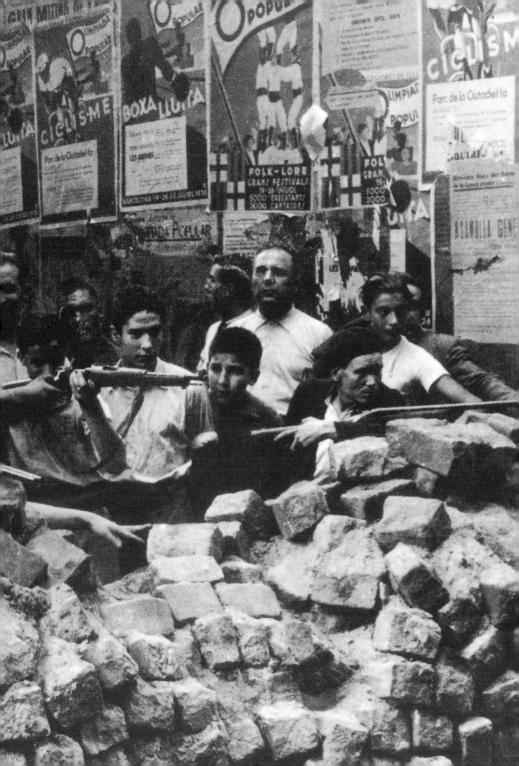

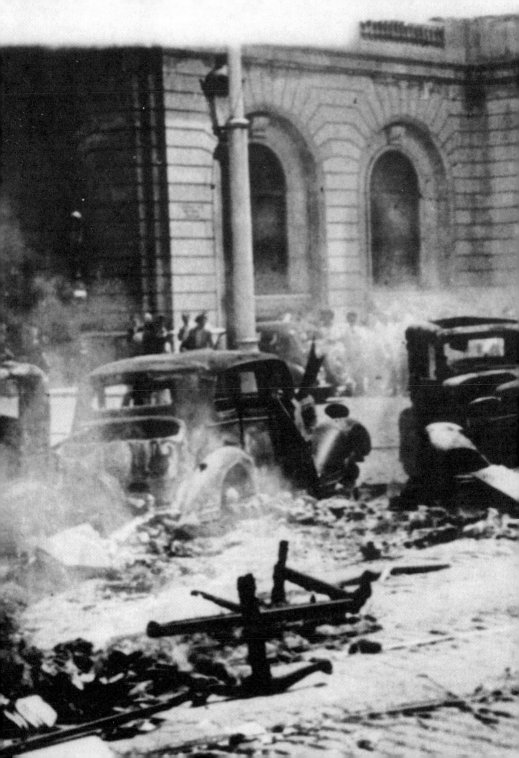

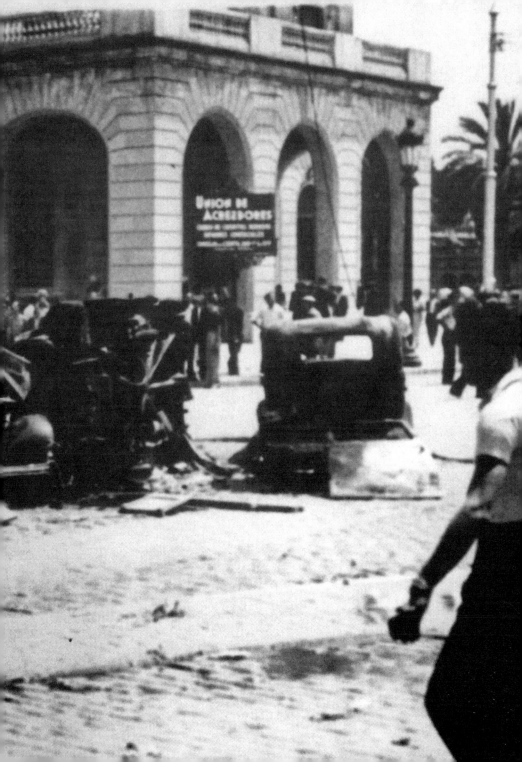

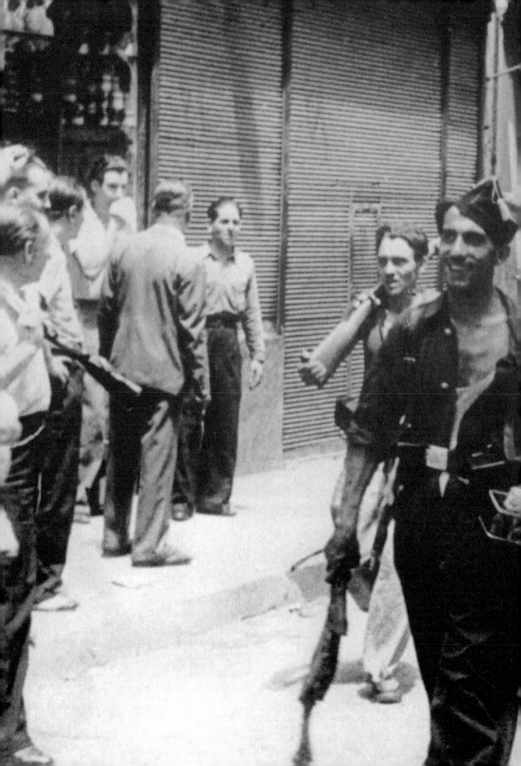

Group of militia members dressed with items seized from the Catholic Church.

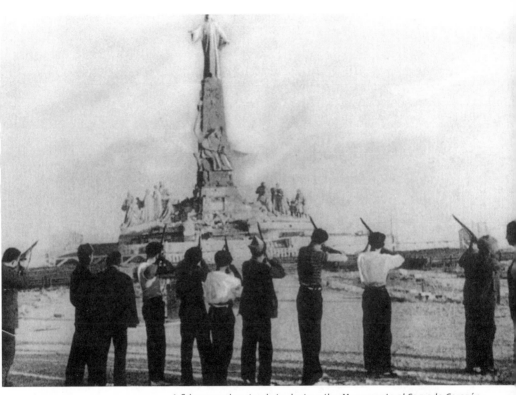

A firing squad pretends to destroy the *Monumento al Sagrado Corazón* on the Hill of the Angels outside Madrid in 1936.

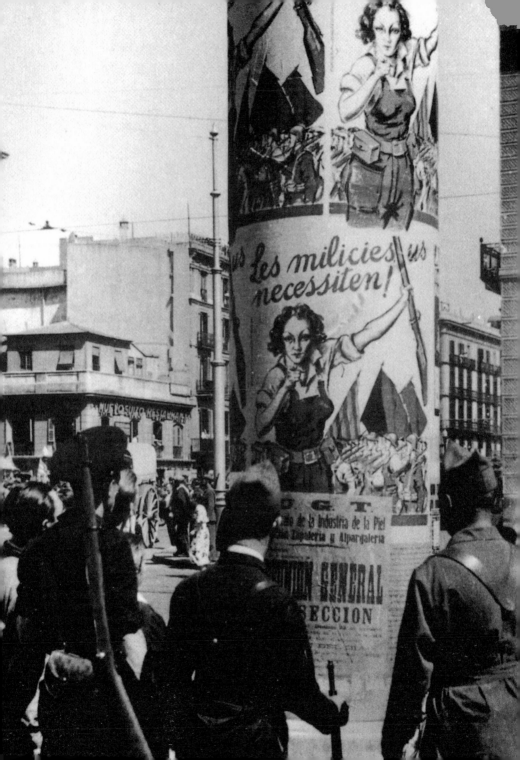

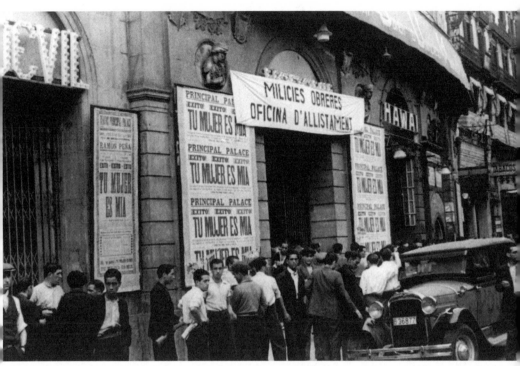

Volunteers line up outside the Havaí cinema, which was turned into a recruiting office for workers' militias in 1936.

Previous page: "The militias need you!" Poster in Madrid, 1936.

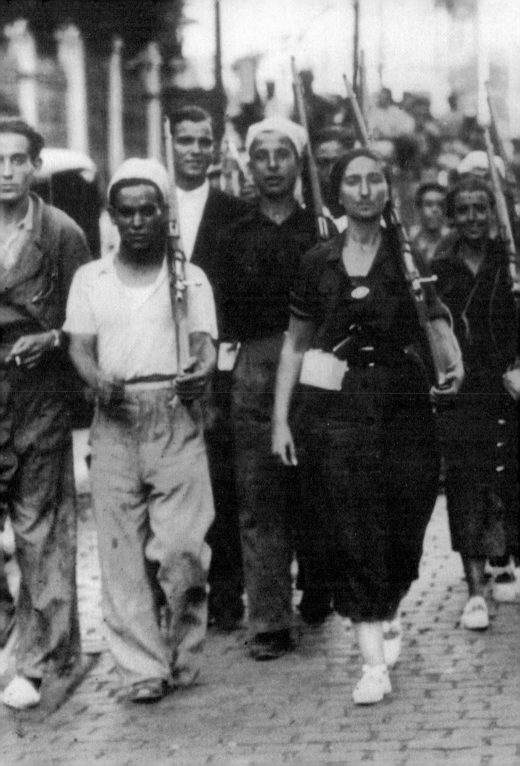

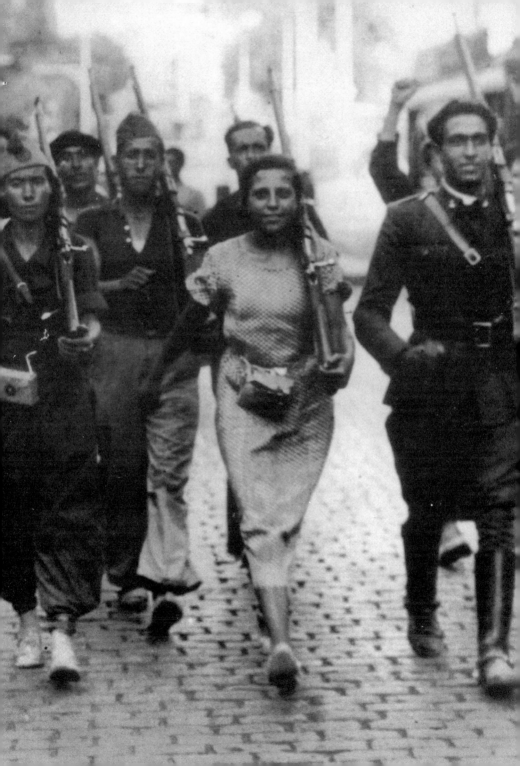

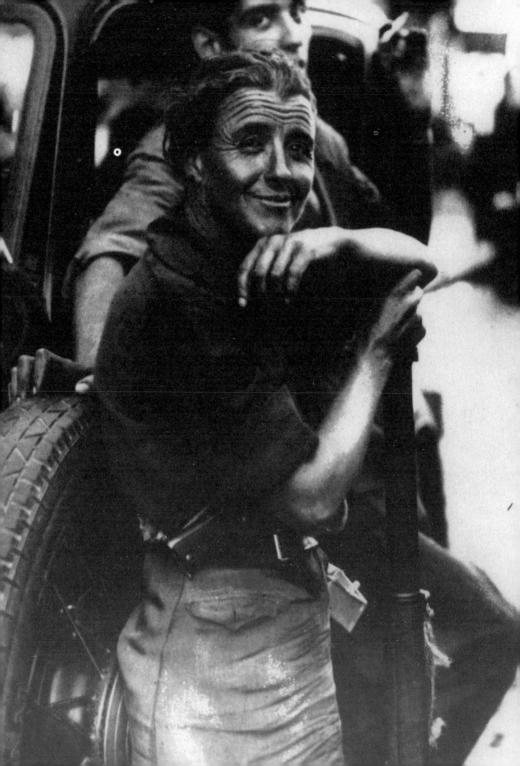

Anarchist militias on the road to the front with a cannon mounted on a civilian truck in 1936.

Previous two pages: Men and women volunteers in the popular militia in Zaragoza in 1936.

Previous page: A militia member rests on her rifle in Madrid in July 1936.

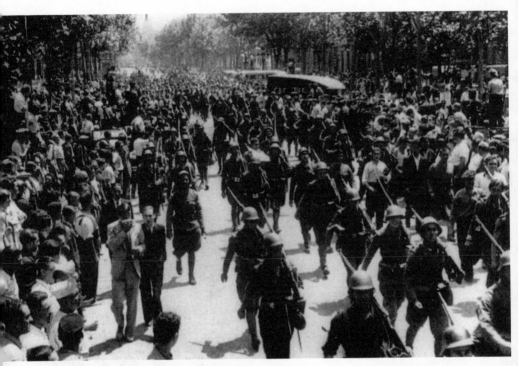

In Barcelona, troops loyal to the republican government are sent to combat the insurgent fascist troops in Zaragoza in July 1936.

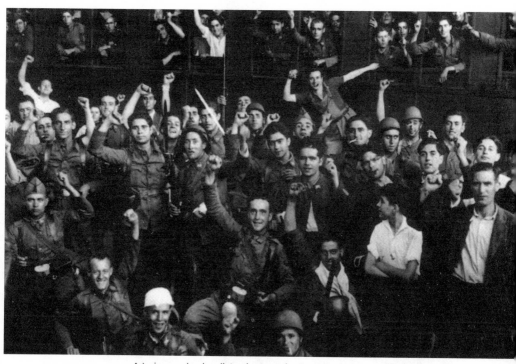

A train carrying loyalist volunteers leaves Barcelona to join the fight in July 1936.

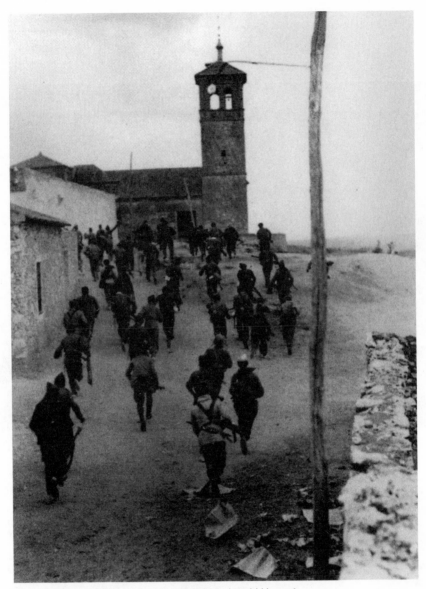

Militia fighters on the road connecting Toledo and Madrid in 1936.

Next page: After leaving the Bakunin barracks, the Garcia Oliver column passes through the Arc de Triomf in Barcelona on their way to the northern front on August 28, 1936.

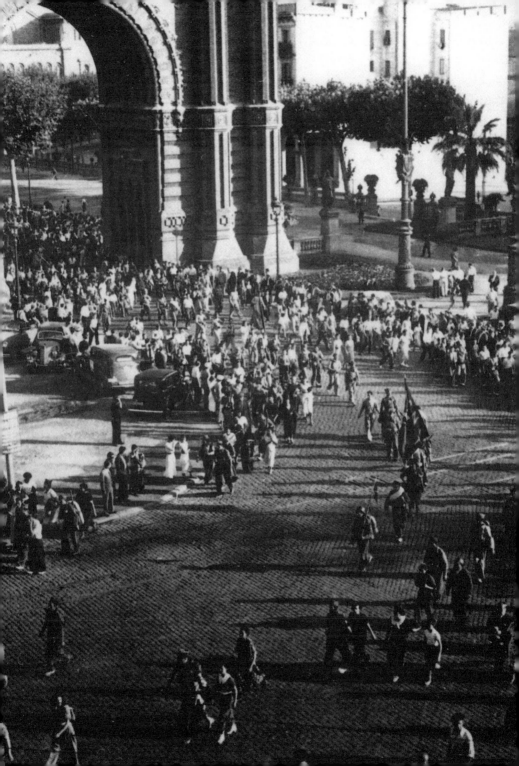

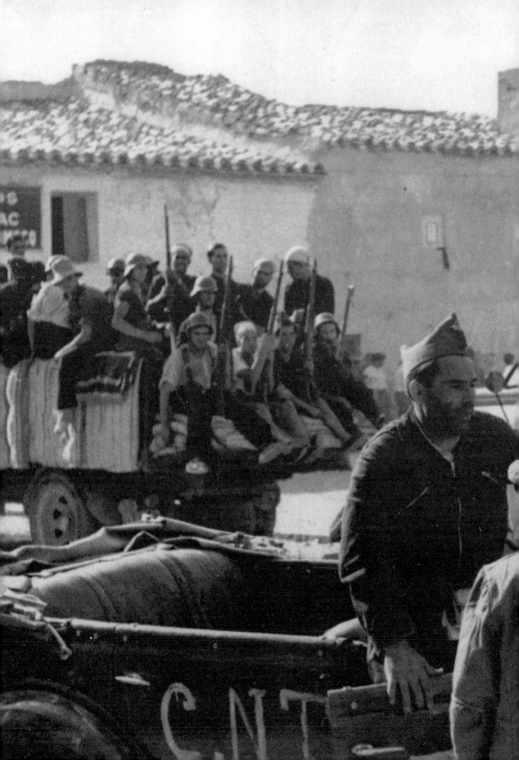

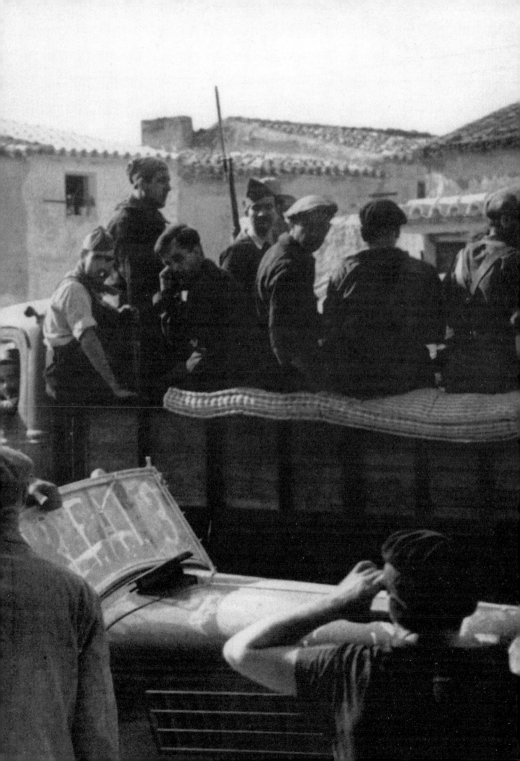

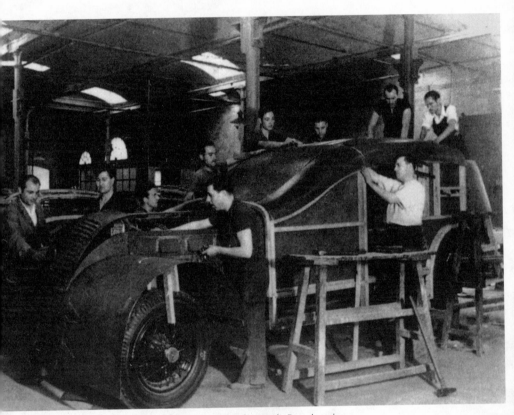

Workers build armored cars in the Hispano-Suiza factory in Barcelona in 1936.

Previous two pages: Part of the first column of reinforcements on the Aragon front arrives on July 24, 1936. José Buenaventura Durrati commands one of the anarchist units.

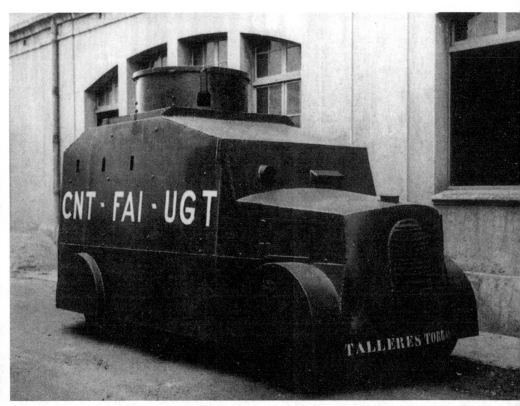

Armored car on a Barcelona street in 1936.

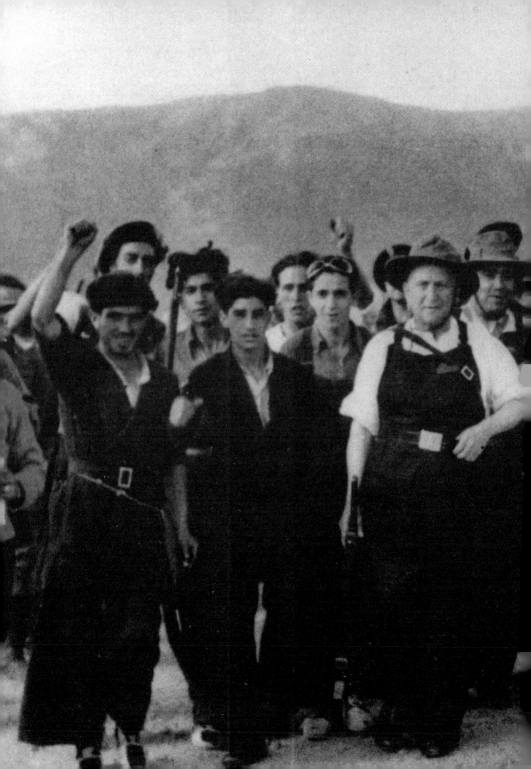

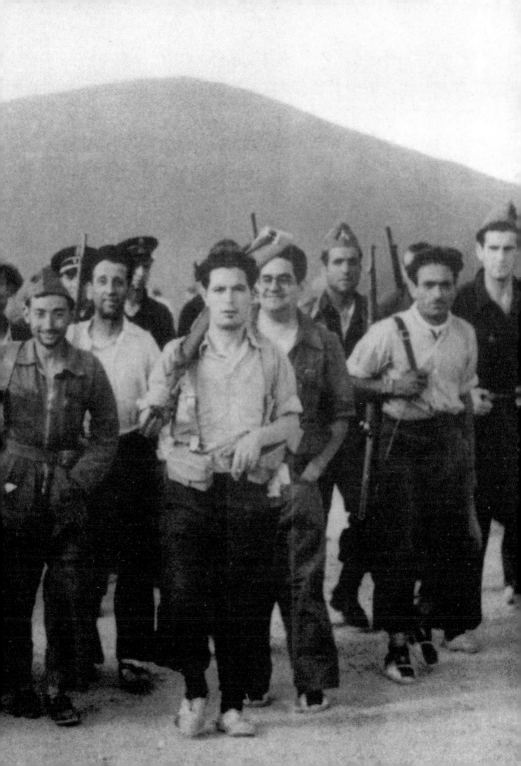

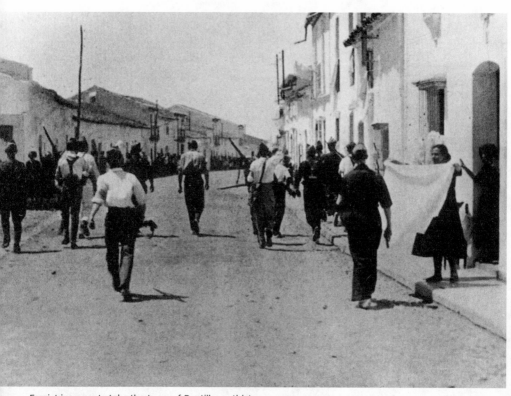

Fascist insurgents take the town of Pantillana, thirty
kilometers northeast of Seville, on August 15, 1936.

Previous two pages: Largo Caballero, leader of the Popular Front,
with his militia members at the Guadarrama front in August 1936.

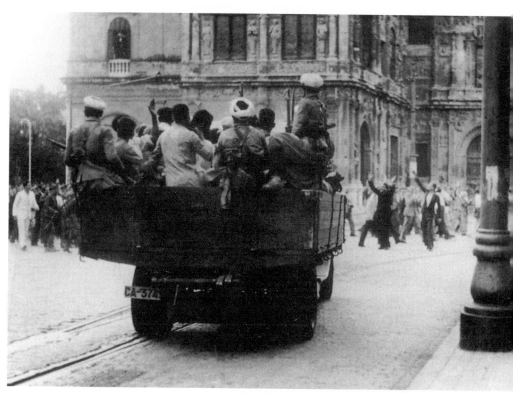

After the fascist General Queipo de Llano takes Seville, his troops return from the Choron front with prisoners.

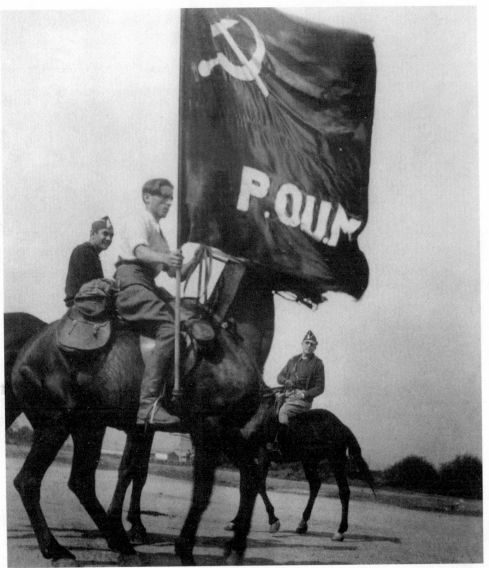

Trotskyist-inspired militia members of the Workers' Party of Marxist Unification.

Next page: International Brigades in Barcelona in 1936 display the flag of the antifascist German militia, Thaelmann Battallion, named after the German Communist Party leader imprisoned by the Nazis.

Pages 434–35: The Soviet cargo ship *Zirianin* is welcomed by huge crowds in Barcelona in October 1936.

Pages 436–37: Men and women militia members in the streets on their way to the front in 1936.

Pages 438–39: Militia members pose in front of an expropriated private car.

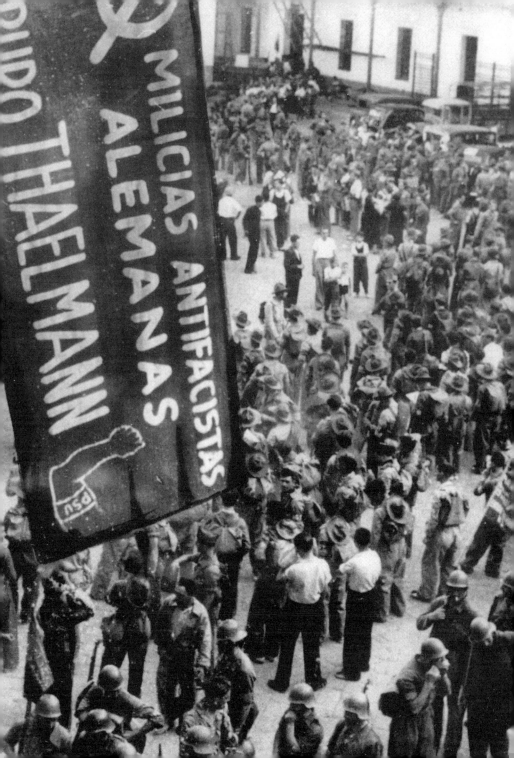

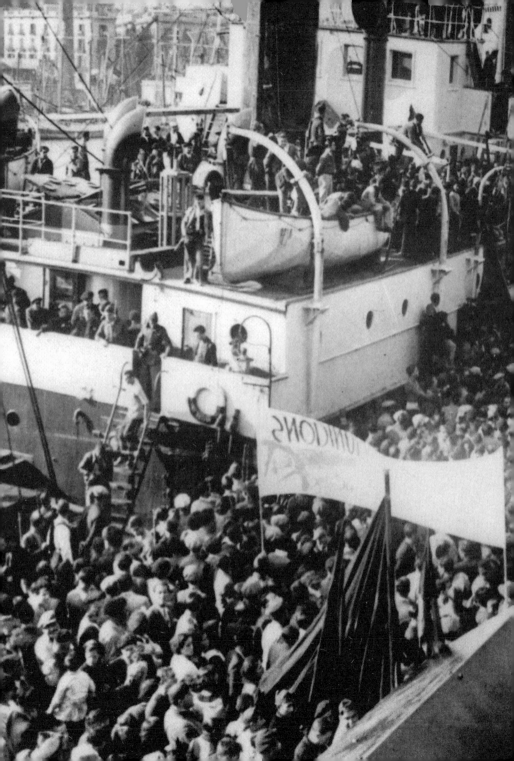

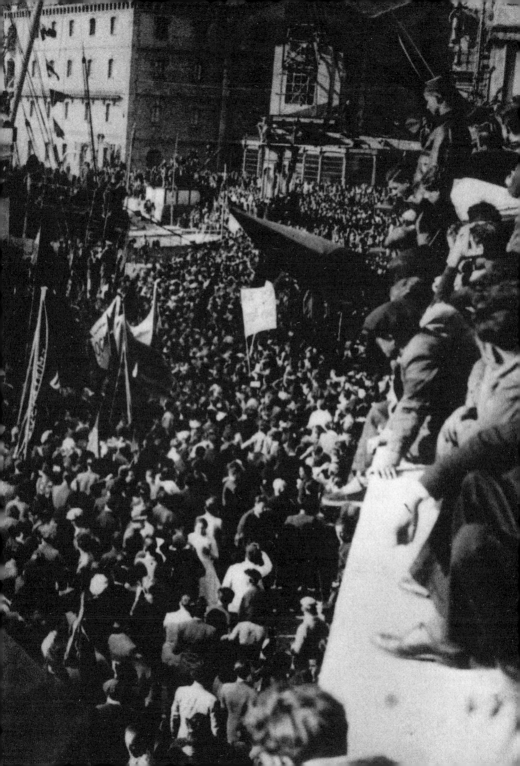

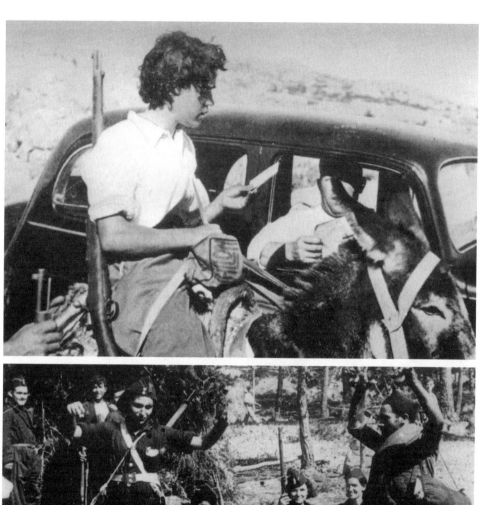

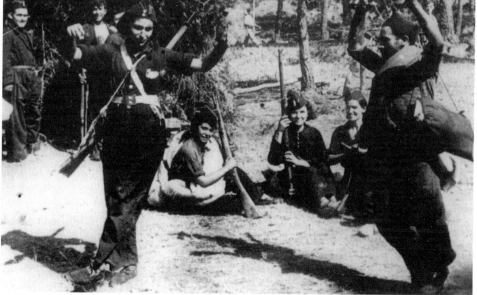

Above: Militia traffic control in Madrid, no date.

Below: Flamenco dancing on the front on September 15, 1936.

Previous page: Children dress up as militia members in Barcelona in September 1936.

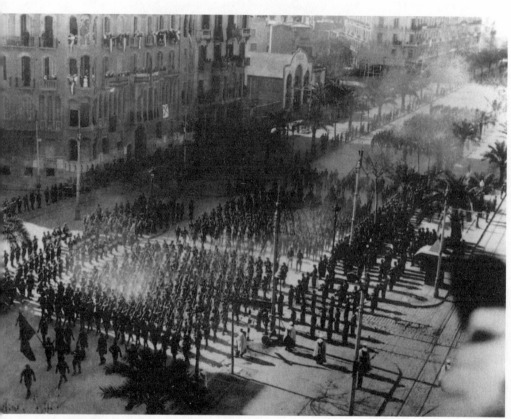

Fascist troops reviewed by General Franco in Barcelona.

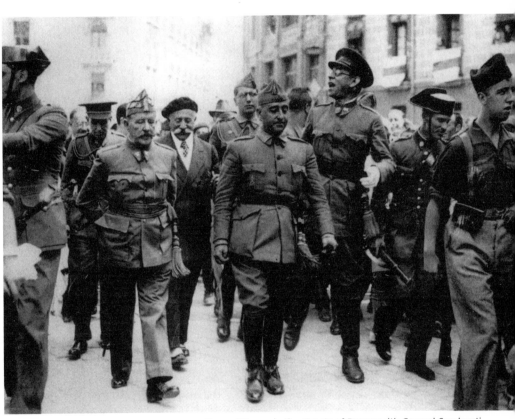

General Franco in the streets of Burgos with General Cavalcanti
(to his left) and General Mola (to his right) in August 1936.

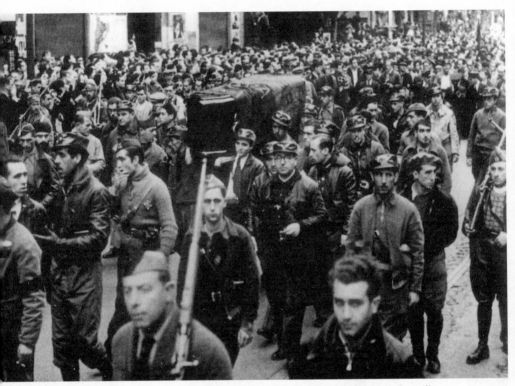

The funeral of Durrati, who was killed on the outskirts of Madrid in November 1936. Durrati's coffin is carried by member of his militia column recently returned from the front.

Political leaders attending Durrati's funeral.

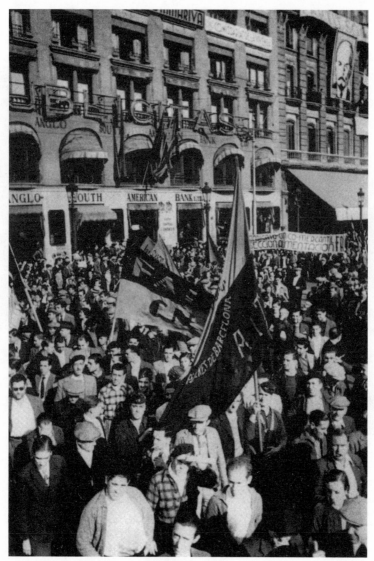

Street scene in Barcelona on November 8, 1936, celebrating the anniversary of the Russian Revolution.

Next page: Anarchist militia members.

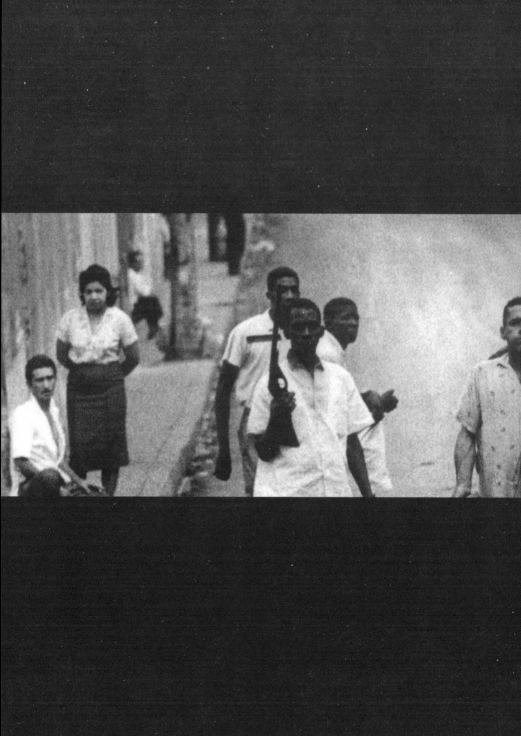

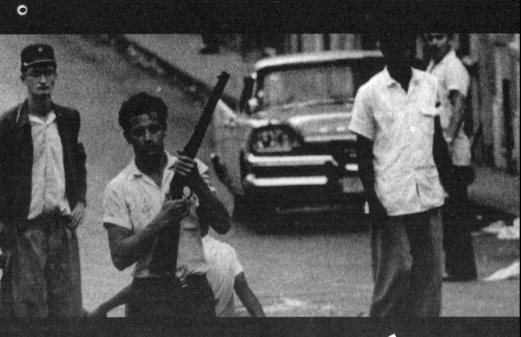

1953–1967

The Cuban Revolution

Janette Habel

The Cuban Revolution

In the casino of the Hotel National, a blond, North American woman plays roulette with a blank look. Leaning over her shoulder in a protective gesture, with a cigar in the pocket of his white *guayabera* (the finely embroidered white cotton shirt that Cubans wear on their days off), a man closely follows the game. Casinos, prostitution, lotteries, games of chance—this is Cuba in the 1950s. Havana is a golden ghetto for millionaires, the bordello of the United States. In this kingdom of corruption, the mafia rules. A new term for the island, imported from Sicily, "bordello" references both thugs and misery, or misery exploited by thugs, a neat summary of life in the city under its boss, Meyer Lansky.

Half drunk, wearing crooked berets, sailors whistle at Cuban prostitutes who pass them by on the Malecon, the avenue that runs along the capital's seashore. In their free time, they urinate on the statue of José Martí, hero of Cuba's wars for national independence. The Yankees feel at home in the Jockey Club, the Biltmore Yacht, and Country Club.

The Continental Hotel, the Hilton Hotel, the Rivera Hotel: their phony, imported neon brilliance is emblematic. A man waits on the sidewalk. In old Havana's narrow streets, Chevrolets, Studebakers, and Cadillacs are parked under the billboards of the Savoy Bar Club and the Jockey Bar. Here, everything is made in the USA. Except the poverty. A stone's throw

from the ultra-modern luxury hotels stand the slums, the *bohios*, which are a kind of small cabana covered with palm fronds. Swollen-bellied children play amid piles of garbage. The odor of decomposition hangs in the air. Cuban writer Alejandro Carpentier's beloved city of a thousand columns seems to have lost its identity.

General Fulgencio Batista, president of the Cuban Republic, rules in the casinos and the brothels on behalf of the mafia. He took power in 1952 in a coup d'état and was protected by Washington despite the dictatorial character of his regime.

But a revolt was shaking the country. One year after the coup, young people rebelled. At sunrise on July 26, 1953, they attacked the Moncada army barracks, in the eastern region of the island, to protest the dictatorship. The assault failed. Taken by surprise, the military recovered, but the repression was terrible. Of the 120 youth who participated in the attack, 71 were killed. In a photo, they lie on the ground in the tropical humidity. The smell of dried blood permeates the barracks. In their corn-colored uniforms, rifles slung on their shoulders, the satisfied guards looks over their victims. These were young men. One of them, clean-shaven, eyes opened wide, lies dead, his abdomen riddled with bullets. The tortured corpses are exhibited on the cemetery lawn alongside their coffins.

For the Popular Socialist Party (PSP, as the communist party was then named), the combatants were "petty-bourgeois adventurers." The attack on the Santiago barracks was a military defeat, but a political victory. From then on, one man would embody resistance to the dictatorship. Belonging to the Orthodox Party, his name was Fidel Castro. Brought to trial, he was handcuffed on the day of his sentencing. He rose to the challenge: once accused, he now has become the accuser. When condemned to fifteen years in prison, he proclaimed, "History will absolve me!"

History bifurcates. The failed attack on the Moncada barracks gave birth to a new political organization: the July 26 Movement. Amnestied, Fidel

Castro departed for Mexico with the intention of training for a guerrilla war under the command of a red officer from the Spanish Civil War. Among his comrades, there was a young Argentine doctor whom Castro met in Mexico, Ernesto "Che" Guevara, who came from Guatemala where he had witnessed the overthrow of Jacobo Árbenz Guzman's democratic government by mercenaries armed by the CIA. Guevara joined the armed struggle against the Batista dictatorship.

On November 24, 1956, eighty-two men left Mexico aboard a boat named *Granma* on their way to the island's east coast. The militants of the July 26 Movement and their prestigious young leader Frank País awaited them. They would save them. Victims of a series of military defeats from the movement's start, the guerrillas quickly benefited from young reinforcements, who came from Santiago de Cuba and then from among the region's *guajiros* (peasants). Installing themselves in the Sierra Maestra mountains, they received military training under the command of Fidel Castro. One photo shows him with a lit cigar teaching a guajiro wearing a red and black July 26 armband how to use a rifle. Victories bolstered the rebel army's prestige, and the revolt spread across the whole island, the struggle against oppression winning over the Cuban population bit by bit. In December 1958, the chiefs of Batista's army disclosed that 90 percent of the population of Santiago supported the guerrillas. In fact, Castro was counting on a relentless urban (*el llano*) resistance organized by País that supplied the rural guerrillas (*las montañas*) with arms, munitions, fuel, and medicines, and helped introduce the guerrillas to the world's largest media organizations, in particular the US press. But Batista was still received in Washington in 1958 as a distinguished guest. Standing next to a sparkling limousine, he relied on exceptional security measures. A police detachment escorted the presidential couple, who were fearful of an assassination attempt.

In the Sierra Maestra, the rebels developed and gained strength, and mass demonstrations multiplied. Spontaneous uprisings were occurring in the

province of Camaguey. In the fall of 1958, the guerrillas organized themselves in units to prepare a march on Havana. The most important of these was led by the Argentine doctor Guevara, who had just been promoted to the rank of commander. The guerrillas gave him the nickname "Che" (Argentine slang for "pal"), which he would keep, and which would become a part of his identity. We see him marching on foot amongst the *barbudos* (bearded ones), who were all armed and pushed forward by his unbending will. He prepared to cross the island, an epic march through swamps and tropical storms, with a band of half-starved men. Headed by troops who slogged through the mud barefoot, the final coup de grâce for the regime was prepared: aided enthusiastically by the local population, Che derailed an armored train carrying heavy arms sent by Batista and then seized the city of Santa Clara in the middle of the island on December 30, 1958. This decisive battle was a strategic victory, and it took place in a city that was totally unknown only a few weeks prior, propelling the men with stars on their berets into history. Followed by a bodyguard no more than twenty years old, Che, with a sparse beard and thin face and an inhaler in hand to control his asthma, is seen listening attentively to the information passed on by his interlocutor.

Five years after the Moncada attack, the dictatorship collapsed under the repeated blows of the rebel army. The Santa Clara victory sealed Batista's fate. Castro, who was still in the Sierra Maestra, issued a call for a general strike. The entire country was paralyzed. On New Year's Eve, January 1, 1959, Batista fled. The former army commander General Tabernilla accompanied him. Much later, Tabernilla would write, "In the eyes of our comrades, who we abandoned to their own luck, in the eyes of the Cuban people and the entire world, we left as cowards, thieves, profiteers without the slightest sense of patriotism." The victory was complete. Spontaneous demonstrations were occurring all over. When Castro entered Santa Clara, the city recently liberated by Che, such an enthusiastic crowd came to welcome him that the rebels riding in tanks struggled to clear the road.

Hanging from the shops, signs for US companies Firestone and Esso bore helpless witness to the rebels' triumph.

While all this was happening in Santa Clara, in Havana's devastated streets July 26 sympathizers wearing armbands were building barricades to impede the dictator's police as they fled. After long days on the march, Fidel Castro arrived in the capital. The population received him as a liberator. He had crossed the entire island. He stood on a tank covered with the Cuban flag with its single star—a symbol of national independence achieved at long last—surrounded by an enthusiastic multitude. More spectacular still was the arrival of the *guajiros*, peasants in straw hats adorned with a solitary star, riding ragged atop their mules. On the side of the road, others marched in single file between the royal palm trees, side by side with US Chevrolets. In old Havana, residents waved to the rebels from their balconies. An astonished sugarcane cutter—hat raised in his left hand and machete in his right—expressed his enthusiasm.

A new stage had begun. The old corrupt regime and its institutions had been destroyed. At this historic moment, two men conversed. The exchange between Castro and Camilo Cienfuegos, one of the brilliant commanders of the Sierra Maestra, was evocative. The one man, his torso rigid, hat placed squarely on his head, looks towards the future; he has already become an institution. The other has shaggy hair and a crooked hat, and he is putting a question to the chief, the *líder máximo* (the highest leader). Pictured alone, Che listens with an uneasy look. His expression is more determined, romantic, methodical, and rigorous, as if he embodies eternity. He knows that more dangerous challenges are yet to come.

In the first months of 1959, relations with the United States became tense. A US military mission left Cuba along with the dictator. Batista's police and executioners, accused of abuses and killings under the dictatorship, were executed following summary judgments, provoking protests from Washington. The population demanded punishment for the guilty. They had not forgotten the brutality of the police, or the savage repression it

carried out, Cuba's youth being the main victims of both. The accused were taken to La Cabaña fortress, where Che Guevara had established himself. Hands on their heads, terrified, disarmed, with their eyes cast down, Batista's men huddled together in a small office. In a photo, the militia of the July 26 Movement stands in front of them, armed with loaded rifles. Shadow and light. The clock on the wall tells the time: it is noon. History trembles.

Sentenced, Batista's men would be executed despite strenuous protests from the United States. In Havana, these criticisms were considered unacceptable and only reinforced Cuban nationalism. The population called for vengeance, for they had not forgotten that the United States had supported this dictator, supplying arms for him until March 1958.

It was not until April 1961 that the United States would recognize in a white paper that:

> The character of the Batista regime in Cuba made a violent popular reaction almost inevitable. The rapacity of the leadership, the corruption of the government, the brutality of the police, the regime's indifference to the needs of the people for education, medical care, housing, for social justice and economic opportunity—all these, in Cuba as elsewhere, constituted an open invitation to revolution.

This after-the-fact lucidity did not prevent the United States from preparing to overthrow the new regime, starting in 1959.

In the revolutionary atmosphere of these first months, there were strikes in foreign businesses, especially those with tight links to the dictatorship, during which the workers sometimes demanded their expropriation. The same occurred in the countryside, where agrarian conflicts broke out on the large sugar plantations. The agrarian reform law, decreed in May 1959, was moderate, but the White House lodged official protests in June against abuses and irregularities committed, according to US officials, in the application of the agrarian reform to US properties. Soon, cane fields were burned.

In Havana, these tensions prompted the first ministerial crisis and, in July, the exit of the moderate Cuban president Manuel Urrutia Lléo. In response to escalating reactionary attacks, the government decided to create popular militias. The country was now checkered with familiar silhouettes, both masculine and feminine, dressed in blue shirts and drab olive pants, berets fitted squarely, rifles slung over shoulders, guarding workplaces and neighborhoods.

In November 1959, Che was named president of the National Bank. With his long hair, restless eyes, thin beard, his at times unkempt uniform, the new bank president didn't look the part, except for the cigar smoke that surrounded him. His wife, Aleida March, was Cuban and a member of the July 26 Movement. They met during the insurrectional struggle. She participated in work meetings, often pictured grinning, and accompanied him to many events. Che was soon exhausted by the role, spending long nights in his office studying the banking system. He quickly decided to sell Cuba's gold reserves, which had been deposited in Fort Knox in the United States, and to transfer the money to Swiss and Canadian banks to prevent Washington from confiscating it. As a consequence, relations between Cuba and the United States deteriorated even further and Washington accused Havana of falling under communist influence. In February 1960, Soviet leader Anastas Mikoyan visited Cuba and signed the first bilateral agreement between Cuba and the USSR. On March 4, 1960, a French cargo ship, *La Coubre*, loaded with Belgian weapons, exploded in the port of Havana, and relations with the US worsened again. Castro accused the US government of sabotage. On March 17, 1960, President Eisenhower authorized the CIA to train exiled Cubans with the intention of invading the island.

The deadly explosion on the cargo ship left one hundred dead. The CIA was blamed. Alberto Korda recorded Che's somber expression for posterity; it is an image that would become immortal. The photograph spread

around the world. The man in star-emblazoned beret would, from then on, represent rebellion against injustice in the twentieth century.

Events rushed forward. In June 1960, the Cuban government demanded that foreign refineries process Soviet crude oil. If they refused, they would be expropriated. This marked an escalation. On July 3, the US Congress authorized the president to cut Cuba's sugarcane quota. On July 4, Cuba's Council of Ministers authorized the expropriation of all US properties. On July 6, President Eisenhower cut the Cuban sugar quota. On August 7, all large US businesses, industries, and land holdings in Cuba were nationalized, followed by US banks on September 17.

In September 1960, Fidel Castro visited New York, where the General Assembly of the United Nations is held. Venturing beyond the UN's neighborhood, where he was supposed to stay, he visited Harlem and installed himself there for the duration of his trip. There he met with Malcolm X and Nikita Khrushchev. Alongside the delighted Soviet head of state, the Cuban leader—uniformed with cap in hand—is seen savoring his triumph and, at the same time, with a wave of his hand, silencing the locals cheering him. He responded to journalists' questions. He knew that, from then on, he could count on Soviet economic and military aid. The revolution's survival seemed to be provisionally guaranteed.

But on October 9, 1960, the Eisenhower administration prohibited all exports destined for the island, with the exception of pharmaceutical products: the island was put under quarantine, as President Nixon would later state.

The Cuban response was not long delayed. On October 24, Havana expropriated all US goods, including retail businesses. The Cuban Revolution entered a decisive stage: all banks, all important commerce and industry, passed under state control, that is, approximately 382 Cuban and foreign businesses, including sugar processing factories, mines, the tobacco and coffee industries, etc. At the same time, the government promulgated an

urban reform law that allowed renters to become owners of their apartments or homes after paying rent for a period of five to twenty years.

US ambassador Philip Bonsal left the island on October 29. Diplomatic relations were cut off in January 1961, coinciding with the end of the Eisenhower administration. In a few months, the rupture between the two countries would be complete.

In Havana, it was a time of mobilization. On January 1, 1961, a campaign to end illiteracy was launched. In the countryside, nearly 25 percent of the population could not read. Responding to the government's call, thousands of young people left their homes for several weeks to teach peasants to read. Along the Malecon avenue, facing the sea, an immense lighted sign proclaimed: "Cuba, a land free from illiteracy." An official UNESCO report published in 1965 called the campaign a "model of organization." The Colombia military base and the Moncada barracks in Santiago were transformed into model schools; the latter became a study hall where female students revised their homework. The year 1961 would be declared the "Year for Education," and the phrase "Homeland or Death" was now incorporated into all speeches.

The líder máximo was everywhere. Riding in his jeep, he visited the villages and spoke to peasants and women. He hardly needed bodyguards to protect him. Thirty years later, we see him in Havana in a black, bulletproof Mercedes with the curtains drawn, with two more Mercedes on either side in staggered rows, driving through the streets where traffic has been stopped to allow him to pass.

Cuba strengthened its links with the USSR, including militarily, further increasing Washington's hostility to the Cuban regime.

Military intervention was the order of the day: various Cuban personalities exiled in the United States prepared for the creation of a "Cuban Revolutionary Council." It was founded in March 1961 in Miami with the intention of transforming itself into the "government of a free Cuba."

José Miró Cardona, who served briefly as prime minister in the revolutionary government between January and February 1959, presided. The future provisional government counted on support from the 2506 Brigade, a group composed of exiles armed by the United States who were training in Nicaragua and Guatemala in preparation for an invasion of Cuba. The same script was used to overthrow Guatemalan president Árbenz in 1954—the very one that contributed so much to the political radicalization of a young Che.

John F. Kennedy, now president of the United States, took office on January 20, 1961, and ratified this invasion plan, on the condition that no US forces took part. The attack began on April 15, 1961, in the middle of Cuba's southern coast, on Playa Girón in the Bay of Pigs. The Cuban government sounded the call for a general mobilization. Popular militias marched en masse. Arm in arm, uniformed women, Black and white, prepared for combat. Others guarded official buildings. Combatants piled onto trucks with high wooden sides normally used to transport sugarcane and joined the caravan, headed for the site where the enemy troops were disembarking. Young and old brandished machine guns, running toward the beach to take on the invaders. The trucks got stuck in the muddy marshes, but nothing could hold back the militias. It would take less than seventy-two hours to defeat the invasion. The victory belonged to them. Popular enthusiasm and the power of the mobilization inflicted an unprecedented defeat on the aggressors. On site, Castro is shown, speaking to the soldiers with broad gestures, cigar in hand, and then inspecting a downed plane. Never again would nationalist fervor be so strong. Havana buried its dead. Hundreds of thousands of people accompanied the caskets, which were covered with the single star of the Cuban flag. A giant banner captured the popular sentiment: "Yankee killers."

The mercenaries were detained by the hundreds. Dressed in their American blue jeans, they bowed their heads and asked themselves what lay in store. Trials of the anti-Castro invaders would be broadcast all over Latin America.

Seated on benches, the defendants provided testimony and confirmed the CIA's involvement in the military intervention and that they had received the green light from President Kennedy. Havana took almost 1,200 prisoners. The whole episode constituted a real thrashing for the reactionary forces.

The Cuban government negotiated with Washington to free the prisoners and, in return, received a financial indemnity of $63 million for war damages and further material compensation.

For the first time in the twentieth century, an intervention planned and armed by Washington had been defeated. The repercussions in Latin America were without precedent.

On May 1, 1961, in Havana's Plaza de la Revolución, hundreds of thousands of Cubans marched under a gigantic banner waving in the breeze. In the euphoria of the victory, Castro proclaimed the socialist character of the Cuban Revolution: "Yes, in the Sierra Maestra, we fought for the program of Moncada; at Girón, our people courageously spilled their blood for socialism." Holding hands, the immense crowd sang the "Internationale" and carried thousands of placards and flags reading: "Long live the socialist revolution."

But the truce won in the wake of the Bay of Pigs would not last long. Washington had not given up on overthrowing the Cuban government; this time it relied on support from Latin America's strongest governments. In January 1962, during a meeting of the Organization of American States (OAS) in Punta del Este, Uruguay, Cuba was expelled from the organization. In Panama, Robert McNamara declared that the island threatened the Western Hemisphere, and that the United States and its allies must prepare to confront the danger, including by military means. In Havana, popular mobilization reached its apex. National feeling was at a height. A second *Declaration of Havana* was written in response to Cuba's expulsion from the OAS. In a photo, a crowd is shown surrounding a large coffin with a Yankee top hat attached to it. The oversized initials declare "EPD OEA"

(OAS RIP), demonstrating the Cuban sense of humor. Under a crocodile symbolizing Uncle Sam, we read, "Watch out for the alligator." Another banner carried by trade unionists says, "With or without the OAS, we will be free!"

However, the country was once again on a war footing. Where would the aggression come from this time? No one knew, but everyone got ready. Havana took a step toward the USSR, which defended Cuba's sovereignty. Moscow planned a mighty blow. The installation of ballistic missiles less than 200 miles from the coast of the United States altered the balance of nuclear forces between the two great powers.

On October 22, 1962, Kennedy denounced the installation of Soviet nuclear rockets in Cuba, demanded the retraction of these "offensive missiles," and imposed a naval blockade on the island. In response to the US president's speech, the Prime Minister Castro once more called for general mobilization in Cuba. Trucks carrying revolutionary militia combat units crisscrossed the capital's streets. The climate was tense. The capital was covered with posters that said, "Commander-in-chief: give us our orders!" This time there was no disordered drive by militias to get to the beach, as there was during the Bay of Pigs. Now the Cuban infantry reported in uniform with a severe countenance and a martial air, marching in cadence. This time the risks were of a higher magnitude. Outside of Havana, large trailer trucks were on the move, covered by huge canopies that hid long, indistinct cylinders. The trucks were driven by Soviet soldiers. The people called them "etcetera" because Castro, when describing the arms that Cuba had in its possession to defend itself, concluded a long list of weapons with a mysterious "etc." These were the famous "clandestine" missiles delivered by the USSR, which US spy planes quickly discovered under the cover of palm trees. The world was on the edge of nuclear war.

Direct negotiations between Moscow and Washington began, from which Havana was excluded. The USSR agreed to withdraw the nuclear warheads

on condition that the United States promised—in a secret memorandum—not to attack Cuba. The Cuban leadership was not consulted. Castro responded with a five-point declaration. The líder máximo barely disguised his rage. To avenge the withdrawal, he demanded the evacuation of the US Navy's base in Guantánamo Bay and rejected inspection of Cuban defenses by the UN. Washington required flyovers of Cuban territory to confirm the withdrawal of the strategic arms. The crisis was overcome thanks to compromises reached by the two great powers, but at the cost of the first break between Moscow and Havana, one that would leave marks.

Although the compromise was ratified by signed commitments, Cuba was the target of incessant guerrilla attacks, which were encouraged from abroad, in the interior of the country, in the mountains of Escambray. On the other hand, the US embargo aggravated the economic situation, which had become strained. The first two years of the revolution saw an increase in the standard of living as well as the eradication of illiteracy for the population, but now it was necessary to overcome the problem of development. The challenge would be immense in the small country, which lacked its own energy resources, in the backyard of the United States. The debate over economic strategy went hand in hand with the challenge of founding new political institutions. The tensions were strong and the conflicts between the political forces which supported the revolutionary process were numerous. And they were exacerbated by growing Soviet influence, an influence that benefited a well-organized group inside the revolutionary camp, that is, the PSP, the old communist party that was closely linked to the Soviet embassy. However, the PSP's previous collaboration with Batista during the 1940s, its rejection of the insurrectionary strategy, and, later, its hesitancy to adhere to Castro's project all served to discredit it and drum up hostility from multiple sectors. The July 26 Movement was also undercut by internal divisions, as it had inherited a military structure from the rebel army but lacked the means to confront new political tasks. The same was true for the Revolutionary Student Directorate, which was incapacitated by Batista's repression. In 1961, Castro

tried to unify these three forces into what would be named the Integrated Revolutionary Organizations (ORI), but this group's existence would be ephemeral. Suddenly, a new crisis arose. In March 1962, Anibal Escalante, ex-leader of the Stalinist PSP and now secretary of the ORI, was accused of wanting to replace members of the July 26 Movement and the Revolutionary Student Directorate with old PSP militants. He was exiled to Czechoslovakia. This marked the first open conflict between earlier stages of the Cuban Revolution and the current one, which was linked to Moscow. In the wake of the missile crisis, Che had already begun to distance himself from so-called "real socialism."

Step by step, political power in Cuba was consolidated in the hands of the líder máximo, losing any real relation to its revolutionary institutions. It would remain that way for fifteen years. The organization of political power was delayed by problems with military defense and the deterioration of the country's economic situation, both of which demanded the adoption of urgent measures.

How to carry on? How to survive? These were the concerns that nagged at the government. The island continued to rely on sugar and cigar exports. H. Upmann and Partagas cigars were still rolled by hand in factories and sold for a high price to cigars aficionados.

In the short term, sugar sales were indispensable for financial development. In one photo we see sugarcane, its long stems filled with sugar, being cut by hand by Cuban women working under the sweltering sun. In 1963, Castro decided to delay industrial development and ramp up sugar production. Little by little, the sugarcane harvest was mechanized thanks to the introduction of Soviet machinery. In 1964, long-term commercial agreements were signed in Moscow, which had taken the place of the United States in buying ever-greater quantities of Cuban sugar. In this way, the island's sugar dependency was perpetuated. Thirty years later, the costs would be terrible.

Thanks to Soviet credit, the Cubans constructed a huge amount of housing in the outskirts of the capital to replace the old slums and to provide housing for peasants. No one paid attention to the lack of transportation. Three decades later, the disrepair of this prefabricated housing would cause problems.

As the minister of industry, Che Guevara hoped to diversify the economy and industrialize the nation. Untiring, he spent nights in the ministry and Sundays in the sugarcane fields or in the state firms to boost production— giving new meaning to voluntary labor. Between meetings, he received writers, including Jean-Paul Sartre and Simone de Beauvoir, and he wrote some poems.

A confrontation arose between two socialist projects, pitting the partisans of Soviet socialism against the supporters of a different kind of socialism, the contours of which Che Guevara was attempting to define empirically. Although he had been one of the architects of the revolution's radicalization and of the closer alliance Cuba had built with the Soviets, the minister of industry now quickly distanced himself from Moscow. However, he would lose. His commentaries became more critical over time. For instance, in his speech in Algeria in February 1965 he criticized the Soviet's commercial policies. Such criticisms, expressed publicly by a representative of such a prestigious allied Third World government, could not be tolerated by the Kremlin. Che left Cuba, a departure negotiated by Castro—but he ignored the conditions Castro set for him. In the Congo, and then in Bolivia, he would attempt to advance the revolutionary struggle, two efforts that would result in two failures and, finally, in his own death.

Che arrived at the edge of Lake Tanganyika in April 1965 and remained there until the end of the year, accompanied by nearly one hundred Afro-Cubans volunteers who had joined him to fight strongman Moïse Tshombe. These descendants of enslaved people crossed the Atlantic, going the opposite direction of their African ancestors, who had been brought west in inhuman conditions to be sold as laborers in the Antillean

sugarcane fields. However, after Congolese prime minister Patrice Lumumba's assassination in March 1961, the Congolese national liberation forces became disorganized and divided, and were put on the defensive. They avoided combat, and corruption reigned amongst their leaders. Che left the Congo in failure. But where would he go?

In October 1965, Castro announced the foundation of a new unified party, the Cuban Communist Party. Che Guevara was not included as a member of its Central Committee. Eight months passed before he left once again. He was in the Congo when Commander-in-Chief Castro read the former minister of industry's farewell letter to the Communist Congress: "I hereby formally resign my formal responsibilities in the Party leadership, and my post as Minister, my rank as commander, and my Cuban nationality. There are other lands in the world that require the contribution of my modest efforts." Guevara then left for Bolivia, arriving in November 1966. He was unrecognizable: bald, with a prominent mandible and a slight paunch, he disguised himself as a Uruguayan businessman.

Why and how in Bolivia? Thirty years later, this choice remained the object of many investigations. Encouraged by Moscow, which did not want a conflict with Washington in its backyard, the Bolivian Communist Party, one of the supposedly essential pillars of Che's operation, turned against him. Conceived of as a training camp, the guerrillas' locations were prematurely discovered, and any communication between Che and Havana was soon cut off. Urban support networks, infiltrated from the start by the CIA, were dismantled. Owing to a confrontation soon after being discovered by the army, the guerrillas were isolated in a hostile region, lacking logistical support and arms. In a few months, the guerrillas would be wiped out by the Bolivian Rangers, who would encircle the region. Che's presence was discovered. Contact with Havana was never reestablished. On October 9, 1967, Che was executed in La Higuera by a Bolivian officer acting on orders from the CIA. He died alone, abandoned.

His thin, naked corpse was laid out across a sink. With his head slightly inclined, his shoulder-length hair, and his wide-open eyes, he brings to mind the *Lamentation of Christ* by the Italian painter Andrea Mantegna. Later, icons will pay homage to "St. Ernesto of La Higuera."

Che's death ratified the failure of guerrilla forces born in the 1960s. For reasons of state that overruled internationalism, Castro changed tactics. Faced with threats of economic retaliation from Moscow, he would tighten relations with the USSR, Cuba's essential source of economic aid. By the end of the 1960s, the die was cast, and Castro joined the Soviet bloc.

Meanwhile, 1968 seemed to contradict the worst predictions. After the Tet Offensive in Vietnam, there was a general strike in Paris in May. Che was reborn in posters and revived in the discourse, and youth proclaimed their solidarity with the people of the Third World. However, in Prague in August, Soviet tanks invaded Czechoslovakia, and Castro supported the military intervention.

Fifty years after its revolutionary victory, Cuba is living through a period of transition in which an intense debate is developing about the future of socialism, a debate that involves socialism's adversaries as well as those who defend it but want to see it evolve.

Timeline

1952

3/10: General Fulgencio Bautista overthrows the government in a coup d'état. Washington does not react.

1952

7/26: Fidel Castro and his comrades attack the Moncada barracks.

1956

12/02: The *Granma* lands on Cuba's eastern shore. Castro and Che Guevara launch an armed struggle in the Sierra Maestra mountains.

1959

1/01: Victory of the rebel army, which enters Havana under the command of Che Guevara and Camilo Cienfuegos. Batista flees.

February: Castro replaces José Miró Cardona as prime minister.

3/10: Secret meeting of the US National Security Council to plan the overthrow of Castro's government.

May: First agrarian reform.

1960

First commercial agreement with the USSR. In October, Washington decrees the first embargo measures against Cuba.

1961

Literacy campaign. In April, exiled Cubans trained by the CIA land in the Bay of Pigs aiming to overthrow the Cuban regime. They are repelled by Cuban troops. It is the first defeat in Latin America for the United States.

1962

January: Cuba is expelled from the Organization of American States.

October: A US surveillance plan discovers nuclear missiles in Cuba. President Kennedy orders a total naval blockade of the island. The world is at the brink of nuclear war. An agreement between the United States and the USSR ends the crisis.

1963

First visit by Fidel Castro to the USSR. Second agrarian reform.

1965

February: Guevara publicly attacks the USSR in a speech in Algeria in front of representatives of the Third World. He returns to Cuba but never appears in public again.

April: Cuban combatants led by Guevara leave for the Congo.

October: Founding of the new Cuban Communist Party. Guevara is not included as a member of its Central Committee.

1966

November: After his failure in the Congo, Guevara departs for Bolivia to organize a continental guerrilla training center but is prematurely discovered.

1967

10/09: Guevara is assassinated in La Higuera in Bolivia.

1968

August: Fidel Castro supports the Soviet intervention in Czechoslovakia.

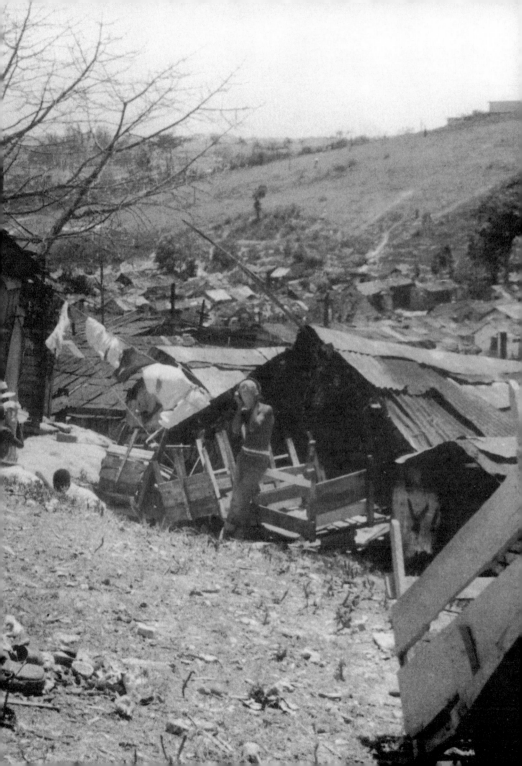

US sailors watch as Cuban prostitutes pass by on the Malecon in Havana in 1958.

Previous two pages: Havana slum in 1958.

Roulette in the Hotel Nacional in Havana in 1958.

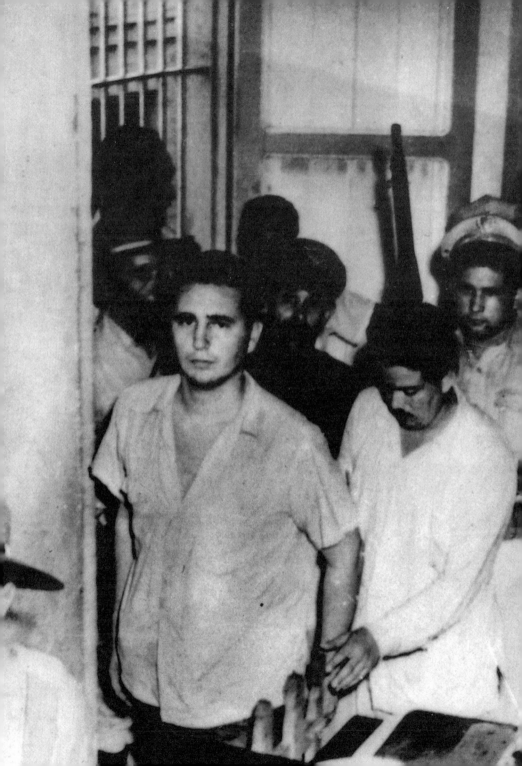

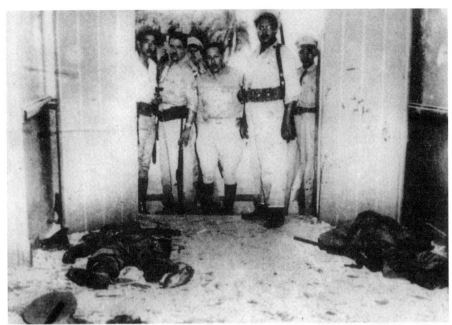

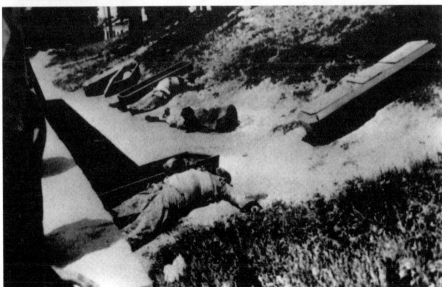

After the attack on the Moncada barracks, Batista's soldiers view guerrillas' corpses.

Previous page: Fidel Castro is led to his trial for participating in the Moncada assault on July 26, 1953.

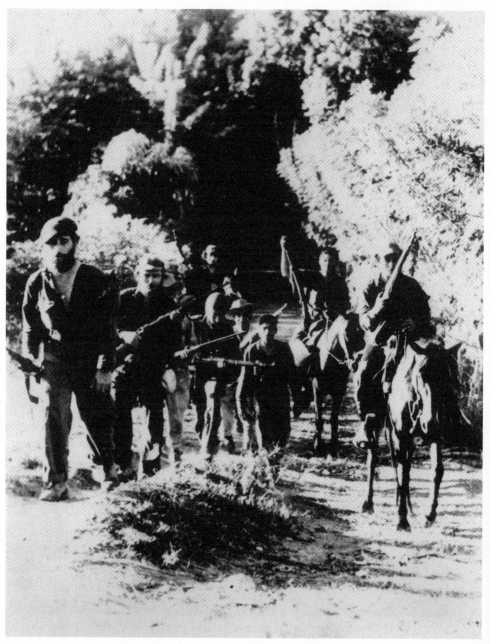

A group of guerillas, including Che Guevara, in the Sierra Maestra mountains.

Next page: Fidel Castro in the mountains instructs a new recruit in the use of firearms.

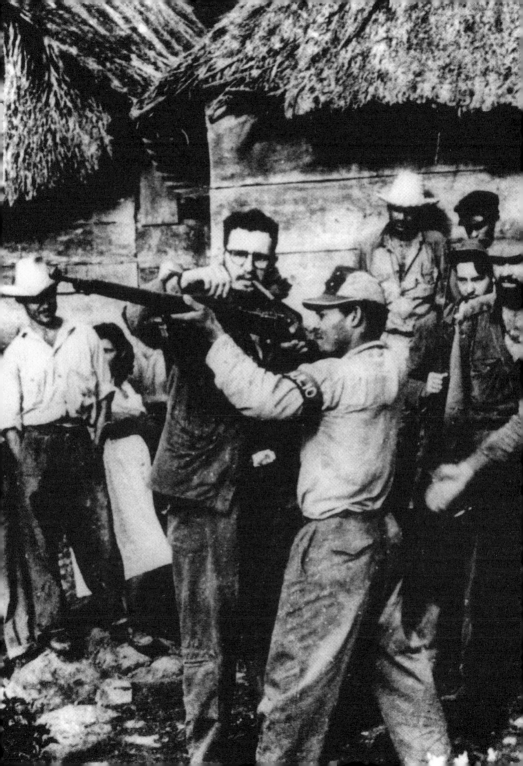

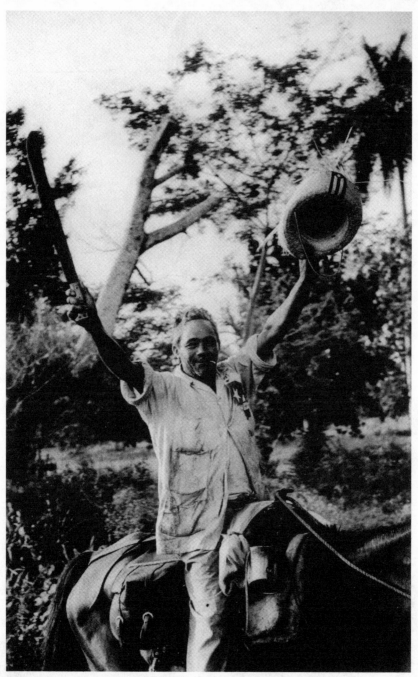

Above and next page: *Guajiros* (peasants) support Fidel Castro and his troops in crossing the mountains in January 1959.

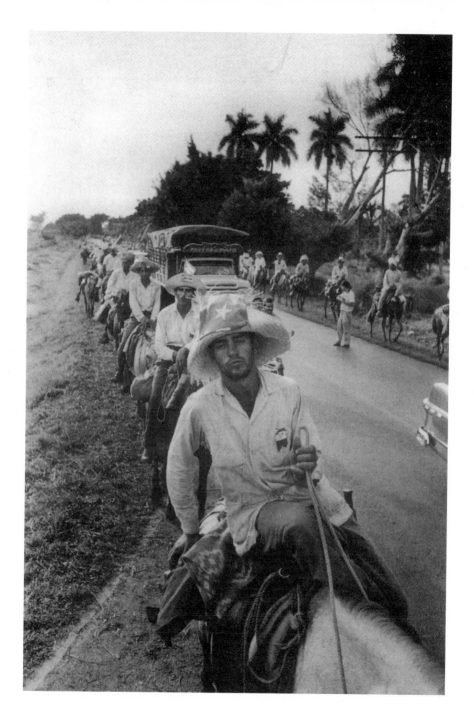

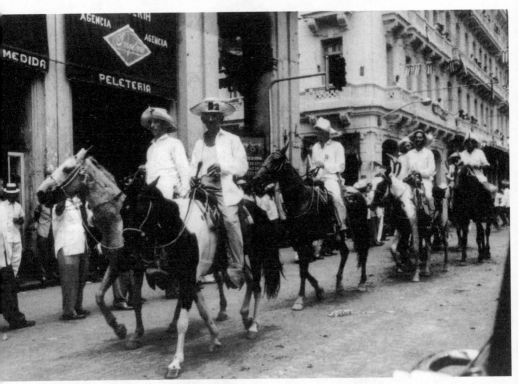

After providing enormous support for Castro,
peasant fighters enter Havana in January 1959.

Next page: Fidel Castro arrives in Havana with his troops in January 1959.

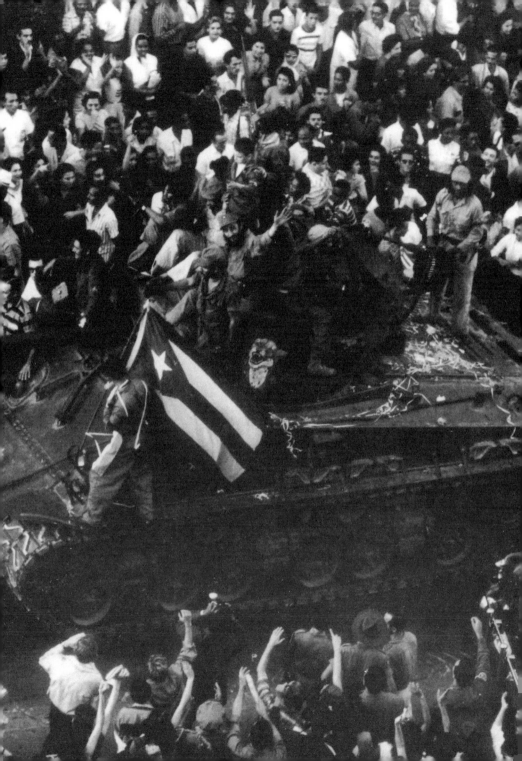

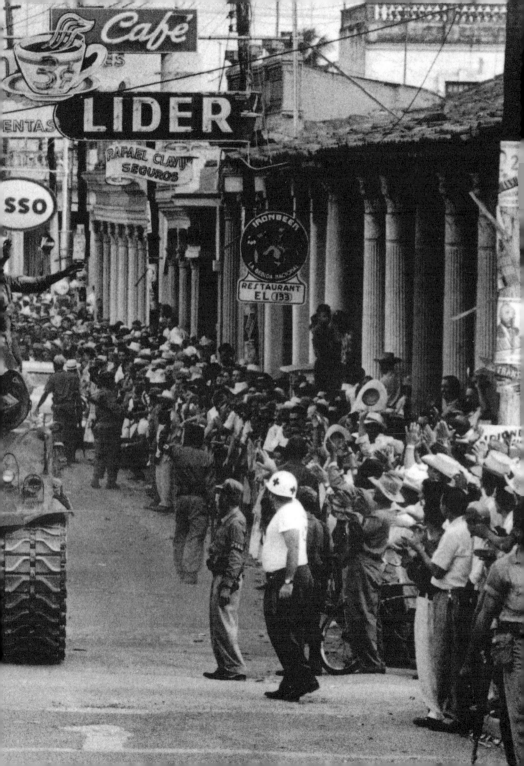

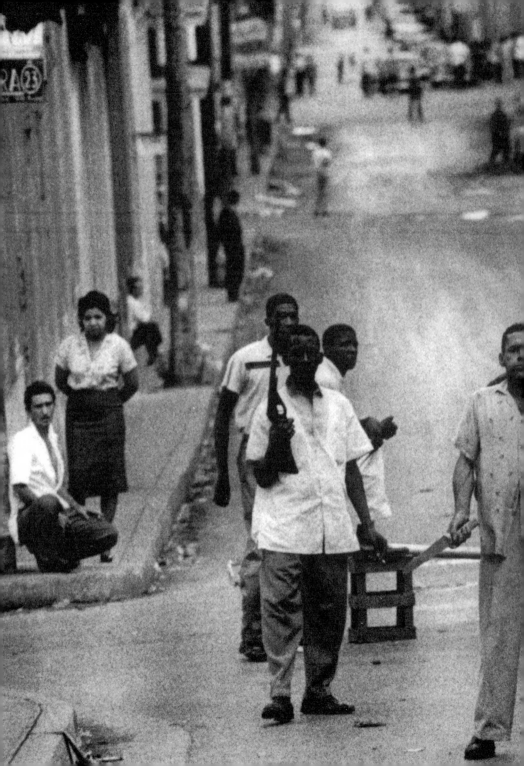

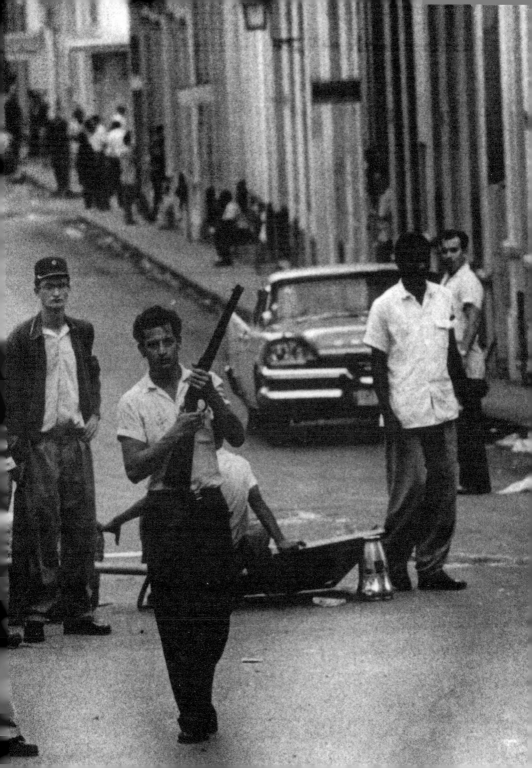

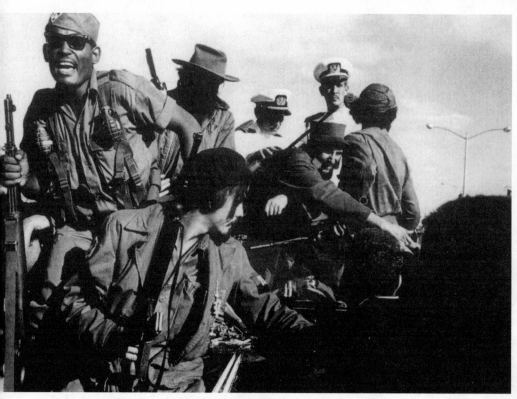

Fidel Castro and rebel officers in Havana in January 1959.

Next page: Fidel Castro and Camilo Cienfuegos enter Havana in January 1959.

Pages 482–83: Castro's troops in the streets of Santa Clara, liberated by Che Guevara in January 1959.

Pages 484–85: Supporters of Castro taking Havana, constructing barricades to block the flight of the remaining Batista forces in January 1959.

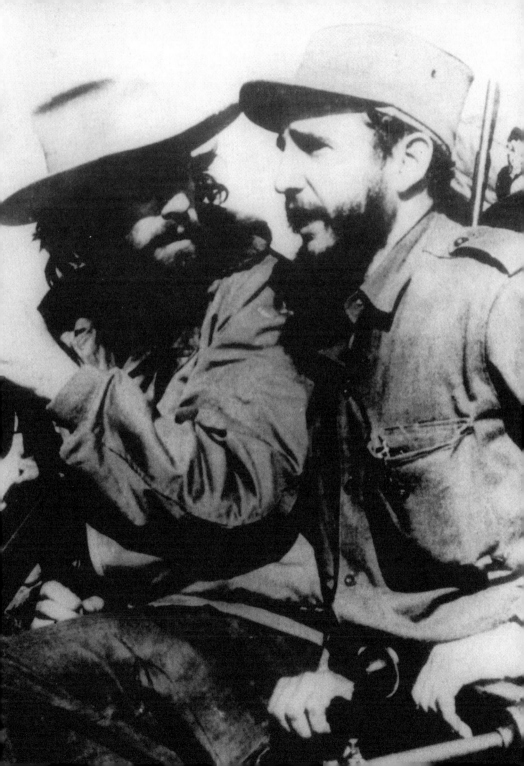

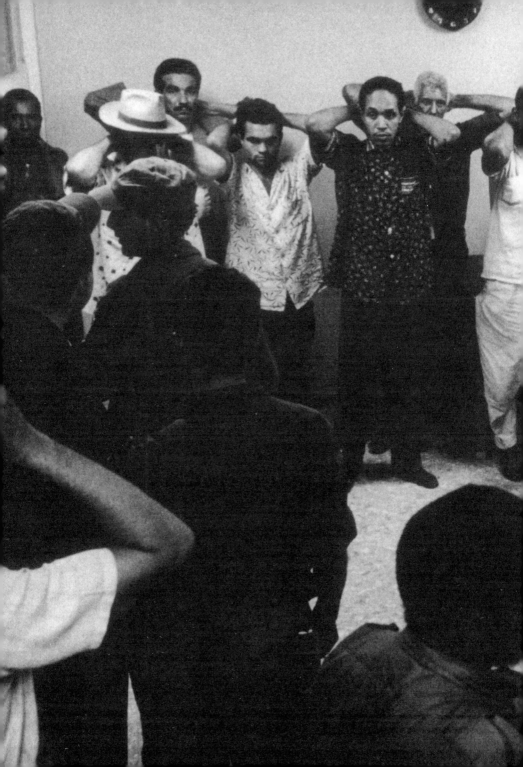

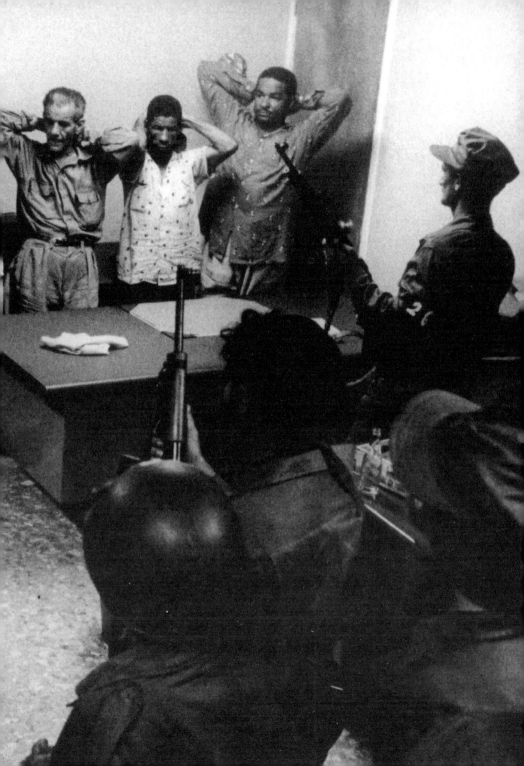

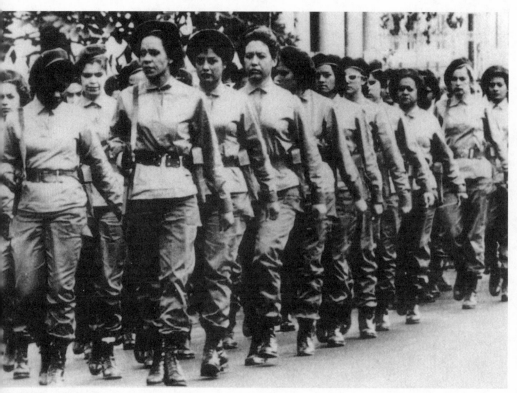

Militia on the march.

Previous two pages: Members of Batista's police and secret
agents held prisoner by Castro's troops in Havana in January 1959.

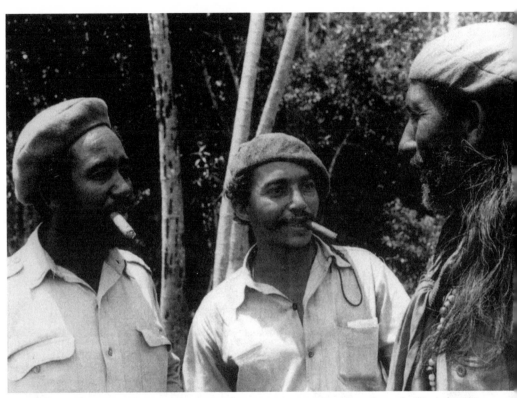

Two generations of militants in Cuba.

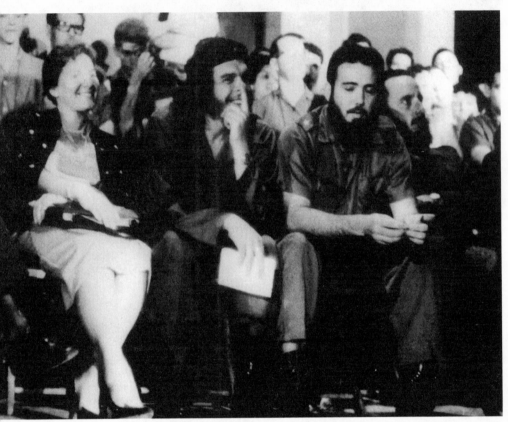

Che Guevara and his wife, Aleida March, with Fidel Castro during a group interview.

Next page: This photograph of Che, taken by Alberto Korda, was shared around the world. Dated March 5, 1960, the day of funerals for victims of an explosion aboard the French ship *La Coubre* in the port of Havana.

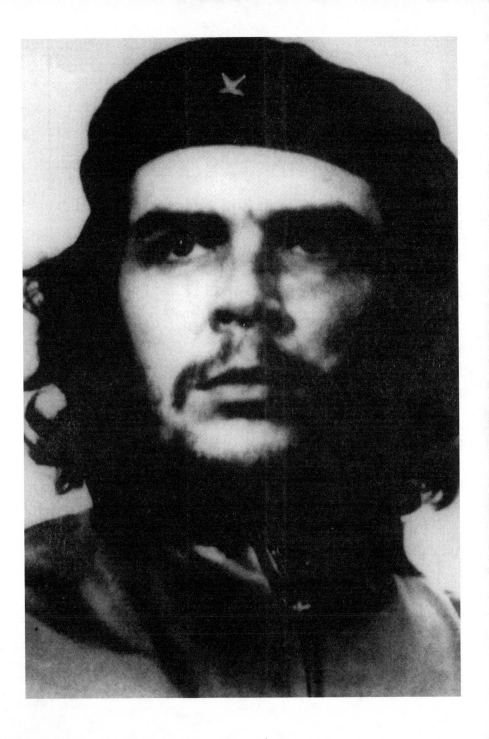

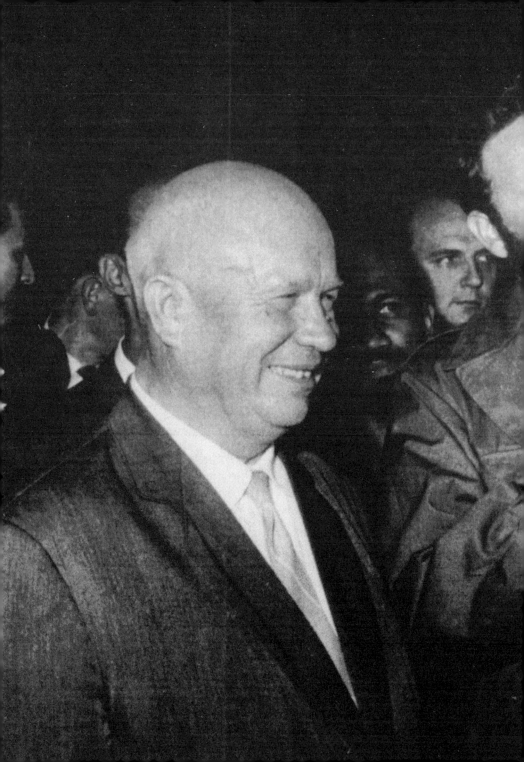

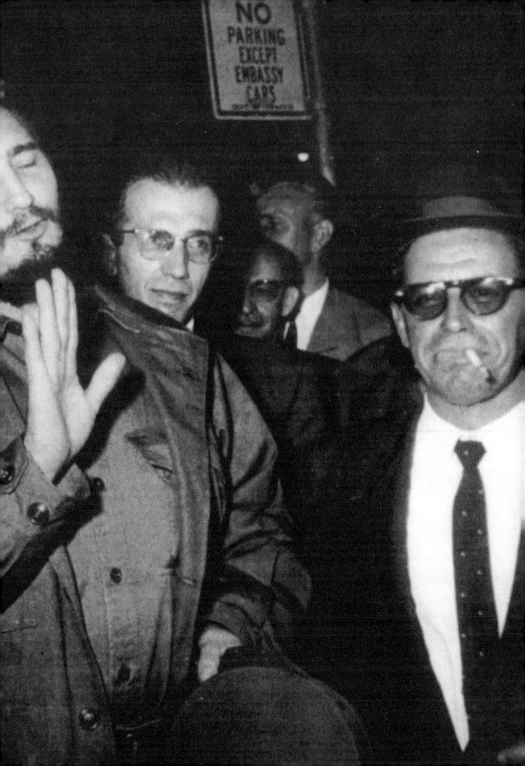

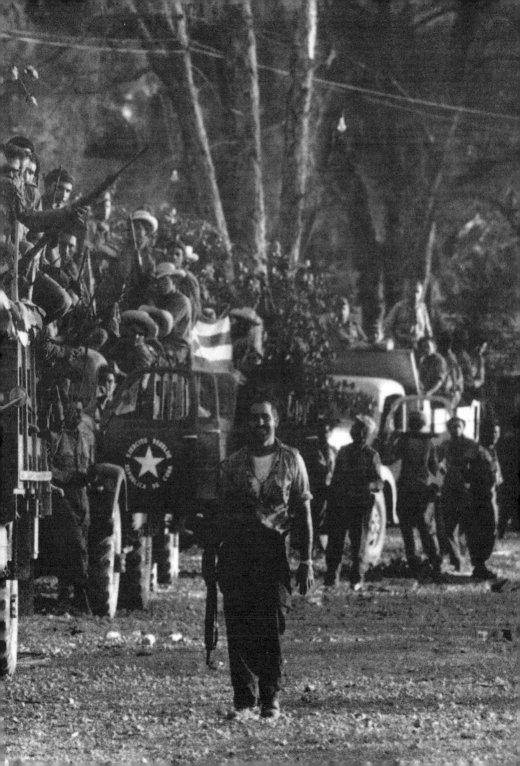

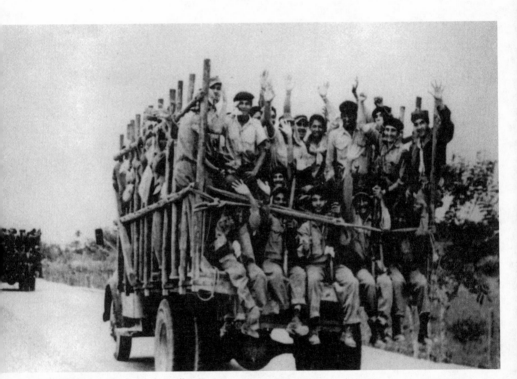

Bay of Pigs before the battle in April 1961.

Pages 494–95: Fidel Castro with Nikita Khrushchev in New York in September 1960.

Pages 496–97: Fidel Castro in the Sierra Maestra in 1961.

Pages 498–99: Cuban militias at the Bay of Pigs before the fighting in April 1961.

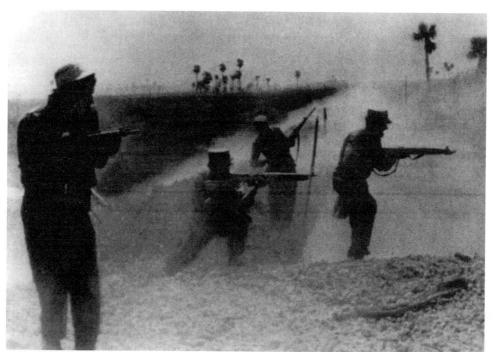

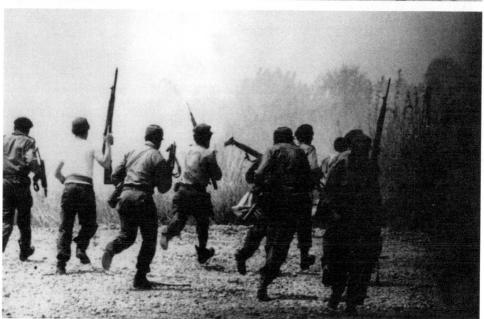

Fighting in the Bay of Pigs in April 1961.

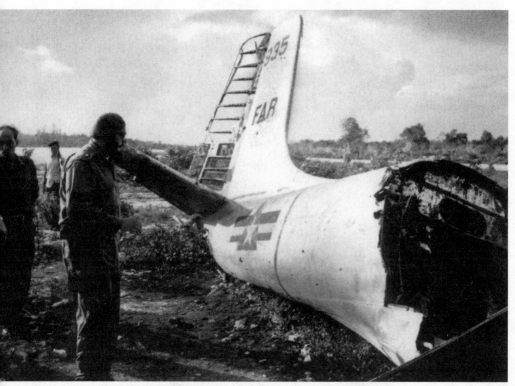

Fidel Castro on Giron beach, site of the American invasion, next to a crashed plane, in 1961.

Next page: Fidel Castro in 1961.

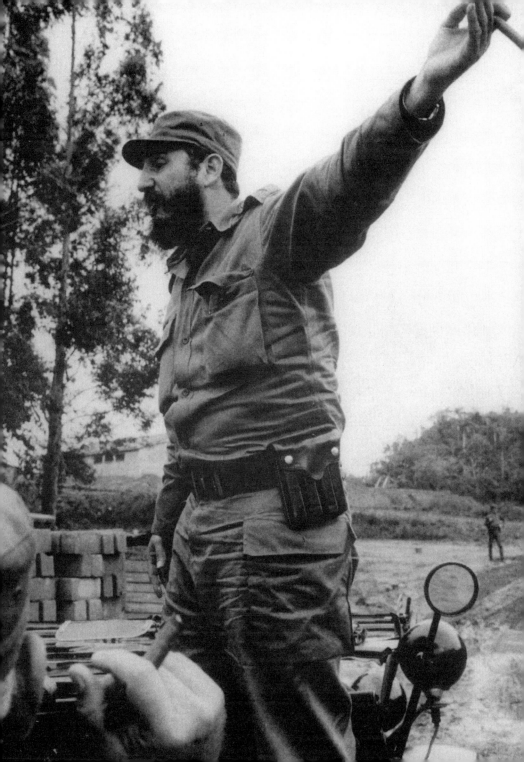

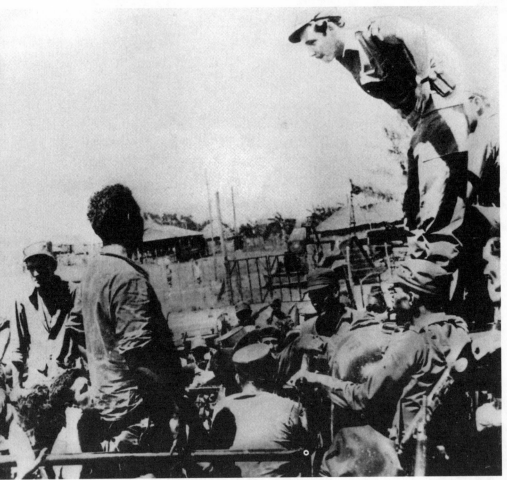

Suppression of counterrevolution, Raul Castro, Fidel's brother, questions prisoners on November 21, 1961.

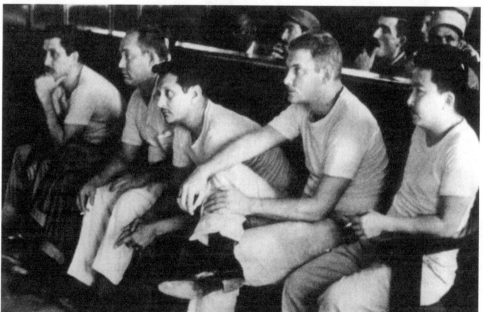

Trial of counterrevolutionary mercenaries.

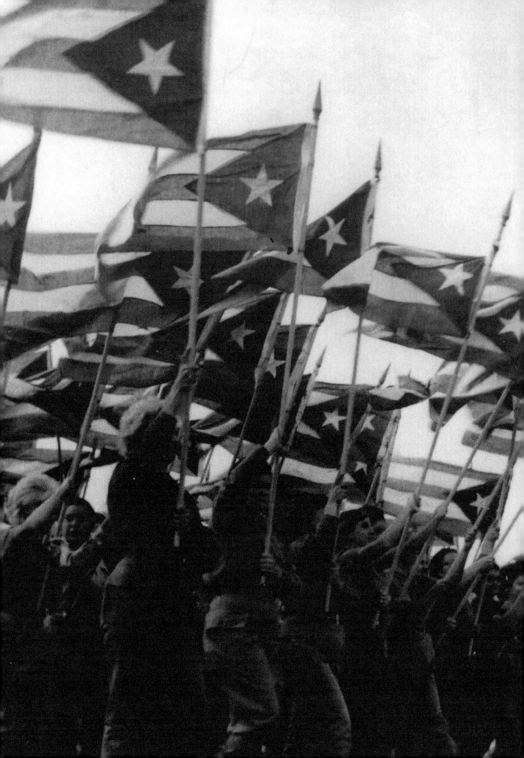

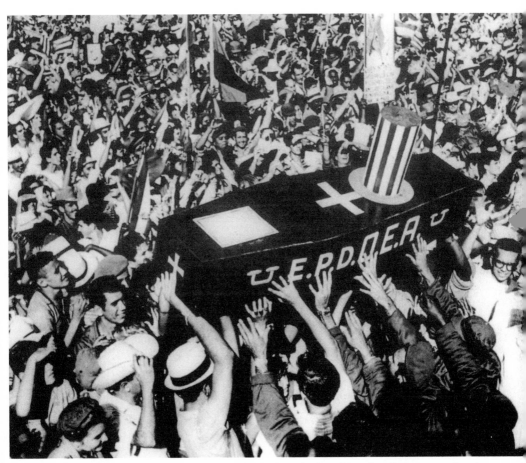

Protesting the exclusion of Cuba from the Organization of American States, a crowd carries a large coffin with US colors and Uncle Sam's top hat in January 1962.

Previous page: May 1, 1961, Cuban women commemorate the victory.

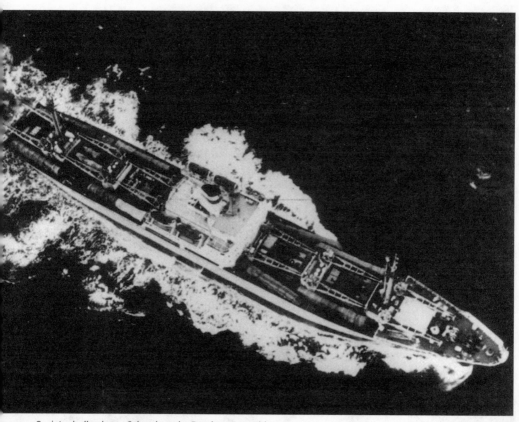

Soviet missiles leave Cuba aboard a Russian cargo ship.

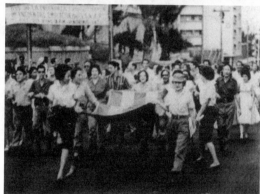

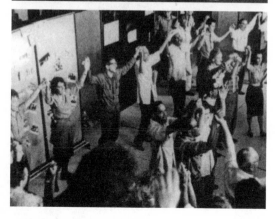

Above: Soviet soldiers in the streets of Havana in December 1962.

Center and below: Workers in Havana organize protests in October 1962 in response to the announcement of a US blockade.

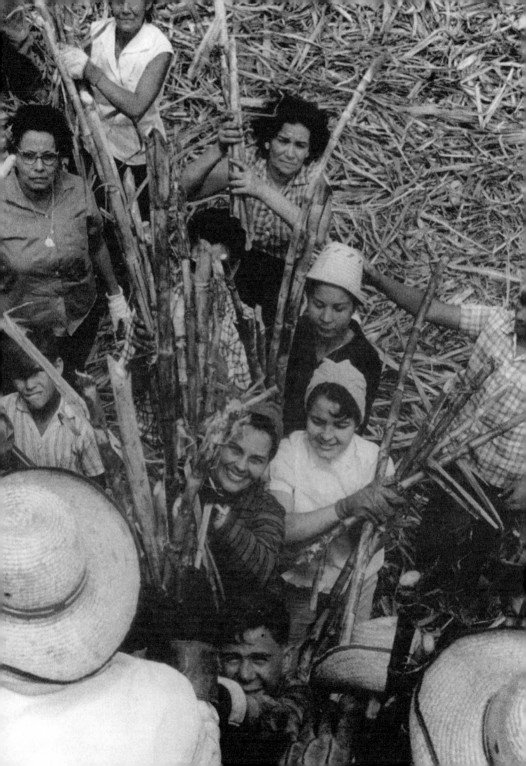

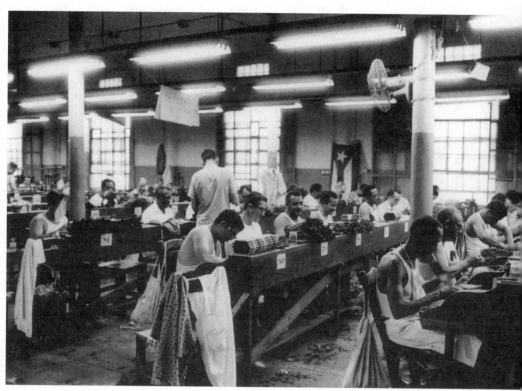

Cigar factory in Havana in 1961.

Previous page: *La zafra* (the harvest), aided by
volunteer workers in 1962.

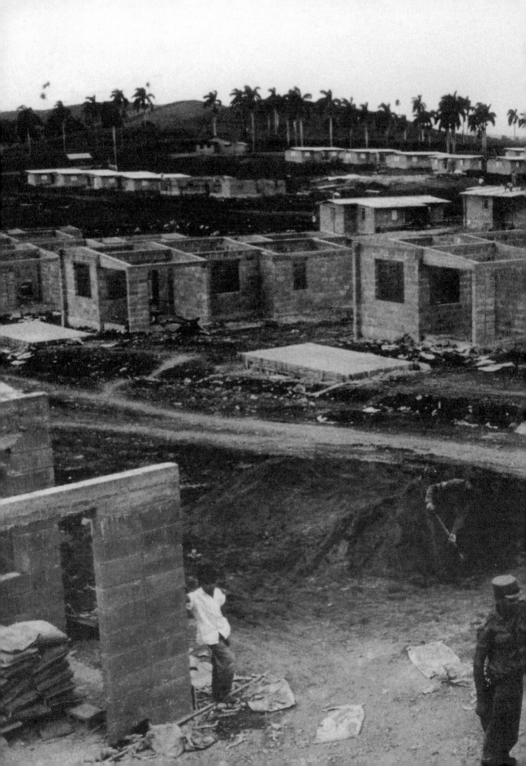

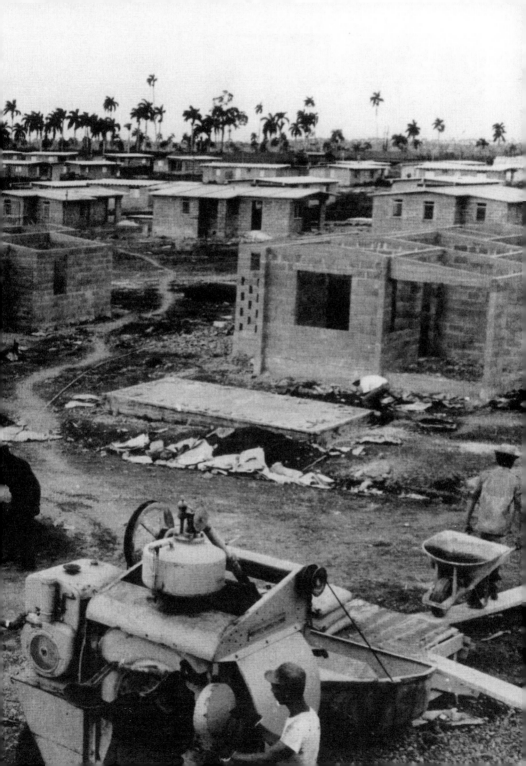

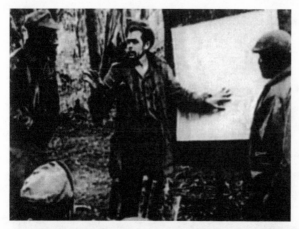

Che Guevara in the Congo in 1965.

Previous two pages: Large-scale housing construction in Matanzas province in 1962.

Che Guevara in Bolivia in 1967.

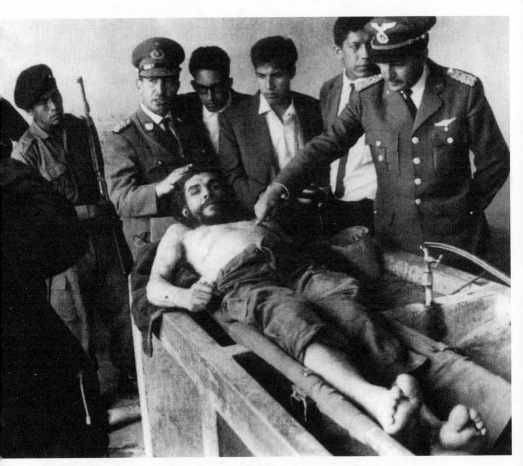

Above and next page: Che Guevara's corpse is displayed
in the Vallegrande hospital in Bolivia on October 9, 1967.

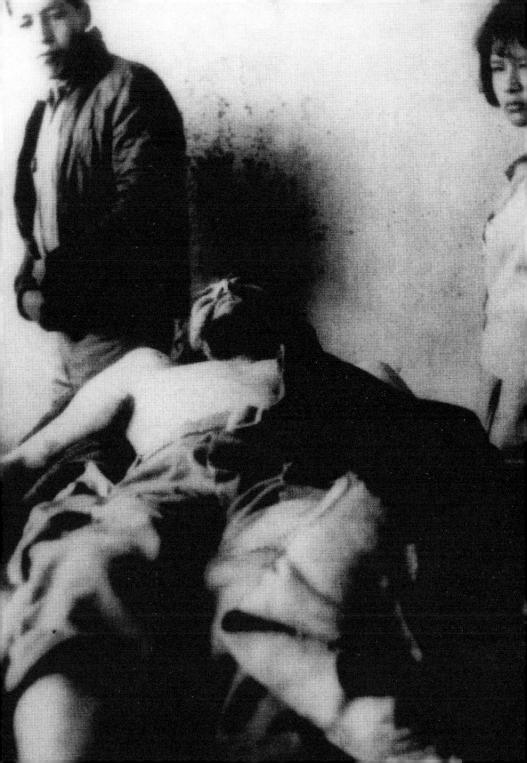

History Has Not Ended

Michael Löwy

History is a long way from ending. In the last thirty years, we have seen, in Europe and across the globe, a series of revolutionary events of the greatest social and political importance—even if they differ from the classic revolutions of previous decades. Among these upheavals of an emancipatory vocation, five inflame the imagination: May 1968 in France, the Carnation Revolution in Portugal (1974), the Sandinista insurrection (1979), the fall of the Berlin Wall (1989), and, more recently, the Zapatista uprising in Mexico (1994). Still, we are faced with very different sorts of events, each of which has its own distinct political logic, situated in unequal social and political universes, but all sharing in common liberatory impulses, popular rejoicing, and massive youth participation. Each in its own manner has made its mark on the last third of the twentieth century, leaving an imprint on the collective memory of the world's people.

May 1968 was not a revolution; rather, it was an immense wave of social, cultural, and political contestations, sustained in its most radical expressions by revolutionary aspiration. Its imagination fed off revolutions past and present—from the Paris Commune to the Vietnamese and Cuban Revolutions; thus, we are dealing with an innovative event with its own original characteristics. The gestures that it inherited from the past, such

as the building of barricades from paving stones, passed hand over hand in a human chain of solidarity, did not have the same functions as they did in the past: they are now symbolic acts. There are no rifles or grenades, much less machine guns or artillery. The violence is controlled and limited to the throwing of rocks and paving stones, to which the "forces of order" respond with clubs and tear gas. At times the youth launch Molotov cocktails, but this serves first and foremost to set fire to cars—a material embodiment of commercial alienation—or their own barricades in hopes of slowing the advance of the police. The fires glowing in the streets of Paris have illuminated the social imagination of the last three decades, not only in France, but all over the world.

It is young people, without a doubt, who drive the movement, starting at the Université Paris Nanterre, on March 22, 1968. And it is also young people who serve as the movement's leaders and spokespeople, people like Alain Geismar, Jacques Sauvageot, and Daniel Cohn-Bendit, whom we find, fists raised in the air, at the head of the mass demonstrations like the one of May 13 that brought together students, teachers, and workers. Off to the left in one photo, we see Michel Recanati, alias "Ludo," chief of security for the Revolutionary Communist Youth (JCR) who would commit suicide some years later (in 1978) and whose actions would be retraced in a film by Romain Goupil, *Mourir à trente ans* (1982).

If the young, red-headed Jewish-German anarchist Daniel Cohn-Bendit has become the most representative figure of the movement, it is undoubtedly because he expresses the liberatory and insolent spirit of May 1968 wonderfully. There is a famous photo—which has been transformed into a silkscreen—that shows him standing off against a police officer. Cohn-Bendit is armed only with his mocking grin, an image that perfectly captures the daring and ironic and corrosive humor known as chutzpah in Yiddish.

The photographs of the time are surprising for their evidence of the high level of participation by women, not only in strikes and factory occupations, university debates, and street demonstrations, but also in the construction

of barricades. It is no accident that a photo destined to become a symbol—or, if we prefer, an allegory—of May 1968, one that is reproduced thousands of times in innumerable publications, depicts a young Jewish woman perched on a boy's shoulders waving the flag of the Vietnamese Revolution. Thanks to an article in *Le Monde* published in 1990, we now know that the picture was of a young English aristocrat who paid dearly for her rebellious gesture: when the photo was publicized, her grandfather disinherited her.

We must not forget that May 1968 was also an enormous and extraordinary festival where, if imagination itself could not take power, it did cover Paris in splendid posters, handcrafted in

May 1968: a female participant.

the popular studio of the School of Fine Arts, specializing in poetic, subversive captions of Situationist inspiration. It was also a festival of music, be it Jean Ferrat playing his guitar for workers on strike at the Renault factor or an anonymous pianist playing in the heart of the Sorbonne University occupation.

The students' Sorbonne and the workers' Renault were the two symbolic centers of May 1968, sites of occupation, of discussion, of festivities. There,

we find in concentrated form the strengths and weaknesses of the two movements, whose convergence—despite reciprocal disagreements, conflicts, and mistrust—came close to overthrowing General de Gaulle and his Fifth Republic.

The April 1974 Carnation Revolution in Portugal hardly resembles the French May. Instead, we are dealing with a frankly revolutionary movement that overthrew one of the oldest European dictatorships, namely, the regime established by António de Oliveira Salazar in 1932, which combined authoritarian, corporatist, and fascist traits. Although quite unusual in modern history, it was a group of young military officers—discontented with the interminable colonial war in Africa—that took the initiative and launched the movement against Salazar. United around Captain Otelo Saraiva de Carvalho, these officers overturned the dictatorship, then headed by Marcelo Caetano, Salazar's successor, by means of an armed uprising on the night of April 25, 1974.

Crowds immediately took to the streets and headed to the prisons with the aim of freeing political prisoners and sacking the archives of the International State Defense Police (PIDE), the regime's feared political police. Photos used by the police to identify dangerous "subversive" militants ended up in history's waste bin.

Cars drove through Lisbon filled with jubilant young people flashing victory signs. Surprisingly, a massive number of soldiers and sailors took part in street demonstrations. The same naval marines who only months before had filed past the regime's dignitaries in formation were now participating in the revolution. They can be seen marching joyfully, signing or shouting revolutionary slogans, each carrying a carnation in one hand and in the other a very popular leaflet that proclaimed "For the immediate return of all soldiers," printed with a hammer and sickle and the number four—most likely to designate the Fourth International. Soldiers had been sent to Angola, Mozambique, and Guinea-Bissau to fight against liberation movements, in defense of Portugal's colonial possessions. One must recall

scenes from the 1905 Russian Revolution in Odessa—or at least the film version created by Eisenstein in *Battleship Potemkin* (1925)—to find soldiers, sailors, students, workers, and women marching together arm in arm.

One of the first measures of the new provisional power, which was essentially composed of insurgent officers in the Armed Forces Movement (MFA), was to allow political exiles to return. Crowds gathered in front of the train station to welcome back communist leaders like Álvaro Cunhal and socialists like Mário Soares. The slogan "Freedom, Democracy, Socialism" seemed to summarize

Carnation Revolution, Portugal: the lieutenants take power.

the Portuguese people's revolutionary aspirations. There was a certain air of May 1968 in the innumerable demonstrations that flooded Lisbon's streets and squares, with throngs of young people scaling monuments to raise their fists—the traditional gesture of the Reds in every country and continent.

May 1, 1974, was the first public, united, and massive gathering of a left-wing people repressed during a half-century dictatorship. An immense crowd filled Lisbon's stadium waving banners and flags. Something new was underway; a profound change was taking place. The left demanded that soldiers be recalled from Africa and, a few months later, the troops disembarked on Lisbon's docks, welcomed with open arms by their

families, who could not contain their delight: the revolution put an end to the colonial "dirty war" that had lasted for many years.

One year later, on April 25, 1975, elections for a constituent assembly took place. Long lines formed at polling places, including in the most isolated villages. Everyone—young and old, men and women, students and illiterate peasants—wanted to participate in the first democratic elections in fifty years. The left—socialists and communists—won a wide majority, but disagreements between the two forces impeded united action. Soon after, the revolution would end: the most left-wing militants would be marginalized and Portugal would return to "normalcy" under the leadership of a social democratic government headed by Soares.

Of all the events of the last thirty years, the Sandinista Revolution of 1979 is perhaps the one whose images most closely resemble the paradigmatic revolutions of the first half of the twentieth century: barricades bristling with rifles, armed insurrection, mass rebellion, bloody confrontations, and the downfall of a tyrant all mark key moments of this new epoch in Latin America.

The revolt was directed, above all else, against the Somoza dynasty that reigned sovereign over Nicaragua for a half-century. Like his father before him, Anastasio Samoza Debayle ruled through fraud, corruption, and especially his omnipresent Praetorian guard, the Military Police of the National Guard.

The Sandinista Front for National Liberation (FSLN), founded in the 1960s by Carlos Fonseca Amador, laid claim to the memory of Augusto César Sandino, the legendary guerrilla who fought against the US Marines until he was assassinated in 1929 by General Anastasio Somoza (the elder), who went on to found the dictatorship in the 1930s. It was not until 1978, after long years of employing rural guerrilla tactics under trying conditions, that the FSLN managed to overcome its divisions and become a real force based on widespread popular support.

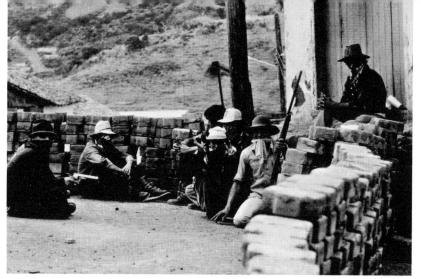
Sandinista barricade. Youths participate in large numbers.

One of the factors that contributed to the Sandanistas' clout was the participation of a considerable number of Christians. The best known was Ernesto Cardenal, a priest and poet, who was both a Catholic and a revolutionary. With his long white hair, jeans, and his ever-present beret, he became—first in Nicaragua and then after, in exile—one of Sandinismo's most popular personalities. His brother, the Jesuit professor Fernando Cardenal, played an important role in integrating many Christian youth and students into the FSLN. Thanks to the development of a current inspired by Liberation Theology in Nicaragua, the Sandinista Revolution was the first in modern history in which Christians made up a recognized and decisive component. This translated not only into a presence of priests and personalities in the FSLN leadership, but also into the massive participation of young Christians in the revolution. The number of photos showing young combatants brandishing a rifle or Molotov cocktails, with a cross hung around their neck, testifies to the revolution's originality.

Grouped around a nucleus of experienced guerrillas, who often came down from the mountains and the jungle—and who could be recognized by their uniforms and modern rifles—were thousands of youths who participated in different attempts at local insurrection, which, finally, led to the Somoza regime's downfall in July 1979. The most surprising thing

about photos from 1978–1979 is how young the combatants are, so young—children almost—that they are generally referred to as *muchachos*. Very often armed with simple pistols, trained to use grenades by throwing rocks, they fought from improvised trenches against military tanks. One photo of a barricade shows its rudimentary structure and fragile construction, the youth of the combatants who cover their faces with bandanas, and the unreliable nature of the weapons at their disposal.

Temporarily defeated, they dispersed, took cover, reorganized themselves, and went on the attack a few days later. This explains the importance of the masks that we frequently see in photos, ranging from simple bandanas that (partially) covered their faces to masks used in games or popular celebrations. These protected the insurgents from being identified by the police and military who, in the hours after a thwarted attack, conducted

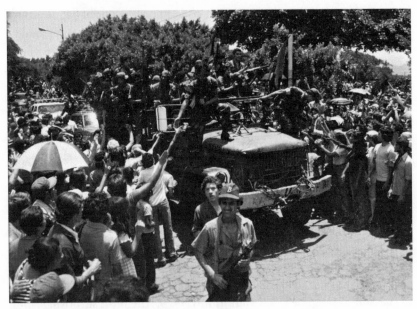

Nicaragua, July 17, 1979. The end of the dictatorship.

house-to-house searches, detaining anyone they suspected of involvement—as any young person was almost automatically considered to be.

A unit of Sandinista fighters headed by a truck is shown celebrating the fall of Somoza in one photo from July 17, 1979. The image captures the enthusiasm with which the population supported these *muchachos* and *muchachas* who had liberated Nicaragua from the sinister dynasty. The jubilant crowd, arms raised, reach out to shake hands with the Sandinista combatants.

However, after their triumph, the Sandinista dream would last no more than a dozen years. Attacked by the US government under President Reagan, by the conservative church hierarchy, and by the Contras—a coalition of former Somoza military officers and other opponents of the revolution—the Sandinistas would be defeated in the 1990 elections.

The curtain rises on an entirely different scene: the fall of the Berlin Wall in November 1989. A symbol of bureaucratic authoritarianism in Eastern Europe, this ominous fixture divided Berlin in half starting in 1961 and was guarded, day and night, by police dogs and security forces armed to the teeth. The goal was to prevent citizens from East Berlin crossing over to the "other side" at all costs, including the use of deadly force if necessary.

By 1989, we are long ways from the Berlin of Spartacist insurgents of 1919. The "socialist" bureaucracy inherited from Stalin had confiscated the revolution and locked it up behind a wall. But the regime was in crisis, and the new Soviet leadership (Gorbachev) did not come to East German leader Erich Honecker's aid when the people took to the streets. This was a peaceful crowd—it was not afraid, and it knew what it wanted: democracy, free elections, open borders. Men and women, workers and intellectuals, students and retired people marched side by side in the demonstrations, smiling, ironic, irreverent. The fight was directed against Stalinism and/or "Stasi-ism"—a term derived from the name of the feared political police,

the Stasi (Staatssicherheit, or State Security Service), whose burial would be held as soon as possible.

While the bureaucratic regime, now desperate, tried to buy time, the multitude went on the offensive and attacked the symbol of authoritarian power, the barrier that cut the city in two, the obstacle that impeded the free circulation of people . . . the wall. Quickly, hands armed with pliers cut the coils of barbed wire, while others, with pick axes at the ready, opened holes. In a few hours, whole segments of the wall were in ruins and the people were free to pass, to come and go as they chose.

Unlike Nicaragua in 1979, in Germany there were no dead or injured, nor were there bombardments or barricades: the violence was symbolic, the revolt peaceful. The regime, which only one year prior had succeeded in dispersing protesters, recognized its political defeat and did not attempt to oppose the popular will for change.

The images of the fall of the Berlin Wall circulated around the world. Co-inciding with the two hundredth anniversary of the French Revolution, the images appealed to people's collective memory: just like the Bastille two centuries before, the Berlin Wall fell under the pressure of the masses hungry for freedom. These images surely accelerated the breakdown of the remaining authoritarian regimes in Eastern Europe, which, except for Romania, followed the same peaceful, nonviolent path as in East Berlin. This is one example that shows how photography can be more than a simple reflection of reality, how it can become a component in historical processes of social transformation.

In little time, nothing remained of the hated wall, except its pieces—whether they were genuine or not matters little—which soon become lucrative objects of commerce between Berliners and tourists looking for "original" souvenirs.

The reality of the following years, however, would often be disappointing for the population of the former Democratic Republic of Germany, as

they soon discovered the malevolent aspects of Western capitalism: unemployment, social insecurity, individualism, an absence of solidarity, and the dismantling of social gains.

The Zapatista movement was born in Chiapas in the south of Mexico in January 1994, arising from a revolt that surprised all its observers. The Zapatista Army of National Liberation (EZLN) protested the lack of democracy in Mexico, where a single political party aided by the army had dominated the country for seventy years. However, the movement was, above all else, an expression of rebellion by indigenous communities of Mayan ancestry in Chiapas against the miserable conditions in which they lived. The EZLN's combatants, who laid claim to Emiliano Zapata's legacy, carrying rudimentary wooden arms, were the inheritors of five centuries of indigenous and peasant resistance against (Hispanic) "civilization" and (US) "modernization." They hid their faces behind bandanas, like the Sandinistas, or balaclavas, so as not to be identified by the police and military authorities. The EZLN was not a guerrilla organization in the traditional sense of the word but rather a type of "indigenous army," composed of families or entire villages who, from one moment to the next, could pull on their balaclavas and pick up their rifles. The prevalence of women in the

Zapatista youth in Chiapas in 1998.

Zapatista movement—including women commanders—marked a new development with respect to the *machismo* of Mexican society.

As with the Sandinista front in 1978, the Zapatista army was made up of two components: on the one hand, there was a nucleus of seasoned combatants, and armed youth in the Lacandon Jungle; on the other hand, there were indigenous families organized by the Zapatistas. The image of a young combatant with her face covered, weapon in hand, illustrates an innovative dimension of the EZLN. The photo is from 1998—at this point, the Zapatistas have agreed to a truce, but they have not surrendered their arms.

From the first moments, in the face of the January 1994 revolt by the insurgents in the city of San Cristóbal de Las Casas, the Mexican army responded with repression, sending tanks, armored vehicles, and troops. However, the support and sympathy the EZLN received from across Mexican society, such as from the antiwar demonstrations in Mexico City, obliged the authorities to negotiate, calling on Monsignor Samuel Ruiz, known as the "bishop of the Indians," to mediate.

The EZLN's communications—frequently written by their spokesman, the celebrated Subcomandante Marcos, a mestizo intellectual with Marxist training—were notable for their imaginative, ironic, poetic style, replete with indigenous myths. These communications contributed significantly to the EZLN's popularity and, as is apparent from the success of the Intergalactic Conference against Neoliberalism and for Humanity, organized by the Zapatistas in Chiapas in the summer of 1994, its echo was heard well beyond the mountains in southern Mexico.

Postscript

Michael Löwy

This book was published in 2000, and the last revolutionary movement mentioned is the Zapatista uprising of 1994. Since then no revolution similar to those of the past 150 years has taken place, but there have been several popular movements with a truly democratic revolutionary dimension. The most important were those of the Arab Spring, which succeeded, in two separate moments during the last decade, to bring down corrupt dictatorships in Egypt, Tunisia, Sudan, and Algeria. Something similar happened also in Libya, but was interrupted by foreign intervention, leading to a long period of chaos. In Egypt the democratic revolution was stopped, first by the Muslim Brotherhood and then by the military (General el-Sisi), and in Syria, the popular uprising ended in a murderous civil war between the dictatorial regime of Bashar al-Assad and various Islamic fundamentalist groups.

The most advanced revolutionary experience in the Arab region is the Democratic Confederation of Northern Syria ("Rojava" in Kurdish), under the leadership of the PKK (Kurdish Workers Party) in alliance with various local Arab democratic forces. Inspired by the socialist municipalism of the well-known American anarchist thinker Murray Bookchin, and with a strong commitment to women's emancipation, this is a unique social and political experiment. It is, however, very fragile, under the

threat of powerful enemies (Turkey and the Syrian regime), and very much dependent on the geopolitical strategies of the great powers.

During the two decades after 2000 there were also many popular uprisings in Latin America, leading to the establishment of leftist governments in various countries: Brazil, Uruguay, Argentina, Ecuador, Bolivia, Venezuela, etc. The most advanced experience in the continent was the Bolivarian Revolution in Venezuela, under the leadership of Hugo Chávez, whose aim was to establish a "Socialism of the 21st Century." This resulted in a confrontation with US imperialism, and an important redistribution of oil profits among the country's people. But the economic structure of Venezuela remained capitalist, and entirely dependent on the exportation of fuel. After Chávez's death, the declining price of oil in the world market led to a serious economic and political crisis, aggravated by Nicolás Maduro's authoritarian policies. The present US imperialist intervention—economic sanctions, military threats—is the main danger for the future of the Bolivarian Revolution.

Europe and the United States did not witness revolutionary movements, but very impressive popular mobilizations, in the form of Indignados occupying the main squares of the cities (Spain, Greece, the United States) and, more recently, the Yellow Vests demonstrations in France. An important wave of protest has been led by youth in response to the ecological crisis: "Change the System, Not the Climate" is their motto, which certainly has anticapitalist and revolutionary potential. At the moment this book is going into print, an extraordinary semi-insurrectionist upsurge has broken out throughout the United States, against police violence, racism, and social injustice. Black, brown, and white united in a popular rebellion without precedent since the 1960s. Is this the sign of a coming revolution, or just the latest expression of the subaltern's rage against the system? The answer, my friend, is blowing in the wind . . .

Bibliography

Paris Commune

The History of the Paris Commune of 1871
Prosper-Olivier Lissagaray
Translated by Eleanor Marx
Preface by Eric Hazan
Verso Books

The Civil War in France
Karl Marx and Friedrich Engels, 1871
Martino Fine Books

The Women Incendiaries
Edith Thomas
Haymarket Books

The State and Revolution
(especially chapter 3)
Vladimir Lenin
Haymarket Books

The Meaning of the Paris Commune
An interview with Kristin Ross
Jacobin
https://www.jacobinmag.com/2015/05/
kristin-ross-communal-luxury-paris-
commune/

Russian Revolutions of 1905 and 1917

1905
Leon Trotsky
Haymarket Books

The History of the Russian Revolution
Leon Trotsky
Haymarket Books

The Women's Revolution, 1905–1917
Judy Cox
Haymarket Books

Ten Days That Shook the World
John Reed
Haymarket Books

Alexandra Kollontai: A Biography
Cathy Porter
Haymarket Books

Eyewitnesses to the Russian Revolution
Todd Chretien (ed.)
Haymarket Books

The Russian Revolution at 100
A collection of 17 articles
Jacobin
https://www.jacobinmag.com/2017/11/
the-russian-revolution-at-100

Hungarian Revolution

Painting the Town Red: Politics and the Arts During the 1919 Hungarian Soviet Republic
Bob Dent
Pluto Press

Record of a Life: An Autobiographical Sketch
Georg Lukács
Edited by István Eörsi, Translated by Rodney Livingstone
Verso Books

Painting Budapest Red
Interview with Bob Dent by David Broder
Jacobin
https://www.jacobinmag.com/2019/03/
hungarian-council-republic-cultural-work-arts

The Conversion of Georg Lukács
Daniel Lopez
Jacobin
https://www.jacobinmag.com/2019/01/
lukacs-hungary-marx-philosophy-consciousness

German Revolution

The German Revolution, 1917–1923
Pierre Broué, Introduction by Eric D. Weitz
Haymarket Books

In the Steps of Rosa Luxemburg: Selected Writings of Paul Levi
Paul Levi, Edited by David Fernbach
Haymarket Books

The German Revolution
Chris Harman
Haymarket Books

Witnesses to the German Revolution
Victor Serge
Haymarket Books

Working-Class Politics in the German Revolution: Richard Müller, the Revolutionary Shop Stewards and the Origins of the Council Movement
Ralf Hoffrogge
Haymarket Books

A People's History of the German Revolution 1918–19
William A. Pelz
Pluto Press

The German Revolution's Bloody End
Ralf Hoffrogge, Translated by Loren Balhorn
Jacobin
https://www.jacobinmag.com/2019/03/
german-revolution-1919-strikes-uprising-democracy

Mexican Revolution

The Mexican Revolution: A Short History 1910–1920
Stuart Easterling
Haymarket Books

Zapata and the Mexican Revolution
John Womack
Vintage Books

The Mexican Revolution
Adolfo Gilly
The New Press

Las Soldaderas: Women of the Mexican Revolution
Elena Poniatowska
Cinco Puntos Press

"Mexico's Revolution 1910–1920" (3-part series)
Stuart Easterling
International Socialist Review
https://isreview.org/issue/74/mexicos-revolution-1910-1920

Chinese Revolution

The Tragedy of the Chinese Revolution
Harold Isaacs
Haymarket Books

The Mandate of Heaven: Marx and Mao in Modern China
Nigel Harris
Haymarket Books

Women and China's Revolutions
Gail Hershatter
Rowman & Littlefield Publishers

Origins of the Chinese Revolution, 1915–1949
Lucien Bianco, Muriel Bell (translator)
Stanford University Press

The Chinese Revolution at Seventy
Dennis Kosuth
Jacobin
https://www.jacobinmag.com/2019/10/
chinese-revolution-anniversary-mao-cpc

Spanish Civil War

Homage to Catalonia
George Orwell
Mariner Books

The Revolution and the Civil War in Spain
Pierre Broué and Émile Témime
Haymarket Books

War and Revolution in Catalonia, 1936–1939
Pelai Pagès i Blanch
Translated by Patrick L. Gallagher
Haymarket Books

Revolutionary Marxism in Spain 1930–1937
Alan Sennett
Haymarket Books

Women's Voices from the Spanish Civil War
Jim Fyrth and Sally Alexander (eds.)
Lawrence & Wishart Ltd.

The Spanish Civil War
Geoff Bailey
Socialist Worker
https://socialistworker.org/2011/08/18/
the-spanish-civil-war

Cuban Revolution

Guevara, Also Known as Che
Paco Ignacio Taibo II, Martin Michael Roberts (Translator)
St. Martin's Press

A History of the Cuban Revolution
Aviva Chomsky
Wiley-Blackwell

Women and The Cuban Insurrection
Lorraine Bayard de Volo
Cambridge University Press

The Origins of the Cuban Revolution Reconsidered
Sam Farber
University of North Carolina Press

Che Guevara Reader: Writings on Politics and Revolution
Ernesto Che Guevara, David Deutschmann (ed.)
Ocean Press

The Cuba Reader: History, Culture, Politics
(The Latin America Readers)
Aviva Chomsky and Barry Carr (eds.)
Duke University Press

The Marxism of Che Guevara: Philosophy, Economics, Revolutionary Warfare
Michael Löwy
Rowman & Littlefield Publishers

Che's Revolutionary Humanism
Michael Löwy
Monthly Review
https://monthlyreview.org/1997/10/01/
che-revolutionary-humanism/

Photo credits

Acervo Alberto Korda: 493

Arquivo pessoal de Anita Leocadia Prestes: 535, 537

Arquivo Edgard Leuenroth, Coleção História da Industrialização: 533

Austin, The University of Texas at Austin: 64a

Berlin, A B Z: 258a–c, 259 © Willy Römer

Berlin, Bildarchiv Preubischer Kulturbesitz: 80–1, 96b, 102, 224, 225, 229, 230–1, 232–3, 234, 235, 236–7, 240–1, 298a, 300, 301b, 305, 311, 339, 340, 500

Berlin, Ullstein: 222–3, 242, 252–3, 260, 341

Pachuca, arquivo Casasola © Conaculta–Sinafo–Fototeca INAH: 276–7, 278, 280, 281, 283, 289, 292–3, 294–5, 302–3, 308–9, 310, 312–3

Paris, Biblioteca Nacional da França, Departamento de gravuras: 50, 56

Paris–Berlin, A K G: 58, 83, 84, 92, 93a–b, 97, 126, 127a–b, 130, 132–3, 136, 137, 142, 143, 147, 150–1, 152–3, 155, 158, 160, 161a, 162, 163, 227, 227, 228, 238, 239, 254a–b, 255, 257, 257, 261, 279, 282, 285, 286–7, 296–7, 301a, 304, 306–7, 487, 501a, 505b

Paris, Bulloz: 34–5

Paris, Keystone: 342, 393, 432, 433, 434–5, 442, 444, 445, 474, 475a–b, 477, 505a, 506, 507, 508, 509b–c

Paris, Keystone, arquivos *L'Humanité*: 492

Paris, L'Illustration/Keystone: 98–9, 124–5, 128, 138–9, 140–1, 145, 146, 148, 149, 154, 156–7, 161b, 176, 181a, 186–7, 188, 190–1, 202, 203, 288, 338, 344a–b, 345, 391a, 394–5, 396–7, 405, 410–1, 417–7, 419, 420, 421

Paris, Magnum: 481, 484–5, 488–9, 486

Paris, Musée de L'armée: 44

Paris, Roger Pic: 470–1, 491, 496–7, 510, 511, 512–3

Paris, Roger–Viollet: 36, 37, 38–9, 40a, 42, 48–9, 51, 52, 53, 54–5, 57a–b, 58, 60, 61a–b–c

Paris, Sipa: 85, 88, 90, 91a–b, 159, 392, 398, 399, 400, 402, 406–7, 412, 416, 424–5, 438–9, 472, 473, 490, 494–95, 498–9, 501b, 509a

Paris, Sygma: 388–9

Paris, L 'Illustration/Sygma: 82, 86–7, 94, 95, 96a, 100–1, 103, 104, 105, 122–3, 129, 131, 134, 135a–b, 144, 194–5, 196–7, 198–9, 288, 290, 291, 298b, 299, 336–7, 386–7, 391b, 408–9, 413, 428–9, 430, 431, 436–7, 443

Rio de Janeiro, *Correio da Manhã*: 536

Rio de Janeiro, Museu da República: 532

Saint–Denis, Musée d'Art et d'Histoire: 45, 47, 47, 62, 63, 65

São Paulo, Arquivo do Estado: 539

© Burt Glinn: 482–3

© Carlos Granja: 523

© Henri Cartier–Bresson: 358–9, 360, 361, 362, 363, 364a

© Henriques: 478, 479, 480, 502

© JAF: 346–7, 348, 354a

© Jean Pierre Rey: 521

© Marc Riboud: 365

© Matthew Naythons/Getty Images News: 525–6

© New China Pictures: 349

© Omar Menezes: 529

© Robert Capa: 343, 352–3

© Sebastião Salgado/Amazonas Images: 541

Captions indicate the location on each page, from the top to the bottom. It was not possible to identify the creator of many of the photographs in this book. If they become known to the editor, they will be immediately credited in subsequent editions. Non-credited illustrations are part of the French publisher's collection.

About the Authors

Bernard Oudin: Oudin was a historian and specialist in the Mexican Revolution. He lived in Germany and was a professor at the University of Heidelberg. He was the author of *Villa, Zapata et le Mexique en feu* (Gallimard, 1989) and, with Michèle Georges, *Histoires de Berlin* (Perrin, 2000), among other books.

Enzo Traverso: Traverso is a historian and professor at the University of Picardie Jules Verne. Born in Italy and based in France, he has authored many books on the history of the Nazis. He has published, among other books, *Fire and Blood: The European Civil War, 1914–1945* (Verso Books, 2016) and *Left-Wing Melancholia: Marxism, History, and Memory, 2nd rev. ed.* (Columbia UP, 2017).

Gilbert Achcar: Achcar is a professor at the School of Oriental and African Studies at the University of London and a member of the International Institute for Research and Education. His research interests include economic development polices in the Middle East and North Africa, and the sociology of religion. He is the author of many books, including *The People Want: A Radical Exploration of the Arab Uprising* (trans.) (University of California Press, 2012) and *Marxism, Orientalism, Cosmopolitanism* (Haymarket Books, 2013).

Janette Habel: Habel is a professor at the University of Marne-la-Vallée and the Institute for Advanced Latin American Studies (IHEAL) at the University of Paris III. Her research includes Cuba and United States foreign policy in Latin America, as well as contemporary Latin American history. She also participates in the Research Center for Latin America and the Caribbean at the University of Aix-Marseille. She is the author of *Ruptures à Cuba: Le castrisme en crise* (La Brèche, 1992).

Michael Löwy: Born in Brazil and educated in social sciences at the University of São Paulo, Löwy has lived in Paris since 1969. He is the director emeritus of research at the National Center for Scientific Research (CNRS). Honored in 1994 with a silver medal by CNRS for his work in the social sciences, he is the author of *The Theory of Revolution in the Young Marx* (Haymarket Books, 2004) and *The Politics of Uneven and Combined Development: The Theory of Permanent Revolution* (Haymarket Books, 2010).

Rebecca Houzel: Houzel is a historian whose research focuses on the representation of the political police in Soviet society.

Pierre Rousset: Rousset, who holds a doctorate in history, works with the Institute for Research and Education in Amsterdam (IIRE-Amsterdam). He is also a member of Europe without Borders and has been an advisor to the European Parliament. He is the author of *Le Parti Communist Vietnamien* (Maspéro, 1973) and *Communisme et nationalism vietnamien* (Galilée, 1978), among other works on revolutions in Asia.